EARTH-MAPPING

EARTH-MAPPING
Artists Reshaping Landscape

Edward S. Casey

University of Minnesota Press

Minneapolis • London

The author gratefully acknowledges the State University of New York, Stony Brook, for a subvention toward the production of this book.

See pages 227–28 for permission and copyright information.

Published by the University of Minnesota Press
111 Third Avenue South, Suite 290
Minneapolis, MN 55401–2520
http://www.upress.umn.edu

Library of Congress Cataloging-in-Publication Data

Casey, Edward S., 1939–
 Earth-mapping : artists reshaping landscape / Edward S. Casey.
 p. cm.
 Includes bibliographical references and index.
 ISBN 0-8166-4332-6 (hc : alk. paper) — ISBN 0-8166-4333-4 (pb : alk. paper)
 1. Cartography—History. 2. Artists as cartographers. 3. Cartography—Philosophy. I. Title.
 GA203.C37 2005
 758'.1—dc22

 2004020157

Printed in the United States of America on acid-free paper

The University of Minnesota is an equal-opportunity educator and employer.

12 11 10 09 08 07 06 05 10 9 8 7 6 5 4 3 2 1

To Jan Larson
Kansas soulmate and first mentor

To Parviz Mohassel and Christina Maile,
Wendy Gittler and Henry Tylbor,
Donna and Bruce Wilshire
East Coast painters, thinkers, friends

CONTENTS

ILLUSTRATIONS

ACKNOWLEDGMENTS

This book, which carries forward my earlier efforts to rethink art as a form of mapping, is truly a work of many hands. The first set of hands belongs to those artists whose living work suggested to me the rich potentiality of earth-mapping and who were willing to talk with me at length about their evolving projects: Sandy Gellis, Michelle Stuart, Margot McLean, Eve Ingalls, and Dan Rice. I met Sandy Gellis and Michelle Stuart at a seminar on "Art and the Environment" at the Esalen Institute a decade ago, and I have pressed questions on each ever since. Gellis's adventuresome mind and bold practice led me quickly to the frontiers of earth art. From Stuart I learned how such art can profit from multiple implacements—and how a dash of audacity ("Why can't I do it?" as she once exclaimed) serves such art so well. Margot McLean was also at Esalen, and since then viewing her exemplary landscape paintings has been of particular inspiration to me. Intense discussions in New York City and Thompson, Connecticut, with McLean and James Hillman have been especially clarifying. Eve Ingalls and I have been talking about art (her art and that of others) for more than two decades, and she first pointed me to the significance of Robert Smithson's work. I never cease being amazed at the innovations unleashed in her own artwork and at her crisp conceptualizing power. Dan Rice and I brooded over issues of painting and mapping during the past twenty-five years, patiently and probingly as befit his character, until his untimely death in 2003. To each of these figures I am immensely indebted, both for their thought and for their work—and for their enlivening personal presence.

A second group of hands is that of pioneers in the field whom I did not know personally but whose remarkable creations opened the path to earth-mapping, whether by way of earth works or by paintings that embodied such mapping. I refer to Jasper Johns, Richard Diebenkorn, and Willem de Kooning, none of whom expressly intended to map but who nonetheless practiced mapping in unexpected and inspiring ways. Robert Smithson first foresaw the profound link between earth works and mapping, and in his own extraordinary oeuvre and in a series of brilliant essays and interviews he laid out the entire field in a dazzling but short-lived career. His spirit still circulates among all those who dare to make artworks that map the earth.

Other hands contributed both personally and intellectually to the emergence of this book in ways too numerous to specify here: Eric Casey, David Michael Levin, Bruce Wilshire, Alexander Kozin, Donna Wilshire, Irene Klaver, Gary Shapiro, Véronique Fóti, Kelly Oliver, Glen Mazis, Janet Gyatso, Hugh Silverman, Andrew Haas, Brenda Casey, Lorenzo Simpson, and Ed Emmer. I appreciate Tanja Staehler's help with obscure bibliographical references and other vexing editorial matters. Martin Axon and Robert Rattner contributed their photographic expertise. Virginia Foster was indispensable at certain crucial moments. Mary Watkins was of special assistance near the end of the project.

This book is dedicated to the person who first took my passion for art seriously and who nurtured my fledgling attempts to move between the practice of art and its theory: I met Jan Larson in the art department of the Topeka Public Library in the early 1950s, and she has been my guide ever since. I also dedicate the book to three pairs of more recent friends: Parviz Mohassel, who is equally accomplished as painter and philosopher; Christina Maile, painter and printmaker of dark vistas whose wit lightens the lives of all who know her; Wendy Gittler, landscape and figure painter extraordinaire and compelling lecturer on art; and Henry Tylbor, who brings his brilliant mind and his mastery of many languages to bear on the most challenging of philosophical problems, all the while retaining his inimitable personal charm; Donna Wilshire, eminent feminist, mythologist, and musician; and Bruce Wilshire, philosopher of deep conviction and expansive vision.

Without the generous support of two deans of humanities and fine arts at the State University of New York, Stony Brook, Paul Armstrong and James Staros, this book would not have materialized in such a timely fashion.

My primary editor at the University of Minnesota Press, Pieter Martin, was stalwart in his support at every stage. Robin Whitaker did admirably exact and exacting copyediting, and Laurie Prendergast put together a fine index. Laura Westlund adroitly intervened at a critical moment in the production process, while Catherine Clements brought that process to an elegant end. To Douglas Armato, director of the Press, I am deeply grateful for his unstinting encouragement of this project from its inception.

Prologue

MAPPING IT OUT WITH/IN THE EARTH

> From *Theatrum Orbis Terrarum* of Ortelius (1570) to the "paint"-clogged maps of
> Jasper Johns, the map has exercised a fascination over the minds of artists.
> —Robert Smithson, "A Museum of Language in the Vicinity of Art"

Painting and Mapping Reconverge

One might have thought that in the late modern and postmodern worlds painting and mapping had long since parted ways. Cartography has become increasingly rigorous and demanding, to the point that the pictographic and topographic elements that were such important features of earlier maps (e.g., in late medieval portolan charts and in sixteenth- and seventeenth-century Dutch world maps) have been virtually eliminated. Even the purely decorative components of maps, so widely employed in the most diverse cultural settings, have ceded place to strictly utilitarian symbols that have to do with the measurement of space rather than with the landscape of place: sober signs for distance and scale have replaced images of colossi and cities, gods and mountains. We are left with the ordinary road map, primarily of practical value, or with the detailed and precise surveyor's map. Nothing painterly in either case; indeed, nothing even ornamental.

In contrast, painting from early impressionism down to the present moment has become ever more detached from issues of exact pictorial representation. Where Thomas Cole struggled to make *The Oxbow* (1836) a faithful depiction of the scene he beheld from the top of Mt. Holyoke (on which he made a series of careful preliminary pencil sketches to guarantee this fidelity),[1] the situation changed radically a half century later: by 1886 Van Gogh, Cézanne, and Monet were creating landscape paintings in which isomorphism with an original scene was no longer a controlling criterion. Being "true to the motif" (in Cézanne's phrase) became more important than being true to the site, even though a passion for elements of representation remained. In the succeeding fifty years, almost all pretense to accurate representation vanished in the wake of Kandinsky and Klee and Picasso, even if traces of the represented world persisted and a choice between representational landscape (e.g., in the work of Benton, Marin, and Porter) and wholly nonrepresentational art (such as the paintings of Malevich, Albers, and Rhinehart) was still palpable. After that, the

final vestiges of representation were removed, most saliently in the paintings of abstract expressionism, but also in minimal art and conceptual art. If representational painting still occurs, it seems an anomaly, even a parody of its former hegemonic position.

In light of this divergent history, it would be plausible to think that mapping and painting can no longer communicate with each other, much less join forces in a single work. The augmenting demand for cartographic exactitude in mapping and the equally intense rejection of ideals of pictorial representation in painting would seem to move these two activities in diametrically opposed directions, leaving an unoccupied abyss between them.

Despite this severance of the cartographic from the painterly—itself reflective of a much more pervasive alienation between humanistic values and those prevalent in science and technology in Western culture at large—certain countertendencies have emerged in the past several decades. The self-absorption of the visual icon that reached its most convincing peak of expression in the numinous abstractions of Mark Rothko in the late 1950s and 1960s, along with the equally abstract works of Barnett Newman and Clifford Still and Hans Hoffman, led to a renewed interest in what might be called an ultimate concrete referent. Whereas Rothko, Newman, Still, and Hoffman (standing on the shoulders of Albers and Mondrian and Kandinsky in an earlier generation) all sought a transcendent abstract referent that was quite literally transcendent to the world of lived experience—hence the enigmatic, sometimes religious aura of their works—younger painters became concerned with a referent that could be considered both specific and immanent. An emphasis on the self-absorbed icon gave way to a concerted connection with context, with the singularities of the surrounding world.

The most conspicuous instance of this latter tendency is that of "earth works" of various sorts, most prominently those of Robert Smithson, who not only placed the work of art *in the earth* (as Henry Moore had done for decades and Claes Oldenburg more recently) but made the *earth itself,* suitably reshaped, *into the work.* Others followed suit with significant variations on this move, for instance, Christo's "wrapped" landscapes and buildings, wherein the natural scene or architectural object was transformed by enormous coverings that at once shrouded and decorated them. Of kindred spirit was a new passion for "environmental art" that is sensitive not just to the natural world as such but also to its cultivation and conservation; to this passion, in the wake of Smithson's inaugural efforts, I shall return in part I, where the work of Margot McLean, Sandy Gellis, and Michelle Stuart will be under discussion. Common to all of these trends was a renewed respect for the earth, its hidden potential and unsuspected power. The world of abstraction—a self-enclosed whole, with an otherworldly referent at best—ceded place to the earth of concrete sensibility.

In keeping with this earthward direction, a renewed interest in the marriage of mapping and painting has arisen. This marriage takes a very different form, how-

ever, from earlier such alliances. Whereas Vermeer placed scrupulously detailed representations of actual maps on the walls of his interior scenes, and many other painters (not only Cole but also Albert Bierstadt and Frederick Edwin Church among others) made precise pencil sketches that were the functional analogues of maps, now the aim became the very different one of regarding the painting itself as a map (or as its virtual analogue). In this way, the landscape of the earth, its sensuously presented surface, was not merely represented—representation per se became something optional rather than required, sometimes highlighted as such, sometimes neglected altogether—but *mapped*. The result was a genuine *mappa terrarum*, not an earth work in any literal sense but an *earth-map*.

An earth-map consists in laying bare what Heidegger calls the "self-secludingness" of the earth—its penchant for self-enclosed obscurity: for taking itself (quite literally) *underground* and then *turning itself inside out*, putting itself on display, as it were.[2] Unlike the modern poet, who must (in Rilke's words) effect an "intimate and enduring transformation of the visible into the invisible," the postmodern artist is engaged in letting the *invisible become visible*, bringing the obscure into the very light of day, into sheer visibility.[3] Not to the point of fully clarified transparency—that way lies luminism and impressionism, both intensely heliocentric—but to the point at which mapping of some sort becomes possible. Of *some* sort: not the usually recognizable sort, but something that can still, in some intelligible sense, be considered mapping. The core of this coherence is not that of being a representation of land (or sea) in the ordinary delimited meanings of *representation* (pictorial, isomorphic, etc.) but that of being a *re-presentation* of the earth, its *re-implacement* in an artwork, its *relocation* there. The point of painting that receives this inspiration is to re-create a qualitative aspect of the earth (and sometimes an entire aura of it) *in the painting,* where it is re-presented *as a landscape,* however difficult its recognition may be as part of a given particular scene in the world of perception. The transmutation effected by the painting is the action of mapping that it realizes. When this action is complete, when the work has become a work of art, an earth-map has been created.

Re-presenting the Land in Earth Works and Paintings

What does it mean to *map the land,* the very land that animals and plants, rocks and humans share as their common (if often contested) domain?

Mapping the land departs in significant ways from Western notions of mapping prevalent since the Renaissance. There is no longer any privileged sense of looking on from above (i.e., the "plan" perspective) or of seeing from the side (an "elevation" view) or even of viewing from a forty-five-degree angle (the "axonometric" perspective, strikingly present in certain Japanese topographic maps of the nineteenth century). It is a matter, rather, of *going through*—where *going* implies "engaged bodily motion": "per-motion," as it might be named. The view of antelope in Margot McLean's *Wyoming* (Plate 4), forcefully framed inside the work as

a whole, is a case of per-motion: our look goes through the inner frame to see these moving animals. But mapping the land is also and equally *going over,* not in the sense of flying over (the "bird's-eye view," "the view from nowhere"), but in the sense of becoming acquainted with: going over something in order to become more familiar with it. Such going-through and going-over are often realized by touching with one's own hands, getting the feel of the texture of something, its available surface. This provides a haptic aspect of mapping the land: as in McLean's painting, it means giving the viewer a sense of what the earth's surface feels like. At the same time, such mapping encourages one to see for oneself—seeing construed not as looking-on or looking-at but as *looking-into,* where this signifies both getting-into and viewing-from-within. Much as McLean gets us to see the animal for itself, in viewing an earth-map we come to see the earth for itself, becoming visible on its own terms.

Mapping the land, in other words, means showing how it feels and looks to be on or in the land, being part of it, groping through it in a stretch of what Deleuze and Guattari call "smooth space." Unlike "striated space"—which, in its gridlike and homogeneous character, is prone to classical mapping by means of lines of latitude and longitude (i.e., striations on the earth's surface regarded as a single planiform site)—smooth space is

> the space of the smallest deviation: therefore it has no homogeneity. . . . It is a space of contact, of small tactile or manual actions of contact, rather than a visual space like Euclid's striated space. Smooth space is a field. . . . A field, a heterogeneous smooth space, is wedded to a very particular type of multiplicity: nonmetric, acentered, rhizomatic multiplicities that occupy space without "counting" it and [that] can "be explored only by legwork." They do not meet the visual condition of being observable from a point in space external to them; an example of this is the system of sounds, or even of colors, as opposed to Euclidean space.[4]

Deleuze and Guattari need not have been so dichotomous in their description of smooth space, which is not only a matter of "legwork" and of "small tactile or manual actions of contact" in contrast with the visual space that is sedentary, homogeneous, and striated. It is also realized in various kinds of lively vision, for example, the glance. The French thinkers downplay the *visual equivalent* of smooth space by focusing on its tactility and palpability. This equivalent is what a number of contemporary painters provide, often precisely by an emphasis on color; for them, however, it is a matter not of a system "even of colors" but a system organized *especially* by colors. This is what I mean by speaking of showing how it feels and looks to be on or in the land, at its very surface: where feeling and looking overlap in terms of their experiential qualities as well as in their domains of application. In the domain that counts—that of the re-implaced earth—it is a matter of going through, going over, and getting into the land. *As if* by legwork: it is not a matter

of metrically determined motion in striated space but (like McLean's antelope) a matter of *moving in place*,[5] getting intensely involved just there, in a "space of the smallest deviation." (Striated space, on the other hand, is visual with a vengeance; it requires the remove from the land that only the austerities of oculocentric vision can accomplish with full success.)

The closest analogy to mapping the land construed in this expanded sense is the kind of intimate touching and close-up looking that occurs between parent and infant, between lovers, and between humans and certain animals. In these experiences, looking and touching merge in and on the body surface, a paradigmatic smooth space. Thus is realized what Deleuze and Guattari call the "local absolute"—the riveting to one place that is intensely invested with energy and speed—in contrast with the "relative global" of striated space,[6] where all that matters is how to get from one place to another most efficiently (a motion that is facilitated, if not literally represented, by modern road maps). The intensity of speed is thus to be contrasted with the extensity of motion.[7] On the surface of the baby's or lover's or animal's body one moves in-tensely, *in tension,* with the flesh of the other's body, indeed with diminutive steps, and at a speed that is both very fast and quite slow, in other words, not to be measured by the usual standards of locomotion that govern conventional maps. One goes over that flesh, that body, like a nomad circulating through a set of accustomed (but ever newly experienced) regions, always moving in place, always finding one's way on earth.

The artists to be discussed in this book all treat the earth and its land as such a body, however implicit their treatment may be in particular cases; each seeks a local absolute in the earth-body that is the ultimate, as well as the proximate, subject of their artwork. Each travels intensely, not merely extensively, over the body of the earth, the landed locality, the telluric or aqueous place that is the literal "topic" of their works. Each thereby creates earth-maps in which the earth is made to work, to appear, in a two-dimensional image or three-dimensional solid object. As Heidegger has it: "The work lets the earth be an earth."[8] The artist draws the earth out from its self-withdrawal into the brightly glancing realm of intensely realized smooth space.

The lived body is at stake throughout. It is the means of being in touch with the earth, whether the actual earth of an actual scene, the imaginary earth of non-representational landscape, or the virtual earth explored by the viewer's phantom body. The lived body is what affords a "feel" for a given landscape, telling us how it is to be there, how it is to know one's way around in it. Such a body is at once the organ and the vehicle of the painted or constructed map, the source of "knowing one's way about," thus of knowing how we can be said to be acquainted with a certain landscape. This landscape need not be our own; nor need it be the land east of Aix or the fields around St. Rémy. As re-presented to us as viewers, the painted or drawn or sculpted map of the landscape allows—invites, indeed sometimes demands—our lived body to enter into intimate accord with the configurations of

its smooth space. In this way, we come to know this landscape from within the terms of its own re-presentation. Knowing it by means of this re-incarnate knowing is the root of all subsequent representational knowing; it is the way by which we realize our kinship with the landscape itself. Thanks to the *re*-presentation—the presentation *again* of this landscape—we sense just how intimately linked we are with and in this re-implaced earth-world, how much our very "thrownness" is attuned, in mood, with the flesh of the world that we come to know in our own flesh as the world's flesh.[9]

Bodies inhabit places; there are places only as lived by bodies.[10] If the body is at stake in knowing the landscape, then place is equally at stake—and one because of the other. The landscape painters and other artists to be considered in this book delineate places in the landscape: they concern themselves not with the earth as a determinate entity (which is not only too large to be represented except from afar, e.g., from the moon by *Apollo 11,* but also too diverse to encompass) or with the world (construing this as an essentially historical-cultural construct) but with particular places and regions belonging to a given landscape, itself a finite but integral part of the earth.[11] The focused delimitation of the body rejoins, even as it animates, the exuberant finitude of the earth that is experienced by the body and re-presented in paintings and earth works. When body and place are intermeshed in artworks of either sort, not by striations of space but by intensities of speed, the result is mapping of a peculiarly powerful sort. Such mapping is itself a way of getting back into place otherwise than by getting to it in conventional cartographic means that emphasize measure and motion, calculation and counting. Constructed and painted maps of the kind we shall investigate in this book, that is, earth-maps, convey the sense of a place—its fully sensed overall bearing—rather than surveying the extent of a scene.

It will be objected that all great landscape painters do something like what I have just described. They too were mapping the land, and their work also calls us to extend the meaning of mapping beyond its customary cartographic conceptions. Or more exactly, their commitment to representational accuracy, to verisimilitude, cloaked a deeper loyalty to a bodily sense of place, most strikingly perhaps in the case of painters of the earth, such as van Ruisdael and Constable. But this same cloak of pictorial exactness brought only confusion to the issue of whether maps and paintings are kindred efforts, since it gave the impression that painters can pursue their own independent path to precise representation—a path that, in the most successful cases, needs no help from maps (or from any other form of isomorphic representation). Once painters give up their aspiration to pictorial completeness and clarity, however, they are no longer in competition with cartography and can enter into collaboration with it in new and unprecedented ways. (This is one way of understanding the revolution effected by Cézanne.) And when mapmakers in turn overcome their own concerted investment in pictometric representation in striated

space, they, too, become open to the creative collusion between mapping and painting that allows painting to be more than decorative distraction.[12]

Who Maps the Land?

My primary concern in this volume is with certain contemporary artists who have displayed a special sensitivity to novel forms of marriage between mapping and landscape painting (and other assembled or constructed works)—a marriage made possible by considerations of the sort that I am bringing forth in these preliminary remarks. For the relationship between mapping and artwork in general is entering into a new phase of collaboration, at once unprecedented and yet already latent within the earlier history of these two activities. No longer pursued separately or merely made compatible with each other, they are now able to enter into unprecedented forms of creative collusion.

Given the considerable scope that I wish to bestow on the concept of mapping the land, numerous other artists could have been discussed as representative cases in point. Aren't Dalí and Tanguy mapping surrealist landscapes? Did not Picasso and Braque provide cubist mappings of L'Estaque in the summer of 1907? What of Georgia O'Keeffe in New Mexico, Grant Wood in Iowa, John Steuart Curry in Kansas, or for that matter Monet at Giverny: aren't these various "regionalists" mapping *their* preferred land? Is not a new naturalist such as Neil Welliver, who paints painstakingly realistic scenes of woods and streams, mapping the landscape of New England as much as Hopper and Marin did before him?

Any of these figures might be taken as exemplary in indicating how to map the land. Nevertheless, each of those just named is embroiled in dimensions of mapping that are diversionary for purposes of this book. The surrealists were primarily concerned with laying out a certain kind of *space* rather than re-presenting place per se. This is evident in the implicit grid that subtends many works of Dalí and Tanguy: the striated space of regular recession and distant vanishing, onto which incongruous or grotesque objects are then superimposed. Picasso and Braque—unlike Cézanne, who also painted in L'Estaque a few decades before—were less interested in the hills and bay of this coastal city near Marseilles than in cubist deconstructions of linear perspective and complex configurations of pictorial space that owed very little, finally, to the place itself. The American regionalists, along with O'Keeffe and Hopper, certainly did concern themselves with particular places, but they were often more interested in conveying the narrative of a place than with mapping the land it contains.[13] Those who like Welliver are committed to extreme pictorial realism—whether that of Richard Estes's quasi-photographic sort or of Welliver's much more painterly approach—only continue the quest for the exact portrayal of place that I have examined elsewhere in the case of Cole, Bierstadt, and Church a century earlier, with the result that these more recent figures do not significantly advance our understanding of what it means to map the land.[14] Certain

other contemporary painters do, however, constitute such an advance, and for this reason I shall concentrate on their work in part II. I refer to Willem de Kooning, Jasper Johns, Eve Ingalls, Dan Rice, and Richard Diebenkorn. Each maps the land, whether in a recognizably pictographic or topographic manner or in a very different way that I shall term absorptive.

Four Ways to Map

Before entering into detailed discussions of particular artists, we must distinguish between four basic ways in which mapping of any kind occurs: mapping of, mapping for, mapping with/in, and mapping out.[15]

(i) *mapping of.* To make a map *of* something is to make a map of a particular place or territory in the effort to capture its exact geography, its precise structure, its measurable extent. *Cartography* is the institutionalized enterprise that concerns itself with the objective mapping of locales and regions; its aim is mensuration in accordance with the strictest arithmetic and geometric and geodesic standards. An ancient exemplar is still in use: the land survey (sometimes termed cadastre). Husserl argues that the origin of geometry itself is to be sought in the survey maps of ancient Egypt—land surveys in which regular geometric figures were abstracted from certain recurrent natural shapes. As these figures became more rigorously defined, they ceased to reflect natural contours as such and were increasingly *imposed* on land forms in an operation of "application," leading to an early alienation between cartography and landscape.[16] Later on, this alienation was taken for granted—so much so that it became a matter of indifference—and is embedded in the objective genitive *of* contained in the seemingly innocuous phrase "map of." To make a map of X means, typically, to stand apart from X; if it is not to survey it literally, it is to pin it down with resolute exactitude, to position it on a grid in terms of preposited world coordinates, to determine distances between points, and to embody a readable sense of scale for everything represented in the map.

(ii) *mapping for.* Mapping is *for* something, and not strictly *of* something, when it is designed expressly for some particular purpose. For example, You Are Here maps indicate where certain places are located in a given terrain in relation to where you are now situated as you read the map itself.[17] These maps, usually posted in very public spaces (now including the virtual space of web sites), enable the viewer to get to a particular location in the most expeditious way. They do not pretend to cartographic accuracy; rather, their point is to provide a schema of how to move most efficiently across a portion of (implicitly or explicitly) gridded space. Such maps draw on—indeed, are projections of—an easily accessible species of knowing how to get somewhere, that is, geographic "know-how." These are maps not for all seasons but for the sake of indicating to people (especially newcomers) how to go from a given location (usually, where one is now standing when looking at the map itself) to any of several different locations designated by the map—how to do

so *over* or *on* a space whose peculiar landscape features are schematically rendered or even omitted. Such maps are primarily maps for getting somewhere in particular, that is, one's destination. They are in effect *maps for others* (i.e., newcomers, including oneself as a stranger to a place); only rarely does one draw such a map for oneself, though this can occur in the guise of a simple sketch meant to serve as a reminder of how to follow complicated directions to a certain place.

(iii) *mapping with/in.* Where the first two kinds of map are *indicative* signs by their very nature and function—each being a subsistent particular that points to the presumed existence of another such particular (i.e., object, place, or region)[18]—a map *with/in* proceeds by adumbration rather than by indication: by indefinite indirection rather than by definite direction. Instead of the land (or sea or city) as a discrete entity or the relationships among the locales themselves, what is mapped here is one's *experience* of such locales. Such mapping concerns *the way one experiences* certain parts of the known world: the issue is no longer how to get there or just where "there" is in world-space, but *how it feels to be there, with/in that very place or region,* whether the feeling itself is one of amazement or boredom, duress or ease. I divide up the word *within* in order to signal the internal complexity of this experience. On the one hand, the viewer of such a map is drawn *in* rather than encouraged to hover *above,* as in the case of many cartographic representations. On the other hand, one experiences oneself as *with* the landscape instead of *apart from* it. The *with* is of special interest. For one thing, it connotes the *withness of the environing earth,* which is to say the circumambient landscape in which we are stationed at all times. But it also signifies the "withness of the body" (in Whitehead's phrase, echoing Hume),[19] that is, the fact that we encounter things by means of our body as a constant companion and effectuator of experience. The two withnesses entail each other: I am with my surrounding place to the extent that I am experiencing it with my body; and I am with my body to the extent that I experience the landscape laid out around me. I exist with both at once. Thanks to this double facticity, *I am in the landscape itself* instead of being its objective cartographer: withness, not witness, is at stake here.[20] This being with/in the sensuous world, the material earth, is a condition of possibility for inhabiting any given region, any particular place, of that earth or world. To map with/in is to furnish an earth-map of a given place or region: a re-presentation in some specific medium of what it is like to be there in a bodily concrete way.

(iv) *mapping out.* To the degree that I find myself with/in the living landscape, I am part of that landscape, just as it is part of me. The boundaries between myself as mapmaker and the earth I map—boundaries that become strict borders in the case of the official cartographer, who is a representative of a "major science"[21]—are porous when I bodily feel a given landscape. I am *of it,* and it *of me*: in a subjective genitive sense of *of* that means "belonging to." But just because of this mutual incorporation of self and earth, the human subject must find a way *out* if he or she is to re-present the experience of deep immersion in such a manner as to make

this experience accessible to others. There has to be a moment or mode of what is misleadingly called expression—misleading insofar as this implies an enclosed subjectivity that literally presses outward what it already feels or knows—but what is better designated as *mapping out,* getting the experience into a format that moves others in ways significantly similar to (if not identical with) the ways in which I have myself been moved by being with/in a particular landscape. "The truth will out": the truth of the landscape (where the *of* is here used in a Hegelian sense of being the truth found in the next higher stage of realization) is to be found within the framework of a genuine earth-map. Mapping out does not mean tracing out the mere outlines of objects in the landscape; it means following out the lineaments of the earth, putting down its main marks, limning its first features: a procedure of a decidedly nonmajor or renegade science, since it does not pretend to regulate the representation or even to make a representation at all in any conventional sense.

From the publicness of mapping of and for—concerns of the major science of cartography and the practical science of orientation, respectively—we proceed to the immersion of mapping with/in, only to enter into the institutionally minor but humanly very important science of mapping out. Three major moments (public, bodily, interpersonal) demarcate four modes of mapping the earth.

Earth Art: A Prospectus

Earth-Mapping is the fourth in a series of studies on the importance of place in people's lives. In the first two volumes, I explored the concrete experience of place (in contrast with site) as well as the history of philosophical thought about place (versus space). The third of these works, *Representing Place: Landscape Painting and Maps,* considers basic issues in the representation of place in landscape painting and maps. Far-ranging as it is in subject matter (from paleolithic petroglyphs to modern survey maps), it has two inbuilt limits: First, it examines only those Western and Chinese and/or Japanese artworks and maps that were created before the end of the nineteenth century. Second, it regards mapping and painting as distinct activities that converge and overlap in certain significant instances but almost never fully coincide. I pointed to creative combinations of cartographic and painterly traits in single works—for example, van Linschoten's *View of the City of Angra on the Island of Terceira* (1595) and Keisai's panoramic map of Japan (c. 1824)—but found only rare cases of works that were altogether, and at once, maps and paintings.[22]

The picture has changed drastically in the past fifty years. On the one hand, ways of painting have developed that can be considered mapping—not just incidentally or partially, but through and through. On the other hand, a new art form has evolved, that is, earth works, which map by their very essence and not just exceptionally. These two new directions, through evolving independently, call for reassessment of the relationship between art and mapping. To do this, we must open up the concept of mapping along the lines I have suggested just above, in the section

"Four Ways to Map," in this way preparing us to find new forms of mapmaking at play in artworks of the most diverse descriptions—anything from canvases that present themselves as landscape paintings to outsized earth works that dominate a desert scene. I shall endeavor to show that works at these two extremes and others at various intermediate points should be construed as fully hybrid entities, at once artwork and mapwork. There now exist in abundance two-dimensional works (drawings, paintings, photographs) that map in some intelligible sense, as well as three-dimensional entities (earth works proper, certain architectural works, some kinds of sculpture) that accomplish mapping in equally convincing forms. This book explores this dual development in two major parts.

In part I, I follow out the fate of earth art in recent decades, starting with its primary pioneer, Robert Smithson, who is responsible for the first genuine earth works and for their conceptual basis. I also take up the innovations of Margot McLean, who incorporates earth (literally) and animals (by image) into her paintings; Sandy Gellis, whose projects include the effects of rainfall over time and of rivers and other waterways sampled periodically; and Michelle Stuart, who works in many media, locations, and scales. Each of these artists sets forth his or her connection with the earth and, in the process, suggests new ways to map the places and regions that make up its rich textured surface.

In part II, I discuss the works of a group of painters who find their path to mapping in complex ways; in terms of style, these range from abstract expressionism (Willem de Kooning) to abstract impressionism (Dan Rice), from ironic pop art (Jasper Johns) to a lean quasi geometrism (Richard Diebenkorn), and include an artist who defies any single descriptive tag (Eve Ingalls). I argue that, despite their manifest disparities, these artists manage to map in and through their painting and drawing and, in the process, devise a novel form of mapping that I call *concrete* and, in particular, *absorptive* and that exemplifies mapping with/in and mapping out. In so doing, these artists valorize the role of the lived body in the creation of the hybridized painting-maps they create, and I investigate in depth this bodily basis of the earth-mapping that is thereby accomplished.

The two directions here to be discussed (earth works created for the first time, painting taken to a new limit) are the main modalities of what I shall call earth art. Whether realized in two dimensions or three—whether displayed in galleries or located outside on the land, whether representational in status or resolutely unrepresentational—earth art is characterized by the recognition of the earth as the unique home-place for human beings and the other living and inanimate things (animals, trees, rocks, elements) that inhabit its delimited but diverse domain. Earth is the ultimate place, the Place of places, for all these entities. This is not to privilege wilderness over civilization but, rather, to point to the *wild* as the deepest dimension of such a world. The wildness of earth is permeable by culture, just as culture itself retains a wild side that cannot be extirpated. Making this compenetration possible is the lived body as the mediatrix of culture and nature alike.

Earth art in its two exemplary forms points to earth as the most encompassing place-world. Such art no longer seeks representation of the earth as an aesthetic ideal of the sort that was actively embraced in nineteenth-century landscape painting—and that reflected in turn the modern era's obsession with "the world as representation" (in Schopenhauer's telling phrase). Instead, it seeks to re-embody integral parts of the planet (e.g., mountains, rivers, deserts) in singular paintings and earth works—to re-present and re-implace the earth in artworks that map. In the leading directions of earth art we witness new ways of experiencing the place-world: ways that map out this world from with/in it, thereby enabling its renewed comprehension at a historical moment when it is desperately needed.

PART I

EARTH WORKS THAT MAP

Chapter 1

Mapping with Earth Works

Robert Smithson on the Site

I'm more interested in the terrain dictating the condition
of the art.—*Robert Smithson, "Fragments of a Conversation"*

It was all a sort of product of a kind of jeopardized
map making.—*Robert Smithson, "Conversation with
Dennis Wheeler"*

Maps are very elusive things.—*Robert Smithson,
"Discussions with Heizer, Oppenheim, Smithson"*

Bringing the Map onto the Earth

In most conventional views of mapping, a map is about the earth. It is about it
in the sense of giving information concerning it, furnishing data about its extent
and shape, its primary and secondary features. In order to achieve this goal of
most modern cartographic mapping, the map must also be about the earth in
another way: it must hover about the earth, taking a view from above, an aerial
view that purports to be at once objective and comprehensive. Not surprisingly,
then, most post-Renaissance maps in the West provide plan views, as if the map
were a window on a place or region through which the map viewer looks down
as if from a tower or an airplane. The implicit verticality of this elevated posi-
tion is as mandatory and striking as the laid-out horizontality of the landscape
onto which the map affords a view. Any such map claims to be independent of
the earth it represents; it has departed from that which it depicts. And the further
the departure, the better: the ultimate map is the photograph that is taken from
an unmanned space satellite circulating high and free above the earth. Thanks
to its powerful cameras, the satellite generates information about anything and
everything that creeps on earth, indeed, more information than we might ever
want—the higher the view, the more sweeping the vista below. Hence the need

3

for grid lines to contain as well as to locate the otherwise overwhelming mass of data received and recorded. (We shall return to grid lines later.)

But what if mapping were to happen otherwise? What if a map were not about the earth in the various senses just discussed but about something belonging to the earth itself? That is to say, *part of its very surface*. Not covering the surface completely on a scale of 1:1 (as in the Borgesian fable of the map that was constructed to match every square foot of a region), but somehow situated *on* that surface. What then? Then the map would not just describe or designate natural (or artificial) features of the earth but would also join these features; it would be itself a feature of the earth of which it is a map. Indeed, the map itself would merge with the earth. It would become part of the earth it is presumed to describe graphically (i.e., cartographically, photographically, etc.). The map would become an earth work.

On this conception, an earth-map is a map that no longer has the status of an indicative or iconic sign—the status of most conventional maps that point the map reader to terrain whose existence is separate from that of the map even if it is isomorphically represented on the map. Instead, an earth-map has become part of the earth's existence. No longer is the earth presumed to possess a primary reality that is merely mimicked by the second-order reality, the representational status, of the map. Now the map is itself a primary reality; it is as primary as the earth, since it has become part of the earth.

A map that is an earth work is something that has become sensuously actual. It is no longer something just to be seen, as in the case of traditional maps; it can also be touched, manipulated, sculpted, recast, and so forth. It has gained the standing of a Thing, an entity with its own depth: it is a map in three dimensions. Like the surface of the earth to which it belongs, it can be *worked* as well as *reworked*. It is an earth work in both senses of this ambiguous term: it is the effect or product of work, but it is also the very activity of working. An earth-map as earth work entails the working-through of materials furnished by the earth, either directly (in the case of soil, rocks, minerals, etc.) or indirectly (in the case of metals or other synthetic products). Earth-maps can be drawn—inscribed or printed on paper—but they are mainly worked up from elemental materials, beginning with the four ancient elements of fire, earth, air, and water. The graphic is thereby subordinated to the sculpted, the line to matter, the chemical to the alchemical, the hand to the whole body.

In part I, I explore various efforts to merge maps with the earth, to meld their descriptive powers with the earth's elemental matrix. I leave to part II a more complete description of the role of the lived body in earth-mapping. At this early point, I focus on various ways in which the very idea of mapping has been altered by certain artists who have taken the map back down into the earth, *down here below* instead of letting the map linger *up there above,* its classical as well as its modern position. The supposed superiority of the map in plan—its superposition, indeed its imposition—is here challenged and replaced by mapping in the material realm. Such mapping can occur by means of the materiality of paint or by directly dealing with the constituents

of the earth. If paint is the privileged medium, as it often is with Margot McLean and sometimes with Sandy Gellis and Michelle Stuart, it is paint pursued in its very physicality, its earthiness. The mapping that results remains earth-mapping, even if it is not an earth work in any strict sense—that is, a work that is no longer confined to canvas but is located in or on the surface of the earth.

By "surface" I do not mean the literal top layer of the earth, its outer surface alone, but the characteristic depth that the earth's surface brings with it. Different depths cling to every earth surface. Some of these are literal (as in topsoil), some are metaphorical or mythical (as in chthonian depths), but they all endow the surface with the requisite complexity and resilience to become the basis for the kind of working that creates earth-maps instead of cartographic representations.[1]

Site versus Non-site

In this telluric enterprise one figure stands out as the genuine pioneer: Robert Smithson. Others of his generation were important as well: for example, Michael Heizer, Dennis Oppenheim, Edward Ruscha, Nancy Holt, Robert Morris, and Carl Andre.[2] But Smithson had the vision and persistence, until his early death, to set forth an entire program of creating earth works that were at the same time earth-maps. Not only did he create exemplary works of this kind, but he also wrote lucidly about their conception. Here I shall offer only a brief conspectus of his achievements, singling out those aspects that bear on mapping. Others have assessed his overall accomplishment, most notably Gary Shapiro in his book *Earthwards*.[3] Rarely, however, has the mapping dimension of Smithson's work been emphasized, despite his own recognition of its importance and his frequent recourse to the language of maps in his writings.

Perhaps the single most symptomatic action of Robert Smithson as a young artist living in New York City was to leave the city itself and go into the New Jersey countryside. He did so not just to escape the stifling atmosphere of art galleries and museums—part of what he liked to call "the urban desert"[4]—or to seek the consolations of natural beauty or to return home (he grew up in New Jersey). More important, he rejected the blandishments of technology in art, as in the perfected techniques of cast aluminum and molded steel sculpture as practiced by David Smith and Anthony Caro. He was looking for something else in New Jersey, something he assimilated to the "picturesque" in the original sense of a raw dialectic of change and chance.[5] What Smithson sought in the blighted suburbs of his home state was the rawness of abandoned stone quarries, the "burnt-out ore [and] slag-like rust" of industrial debris, and the offensively ugly pipes that spewed refuse from factories into the Passaic River; these last he called "Fountain Monuments."[6] Smithson's interest in such decidedly unbeautiful and unsublime things was more than academic or escapist or perverse. He found in them an authentic energy and an unrehearsed assertiveness that was lacking on the New York art scene, then in

a period of high abstractionism, which, whether expressionist or formalist, was effete in Smithson's eyes. What he sought was "the *elemental* in things,"[7] and the elemental is far more evident in piles of industrial detritus and relics of quarrying than in the sophistication of studio art—its craft and craftiness. Smithson liked to cite Heraclitus in this connection: "The most beautiful world is like a heap of rubble tossed down in confusion."[8] The heap, a disordered mound of matter, was as distasteful to gallery dealers on Fifty-seventh Street in New York City as it was to Aristotle, who disdained the random distribution of a mere heap.

Smithson was not content to leave the city and to contemplate the debris of civilization outside it, as if the two regions could be kept entirely separate and sealed off from each other. He insisted on bringing back the heaps of rubble to the city and exhibiting them, as sheer piles, in the very galleries he found to be otherwise so confining and purblind to the rawness of the elemental. In this spirit, he put on display boxes of rocks and unboxed piles of gravel, sometimes accompanied by mirrors, or maps, or photographs.[9]

Thus commenced a dialectic between inside and outside that was to preoccupy Smithson for the rest of his short career. Just as he had to get out of the studio and museum to reestablish contact with the earth, so he also had to return to exhibit what he found. Smithson called "sites" the places he visited outside the city and "non-sites" the exhibited collections from his site visits. In referring to a later foray, he said:

> I was sort of interested in the dialogue between the indoor and the outdoor and on my own, after getting involved in it this way, I developed a method or a dialectic that involved what I call site and non-site. The site, in a sense, is the physical, raw reality—the earth or the ground that we are really not aware of when we are in an interior room or studio or something like that—and so I decided that I would set limits in terms of the dialogue (it's a back and forth rhythm that goes between indoors and outdoors), and as a result I went and instead of putting something on the landscape I decided it would be interesting to transfer the land indoors, to the non-site, which is an abstract container. This summer I went out west and selected sites—physical sites—which in a sense are part of my art. I went to a volcano and collected a ton of lava and sent it back to New York and that was set up in my non-site interior limit.[10]

It does not matter that Smithson here uses *site* in a manner antithetical to my own preferred usage; I would call "natural place" what he terms "site," and his own employment of *non-site* is very close to what I call "site."[11] What does matter is that Smithson felt the urge to ground his art in the actuality of nonurban matter. At first, this meant any raw material encountered outside the city, including any instance of industrialized waste; but increasingly, it signified matter in its altogether natural state—soil, lava, basalt, and so on. It is such matter that belongs to a site first of all and by prior right as it were. About it, the earth artist can only say, "It

was there."[12] But the same artist is more than a passive witness; he is also called to retrieve samples of what has been found in a natural state and to make it available to others in the non-site of an exhibition.

By "non-site" Smithson means mainly a container (e.g., a wood or metal box within which the natural objects are held) and, more completely, a double container. For the gallery or museum is also a containing space, so that it is a matter of "the containment within the containment of the room."[13] Smithson here singles out precisely the same primary predicate of "place" *(topos)* as Aristotle did in his classical discussion in *Physics* 4: to be in a place is to be contained or circumscribed there (the Greek is *periechonta*, literally, "held around"). Aristotle's exemplary case is a vessel that contains a mixture of air and water; Smithson's own leading instance is a simple box that contains rock samples—a box he constructed himself (see Figure 1.1).

A comment by Smithson is attached to the photograph in the essay in which it first appeared: "a slate site in an uncontained condition before being contained in a Non-Site by Robert Smithson." For Aristotle, there is no uncontained condition—unless it be that of the Prime Mover. For Smithson, even a quarry, though created for delimited human purposes, lacks containment. By this, however, he means not *lack of limit*—we shall see that (in his own words) "there is no escape from limits,"[14] not even in nature—but rather lack of artificial enframement. Otherwise put, a site is a world, while a non-site is worldless.[15] The abandoned quarry sprawls over the New Jersey landscape, presenting us with an open

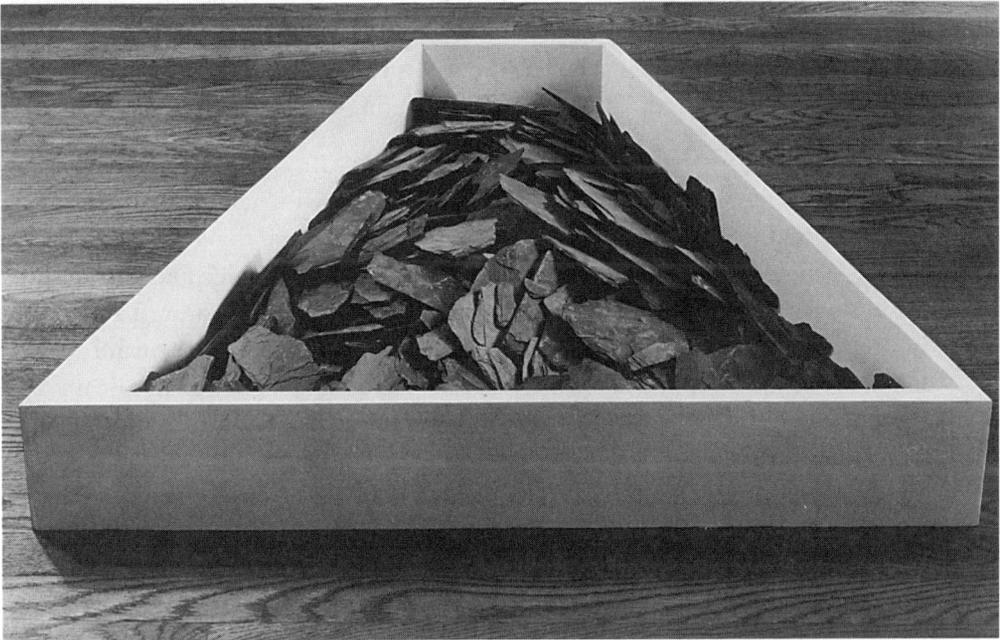

Figure 1.1. Robert Smithson, *Non-site* (1968). Slate from Bangor, Pennsylvania; accompanied by a photograph of the Bangor Quarry by Virginia Dwan.

world, and it becomes *contained* only when certain of its residual shards are put in a box by the earth artist.

Despite the neatness of the site/non-site distinction and its functional value as a basis of "transfer[ring] the land indoors," it did not withstand Smithson's own fast-moving evolution. Already in the White Museum exhibition at Cornell, where he had brought piles of rock salt into the exhibition space from the Cayuga Salt Mines close by, he introduced mirrors underneath the piles. These had the effect of radiating beyond the piles, of decontaining them. As Smithson wrote at the time, "The interior of the Museum somehow mirrors the site."[16] Thanks to its both containing (an image) and reflecting (its surroundings), the mirror is a link between site and non-site.[17] Smithson did not hesitate to place mirrors outside in actual sites, as in his implantation of mirrors at nine different sites in Yucatán.[18]

Moving to a Dialectic of Place

Unlike Aristotle, who insisted on the indispensability of containment to implacement, Smithson came to question the very distinction between site and non-site on which his early earth works were based. He did so in view of his increasing conviction that he had exaggerated the importance of the difference between indoors and outdoors to begin with. Not only is there a "dialogue" between the inside and outside, but also in the end he realized that "there is really no discrepancy between the indoors and the outdoors once the dialectic is clear between the two places."[19] Smithson's point is not that there is finally no effective difference at all between inner and outer, the contained and the uncontained, but that in the right sense of dialectic, a dialectic directly engaged in the vicissitudes of the material world, the two are intimately correlated. This dialectic he defines as a *dialectic of place,* and he describes it thus:

> In terms of my own work you are confronted not only with an abstraction but also with the physicality of here and now, and these two things interact in a dialectical method and it's what I call a dialectic of place. It's like the art in a sense is a mirror and what is going on out there is a reflection. There is always a correspondence. The reflection might be the mind, or the mirror might be the matter. But you always have these two things. They form a dual unity. . . . So that dialectic can be thought of that way: as a bipolar rhythm between mind and matter. You can't say it's all earth and you can't say it's all concept. It's both. *Everything is two things that converge.*[20]

Smithson's effort to set up two separate strings of attributes for site and non-site here collapses. No longer can we keep apart such things as "Edge" versus "Center," "Some Place (Physical)" versus "No Place" (Abstract), "Many" versus "One," "Scattered Information" versus "Contained Information," and so forth.[21] Just as the picturesque sublates the difference between the beautiful and the sublime, so

the very idea of place is the dialectical synthesis of site and non-site. Speaking of Cézanne's habit of painting on location and how this in situ practice was given up by the cubists and their many formalist descendants, Smithson observes that "we have to reintroduce a kind of physicality; the *actual place* rather than the tendency to decoration which is a studio thing. . . . [This is] Cézanne's perception: being on the ground, thrown back on to a kind of soil . . . [onto] the physicality of the terrain."[22]

The actual place is ineluctably physical, whether it is to be found in the natural world or in the museum. For Smithson, it is axiomatic that "there is no order outside the order of the material."[23] It follows that the artwork can be located either inside or outside the gallery or museum. Despite his earlier decision not to "put something on the landscape"—as Michael Heizer, Dennis Oppenheim, and others had begun to do—he no longer hesitated; his earth works began in earnest. In a number of places he boldly reconfigured land or sea, for example, *Broken Circle* (1971) in Holland (140 feet wide), *Amarillo Ramp* (1973), and most famously *Spiral Jetty* (1970). These led Smithson to a direct engagement with the earth—on its own terms. As he put it himself, "I'm [now] more interested in the terrain dictating the condition of the art" than the reverse.[24] An earth work, then, is not a Promethean effort to alter the shape or structure of the earth but an effort to reshape or restructure it in accordance with what the earth itself portends or suggests.

But now we are getting ahead of the story. We shall return to the Spiral Jetty. Before this, we have to ask: What do earth works have to do with maps? Are not maps at once "abstract" and "representational," words Smithson himself does not hesitate to associate with them?[25] Does not Smithson himself link maps expressly to *non*-sites? As he says himself, "My non-sites in a sense are like large, abstract maps made into three dimensions."[26] As ever with Smithson, however, the situation is more complex than meets the eye.

Earth-Mapping: First Approaches

Maps were integral to one of Robert Smithson's most formative early assignments. He had contracted out to an architectural firm to be an artistic consultant in a large new airport complex the firm was designing. As Smithson testifies, "I worked with these architects from the ground up," and he means this literally, since he was made responsible for sculpture on the grounds of the airport, at its fringes. In this capacity, recalls Smithson, "I found myself surrounded by all this material that I didn't know anything about—like aerial photographs, maps, large-scale systems, so in a sense I sort of treated the airport as a great complex. . . . This preoccupation with the outdoors was very stimulating. Most of us used to work in a closed area space."[27] Along with his forays into New Jersey, this airport project (located in the Dallas–Fort Worth area) brought him outside and put him face to face with the monumentally large, whether natural or architectural. But the consulting project

had the further effect of allowing him to tie together work in large open spaces, that is, "sites," with maps. From that moment on, mapping was of central concern to the artist—and in many ways.

One conspicuous way in which maps began to figure in his work was as a locatory index for his non-site collections of stones and other natural materials. An example of this speaks for itself (see Figure 1.2). Here the non-site is not only *like* a "large, abstract map" but also incorporates a functional aerial map into its midst. This map is at once a reflection of the ore—as if the shapes of its boxes had been projected onto the wall—and a representation of its source in topographically precise terms. There is an effect of mirroring, but without the employment of any actual mirrors. In another variation, both photographs and a map are mounted together, reinforcing each other as two ways of capturing the topography of a given site, from which broken pieces of concrete had been taken and placed in an aluminum box.[28] As we shall see in the cases of Gellis and Stuart, the artist is here impelled to acknowledge the origins of the particular materials employed in a given artwork. Thanks to maps, or photographs serving as maps, "you are thrown back onto the [original] site. . . . You are sort of spun out to the fringes of the site. The site is a place you can visit and it involves travel as an aspect too."[29]

To visit a site, you often need a map. Otherwise, the approach is risky (unless you already know the way): "the route to the site is very indeterminate."[30] But even when you've reached the site itself, you may still need a map. Moreover, sites not only can *be mapped* but also may themselves, like non-sites in this respect, *be maps*. But what kind of a map would this be? In an interview of 1969 Smithson has this to say:

> There are three kinds of work that I do: the non-sites, the mirror displacements, and earth maps or material maps. The mirrors are disconnected surfaces. The pressure of the raw material against the mirrored surface is what provides its stability. The surfaces are not connected the way they are in the non-sites. The earth maps, on the other hand, are left on the sites. For instance, I have a project pending in Texas that will involve a large oval map of the world that existed in the Cambrian era. Like the map of a prehistoric island I built on quicksand in Alfred, New York. The map was made of rock. It sank slowly. No sites exist at all; they are completely lost in time, so that the earth maps point to non-existent sites, whereas the nonsites point to existing sites but tend to negate them.[31]

Most significant here is the idea of an earth-map, which is situated on an actual site in the landscape. Such a map is not so much about the earth as on it or, more exactly, *of it*. For it is made of natural materials: "The map was made of rock." Most maps are made of paper, but what of a map that is constructed from what the earth itself provides? Such a map is "not of paper but made of materials."[32] An example is a projected map, *The Hypothetical Continent of Lemuria* (1969), in

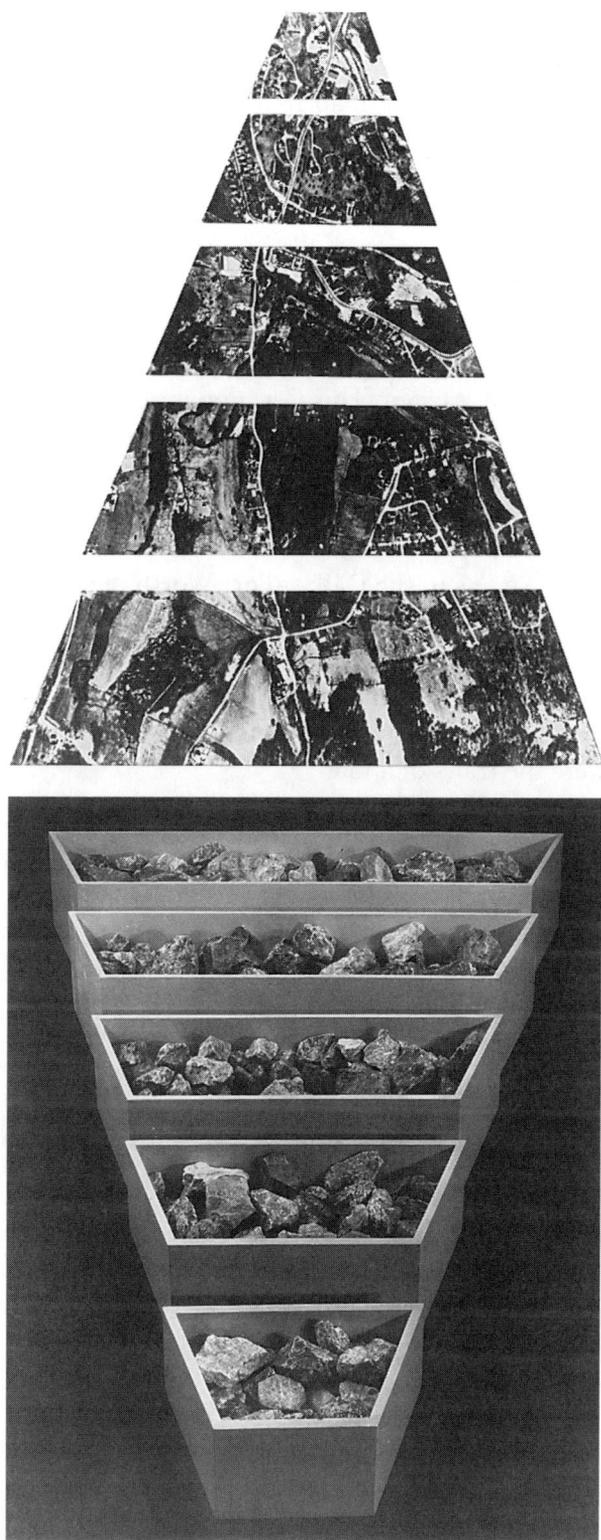

Figure 1.2. Robert Smithson, *Non-site, Franklin, New Jersey* (1968). Bottom is 16½ inches high; each of the trapezoidal wood bins corresponds to a sector of the aerial photo-map of the actual site from which ore was taken. The amount of ore in each bin is proportional to the amount of the area shown in the photo-map.

which the map mass is to be made of seashells collected from the shores of Sanibel Island, Florida, and then located inland on Sanibel Island (see Figure 1.3). There is a double displacement here: the map is drawn even though it is meant to be constructed; and it is to be located in Florida even though it represents Lemuria, a hypothetical continent where lemuroid primates existed long ago. The continent is an instance of a site completely lost in time and thus forever nonexistent, whereas the non-site (here the drawn map) points to a site that could exist were it to be built, that is, the island of seashells.

Just as important as its construction from natural materials (which is not to exclude the occasional use of technological materials such as glass)[33] is the process by which an earth-map is constructed. This is a subtle process of scanning that arises when the artist traverses a site to get a sense of the lay of its land. Such scanning is done by the lived and moving body at a tacit level and is not to be confused with surveying, which is done by the eyes alone and at a remove from the surface of the earth. Where earlier Smithson imagined an "aerial art" that would be seen mainly or only from aircraft (e.g., as in the Dallas–Fort Worth regional airport project),[34] later he insists on the importance of the body walking over the site itself, measuring its contours by the cadences of perambulation, in order to scan it more effectively. The scanning picks up features rather than imposing them, and Smithson analogizes his sense of scanning to the movement of animals over a terrain, leaving tracks as if they were the traits of a map:

> Actually if you think about tracks of any kind you'll discover that you could use tracks as a medium [for mapping]. You could even use animals as a medium. You could take a beetle, for example, and clear some sand and let it walk over that and then you would be surprised to see the furrow it leaves. Or let's say a sidewinder snake or a bird or something like that. . . . You are sort of immersed in the site that you're scanning. You are picking up the raw material.[35]

Such earth-hugging and land-tracing scanning is of equal value in selecting a site and in mapping it: two activities that Smithson assimilates to each other, as in this statement:

> The open limit is a designation that I walk through in a kind of network looking for a site. And then I select the site. There's no criteria [for this selection]; just how the material hits my psyche when I'm scanning it. But it's a kind of low level scanning, almost unconscious. When you select, it's fixed so that randomness is then determined. It's determined in uncertainty. At the same time, the fringes or boundaries of the designation are always open. They're only closed on the map, and the map serves as the designation. The map is like a key to where the site is and then you can operate within that sector.[36]

Mapping Africa

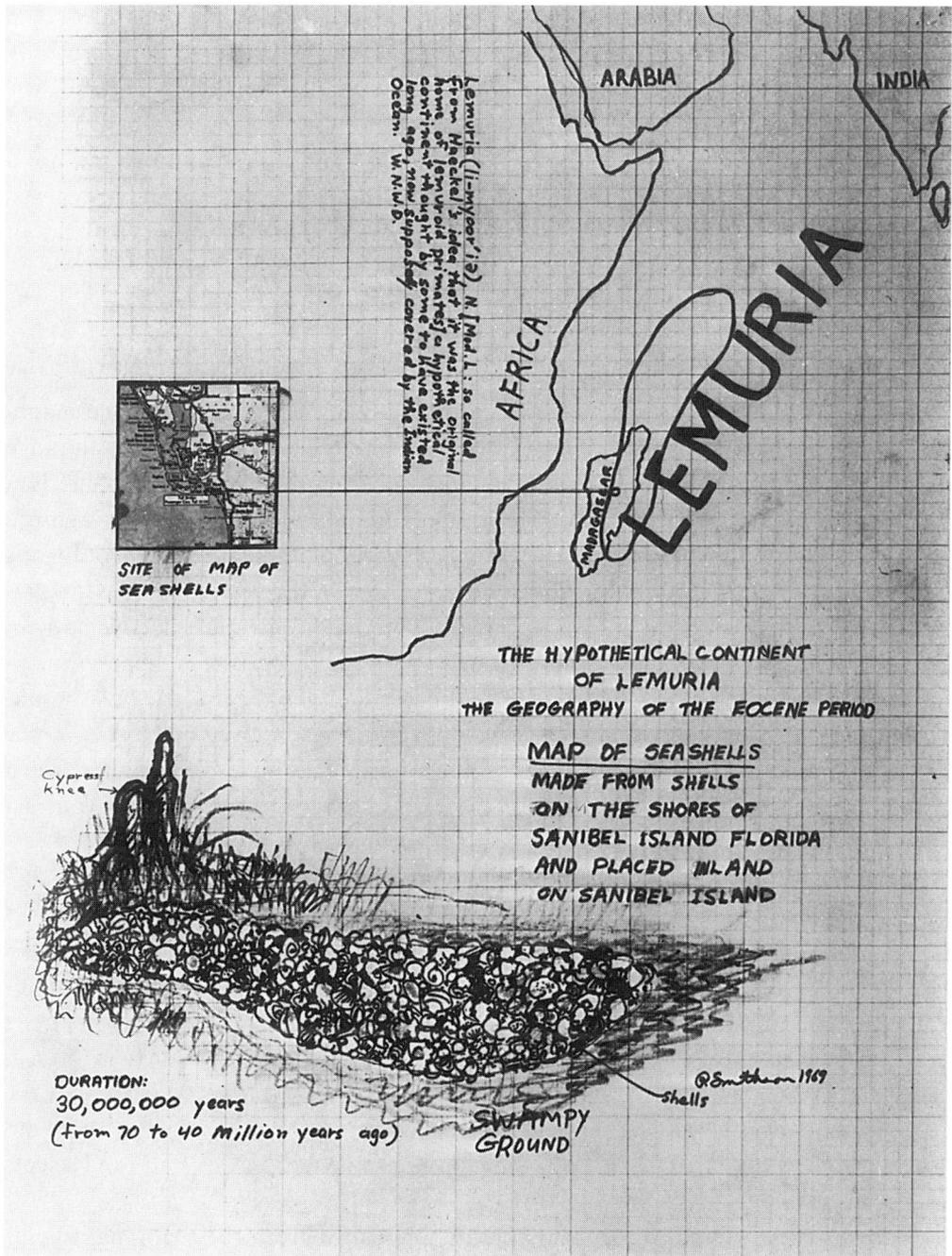

ARABIA

INDIA

AFRICA

MADAGASCAR

LEMURIA

Lemuria (li-myoor'ï-e) N [Mod.L.: so called
from Haeckel's idea that it was the original
home of lemuroid primates] a hypothetical
continent thought by some to have existed
long ago, now supposed covered by the Indian
Ocean." W.N.W.D.

SITE OF MAP OF
SEA SHELLS

THE HYPOTHETICAL CONTINENT
OF LEMURIA
THE GEOGRAPHY OF THE EOCENE PERIOD

MAP OF SEASHELLS
MADE FROM SHELLS
ON THE SHORES OF
SANIBEL ISLAND FLORIDA
AND PLACED INLAND
ON SANIBEL ISLAND

Cypress
knee →

DURATION:
30,000,000 years
(from 70 to 40 million years ago)

SWAMPY
GROUND

shells

R Smithson 1969

Figure 1.3. Robert Smithson, *The Hypothetical Continent of Lemuria* (1969). Ink and crayon map, 22 × 17 inches.

This rather dense description contains a crucial clue to earth-mapping as advocated by Smithson. This is not mapping done from a fixed, sedentary position—typically the position of someone delineating landforms on a drawing table. Instead, the mapping is done by someone (human or animal) in motion; more radically still, it is the very activity of moving over the land, literally low-level scanning, and not a separate activity of drawing as the very word *cartography* misleadingly suggests. The latter activity eventuates in a conventional map on which the open limits of fringes or boundaries become *closed limits,* that is, enclosed in certain determinate shapes: determined in certainty, eschewing the "uncertainty" that walking over the terrain entails.

More completely stated, an earth-map made on the Smithsonian model requires these ingredients: terrain over which to move, a moving body that scans the shapes of that terrain, and a psyche or mind that registers these shapes as they impinge on the body ("just how the material hits my psyche when I'm scanning it").[37] Not until we consider Eve Ingalls and Willem de Kooning will we encounter again a sense of mapping in which the active body is a literal ingredient; but where Ingalls and de Kooning prize and retain the gestures of that body, which become integral to their painting, Smithson does not preserve the traces of his site-selective body in the eventual earth work. Initially important as they are (hence the comparison with animal tracks), they are erased eventually in order to make way for the bulk of materiality that constitutes the imposing mass of the work; the lived body cedes place to the constituted site of the work, which becomes a map in its own right. (It is a map in its own right because it has become fully actual as a land mass, in contrast with the "hypothetical" status of the outlines of cartographic mapping.)[38]

The result is "a sense of the Earth as a map undergoing disruption."[39] The disruption is partly that of geological time, whose lapsing leaves permanent marks in the terrain, both above- and underground. But the disruption is also due to the earth artist, who moves and removes parts of the earth (as well as artificial materials) to reshape the earth as a site map. If the earth is always already a map—a map of itself, thanks to the manifestation of its own configurations—a site (in Smithson's sense of the term: an actual location on Earth) can become a map if the earth artist intervenes effectively to make this happen. Which is just what Smithson himself does in his earth works, which reconfigure the earth as he finds and selects and scans it.

Both of these senses of map must be distinguished from the mapping accomplished by the non-site, a mapping that is itself twofold: first, cartographic mapping in the usual sense of abstract and two-dimensional representation of landscape and regional structures (the aerial views of photography become part of this same cartographic venture); then, "non-site" mapping in the strict sense of artificial and three-dimensional, for example, the boxes in which found materials are exhibited and that possess closed limits in the form of frames or sides or walls.

Earth-Mapping and the Grid

Four kinds of mapping, then, are at stake in Robert Smithson's mature work: earth-mapping proper (wherein "the ground becomes a map");[40] the mapping effected by the site of an earth work; carto-photography; and the non-site mapping of materials exhibited in a gallery or museum. The first is a mapping by place of place, the unmodified surface of the earth; the second is mapping of a site whose shape and surface reflect human intervention; the third is mapping on flat and fabricated surfaces, typically on paper; the fourth relies on built surfaces that surround and contain various found materials taken from the earth. Since these same materials come directly or ultimately from the earth and thus mirror the place from which they derive—manifesting "the physicality of here and now"—we come full cycle in this sequence of kinds of map.

This is only to show, once again, that there is continuity between inside and outside in the "dialectic of place." It is also to demonstrate that "there is no escape from matter."[41] Matter circulates and recirculates between the several ways in which it is mapped or itself constitutes a map. But this in turn is to indicate that "there is no escape from limits."[42] Smithson insists on the presence of limits in nature as well as art, both in sites and non-sites and everywhere on earth and in built structures. If it is true that "all legitimate art deals with limits"[43] (e.g., the closed limits of medium, frame, museum), it is equally true that the natural world presents us with "open limits" such as horizons and seasonal delimitations. Smithson was certain that "the major issue now in art is what are the boundaries. For too long artists have taken the canvas and stretchers as given, the limits."[44] But to go out into the larger world beyond the studio and museum as Smithson did so resolutely is not to lose all sense of limit. In response to a question about his working in "expanded areas" such as the sites of landscape, he had this to say:

> You will always be faced with limits of some kind. I think that it's not so
> much expanding into infinity, it's that you are really expanding in terms of
> a finite situation. . . . There's no way you can really break down limitations;
> it's a kind of fantasy that you might have, that things are unlimited, but I
> think there's greater freedom if you realize that you have these limits to work
> against and, actually, it's more challenging that way.[45]

We shall see the truth of this claim again in the case of other artists who map; they would agree with Smithson that there is "a sort of rhythm between containment and scattering." And they would agree too that, even if it is true that "everything is a field or maze," this field is always bounded in certain crucial ways.[46] It is never simply unlimited. Open limits such as horizons are still limits.

When limits are imposed by human beings on the representation of space, one major result is the *grid*. In its classical form of perpendicular lines that are purely locatory (e.g., in terms of latitude and longitude), the grid is a matter of a "closed

limit," or what we could call an *internal boundary*: it encloses and locates from within. Its representational power consists in its employment of *scale,* whereby comparative size and extent are determined, so that, for example, one centimeter on a map represents one hundred meters in geographic reality.

Smithson was early struck by the importance of the grid and its scalariform representation of space. The earth works he first imagined constructing on the boundaries of the taxiways at the Dallas–Fort Worth Regional Airport, where he first "developed an interest in the mapping situation,"[47] he described as "grid type frameworks close to the ground level."[48] Already in this first invocation of the grid he relates it to something other than a conventional map, which he defines somewhat disdainfully as "a mental system made of grids, latitudes and longitudes."[49] But the mental system when institutionalized as a cartographic feature cannot stand on its own: it is continually being undone and undercut by the actualities of the landscape. For example, when a perfect, rectilinear grid system is applied to a prehistoric site, it fails to capture the odd shapes of the site, shapes that are partly natural and partly human-induced. From this Smithson, who was much inspired by archaeological sites, concludes that "the abstract grids [of normal survey maps] containing the raw matter are observed as something incomplete, broken, and shattered."[50]

Only in the case of the boxes of non-sites, which are three-dimensional grids, is there at least functional containment. The shape of the boxes, their gridded form, is derived from the mental map engendered by Smithson's experiences of a given site.[51] In other words, when a preestablished grid is imposed on a site in relation to which it is "abstract" (i.e., in the literal sense of unrelated to present experience of a site), it will break down and show itself to be incongruous vis-à-vis the site itself. But when this same site gives rise to an experiential map in the mind (as well as the body) of the person who moves over it, then it can manage to reflect the materiality of the site: either as an earth-map proper or as the shape of a non-site that in effect maps it.

The truth of the matter is that there are two kinds of grid, regular and irregular. The regular grid—the familiar, rectilinear pattern of parallel lines—is not an arbitrary concoction of the cartographer. Smithson traces its intrinsic regularity to a "reduced order of nature," that is, the lattice structure of crystals.[52] Nevertheless, the fate of the regular grid is to disintegrate when it is applied, wholesale and close-up, to landforms. In that case, the grid can be seen as melting down into the site it locates in world-space: "The rationality of a grid on a map sinks into what it is supposed to define. Logical purity suddenly finds itself in a bog, and welcomes the unexpected event."[53] The unexpected event cannot be mapped by a rational and regular grid. This is preeminently the case with the Spiral Jetty:

> The flowing mass of rock and earth of the Spiral Jetty could be trapped by
> a grid of segments, but the segments would exist only in the mind or on

paper. . . . the surd takes over and leads one into a world that cannot be expressed by number or rationality. Ambiguities are admitted rather than rejected, contradictions are increased rather than decreased—the *alogos* undermines the *logos*. Purity is put in jeopardy.[54]

The unexpected event mapped by the Spiral Jetty—an event to which we shall soon turn—calls for an irregular grid, a grid that is directly empathic with the concrete figures of the landscape rather than the abstract figures of geometry. Instead of opting for the easy solution of saying that the specific shape of sites resists all grids, and keeping in mind his axiomatic commitment to the idea that there are limits everywhere, Smithson posits just such a grid in the following statement:

> The [earth works] that are done outdoors follow the irregular contours of the land, and deal with the given raw materials. They are juxtaposed in an irregular grid rather than a regular grid.[55]

Thus Smithson reaches by his own route the position endorsed by Husserl: there can be a geometry of intrinsically vague shapes, which are often the contours of given landmasses. This "geomorphology" (as it can be called) is of equal interest to the phenomenologist and the artist: to the former, in questioning the dogma that Euclidean and Cartesian geometries are of universal significance; to the latter, in the effort to capture the living map of emerging and unexpected events. For both figures, the irregular grid is essential, either as the original basis of geometry in the experience of land surveying (in which the natural contours of landforms have to be taken into account) or as the basis of artworks that reflect their origin in the bodily/psychical experience of the earth.

The Spiral Jetty

The Spiral Jetty has been twice mentioned in passing, and it is time to come to terms with this exemplary work. How did it come to be? As we might suspect, the site selection was especially important. We have seen Smithson's insistence on the unwillful character of selecting sites by means of tacit body movements and a less than deliberate scanning. But the situation that obtained in this case carried this method of discovery to a new level of intensity. It also suggests a new understanding of what mapping the earth can mean.

Smithson knew only this much beforehand: he was drawn to the prospect of red water—a "red sea"—and had heard that parts of the Salt Lake were deep red. The conventional geographic map he and his wife, Nancy Holt, employed to get to the lake took them past Corinne and Promontory and the Golden Spike Monument but then began to fail them: "The roads on the map became a net of dashes."[56] Many roads simply gave out, and others were not marked on the map at all. They passed abandoned shacks and dilapidated oil derricks and finally stopped at a point on the

lake where the water comes up to the mainland and is flanked by beds of limestone and basalt.

> About one mile north of the oil seeps I selected my site. . . . Under shallow pinkish water is a network of mud cracks supporting the jig-saw puzzle that composes the salt flats. . . . This site was a rotary that enclosed itself in an immense roundness. From that gyrating space emerged the possibility of the Spiral Jetty. No ideas, no concepts, no systems, no structures, no abstractions could hold themselves together in the actuality of that evidence. . . . The shore of the lake became the edge of the sun, a boiling curve, an explosion rising into fiery prominence. Matter collapsing into the lake mirrored in the shape of a spiral. No sense wondering about classifications and categories, there were none.[57]

This is the "unexpected event" that precipitated the selection of the site. Such an event, which overtakes the human subject, cannot be anticipated by the usual categories and concepts. Much less defined by them: Smithson here bears out the truth of Kant's claim that in aesthetic experience concepts are never determinate but only "reflective," that is, out of reach, not yet available.

But Smithson was not merely lost in an ineffable epiphany on the shores of the Great Salt Lake. Despite his dazzlement—or rather, very much thanks to it—he was attuned to the shape of the site, a shape that suggested the form that his own earth work was to take. Earlier on, when Smithson and Holt first arrived at the lake, he says, "I was still not sure what shape my work of art would take. I thought of making an island with the help of boats and barges, but in the end *I would let the site determine what I would build.*"[58] But the site did not determine what was to be built in any simple way, as if, for instance, its shape were just there to be copied by the earth work. A vision had to intervene that linked the existing terrain to the work to be constructed. This was a vision of a cyclone and an earthquake that set the scene in a rotating motion in the midst of an immense roundness. These unexpected natural events did not in fact happen, but they were adumbrated by the site as Smithson experienced it; and their concatenated effect led to a "spinning sensation without movement" in the artist and a sedentary spiral shape in the lake, which was surrounded with commotion: "It was as if the mainland oscillated with waves and pulsations, and the lake remained stock still."[59] The elements of the site—water and earth and air—colluded with the receptive body and psyche of the artist in a sudden sense of the work to be done: "One apprehends what is around one's eyes and ears, no matter how unstable or fugitive. One seizes the spiral, and the spiral becomes a seizure."[60] The shape of the ponderous earth work to come was gleaned in a glance.

We witness here an uncanny combination of the extremely slow—briny unmoving water set in stony sediment—with the celerity of eye and mind. In fact, Smithson's entire description thrusts together metaphors of rapid motion with indications of the unmoving, often in oxymoronic phrases such as "immobile cyclone," "dormant

earthquake," "fluttering stillness," "spinning sensations without movement." Most crucial of these descriptions is "a rotary that enclosed itself in an immense round-ness": where *rotary* signifies the circular motion of rotation; and *immense roundness,* a settled stolid earth-figure. Indeed, the prime figure of the spiral itself bears the same double-sided destiny: stable as a set form (this is what "one seizes"), yet suggesting incessant motion (when it "becomes a seizure"). Reinforcing this double identity of essence and counteressence is the paradox that a spiral at once circulates—and thus entails a center around which to circle—and yet has no precise center: "The center is the site of the loss of any center."[61] At the same time, the spiral is both centripetal and centrifugal: it swirls in upon itself, and it flings itself outward.

Robert Smithson had been heading toward the creation of the Spiral Jetty for a long time. In his plans for the Dallas–Forth Worth Regional Airport sculptures, he had already projected an earth work in the form of an enormous spiral configuration that could be seen only from the air. He made a model for *Aerial Map* out of mirrors (see Figure 1.4). By the next year he had created a large sculpture he called *Gyrostasis*—whose very name connotes gyrating motion cum immobility—which looks further forward to *Spiral Jetty* (see Figure 1.5).

A short text includes the following statement:

> The title GYROSTASIS refers to a branch of physics that deals with rotating bodies, and their tendency to maintain their equilibrium. . . . When I made the sculpture I was thinking of mapping procedures that refer to the planet Earth. One could consider it as a crystallized fragment of a gyroscopic rotation, or as an abstract three dimensional map that points to the SPIRAL JETTY, 1970, in the Great Salt Lake, Utah. GYROSTASIS is relational and should not be seen as an isolated object.[62]

Mapping? Just looking at a sculpture like *Gyrostasis,* with its clawlike structure and triangulated surfaces, does not readily suggest a map. Nevertheless, the enclosing action of the gyrostatic sculpture can be seen as an encircling of a site in a landscape—hence a "mapping procedure"—and, considered as itself a non-site, it is indeed an *"abstract* three dimensional map": abstract in the sense of offering a geometrically regulated model for a site in its concreteness. In that sense, *Gyrostasis* not only "points to" *Spiral Jetty*; it *demands* it as its on-site realization.

But in what sense is *Spiral Jetty* itself a map? In two senses: For one, in contrast with the predecessor sculpture (described by Smithson himself as "a *standing* triangulated spiral"),[63] *Jetty* has been set back into the earth: laid flat on the earth as an inscription on its surface. As Gary Shapiro puts it, "The spiral is a standing structure of a certain sort that has been reduced to a two-dimensional plane."[64] Reduced not to the two-dimensionality of *Aerial Map,* which is nothing but a concatenation of mirrors on one plane, but to an imperfect two-dimensionality (imperfect because *Jetty* is composed of rock and salt and has its own thickness) that lies directly on the earth below: literally *sinks into it,* just as Smithson had said

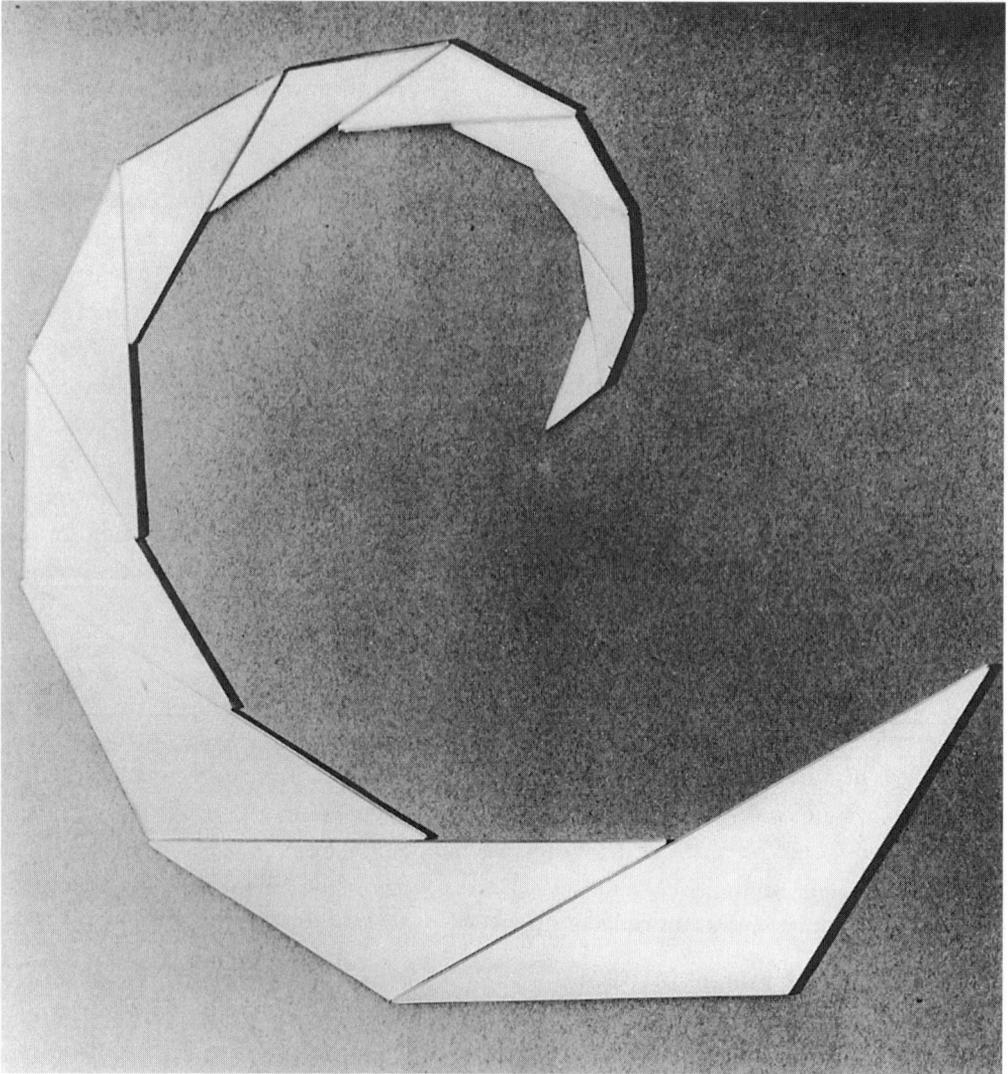

Figure 1.4. Robert Smithson, *Aerial Map: Proposal for Dallas–Fort Worth Regional Airport* (1967). Mirrors, 8 × 50 × 70 inches.

any rational grid ultimately does. (In fact, the Spiral Jetty sank under the surface of the rising lake not long after its creation, only to resurface recently.) In its other sense as a map, the spiral shape has lost the crisp geometric tidiness evident in both *Aerial Map* and *Gyrostasis*. Thanks to its rough-hewn composition, its own shape and surface are as rugged as the earth onto which it settles; only the lake around it retains smoothness as a dominant quality. This is evident in the accompanying photographs (see Figures 1.6, 1.7, 1.8, and 1.9). These images testify not just to the irregularity of the grid that the Spiral Jetty throws down upon the earth but also to something quite special about the particular grid form they instantiate. This is the

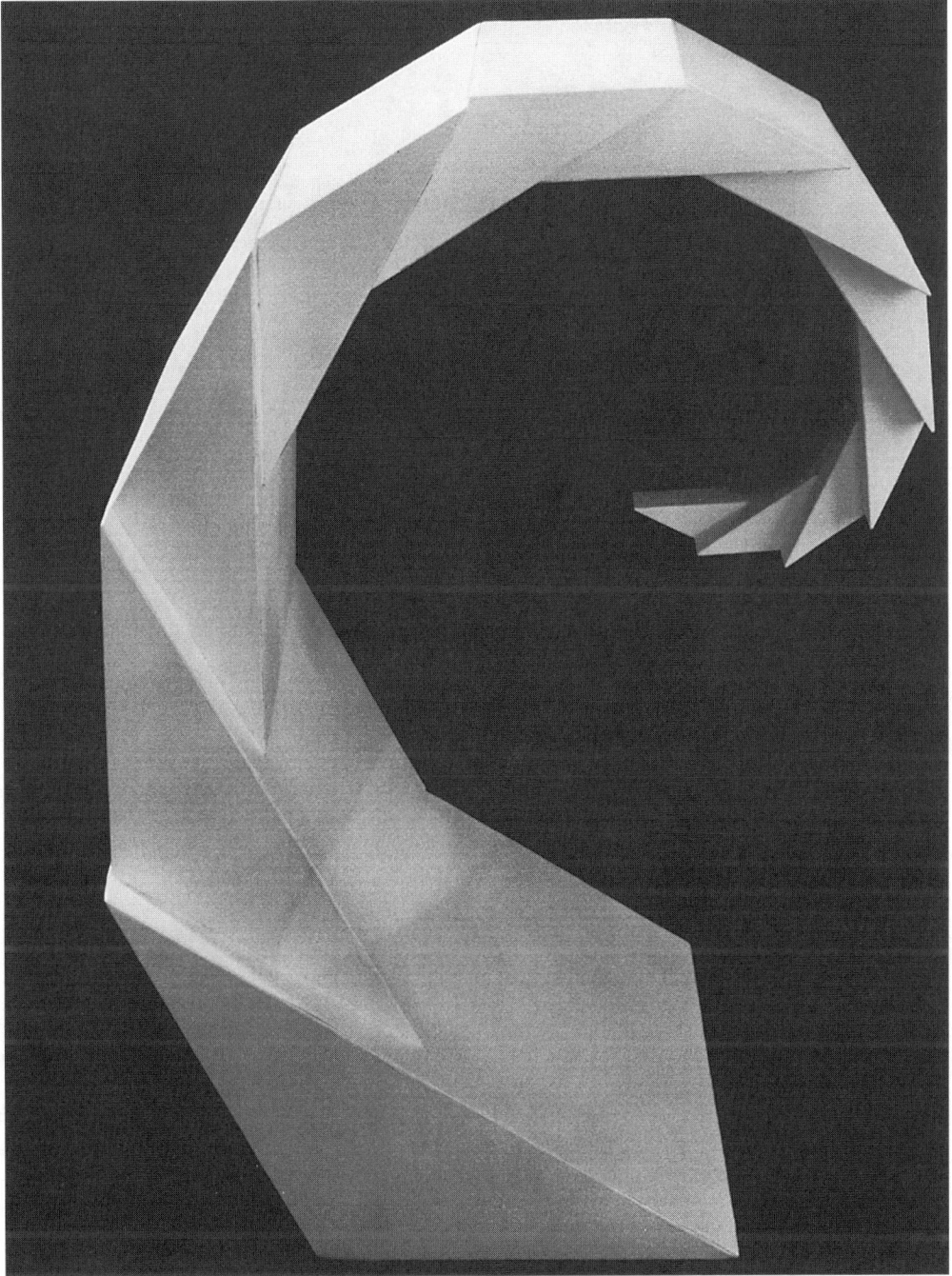

Figure 1.5. Robert Smithson, *Gyrostasis* (1968). Painted steel, 73 × 57 × 40 inches. Hirshhorn Museum and Sculpture Garden.

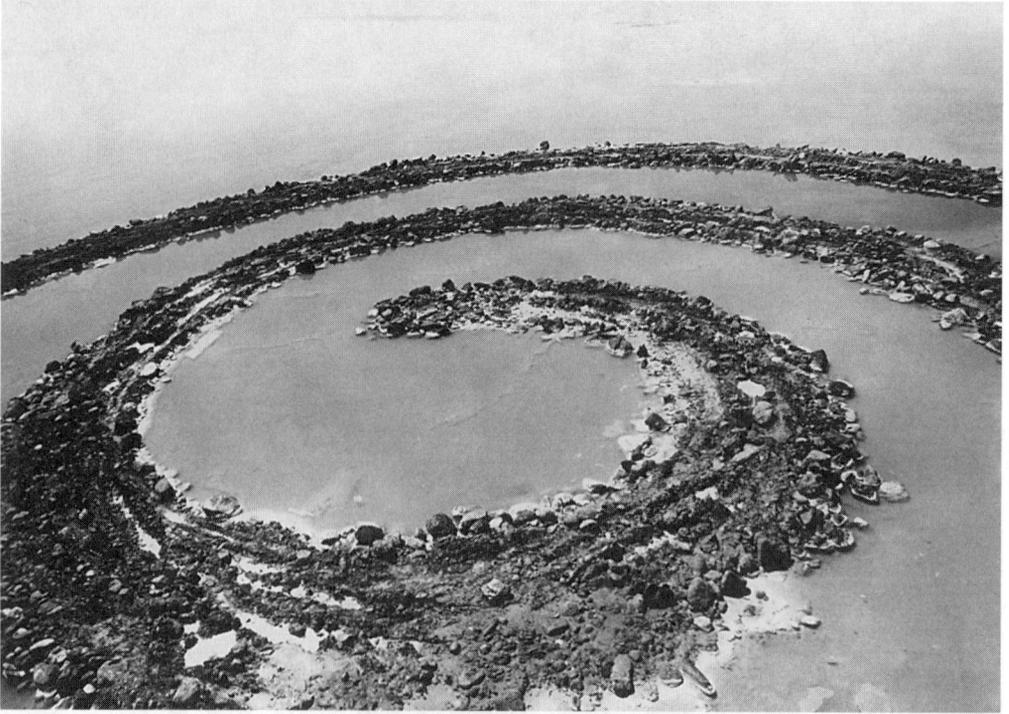

Figure 1.6. Robert Smithson, *Spiral Jetty* (1969–70), seen from helicopter.

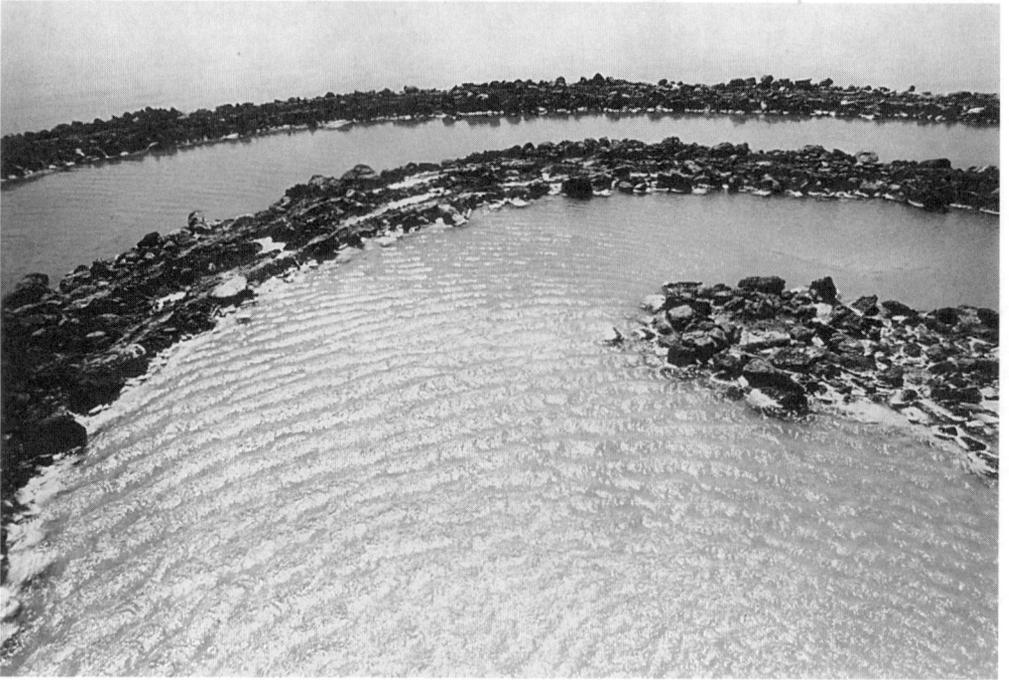

Figure 1.7. Robert Smithson, *Spiral Jetty,* seen from close up.

Figure 1.8. Robert Smithson, salt crystal formations on *Spiral Jetty*.

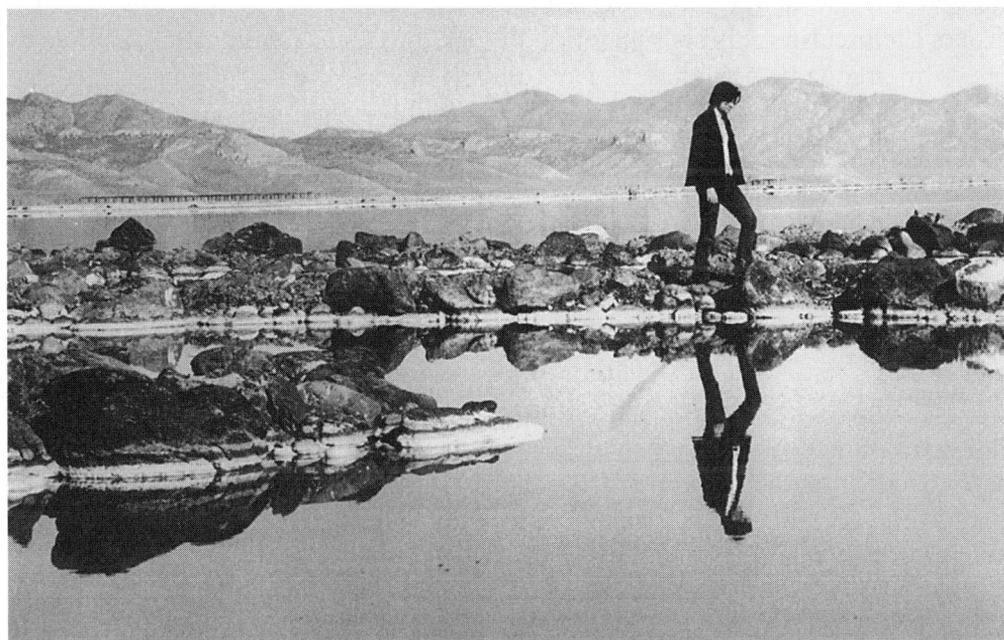

Figure 1.9. Robert Smithson on the Spiral Jetty (1970). Photograph by Gianfranco Gorgoni.

way in which it is a spatiotemporal embodiment of a journey on the earth's surface. We are presented with an inward-turning gyre that invites the viewer to walk along its craggy surface. In other words, to do just what Smithson himself is doing in the last photograph: walking along its uneven surface.

And what is Smithson doing in this striking image? He is not just inspecting his completed work and taking satisfaction in it (though doubtless this is also happening). He is *walking the earth map he has himself created*. This is not just a matter of a mapping procedure, much less of an abstract three-dimensional map. It is not just undertaking to map or mapping abstractly in a non-site; it is a matter of *mapping concretely in the site itself*. Robert Smithson maps in the very place he has established as the scene of mapping. This place, as embodying a "non-objective sense of site," is indeed "close to the ground level"—here, close to sea level as well.

Thus the irregularity of the grid is realized by the movingness of a map—a map that puts the body in motion: that (to modify Valéry's phrase) "takes the body with it."[65] Body and motion constitute mapping in a place: they constitute a place as a map. A given place is always at once spatial and temporal; or better, it trumps the putative priority of space or time, those modernist megaliths, by combining both in a scene of motion (which is itself inherently spatiotemporal).[66] The dialectic of place is an intensified dialectic of space and time, brought together in motion.

It is thanks to the motional mapping effected by the Spiral Jetty that it can be considered equally a cosmographic creation or a postmodern manifesto. It has cosmic implications in its evocation of a spiral nebula, time before time: "Following the spiral steps [of the Jetty] we return to our origins."[67] The same work also evokes the prehistoric in its suggestion of ziggurats, which Smithson was sketching during the same period as he was building the Spiral Jetty.[68] Time past is also manifest in the sense of geological decay induced by the immediate encroachment of salt crystals on the rocks of the Spiral Jetty (see Figure 1.8)—and by its gradual sinking into the water, as was foreseen. The result is "a monument already in ruins and destined for further entropic ruination."[69]

On the other hand, the postmodern is present in Smithson's emphatic erasure of any signature as well as his elimination of all the accoutrements of the gallery: the Jetty has neither frame nor walls nor room in which to be presented. It is a site that presents itself even as it withdraws from any simple presence. As Smithson testified himself, in the Spiral Jetty "the prehistoric meets the posthistoric," and in this extraordinary work he created "a map that would show the prehistoric world as coextensive with the world [he] existed in."[70] The spatiotemporal spirals of both worlds are linked in the single spiral of the Spiral Jetty: they are place-worlds mapped out in a monumental but entropic earth work.

The two extremes of Smithson's mature work become evident when we compare *Spiral Jetty* with a slightly earlier work (see Figure 1.10). Here two regular, literally square grid patterns of different scales are both set within a frame, thus ready for exhibition in a gallery. Only on close inspection can we see the features of the two

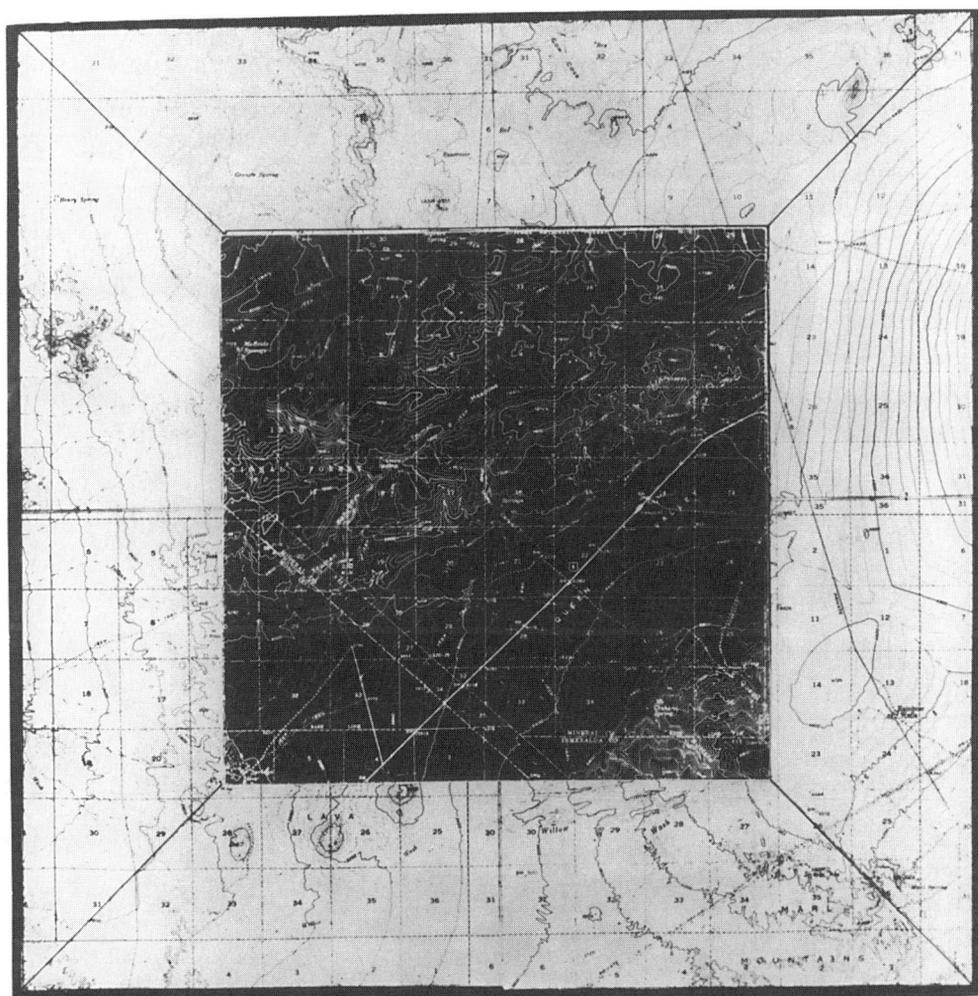

Figure 1.10. Robert Smithson, *Map for Double Non-site, California and Nevada* (1968).

landscapes emerge from within the two grids, and then only in bare contour. This is the ultimate non-site: mapping in a projective cartographic modality, at once abstract and representational. It is triply contained: square (of frame) within square (of outer map) within square (of inner map).

Smithson, in discussing this work with Dennis Wheeler, is clear that the regularity of the gridding is secondary:

> WHEELER: Do you actually denote the boundaries? Like you draw a map of a particular square and constrain yourself from traveling other routes?
> SMITHSON: No, first I find the sites. Then I draw the squares. I'm scanning the physical material before I start to set up the plan; in other words, the map layout is following after the scanning. It's not preconceived, so that it's discovered rather than pinpointed.[71]

Spiral Jetty demonstrates the truth of this last claim. Smithson first found the site—thanks to the "unexpected event" of its discovery. Then he built the map, its layout following the scanning his body did in experiencing the site. But instead of laying down a rectilinear grid upon the Great Salt Lake, he exposed a gyrostatic form he had sensed was in it from time immemorial. Although this form, the spiral, as here realized, was bound to slow disintegration and was to this extent entropic, it was not an utterly dissolute shape. "The dizzying spiral yearns for the assurance of geometry," remarked Smithson in his essay on his Great Salt Work.[72] Yet the geometry for which it yearns, like the map it seeks to become, is not the regular and regulated geometry of Euclid or Descartes; it is an irregular geometry whose aim is to discern geomorphic shapes wherever they appear on the surface of the earth—in the midst of a swirling grid that reflects that surface even as it sinks into it.

Chapter 2

Memorial Mapping of the Land
Materiality in the Work of Margot McLean

> It's the place that moves me.—*Margot McLean in conversation, July 29, 2000*

> It is the memory in the matter.—*Margot McLean in conversation, January 17, 2001*

> Live in the layers,
> not on the litter.—*Stanley Kunitz, "Next-to-Last Things" (1985)*

Gathering Materials for Mapping

Earth-mapping comes in many forms. Robert Smithson, in his very short career, explored several of these—indeed, invented them. Each of these stood outside the domain of "painting" as this term is conventionally understood; in fact, Smithson had worked in paint at one early point but gave it up entirely to engage in earth work. But there are other ways of mapping the earth that can be pursued within traditional artistic media, including paint. The work of Margot McLean is a scintillating case in point. This New York–based artist creates neither earth works in Smithson's sense nor "land works" in the manner of Michelle Stuart. Her completed works present themselves as "paintings," even though upon closer inspection one notices that other materials have been worked into the paint or applied to its surface.

These materials have been collected from particular places: places where the artist has lived or new places she has come to know in an especially intense way. Images of animal denizens of these places, sometimes based on actual photographs, are often employed as insets in the painted work; however striking these images may be, they are always set within the materiality of the medium, not merely surrounded by a painterly frame, but presented as emergent from this medium. McLean's *Sphenoidal Fissure* is a case in point (see Plate 1). The tiny animals in

the inset—horses? zebras?—are seen from afar in their desert world, and the window into this world is itself set in an imbroglio of high-tinted paint, yellow and red ochres, white washes, drop marks, and uneven dryings. The mixed media create a material matrix through which the animal world is seen. And remembered. Animals, especially wild animals, are what we characteristically forget and overlook in our civilized mania for technological control and power. In this mania, everything belonging to the earth—animals and forests, seas and skies—becomes (in Heidegger's celebrated fable) nothing but "standing reserve" *(Bestand)* for the "framing action" *(Gestell)* of modern and postmodern culture.[1] The task of the artist in McLean's vision is to restore to the earth and earthlings their rightful place in our perception of them. This means to remember them, to bring them back in paint. Earth work is thus memory work, working through the materiality of the medium to commemorate the presence of what has been forgotten in our midst. The tiny size of the animals in *Sphenoidal Fissure,* their distant position, exemplifies the difficulty of this task of memorial reclamation of the lost animal to a position of new respect in the human world.

McLean's earliest work was overtly political and often dealt with the human figure in an enclosed domestic setting (e.g., *Silent Partings* [1986]). But she soon became convinced that rather than taking inspiration from explicit political issues or from the visible form of the human body she could learn more from a direct engagement with matter: matter as paint and matter as material from the environing world of the natural landscape. From this engagement with materiality at two levels, a special sense of mapping arose. She began to think of various materials (leaves, sticks, mud) as providing the means for creating maps in a new sense. Maps not as cartographic images of specific sites but as distillations of remembered landscapes.

An exemplary instance of such memorial mapping in material terms came in the late 1980s when she lingered one day longer than planned at the home of her parents. She felt she could not leave the house, which had been sold and was about to be vacated. During that extra day, she was acutely aware of leaving certain trees and the earth on that familiar plot of land. Experiencing an "epiphany" of sorts by her own description—the earth seeming to call out to her to be remembered—she gathered samples of soil, leaves, rocks, and other natural detritus from the yard of the soon-to-be-abandoned house. These materials were hung in transparent plastic bags on the wall of her New York studio. Seeing them hanging there as she worked in her studio was not merely comforting or a matter of nostalgia. Instead of this, it felt to her as if the plot of family land was *present* before her. The materials on the wall, rather than indicating the home-place from which they came, *were that place*; they embodied it and carried it forward into her workplace. In other words, she saw *in the present* a condensed and schematized map of the plot *as it was*. In this redoubled moment of time, she experienced an epiphanic vision of what it would be like to map the place from which the materials came. She had before her

the essence of that place in the form of materials that inspired in her an idea of how to map the place in painting. The materials were not just the physical constituents of a map or a painting, that is, of something at once both and neither; they *afforded* this idea—"afforded" in the sense given to this word by J. J. Gibson[2]—so that she could draw upon them continually in times to come. She explains, "It was as if the material itself began to tell me how landscape is formed. It was forming itself into a map."[3]

Allusive Mapping

What kind of map is this? It is a distinctively different kind of earth-map from that which we have encountered in Smithson and will encounter later in Gellis and Stuart. This is mapping in which forms emerge that are distinctly maplike—topographical, if not cartographical, with a sense of looking onto land formations not just from on high but from many points of view.

The bags of material from the yard in Virginia certainly did not constitute anything like a conventional map: they contained no element of representation or abstraction; there was no grid, no metric for scale, no concern with distance. Nor was it a map in either of the basic senses we shall be led to distinguish in Michelle Stuart's work: it was neither plotting (i.e., drawing a definite course across known terrain) nor charting (sketching a possible trajectory across unknown territory). And it was not anything like Smithson's earth-maps (for the earth was in her studio, not literally on the land) or his non-sites (the studio cannot be confused with a gallery: the material was exhibited only to herself). Something else was going on that, to McLean's mind, was nevertheless a form of mapping. What could this be? If mapping as charting concerns the future of a voyage—a notion to which we will return in chapter 4—the material on McLean's studio wall bore on something that was now in her past: her family's past on a certain plot of land in Virginia, her own past as an adolescent who played on that same plot and revisited it as a young adult. This is not an impersonal primitive past, the geological origins invoked by Smithson. It is a distinctly personal past, though not a past to which one looks back, as in missing or yearning for what has been. Instead, it is a past that invades and inspires the present, constituting a "now of recognizability."[4] On the basis of this recognizability, the materials acted as memorial vehicles, ways of remembering the past in the present of artistic creation.

In other words, the materials that Margot McLean had garnered on that fateful last day in Virginia served as *synedochal souvenirs*: souvenirs in the literal sense of items "coming up to" (i.e., *sur/venir*), entering *into the present* from the past,[5] and synedochal insofar as these same items stood in a *pars pro toto* relationship to the land from which they were taken: each item, each leaf or clump of earth, was a part of the plot of land and thus served as a representative of the plot as a whole. Taken together, these metonymic reminders alluded to the plot—a word whose

linguistic cousin is *place*—without explicitly referring to it, much less describing it. They make up a special form of mapping that we can call *allusive* or *evocative mapping.* This proceeds not by representing that which *is* the case (as in conventional geographic mapping) or what *will be* the case (as in charting) but by alluding to that which *was* so. In McLean's work, this allusion is decidedly commemorative in intent: as she collected the fragments from her former residence, she vowed to herself that she would "give something back" to that place,[6] that she would create something that would pay homage to her experiences there by transforming these fragments into paintings that would be in effect memorial maps. Commemorating a place is here accomplished by a double displacement: first, of native materials into studio space; then, of these same materials into paintings.

Remembering the Place

Inherent in this transformative situation is a peculiar combination of mind and matter. Smithson had been concerned with these antipodal terms as well, but he cast mind into the realm of conception or theory and thought of matter in massive sculptural and even architectural terms. The mind at stake in McLean's studio experience was the contemplative and feeling mind of remembering: it was a matter of *mindfulness.* (*Memor,* the root of *memory,* means "mindful" in Latin.) For this reason, a memorial map need not be drawn or constructed in any of the usual ways; it can arise directly out of the interaction between the mind of the artist and various bits of matter in her studio—matter that serves as an active reminder of the artist's past. This allusive-memorial mapping situation is not to be confused with that of a "mental map" as this term is used in cognitive psychology. The bags of material on the wall served not to spark a visualized depictive image of the artist's past but instead to induce a state of mind that was appreciative and respectful of the past without having to represent that past in particular scenes recollected as such. Memorial mapping arises from the mindfulness of the artist as she gazes at the *disjecta membra* of the plot in Virginia.[7]

The commemoration that occurs in this way stretches from a particular place (i.e., the original plot of land) to the artist's studio (the workplace) to the finished canvas (the artwork as such). These three places are linked by the artist's mindful remembering, which acts as a guiding thread throughout. This remembering is not only of the artist's personal past, important as this is; it is commemorative of *the original place itself.* What is commemorated is not *her* experiences alone but *its* being what it was. If Margot McLean is remembering anything, she is remembering her history with that place—on *its* terms and in *its* matter. It is as if the genius loci kept her captive: the spirit of the place, incarnated in its materiality, wanted to be remembered in her artwork. The memory is as much in the matter as in her mind.

This complex circumstance, in which mapping happens as the spontaneous interaction of (commemorating) mind and (remembered) matter, gave rise to a new

phase of painting in McLean's career. Instead of figures and interiors, the earth became her primary subject. At first, she created installations that employed natural materials of the sort she had brought back from her former home state. In *Darkness Visible* (1987), she placed some of the earth from Virginia in irregular containers on a dark gray wall, displaying it there along with an elk's skull with antlers, tree stalks, and earth and pine needles. Here, matter from her own past was brought bodily to presence in a new place, that of the exhibition wall as a scene of display. In *Metaphorical Forest* (1989), she combined paintings with soil, earth debris, leaves, flowers, water, and stones. This ambitious piece, exhibited in Hartford, created an entire art world from materials and images borrowed from the natural world. It was not a representation of the latter, but its *re-presentation*: the artist presented again, in a very different context, the materials she had gathered from the environing world of nature.[8]

Perhaps the most effective single work from this early period is a painting aptly named *Virginia* (see Plate 2). McLean considers this to be the first of her paintings that actively *maps,* in which the memorial mapping already at work on her studio wall has moved into the painting itself. It is a work of sheer immersion that draws the viewer very close to its painted surface. The effect is that of being brought back forcefully to the "ground level" of which Smithson spoke—a ground level that is of the earth itself. This immersion is relieved only by the lone figure of the centrally located turtle, who is viewed from a certain distance as if to signify the respect due the proverbial slowness of this animal.

The painting began not by applying paint to canvas but by mixing soil with a medium and then allowing this to dry out. From there the artist (in her own word) "complicated" the painting by adding leaves and other debris from her home-place, all this mixed into acrylic paint. Against the modulated gray layer of paint, she added shapes of reddish brown reminiscent of the same type of leaf; the actual leaf and its image literally commingle. The black at the bottom, which continues through a small crevice upward, suggests an entirely different layer of the painting underneath the gray, which is then cast into the role of upper surface. McLean's surfaces are multilayered; embedded in her surfaces are hidden presences: concealed in certain materialities (e.g., soil, leaves) are other things that are barely glimpsed (e.g., compost). The effect is that of a rich painterly palimpsest: a (painted) map that is something other than a (cartographic) map. The result is what we can call *thick mapping*: a densely layered earth-mapping that is evocative rather than indicative. Such mapping is especially appropriate for effecting commemoration, which is always a remembering-*through* a material medium—for example, through a monument or a text.[9]

There is a powerful primitivist thrust in *Virginia,* a sense of intense involvement, a commixture of paint and organic matter, their mutual thickening. The directionality is at once *down* into the earth and *under* the top surface of the soil. The fact that the only easily recognized "earth colors" appear in the turtle and the leaves

(both painted and real) serves to make the spirit of gravitas all the more effective, as if the viewer were being drawn into a magnetic underworld whose colors are metallic (i.e., black and gray). Just as memory takes us *back* into the past, so the painter takes us *down here below*: on, and just under, the earth, from which each of us comes as an earthling and to which we are always in the process of returning, a regressive move reinforced by the ashlike polyvalent gray and the deathlike black.

At the same time, this powerful painting can be seen as an emergent map: the white areas evoking continents; the black regions, seas. There is a ghostly sense of Asia at the far left and of North America at the right, with the Bering Strait in between.

Perceiving this incipient earth-map is a matter of perceptual double take. At one level, we see nothing maplike; this is the ground level of perceptual immersion, our inaugural take on this painting: our first look coming to terms with the only readily discernible objects: the leaf shapes and the turtle in their midst, whose similarity of color links them as establishing the scale of a close-up view. These compelling foci literally draw out our attention and bring it to their level. In relation to them, the black and gray areas are foils from which they emerge. But in a second look, something else of radically different scale and subject matter emerges. The gray regions are seen as land masses rising from the blackness of oceans—both of great extent. At the same time, the leaflike patches are read as islands adrift in the continents and seas: instead of drawing us down as before, they sink back into these enormous earth regions. The whole scene is now viewed from afar, as if the viewer were high above the earth in a satellite.

We encounter here a strange situation of double perception in which a single painting yields two very different scenes. It is a matter of a Gestalt switch, whereby one and the same thing can be seen in two disparate ways in quick succession. At the level of content, the difference is that between small discrete objects on a commensurately small stretch of ground and vast areas of the planet Earth. At the level of experience, a downward draft of immersion is succeeded by a sense of drifting up high above the earth and from there looking down at its major configurations. In the first instance, our perceptual noses are rubbed in the rich loam of earth; in the second, we become detached viewers from afar.

These doublings can be understood in terms of changes of *scale* and of *level*. To change scale is to change the range of sizes one can perceive—hence the kinds of objects that fit into this range. *Scale* can be defined as "the proportion used in determining the relationship of a representation to that which it represents . . . more generally, a system of ordered marks at fixed intervals used as a reference standard in measurement."[10] Although there is no system of marks at play in McLean's painting (e.g., of the sort that is operative in a fully constituted map), there is certainly a relationship between things seen as "representing" actual items in the perceptual world and these items themselves. Indeed, McLean reinforces this sense of scale by including a few actual leaves in the painting, thus establishing a scale of 1:1 in the

first take, the close-up view. This in turn invites us to apply the same scale to the represented turtle, the other recognizable denizen of the intimate world. However, when it comes to the world seen from afar, the earth itself, the viewer spontaneously reads the images according to a scale that could not be calibrated exactly but would read out at something like 10,000:1. Thanks to this implicit but powerful scaling operation, the gray masses are seen as representing entire continents and the black areas as whole oceans.[11]

In close concert with such a double scale is a comparable operation of a double level. I construe *level* in keeping with Merleau-Ponty's discussion of it as the basis of my bodily orientation with the world at any given moment—the way in which I am geared into this world by means of my lived body:

> The constitution of a spatial level is simply one means of constituting an integrated world: my body is geared to the world when my perception presents me with a spectacle as varied and as clearly articulated as possible. . . . This maximum sharpness of perception and action points clearly to a perceptual *ground*, a basis of my life, a general setting in which my body can co-exist with the world.[12]

The idea of "perceptual ground" resonates with McLean's painting. *Virginia* is a painting that, at a literal level, is *of the ground*: the earth as ground. But it is also *grounding*. In particular, it grounds two levels of looking: the close-up view that looks into the earth-ground as a base level, or general setting, within which my body is coeval with the world, the primary world of intimate perception; and the view from far above, the world of distantiated and discerning perception. Different as they are, each level has the effect of providing orientation to the viewer's glance. Indeed, it is just because the two levels are so thoroughly grounding, so perceptually stabilizing, that a glance suffices to determine the kind of world the painting offers. (The very idea of "take" connotes a rapid look, a quick read that does not need prolongation.)

An important trait of every perceptual level is that it presents itself as *already in place*, already set up. This is why "I already live in the landscape,"[13] even a constantly changing one. For the spatial level is something that I do not myself constitute; it is always already there as something I can fit into and take up. Merleau-Ponty puts it thus:

> Space always precedes itself. . . . being is synonymous with being situated. . . . since the perceived world is grasped only in terms of direction, we cannot dissociate being from orientated being.[14]

As the primary witness of the perceived world, the painter provides levels into which the viewer can gear—levels that build on and refer to one another in accordance with the principle that each setting is "spatially particularized only for a *previously given* level."[15] In *Virginia*, the vision of continents constitutes a level

that modulates the ground-level setting we first see close-up; it is striking precisely because of its being at once different from and yet dependent on the base-line level of immersion in the near earth.

This dialectic of close and far—which we shall encounter again in the work of Michelle Stuart—is very much at work in the paintings for which McLean is best known: those that portray animals emerging from indeterminate spaces. The important difference in this series of works, which began before *Virginia* was painted and continued for years afterward, is that the featured animal—cheetah or tiger, crocodile or monkey—is given in a distinctive inset. This inset not only establishes a level of its own (i.e., the level of the immediate habitat to which the animal belongs) but also acts as a frame and a perspective-giving device. Take, for example, *Orinoco* (see Plate 3). Our first take of its inset is of a vaguely depicted crocodile reclining on the bank of a river, presumably the Orinoco (visited by the artist the summer before this work was painted). We see the beast from an elevated position in the middle distance, as if through an irregular window—or is it a gash torn in the canvas? Its ragged edges bespeak an untamable violence belonging both to the animal and to ourselves in violating its natural domain. The effect is telescopic: the inset brings our view down close to the animal, quickly and effectively. Again, we see everything meant to be seen in one glance: the unitary inset, placed in the approximate center of the canvas, shows it all: Here it is, and this is quite enough!

The surrounding surface is wholly abstract in relation to any possible figurative content. Yet its intense ochre coloration—closely related to that of the leaves and turtle in *Virginia*—suggests earth, as does the highly modulated texture of the paint. This is certainly a background, which "let[s] the animal stand out from it and disappear into it."[16] But it also acts as a frame, almost a curtain, for the inset. This time, however, there is no perspective given or suggested, just a surface with its own independent status, not to be seen *from anywhere in particular* (except from the position of the viewer of the painting, for whom it presents itself as a sheer painted surface). No longer a modification of the level of the representational inset, its level stands on its own. The result is that our perception of the painting is not so much a double take as it is *two takes in one perception*: not a single image read in two different ways, but the perception of two parts of the same painting, each of which possesses its own autonomous level. It follows that where the double take we perform upon *Virginia* requires a succession of at least two perceptions—as in the famous duck/rabbit Gestalt switch—we can perceive both levels of *Orinoco* in one comprehensive glance.

Does *Orinoco* map? *Almost.* It is on the edge of mapping, but does not yet fully map. It lacks the minimal comparative mapping that occurs in *Virginia*, wherein two levels and two scales relate to each other, however implicitly. Not that all mapping requires this redoubling of parameters, but, in the absence of an any more recognizable mode of mapping, this binarism sets up a rudimentary mapping situation.

Even this minimal situation is lacking in *Orinoco*. In the inset we are treated to a vignette, which has its own internal spatiality (i.e., "crocodile-on-bank-of-river") and even its own geography (i.e., "Orinoco River" as conveyed by the title of the painting, *Orinoco*, which invokes an entire imaginary geography in the viewer). But this vignette forms no part of a larger drama. Even if we are to think of the river as the Orinoco, we are not led to locate it in the northeastern part of South America: nothing like a continent looms to lure us to place the inset in a larger space. It remains an isolated islet in a framed space that belongs not to geography but to the literal surface of the painting. The crocodile and its river may be relocated from an actual place, the Orinoco, but this place-of-relocation, the inset/vignette, is not itself further located. It may ask to be mapped; it may be on the way to being mapped; but it is not yet mapped.

Mapping as Relocating in the Image

For McLean, the issue of relocation is far from academic. Her paintings of the last two decades concern the relocation not of earth as such—as in Smithson's non-sites—but of *animals*, including those belonging to endangered species. She creates a new place for these increasingly vulnerable beings within the rough-grained textures of her paintings—textures whose coloration and palpability are often reminiscent of the earth's own raw surface. Animals are, in her own words, "relocated into the painting."[17] McLean's paintings provide an aegis in which animals are at once honored in their own habitat and yet attain what Gary Snyder calls "re-inhabitation."[18] Indeed, it is precisely because McLean respects so greatly the original habitat of the animals she paints that she offers to them, whether they are actually threatened or not, *a place of their own in her paintings*: a place of respect in which they can survive in a nonnatural setting. The re-inhabitation and the relocation are both *in the image*. Far from this latter being a mere refuge, it provides its own implacement, at once secure and precarious. Indeed, the image-place incurs new risks, for example, those of misappropriation and misinterpretation. As McLean says quite directly, "[In my paintings] the animals are in another place."[19] In the wild, they are literally in their own place, living on their own terms and in their own way. They can also be located somewhere else (e.g., physically in a zoo or virtually on television), but in such cases their place is not their own. In the painted image, however, they gain a second place that belongs *to them* because it is fashioned *for them*; they are given a place of their own in the world of the image.[20] Take, for example, McLean's *Wyoming* (see Plate 4).

Here we witness in the inset a small pack of barely discernible African antelope with their heads alertly poised to pick up sounds coming from an invisible source out of view to the left. It is a poignant moment in the life of the animal world. The precariousness of their circumstance is underlined by the frame of the inset cutting off their legs, as if they have lost touch with the very earth on which they otherwise

move so elegantly and rapidly. As McLean remarks, "The animals in my paintings aren't completely 'there,' completely visible."[21] Parts of their bodies fade from visibility, and they always seem to look into the invisible: into a nonfigurative distance that has an indiscernible horizon. On the other hand, the generously applied earth-red paint that surrounds them so vibrantly suggests something auspicious: at least *these* four animals have found a new location in the painting, a new habitat there, a "home away from home." Unlike other less fortunate members of their species—and many more members of many other species—they have somewhere to go: an imaged (though not simply imaginary) place that considers them in their very animality, that respects their sheer difference from the human. The animals in this painting are re-implaced into pictorial space, and to this degree protected from what is likely to be a dire fate on Earth today. By calling the painting *Wyoming*, McLean suggests that they have found in such space a momentarily unthreatening world, in which there is room enough to run free and unmolested on an open range. The mere fact that the title names a particular place known for its ample spaces suggests that the painting offers a special kind of aegis to animals: a sheltered space where they can subsist without risk of depredation and destruction.

If *Wyoming* is not yet fully a map in the various senses I am exploring in this book, it takes a significant step toward such mapping and is pivotal in this very regard. The relocation and re-inhabitation that McLean's painting accomplishes are premonitory of the kind of mapping that I will be calling *absorptive* in part II, for animals are here shown clinging to the earth, absorbing its self-concealing strength, and rising from it to achieve their own autonomy and identity. As a statement about relocation—as itself relocatory—this is a painting on the way to being a map. It is on the verge of mapping in an absorptive manner. Or let us say that it is a map in its most extreme liminal state: a map not just about location (as almost all maps are presumed to be) but also about the possibility and the meaning of re-location from a natural to a cultural habitat.

As if answering this implicit call to mapping, McLean has painted a number of other animal paintings that begin to map, though differently from *Virginia*. In these, the inset, though still isolated, is perched precariously on or over what appears to be the earth or something earthlike. Two examples bear this out (see Plates 5 and 6). In *Muscles of Inspiration*, a cheetah, enclosed in its own painted space, glides over the surface of what can be construed as the earth (thanks to its arc and to its red ochre color). Similarly, the diminutive tiger in the inset in *Pons Varolii* is poised upon what appears to be a hill, indeed an entire infernal landscape, as seen at night. In both cases, the animals are situated in their own self-enclosed spaces, which are in turn set in a larger landscape or earth scene that presents a certain sense of scale and level. However disparate these latter may be from their counterparts inside the visual vignettes, they constitute a second system of quasi-geographic reference that encompasses the spatiality of the first system operative in the vignettes

themselves. This is not to say that the animals in question are thereby *located,* if by *located* is meant having a precise position in homogeneous space. The animals, first of all relocated from their natural habitats into the intimate space of the inset, can be considered *situated,* though only in relation to the underlying earth: here indeed, "being is synonymous with being situated." Or we can say, again drawing on Merleau-Ponty, that they are *oriented* in relation to a more encompassing space: thanks to this space, they possess a "general direction."[22] This encompassing and direction-giving space has enough internal differentiation and external shape to suggest the earth as a basis of orientation in both of the above paintings. Seeing this earth from afar in contrast with viewing the animals close-up in the insets assists the emergence of mapping in each case: the contrasting implicit viewing distances, acting in close concert with the answering contrasts in scale and level, help to constitute this very emergence. Situation makes relocation possible by providing for this latter an effective spatial framework.

If McLean's animal paintings stand on the verge of mapping and if the paintings inspired by her departure from Virginia map in emergent and subtle ways, we find in more recent works a development in which mapping comes to the fore and is thematized as such. *Blackbirds* is a representative of this last stage (see Plate 7). This complex work is composed of five distinct levels of orientation: (i) a nearby level to the left of center, in which two blackbirds are seen in profile, just by themselves: this is a sparse and focused view; (ii) a landscape inset in the right upper quadrant: here is a view painted from the artist's memory of being in Maine; it is painted in a classical, almost Renaissance, manner, with an emphasis on the middle distance; (iii) several large masses, with varying shapes and colors, all reminiscent of continents on the earth but none recognizable as such; (iv) dark banded areas on top and bottom, with the latter suggesting a view onto an ocean from a pier (hence the flat shapes); (v) an overlying sky, hinted at by the deep blues and especially the yellow dots, which evoke stars punctuating the nighttime sky.

Most striking for our purposes are the large masses. These are not concealed or graspable only on a Gestalt switch. They are steady presences that subtend and connect everything else in the painting, providing a quasi-geographic *basso continuo* to the painting as a whole. The land masses, though not delineated in any internal detail, together compose a *mappa terrarum* that acts as the "primordial level" for the other levels,[23] which are modulations of this base level and exist only in relation to it as a situational field. Reinforcing this maplike character are horizontal lines in the lower right that suggest parallels of latitude, while the vertical drip-lines seem to allude to meridians of longitude. But these tenuous though effective lines of reinforcement act only as reminders of modern mapping techniques. What matters here is not a persuasive presentation of an actual map but the laying down of a level that acts as an *arena for mapping.* As McLean herself says, "I am not interested in creating maps but in mapping."[24]

Getting into the Depths

Arena, field, situation: these are the bases for mapping in the sense pursued by McLean. Each refers to a certain kind of surface; after all, mapping is minimally an internally differentiated configuration of surfaces: it is precisely this configuration that is lacking in *Muscles of Inspiration*. This painting presents an earthlike entity, an orb, yet one whose surface is not distinguished as anything like a land mass; instead, it reads as the sheer surface of the texture of the actual acrylic paint, not as the surface of any possible continent. This is the primary reason why it stops short of being a map: to be a map means to possess enough differentiation of surface to represent one or more regions within a more capacious space (e.g., that of the ocean, or still another larger land mass). Just this differentiation is what happens in *Blackbirds,* which the viewer spontaneously takes to be maplike from the very start.

A second feature of any surface that is seen as a map or as maplike is a peculiar depth that accrues to it. Not a depth detached from the surface, but a depth that clings to the surface itself. In mapping as in several other domains, "the depths are on the surface."[25] Either the surface comes accompanied with numbers that indicate its metric depth (e.g., in relation to sea level), or it is represented as having a depth of its own, as when mountains and other topographic features are depicted on it, or else as a depth perceived in relation to that of an adjacent region. The latter is the case in *Blackbirds,* since the several continents emerge from the oceanic regions between them, regions that have their own implicit depth. Just as every map must possess sufficient internal configurations to allow the viewer to identify certain places and regions as distinct from one another, so every map must incorporate an indication of depth in some significant manner. In mapping, depth is not just the "third dimension" in addition to height and width; it is the most important of the three dimensions, being "the reversibility of all dimensions."[26] For depth is always at stake not just in overtly topographic mapping (where contour lines, for example, may indicate precise levels of depth) but also in many other ways of mapping as well: even those maps that concern mainly distances between places are in effect representing depth on the land or sea: depth *across,* a specifically lateral depth that contrasts with the horizontal depth of traditional Renaissance perspective. Painters of the Northern Sung era in China distinguished three major axes of depth: "high distance"(i.e., looking up to a mountain peak from its foot), "deep distance" (looking out toward the horizon), and "level distance"(looking at receding mountains from an adjacent mountain).[27]

In the composition of *Blackbirds,* we may discern four kinds of depth:

(i) *Depth of sheer difference* is the minimal depth at stake in the area in which the birds are shown. In that area, we see only the bodies of the birds profiled against a plain flat surface. All that we can tell is that the birds are in front of that surface, though we cannot say how far in front or what the nature of the surface is; yet depth is still present.

(ii) *Depth of regular recession* is the depth that structures the inset depicting the miniature Maine landscape. The classical perspective of this monofocal view, "deep distance" in Northern Sung nomenclature, brings with it an implicit grid with progressively smaller squares as it recedes toward the horizon; this grid *affords* depth, just as it makes movement toward a horizon possible.

(iii) *Earthen depth* is the depth of continents, not only in relation to surrounding seas, but also as integral parts of the earth understood as a sphere with its own form of depth, which reflects the earth's curvature as a globe in space. Such depth is at once intercontinental and global.

(iv) *Celestial depth* is the most elusive depth dimension of all. As if to acknowledge this, McLean does not paint it separately and as such (as she does in *Islands of Langerhans* and in the sky region of *Pons Varolii*); instead, in *Blackbirds* she brings the sky down over the earth as if it were a transparent veil with stars as sequins. The bands above and below also form part of this celestial depth, especially that at the bottom: from the implicit landing it forms, we seem to be looking into an infinity of cosmic depth: into the stars at a "high distance" in Kuo Hsi's term. Celestial depth is limitless, given that the eye can see indefinitely far into the sky. Perhaps for this reason, McLean puts most of the stars into a quasi-regular grid pattern, thereby suggesting that there is a deep order in cosmic depth even if the patterns of stars appear to be arbitrary or random (as in the miscellaneous stars at the right of the painting).

The depths are indeed on the surface—on the surface of this painting, and in four prominent ways. The effect is to give to the work a multilayered character: to make it not only a painting that is composed of several layers but a painting that is in a certain manner about layering as such. In this respect, *Blackbirds,* like many other of McLean's paintings, is a palimpsest: it shows the traces of earlier layers of work instead of covering them over. It is a matter of "overlay" (to borrow a term from Michelle Stuart, who uses it in primarily cultural and geological contexts).[28]

At the same time, McLean's work also has the quality of pentimento, such that showing through certain areas of a painting are earlier stages of work, which are in effect commemorated in this indirect way. This commemorative effect is heightened by the use of insets to set forth the neglected or repressed worlds of animals, or particular landscapes (e.g., that of Maine) that the artist wishes to remember. Just here we encounter a consistent *fil conducteur* of McLean's work: its invocation and commemoration of the past. In the case of a painting such as *Virginia*, this is the past of a place that calls out to be remembered—in mind and body—whereas the animal paintings convey a past of free movement and uninhibited life that is honored by being remembered in paint. The layering so characteristic of McLean's mature work is always in the service of honorific remembering: a tribute to whole worlds, whether human or animal. Moreover, this layering is such that the artwork becomes a pentimento of itself, a palimpsest of its own slow constitution.[29]

I say "slow constitution" because McLean likes to ruminate her works for a long time. She worries them out over years, sometimes brooding over them for a decade

or more. (In this respect, she is very much like Dan Rice, to be discussed in chapter 8.) It is a matter of reflection, of the patient labor of self-correction, of the steady adding of layer to layer—and of subtracting layers as well. In McLean's case, the memorial brooding becomes a mindful mapping out, increasingly so in the course of her work.

Margot McLean thinks and feels and remembers in paint that is water soluble, whether it be watercolor or acrylic. The solubility of the medium embodies and reflects her effort to preserve what is most valid and valuable from the past once the medium of water has dried out. Just as Stanley Kunitz has said, "I've learned to strip the water out of my poems,"[30] so McLean has distilled her paintings to get at the essentials of their subject matter: an epiphany on a particular plot of land, the life of animals, the earth, the sky.

The artist's economic titles reflect this disciplined refinement: *Blood Channels, Bern, Central Park Zoo, Pathetici, Heart, Snake, Trapezius, Unmedullated.* These titles are consciously restricted to three categories: places, animal names, and parts of the human body. This selection is indicative of McLean's effort to honor two things in the end: the earth (in its many places) and bodies on earth (in animal as well as human forms). Her paintings seek to capture the *eau de vie* that nourishes both kinds of thing, while her multilayered mapping aims to relocate animal and human bodies into the places of her work—to put these bodies, so much at risk of extinction and death, somewhere where they can be noticed anew, in a place of their own to which painting as memorial mapping alludes. She brings their remembered past into the perceptual present of her canvas so that their collective future can become more concretely imaginable. Imaginable for herself and for her viewers, as embodied in paint by the effective rendering of scale and level and depth. In short: painted and mapped, mapped as painted, painted as mapped, the two together.

In memorial mapping, the painter paints not *from memory*, where this last phrase implies the exact representation of what happened in the past, but *in a memory* of that past, inhabiting that memory, responding to it even as one lives on its basis. Indeed, lives so much *in it* that to paint it is to commemorate it: by a mindful mapping that is true to the past even as it carries the past forward imaginatively into the present and the future. If Margot McLean has mastered this *ars memoria,* it is because she has succeeded in rendering the past in images that are at once thick and striking: thick with their own origin in the earth, striking in their composition of a world.

Chapter 3

MAPPING DOWN IN SPACE AND TIME
SANDY GELLIS COLLECTING TRACES

These are the reasons why I enter her work.

. . .

To tame my eyes and to remember the
knowledge gained through my skin.
To envision cities where the effects of time as etched
by air and water have regained their place in the
vernacular of making.
To stand in an ethic where decay is accepted
in knowledgeable and even caring ways.
—*untitled poem by Glenn Weiss*

I see it as a map.—*Sandy Gellis, in conversation,
June 2000*

Condensed Spaces and Aerial Views

Sandy Gellis has been active on the New York art scene for more than thirty years.
She has been engaged in a remarkable variety of projects in diverse media and in
quite different formats, ranging from drawing and printmaking to outdoor sculp-
ture and indoor installations. Despite the variety, a strong mapping impulse has
sustained her work and renders it coherent from one end to the other: from her
"Condensed Spaces" (mid-1970s) to her recent "Ocean Fragments" (1997–2000).
The impulse is realized differently on different occasions, but every occasion offers
an opportunity to explore what it means to create an *elemental landscape*. Indeed,
landscape is Gellis's own preferred term for much of her work, early and late;
elemental is my own designation for her ongoing fascination with the materiality
of the medium in which she is working—and with the elements that make up and
surround the earth.

This double-edged fascination first became evident in "Condensed Spaces": a

series of four square boxes, 21½ by 21½ by 2 inches, each containing a different view of the earth from above: in one case, a mottled green earth is manifest, in another a snowy white landscape traversed by lines (in fact, copper wires), and so on. The materials are subject to chemical transformation over time. A transparent cover (glass or plastic) is placed over each box, intended to hold in the contents but also suggesting the sense of viewing landscape through something like a window. In fact, Gellis (like Smithson) is an inveterate observer of earthscapes from airplane windows, sketching and remembering what she sees below her, land or sea. The aerial views of "Condensed Spaces" recall altitudinous looking from thirty thousand feet, even as they are complete landscape re-presentations in their own right, each offering an intact world with its own color and configuration, density and texture (see Figure 3.1). Although each box conveys a self-enclosed world, as arrayed together they give one the sense of traversing a series of closely related, "subtle abstracted landscapes"[1]—related not just by size and similarity of format but also by a sense of comparable intimacy, as if the viewer has been offered a series of privileged points of entry into compressed reconstructions of the earth's surface. This points to a first paradox in Gellis's work: what might otherwise be an alienated and distantiated effect that accrues from looking at a scene from far above—from what the French call "the point of view of Sirius"—is much more like an impression of close proximity to what is seen. Or more exactly, it is as if the viewer has

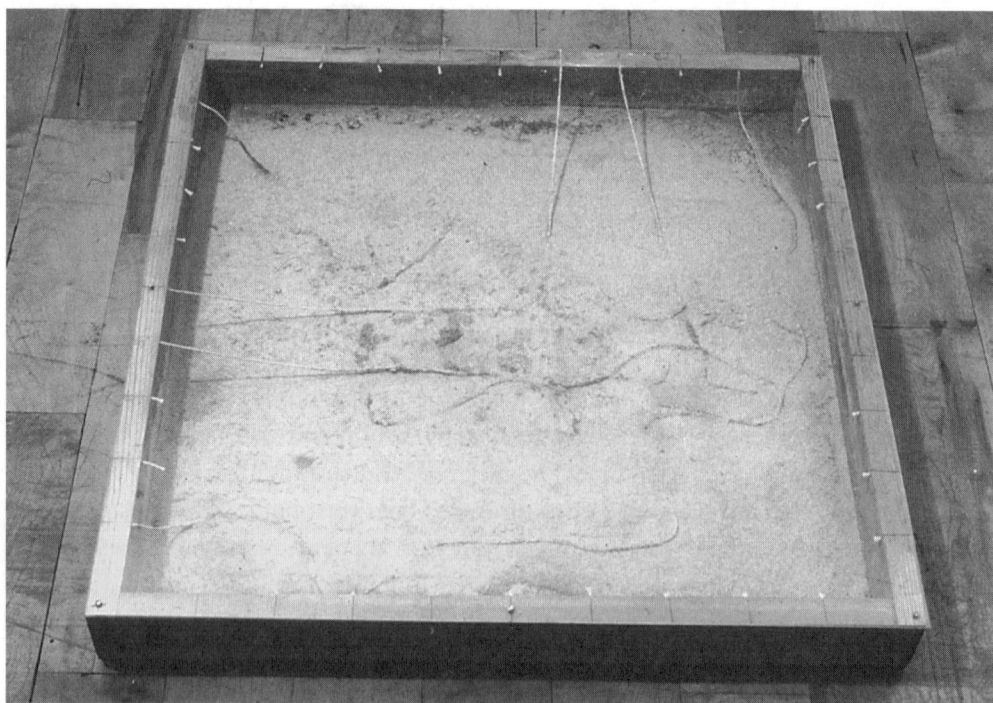

Figure 3.1. Sandy Gellis, *Condensed Spaces: Iron, Sand, String* (1976). Aerial views of fragments of the earth, 21½ × 21½ × 2 inches.

become part of the viewing, sliding down the chute of his or her glance cast at what is seen and thereby entering into "warm intimate [spaces]."[2] The miniature landscape is suddenly *my own landscape*—mine and no one else's—in contrast with the objectively perceived earth seen from a height so great as to eliminate any trace of subjectivity. Thanks to the special effect achieved by each of the four boxes of "Condensed Spaces," what might have been impersonal and general has become highly personal and particular.

If the first paradox involves an unexpected interchange between distance and intimacy, a second paradox has to do with the dematerialization of matter. For each landscape in this group of works is created in its own specific material mode—with the actual matter, whether cement or earth or wire, literally showing—and yet the overall effect is not that of heavy substance closed in on itself. Instead, the landscapes as seen under their transparent covers seem to dissolve into the viewer's very look, as if they were somehow sublimated in this same look. Just as this look goes down the corridor of vision to meet the landscapes on their own terms, so the materiality of these terms rises up into the look, thereby losing some of its inherent mass or substantiality. This transformative process is akin to alchemical *sublimatio,* whereby base matter is transmuted into higher and more valuable metals.

And yet—to complicate the situation further—the matter with which one here begins is valorized for its own sake as well: the naturality of the landscapes seeping through the artificiality of the transparent covers within which they are enclosed. It is as if the elementality of the earth were shown encroaching upon the fabricatedness of technology. As in fact happens with increasing force in all of Gellis's subsequent work, which can be read as an increasing immersion in the materiality of matter itself, albeit often effected by highly sophisticated technological means.

Take, for example, various "Earth, Air and Water Studies" of the mid-1980s. This title is generic for a number of Gellis's studies of this period, many of which fall under this same description. In one striking instance, she paints a series of night views as seen from an airplane, except that in this case the landscapes are abstract and no longer recognizable as such. Powdered pigment is applied to wax on wood panels that are 14 by 14 inches square, which are in turn mounted on a white background. The pigment is mostly monochromatic: azure blue in one case, black in another, green in still another. Small configurations abound, reminding one of local variations in a landscape—again as seen from above and afar. But now there is no glass window through which one looks, no box within which the landscapes are set: there is just paint on a panel set in a neutral field (see Figure 3.2). Here the landscape (in the guise of nightscape) comes forward in its very materiality into our immediate vision. It is not just landscape *viewed* (as through transparent glass) but landscape *seen*—at a glance in a single brilliant and condensed image.

Still these works *are* paintings—each is conventionally framed, for example—in which we encounter not the *earth painted* (i.e., the earth as pigment, or else the earth

Figure 3.2. Sandy Gellis, *Night Views over Land from Seat 8A* (1986). Graphite and gold leaf on paper mounted on wood, 14 × 14 × 1 inch.

as painted upon directly) but the *earth as painted*, seen in a painterly modulation, re-presented in paint. Therefore, it was a big step onward, indeed earthward, when Sandy Gellis undertook the *Diomede Project* in the late 1980s, in the wake of the two series of works just discussed. In this ambitious proposal for a competition in which a Russian island and an American island (both are Diomedes) were to be linked, the artist imagined building up a third island from the ocean floor—an artificial island to be constructed from thousands of stones, each of which would bear a different place-name from a list of thirty-five hundred such names compiled by Gellis (see Figure 3.3). Once the built-up island breaks through the water, it would literally link the other two islands. It would be the interplace for the otherwise isolated initial places. Itself a place, it would be *composed of places*, thanks to the allusions to other places from around the globe. Place to the 3,500th power! This imaginative project,

Boulders chosen from areas of the earth.
Each inscribed at their depth.
Deposited between the Diomedes.
Ecological restoration (pre-glacial)New land mass bridging the diomedes, two days, multifarious philosophies.
Numbers correspond to origins of boulders. Sandy Gellis 1989

129 KOTZEBUE	158 DEBRELEN	187 GRAZ	236 VSK	265 CRAIG	294 US HUAIA	253 BOCAY
130 TAYNCHA	159 CLUJ	188 UDINE	237 PAU	266 CHU	295 KATHA	254 KOBE
131 NOATAK	160 CRAIDVA	189 KOSTROMA	238 ANGREN	267 KIRKUK	296 MINAS	255 GIBEON
132 IRONWOOD	161 TALLINN	190 COSENZA	239 LERIDA	268 ANGOON	297 ROTOTUA	256 DAVAO
133 KIROV	162 BRAILA	191 MESSINA	240 VIGO	269 HILLA	298 BELEM	257 KIFTA
134 NESKAN	163 TILCHIKI	192 KIEV	241 BEJA	270 KIRENSK	299 DACCA	258 KALENA
135 ENURMINO	164 NOORVIK	193 REIMS	242 BRAGA	271 YAZD	230 SURINAM	259 [unclear]
136 GAMBELL	165 TUDOZH	194 LYON	243 VALLADOLID	272 QOM	231 MADRAS	260 ASAB
137 TIKBVIN	166 VELKAL	195 LE MANS	244 RUBTSOVSK	273 FURG	232 POTOSI	261 RECLIFE
138 SAVOONGA	167 KOBUK	196 DIJON	245 SANTA EULALIA	274 KAF	233 MACAO	262 HARBIN
139 WAUSAW	168 RUBY	197 PARIS	246 TOLEDO	275 MA'AN	234 OAXACA	263 KOES
140 STEBBINS	169 CRIPPLE	198 BELORETKS	247 CIUDAD	276 SFAX	235 BELO	264 PHUKET
141 KITLIK	170 KOMSOMOLSK	199 UELEN	248 LORCA	277 BASRA	236 TUMACO	265 TSANE
142 CHELKAR	171 OPHIR	200 IVIGTUT	249 KURSK	278 GOOV	237 KAOHSIUNG	266 JOAO
143 SCAMMON BAY	172 FLAT	201 TOMSK	250 MALAGA	279 GILGIT	238 TUNGUA	267 BOR
144 NEW YORK	173 STARA	202 TUKTUK	251 TURKESTAN	280 DADU	239 MAUN	268 ZIMBA
145 BETHEL	174 LUKI	203 CLYDE	252 TRABZON	281 BELA	240 NULLARBOR	269 IDDAN
146 TULA	175 RUSE	204 HALLE	253 ADANA	282 THIRA	241 ALBANY	270 CELA
147 EGAVIK	176 KAVALLA	205 OKHOTSK	254 AFYON	283 AND	242 PUSAN	271 OTARU
148 ALBANY	177 CHIMKENT	206 TEYKIAVIK	255 AYAGUZ	284 MELLA	243 WALLAL DOWNS	272 MUMBWA
149 KALININ	178 VOLOS	207 BESTOBE	256 HOMS	285 KUMAI	244 KNYSNA	273 UMM RUWABA
150 ROCK ISLAND	179 ALB	208 JARVENPAA	257 MOGOCHIN	286 MITU	245 WOORAMEL	274 YUMBI
151 KOVSK	180 MOSTAR	209 FORBISHER BAY	258 ANCHORAGE	287 KALAT	246 WALVIS BAY	275 DAM GAMAD
152 MADISON	181 NOVI SAD	230 GJOA HAVEN	259 CIRCLE	288 AGRA	247 BINTULU	276 BOKE
153 GDANSK	182 AMGA	231 UPERNAVIK	260 ISIL-KUL	289 LOTA	248 COLAC	277 AKETI
154 VILNUS	183 PECS	232 TURINSK	261 SEWARD	290 COWRA	249 BABO	278 BIRAO
155 CHORZOW	184 LIDA	233 BERN	262 WRANGELL	291 CAMPOS	250 SHERIEK	279 FINGOE
156 OSTRAVA	185 ZAGREB	234 MIKDEN	263 ABOU	292 NAGPUR	251 WILUNA	280 BUNIA
157 PIZEN	186 NEW BERN	235 DNEPROPETRO	264 BATURINO	293 BAHIA BLANCA	252 MEDAN	281 MUEDA

Figure 3.3. Sandy Gellis, sketch for the *Diomede Project* (1989). Proposal consisting of photographs and words on 8½ × 14–inch paper. Realized project was to consist of boulders from varying locations, placed on earth to create a new land mass between two continents.

though never realized, serves to remind us that *the earth, including any earth work created on its surface, is made up of places*—thus, *earth-mapping is ultimately a mapping of places.*

On the other hand, Gellis has not hesitated to employ cartographically correct maps where the situation calls for them. A new work of four etchings entitled *Depth Charts* (1987–88)—as the very name implies (*chart* derives from Latin *charta*, "papyrus leaf or paper" on which maps were inscribed)—brings in maps explicitly, either maps of actual places (e.g., Moorea) or imaginary maps of fantastic places. Moreover, in several of these maps we can distinguish three *levels*: first, depth under water (designated by numbers indicating exact extent of depth); land masses, for example, islands or other solid entities; finally, straight lines that are in effect vectors to infinity—to and from the sky, to and from the stars (see Figure 3.4, especially the map in the panel at the top, Coral Reef Crossings). Striking here is the correspondence of these three levels to three *elements*: water, earth, and air, respectively. These new works fit into the open-ended sequence of "Earth, Air and Water Studies," all of which explore the idea of elemental landscape, which I am taking as the primary leitmotif of the entire Gellisian corpus. In traditional landscape painting, a view of landscape is set into a fixed frame—both a historical frame of reference with respect to a given style and tradition and a physical frame around

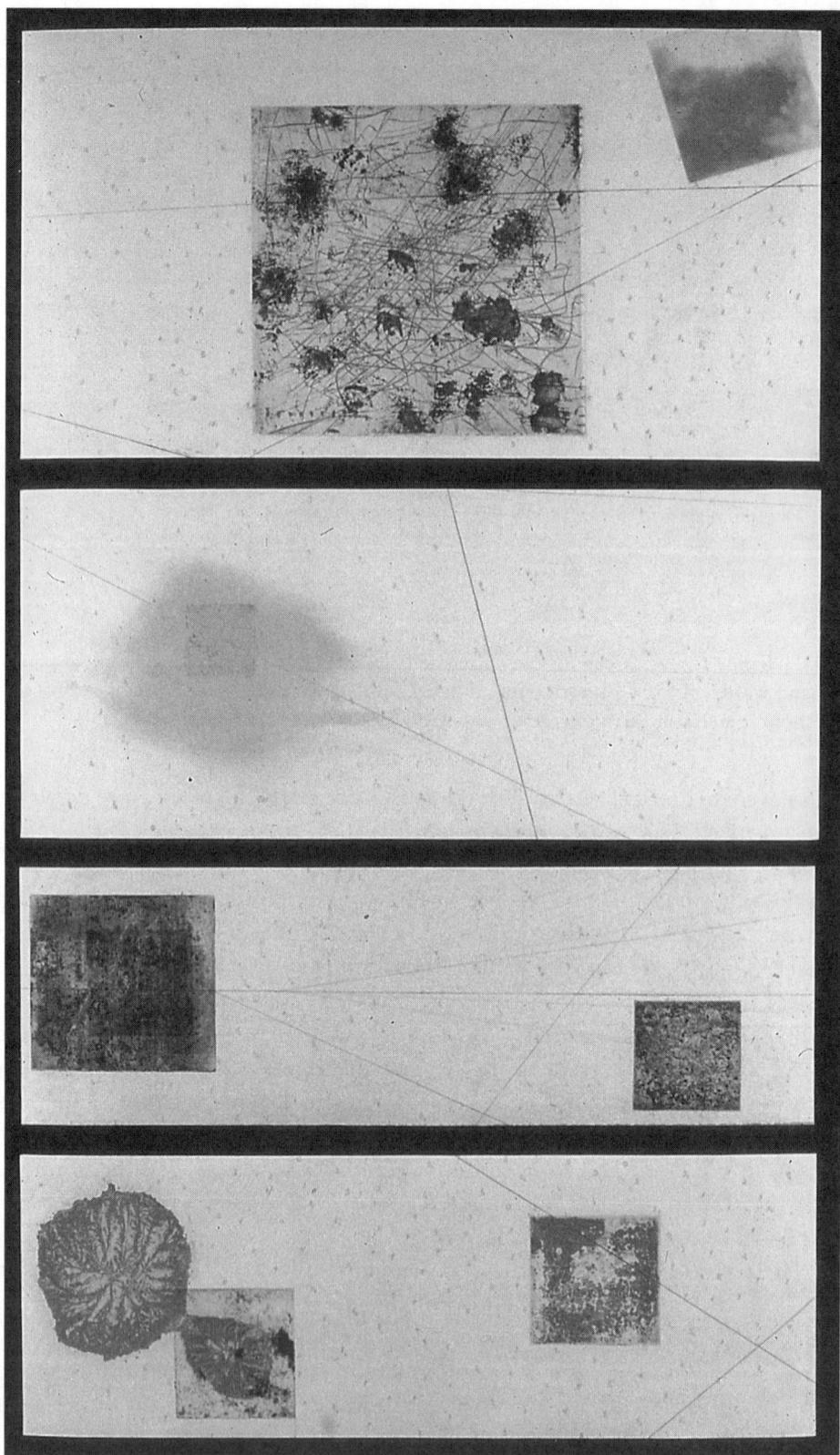

Figure 3.4. Sandy Gellis, *Depth Charts* (1988). Etchings, 43 × 26 inches all together; cross section of space (galactic, terrestrial, oceanic).

the painting itself. In Gellis's work, landscape is allowed to come forth in its own primordial presence, without the circumscription of either sort of frame.[3]

Terraces and Mounds

The most forceful example of elemental landscape that is also multileveled is *Cygnus A*, installed at the Sedgwick Branch Library, the Bronx, in 1994 (see Plate 8). Again there are three levels, each of which corresponds to a level in the maps of *Depth Charts*: the terraces answer to the differing depths of water, even if they cannot contain water (the height of the posts indicates the respective depths of the flat terraces); the rocks (two-thirds of the bulk in each case is underground), to the land masses; and the posts, to positions of stars in the Cygnus A Galaxy, which is detectable only by radio waves. (The tops of the posts contain highly reflective material, e.g., bits of glass and phosphorescent paint, which both marks their height as such and points beyond to the distant stars.) Thanks to this construction, three elements—water, earth (via the rocks), and air (through which we see stars)—are again at play. Although water is not literally present, it is suggested by the differential depths of the various terraces—as if these were all visible under water whose depth is measured by the posts.

Depth is not limited to the allusion to aqueous depth in the terraces. It is active throughout, being not only a matter of "down" but also of "out" and "back" and "up"—every which way. Gellis's installation instantiates Merleau-Ponty's contention that "depth is still new."[4] For neither the artist nor the phenomenologist is depth merely the third dimension of the classical three dimensions. It has become the "*first* dimension."[5] It seems entirely appropriate that the artwork of Gellis's that illustrates these claims best is a quasi-sculptural creation such as that at the Sedgwick Library. For this creation appeals not just to the viewer but also to the ruminator and walker: it draws in the whole body and not the eyes alone. And the whole body is precisely that organic entity most capable of exploring depth in every direction; for this body is the organic basis of all experience of depth, of whatever kind. Its inherent capacity to bend and twist, to orbit and swivel, its very elasticity, makes it the natural subject of depth considered as "the reversibility of dimensions."[6]

About *Cygnus A*, Sandy Gellis says without hesitation, "I see it as a map."[7] This statement is all the more remarkable in that the project, unlike its predecessor *Depth Charts*, involves no explicit maps, no cartographic inscriptions. The map it institutes is of another sort, one in which the human body moves amid basic elements. Just as *Spiral Jetty* invites perambulation along its sinuous curves, so *Cygnus A* calls for moving in its midst. If both are forms of mapping, this is a mapping in which the body figures centrally, as it will again in the work of Ingalls and de Kooning. This striking work, composed of basic elements (of rock and air and, by implication, water), is at the same time a study in depth, a depth that calls for

the body to map it out: the lived body, spurred on by an elemental landscape, maps out the place in which it finds itself.

Closely related to this earth-map is *Viewing Mounds,* a work of 1988 that is located on the edge of the Catskills just beyond Ancramdale, New York, in an open field. The title is deliberately ambiguous: it can mean either *places from which to view* (i.e., the Catskill Mountains in the distance) or *places themselves to be viewed* (i.e., as having an integrity of their own as artworks). A group of some nineteen mounds, they are composed of gravel and clay and a crust of powdered iron amassed into graceful shapes that echo the mountains beyond (see Plate 9).

Taken in one way, the mounds are miniature mountains, small replicas of the Catskills; taken in another way, they stand by themselves. In this delicate equipoise between two identities—two ways of being construed—they are literally "earth works": as composed from what is taken from below the surface (clay, gravel, and the basic element iron), they belong to the *earth*; as *works,* they are constituted by a human artificer. (The region was an iron mining area: an "iron works.") Not wholly unlike the interisland of the *Diomede Project,* they are beings of the between, destined to mediate between the clearing of the lawn on which they reside on Stephens Farms and the wildness of the Catskills in the seen distance. They are also between in a temporal as well as a spatial sense: with time, they are crumbling, and certain of the mounds are already beginning to lose their original crust. Eventually, all the mounds will decompose, leaving only iron(ic) traces of their former presence. The earth work will return to the earth.

Viewing Mounds is a map in its own right. It maps out the mountains for which it provides both entry and reflection. Rather than a contour map, it offers an elemental topographic re-presentation of the Catskills by way of miniaturized sculptural renditions of these mountains on a small scale. As with those three-dimensional configured maps that compress an entire landscape into a single palpable presentation—think of the remarkable models that have been made of the Alps, for example—these viewing mounds remain true to their name in yet another sense: *through* them, one gains a more nuanced appreciation of the topographic features of the actual mountains they condense and mimic. This is an appreciation not of the sameness of features but of the difference between the ever-unpredictable outlines of mountains in the natural realm and the humanly crafted shapes of these micromountains: shapes more regular and repetitive than those of the Catskills in the distance. It is as if the artist were giving us a new kind of You Are Here map, not for the sake of conveying directions, but so that we may better discern the differences between what is right here in our visual near-sphere and the mountainous masses over there. Otherwise put: what is within the immediate ambience of my moving body gives to me the counterimage of that which this body would take days to discover were it to walk all the way over to the mountains themselves. *Viewing Mounds* furnishes us in effect with a sketch-map of possible movement from Here to There.

Letting Living Water Speak

The literal hardness of the rocks and terraces and posts of *Cygnus A*, along with the metallic density of *Viewing Mounds*, is complemented by the soft tractability of the water that is increasingly prominent in Gellis's projects of the 1990s. These various aqueous works, despite their manifest differences, continue to map in their own way. In one recent work, *Ocean Fragments: Water* (1997), an explicit cartographic factor appears in the form of line drawings of the course of rivers; these riverine configurations recall the ancient Chinese stone map, the *Yujitu*, which traced all the major riverways in China in A.D. 1142.[8] At the same time, Gellis also includes aerial photographs of rivers (e.g., the deltas of the Nile and the Mississippi) that recall her own earlier "Condensed Spaces." These recognizably cartographic features are supplemented by statements on placards by T. S. Eliot, John McPhee, and others who write about rivers, for example, "The river is a strong brown god."[9] In addition, there are long tubes of water drawn from actual rivers. In an artist's statement for this installation, Gellis remarks, "There is a fixed amount of water in the world. It occupies 70% of the earth's surface and 65% of our bodies." This claim, though less sweeping than Thales's celebrated thesis that "all is water," points to the artist's gathering conviction that water is a key element.

This conviction is only deepened in the series entitled "Ocean Fragments" (1997–2000), in which objects found at the edge of the sea on a Baja beach are thrown into remarkable relief by being photographed very close-up, scanned, and then magnified in large digital iris prints, which are hand colored with oil pigment and wax. The images of a blowfish, hammerhead shark, and other *trouvailles de la mer* bring home the diversity and surprise of ocean life as it washes up, dead and wasted, on the beach. These images are all the more striking because of the sudden reversal they effect: originally part of the sea, not only have they left their natural habitat (many are skulls or skeletons), but also they leave the beach in turn to become purely photographic objects. They hang in the void of the photographic print and thereby underline, by double absence, the oceanic element they now so permanently lack.

Where *Ocean Fragments: Water* remains a mélange of word and line, photograph and water, and the members of the later "Ocean Fragments" are mainly photographic in their final state, in other projects of the last decade or so Gellis has engaged with water on its own terms. In one of them, *New York City Rainfall: 1987,* the artist placed 5-inch-square brass plates outside her loft window every day for one year; the pattern of rainfall each day affected the white ground of the plates in such a way as to figure (not just register) the amount and pattern of rainfall on a given day: the heavier the rain, the more did abstract washes of dark brown appear. Gellis mounted the entire ensemble, with blank spaces for dry days and etchings of many colors (printed from the original plates with bronze powder worked into ink) representing wet days. The result is "a pattern of rainfall for one year."[10] In effect, as presented on a single

enormous wall space, the pattern is that of a temporal map—a chrono-meteoro-cartography of events recorded in the course of time (see Figure 3.5).

But weather, including rainy weather, is in the end spatiotemporal: rain falls at certain times of day and night, but it also falls into certain definite places. On the one hand, it is evident indeed that Gellis "delights in recording the ravages of weather over time."[11] But the time is not just *any* time: here, it is the full year of 1987, just as in another project it is a period from the spring equinox to midsummer. On the other hand, the rain in which she is interested is that which precipitates on New York—indeed, right outside her studio—just as in the other project the pertinent sites are all located, deliberately, north of the equator: hence the title *Spring 1987: In the Northern Hemisphere.*[12]

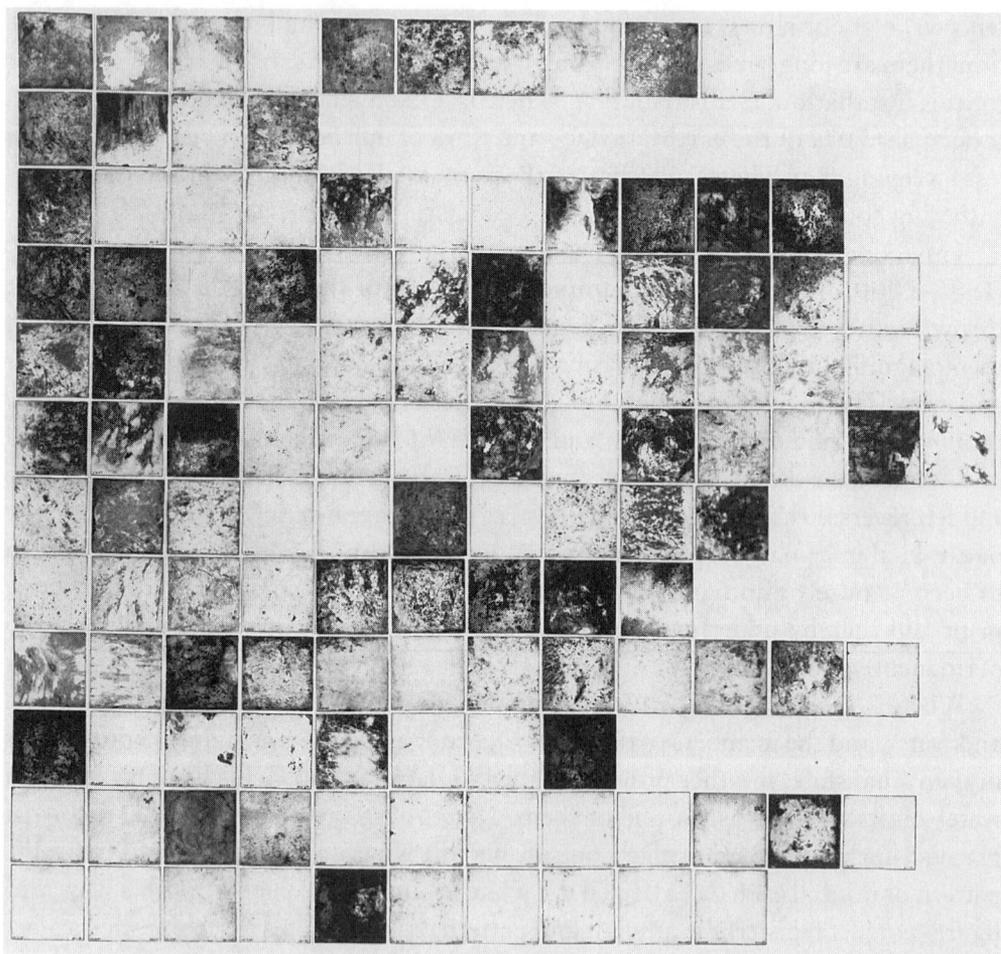

Figure 3.5. Sandy Gellis, *New York City Rainfall: 1987* (1988). Installation of brass plates mounted on wood. Original materials: brass and precipitation. Overall dimensions, 155 × 60 inches; each plate is 5 × 5 inches and represents one day of rainfall during 1987. From the installation an etching of 124 images was created and contained in a box.

Still another ambitious project of this last period, "Hudson River: Sediments," combines spatial and temporal markers along with explicit photography, all within the ambience of water. In this still-ongoing work, Gellis has made photographs of the Hudson River from Lower Manhattan once a week; at the same time, she has collected sediment samples in tubes, 3 feet by 3 inches, from the whole length of the river at ten-mile intervals: quite specific places indeed. These samples were taken at the river's edge and "indicate not only what has naturally settled out of the water, but also reflect the human impact on surrounding areas."[13] In the catalogue from which this statement is taken, Gellis has drawn an image of the entire Hudson estuary system, mapping out the space of her project, whose temporal dimension is the weekly photographing of the river as it passes by Manhattan on its final leg to the sea. In this way, the river, so often taken as exemplary of time's passing, is twice caught up in space—in the sediments it leaves on its floor and in the photographs it inspires of its surface. The result is a multiple mapping of a single estuarine environment: a mapping at once elemental, linear, and photographic.[14]

Multiple mapping, again both spatial and temporal, is evident in Gellis's most extensive project of recent times, her "Landscapes" (1976—continuing). As in the Hudson River project, there is again a collection of samples in glass containers, in this case jars; but the geographic scope has been greatly expanded. Her professed aim is "to collect a sand or soil sample from every natural region on earth."[15] To this end, she has assembled a considerable array of such samples—a virtual "earth bank," in her own term. Each sample is placed in an empty glass bottle to which the artist adds two liters of New York City tap water, with the locatory description affixed to the jar's surface. Most of these samples are contributed by friends and other artists, who provide precise descriptions of the time and place of the act of collection. For example, a typical jar is illustrated in Figure 3.6. Were Gellis to exhibit the totality of jars thus collected, she would place each jar according to where the sample was taken, that is, in the approximate position it would occupy on a world map in terms of latitude and longitude; and with this in mind, she has published the image of such a map in the catalogue of a recent show of hers at Gallery Three Zero.[16]

This is earth-mapping with a vengeance! It takes small portions of the actual earth—soil and sand and stones from particular places, put into water from one particular city—and relocates them to the artificial place of a vessel such as a jar: the very paradigm of any place according to Aristotle, who conceived place as a function of the innermost containing surface of that which surrounds the item-in-place.[17] From this discrete glassed-in place, there is a further displacement onto the represented space of a world map, to a region of which a given jar is affixed in accordance with the coordinates of its place of origin. Double displacement of various constituents of the earth, the terrestrial twice removed! A matter of moving matter!

The New York City water in which each sample is placed—and in which it sometimes dissolves or is chemically altered—is emblematic of the motion entailed by any such relocation and transformation. Water may not be all, yet it takes in all the

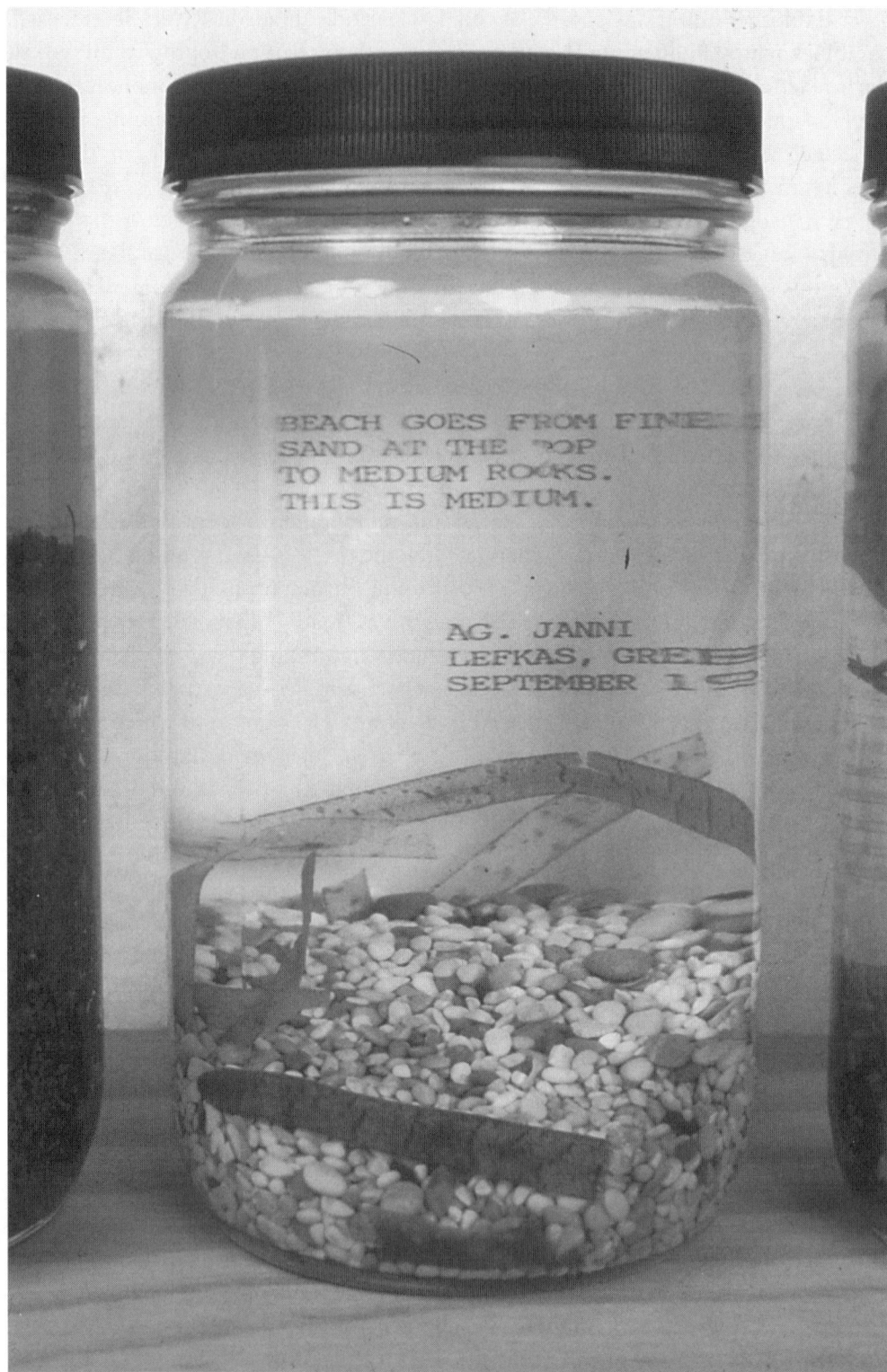

Figure 3.6. Sandy Gellis, "Landscapes" (1976–present). Sand, soil, water, words; materials taken from different parts of the world. This is an ongoing project, still in formation; to date (2005) there are approximately 250 jars.

other great elements—earth and air and fire—and transmogrifies them into its own circumambient elemental being, its all-encompassing embrace. In this light, it is not surprising that an inveterate earth-mapper such as Sandy Gellis should choose water as a universal solution, an indefinitely shaped but definitive dissolvent. Elemental landscapes, even those of rock and soil and sand, find a common medium in water.

Environmental Art as Transmutation of the Elements

Not to be overlooked in Gellis's evolving work is its explicit environmental ethic. This artist is not just working *with* the earth but actively *for* it—for its health and well-being. In a 1989 show called Earth, Air and Water Studies, Gellis exhibited drawings and models for projects that bear on environmental danger and detriment. In one of these, the *New Lake Project,* she proposed placing a layer of transparent material three feet above the ground in the woods around the lake, thereby thwarting human intervention and "giv[ing] the natural growth above and below the material time to recuperate."[18] In another, the *Curtis Bay Project,* she imagined sinking iron rods into reeds in the marshlands of the bay, thereby again discouraging the intrusion of human beings. At the same time, she projected covering a garbage dump at the end of Curtis Bay with black slag that would reflect, by its shape, the environmental damage that has taken place at this location. A critic has written that such projects are "at once critical of our misuse of nature, protective of the environment, and act as reminders and memorials to that which is already lost."[19]

The phrase "reminders and memorials" indicates another important strain in Gellis's earth-mapping: her concern for retaining lasting remnants and records of environmental events. In certain cases, this is a matter of conveying the immediacy and uniqueness of such events, as in her presentations of rainfall and river water. In other cases, it is a question of exhibiting—and thus of valuing—what has already happened some time ago, as we see in her iris print photographs of objects found on a Baja beach or in the miscellaneous contents of the jars that gather material from around the world. Either way, it is evident that "Sandy Gellis's esteem for nature's leftovers never abates."[20] This is true whether the leftover stems from a direct deposit left by the natural world and is retained as such or whether it is the mark made by the natural world in (and *as*) the artwork. Throughout, the artist acts as the medium of transmutation whereby the remainder of nature becomes the rejoinder of art.

Gellis's manifold earthbound enterprises can best be understood in terms of dyadic pairs of terms. First of all, her work exhibits the profound difference between *representation* and *embodiment*. Instead of representing the elemental landscape as such—she comes closest to this in the earliest work above discussed, "Condensed Spaces," although even here there is considerable abstraction (and full abstraction in its painterly sequel, *Night Views over Land from Seat 8A*)—she seeks to bring material substances into the artwork itself. She doesn't just give a painted

image of various ancient elements but imports these elements themselves into the work. Indeed, they *become* the work. They are not just factors in it but serve as the work itself. By "embodiment," then, I do not mean anything merely functional or utilitarian; rather, I signify *making part of, becoming a constituent.* But in such embodiment there is transfer not merely of the same into the same but of the same into the different. As we have seen at many points, elemental transmutation is at stake in Gellisian artworks—an alchemical process in which the literally heavy as well as the scientifically straightforward both gain in subtlety. Matter is subtlized in the earthiness of Gellis's productions, their literal "leading-forth" from dross, their transmutations.

A second pair of clarifying terms is *location* versus *relocation.* Gellis's works are earth-maps, and in this capacity they imaginatively and significantly relocate the earth's many places and its constituent substances in ways that are at once systematic and unpredictable. When exact location figures at all, as in the world map to which the jars of "Landscapes" are meant to be attached, it does so merely as a reminder of the geographic sources from which particular images and samples have come in the first place. In the first place indeed, there being no other place from which they *could* come; but in the second place, which is the place of the artwork, locatory origins do not matter as such, or rather, they are relocalized in the artwork. Instead of being located, as on conventional maps, discrete things themselves become locatory; they make the work itself into a map, which gives the new coordinates of place, whether these be those of a jar, a wooden box, a photograph, a mound of matter, a heap of garbage, a submerged island. Just as elements of things become Things, so their place-of-origin becomes the new place-of-the-work. The original place is not ignored; it is noted and even respected, sometimes diligently. But it figures into the artwork only as re-implaced. It follows that Gellis's work is not site-specific, clinging to a given spot and reflecting its exact dimensions, adjusting to them. (That way again recalls Aristotle's insistence on precise fit and formal specification.) Instead, it transforms the place into which it is put; it constitutes place by its own force.

Closely related to the previous binary pair is *presentation* in contrast with *re-presentation.* An artwork that is sheerly presentational is one in which everything in it is self-signifying, "autotelic." Examples would be the self-absorbed icons to which I have referred in the prologue—for example, paintings of Rothko or Barnett Newman, the sculptural works of Donald Judd, or the fluorescent lights of Dan Flavin. In none of these is there any obvious reference to anything outside the work, that is, anything discrete; if nonetheless something of the numinous is conveyed, it is as a sense, not a referent. By contrast, Gellis's works, though rarely referential (the exceptions are precisely those in which cartography or photography figures into her works), do not conceal their material of origin. Indeed, they make this materiality abundantly, often gloriously, clear, and they do so not by representing it but by *re-presenting* it. *Re-presentation,* a term whose meaning I have explored elsewhere,[21]

signifies not just presenting again but doing so in a transformative manner. Far from implying anything derivative or secondary, it means instead an "augmentation in being" (in Gadamer's phrase). The logic of re-presentation is thus parallel to that of re-implacement. In both cases, there is an aesthetic and ontological gain rather than a net loss. In absorbing the earth instead of being absorbed in itself, the work moves forward into the world that it brings forth, thereby producing it.

Reflection in contrast with *deflection*—in a last basic distinction—is very much at stake in all of this. Gellis shows us that earth-mapping need not be a mere diversion, a deflection, of elemental substances into a counternatural direction, as could be claimed of certain of Smithson's early earth works. Nor is it just a matter of putting these substances to another purpose (e.g., placing sediments of the Hudson River into art jars, refiguring Baja beach objects as photograph-like images), though this displacement (another form of deflection) does indeed occur. What also happens in Gellis's earth-mapping is something quite different: an (artistic) transvaluation of (naturally given) value, not merely by an act of judgment—as the Nietzschean notion of *Umwertung* implies—but, more important, by a bending-back, the literal meaning of *reflection*. When Gellis herself remarks that *Ocean Fragments: Water* is "a reflection on the earth's water,"[22] she does not mean reflection as deliberation: as a cognitive act. She means, rather, that the earth's water is reinstated in the artwork that ensues: whole rivers are transformed into lines and photographs, even into words. All of this belongs to reflection in the richer sense that surpasses any literal deflection of light—that gives to matter a new place to be (itself), as part of the eventual artwork. Such reflection is akin to what Wallace Stevens suggests in the title to one of his late poems: "A Mythology Reflects Its Region."

The reflection is not through mind alone, that is, non-body, but more significantly through the *body of the artist*. *Body* here does not mean the gestural body of action painting that leaves its mark directly in traces made in the work. As with Smithson, we have to do with a reticent body that withdraws before itself within the very work it makes. Gellis likes Husserl's phrase "activity in passivity" as a description of her own body in the process of working.[23] She has been photographed in the course of creating (e.g., in the Hudson River project and at the Sedgwick Branch Library), but she chose not to include these images in the finished work. The bodies of the elements are more important to her than her own acting body. Nevertheless, there could be no thorough reflection of the elements in her work unless these elements passed through her moving-feeling body: they are reflected in and by that body, turned back into something once again material, namely, the artwork that eventuates. Their body is the work's body, yet only by means of the intermediary presence of the artist's own transmutational body. The mapping that results is not the absorptive mapping we shall encounter in part II—in which the artist's body also figures prominently—but a reflective remapping in which the artist creates not so much *with* her body as *through* it. Such a body is the alembic of elemental transformation, its very vehicle, but it is not its content.

There are still other pairs of terms that are pertinent to Gellis's work: for example, *view* versus *re-view* (the latter being accomplished by the framing of an ordinary view, whether the frame is that of an airplane window, a sheet of glass spread over a work, or a jar in which water and earth and air interact) and *animate* versus *in-animate* (Gellis animates the inanimate in its elemental guises; or rather, she shows that the inanimate is already animated and that the artwork consists in this con-tinual demonstration). But superintending all the dyadic terms, including those just mentioned, is the fact of remapping that which would otherwise be the mere subject of ordinary cartographic mapping. Sandy Gellis's magical work remaps the elements of the earth—puts them in another place, augments them by raising them to another register, finds for them another frame, animates them anew, and resituates them in a more sublime mode that is at the same time ethically and politically pointed. Hers is a truly reflective mapwork in which the artist's body is the silent partner of the elemental, its intimate other, its reticent guide. She gives us landscapes that not only represent the elements but embody them—that breathe and bespeak air and earth and water, re-presenting them by transmutation in the work.

Chapter 4

PLOTTING AND CHARTING THE PATH
VOYAGING TO THE ENDS OF THE EARTH WITH
MICHELLE STUART

> I like the idea of putting boundaries on the chaos that is
> there. . . . Why can't I do it?—*Michelle Stuart in conversation,*
> *July 10, 2000*

From Moon to Earth

Michelle Stuart, by her own profession, was "placed in space from an early age."[1] Her prolific career as an artist of the elements had manifold familial and geographic origins. Her mother had come from Switzerland, and she was Scotch-Irish on her paternal side: both parents had immigrated to America. Her father was a water-rights engineer as well as a colonel in the U.S. Navy who had traveled widely in the South Pacific in World War II. Ancestral Stuarts had migrated to New Zealand from Scotland. Travel was in the genes. Journeys—moving from place to place—were continually recounted in the family scene. As a child, Stuart enjoyed tracing out these journeys on a world map in the family kitchen in Los Angeles; the map encouraged her to believe that she could go anywhere on earth. In contrast, history was of marginal interest, and, despite extensive archaeological explorations later in life, Stuart claims, "I don't know where I am in time."[2]

To support herself during art school, Stuart worked as a cartographer making topographical maps for the Army Corps of Engineers. From this literal preoccupation she gained the concrete sense that the earth could be shaped and reshaped for certain purposes: the engineer's reclamation of land could become the artist's exaltation of earth. Moreover, the material on which Stuart made maps in this early job—muslin-mounted rag paper—became her medium of choice as an established artist. Before this happened, she made careful cartographic drawings based on enlarged NASA photographs of the moon; the drawings were done on grids, free-flowing strings were attached, and the result was set within boxes, not wholly unlike Gellis's "Condensed Spaces," which were also boxed and some of

which also contained strong linear patterns. But Stuart began with the moon, to which she returned after a long immersion in the earth. In other words, she started by mapping a place that is way out there in space, even if it is brought close by photographic means (see Figure 4.1).

The grid lines reappear in a series of extraordinary drawings made in 1973. These are not maps in the sense so clearly implied in "Moon," the collective title of the lunar studies. The defining boxes—reminiscent of the edge or frame of or-

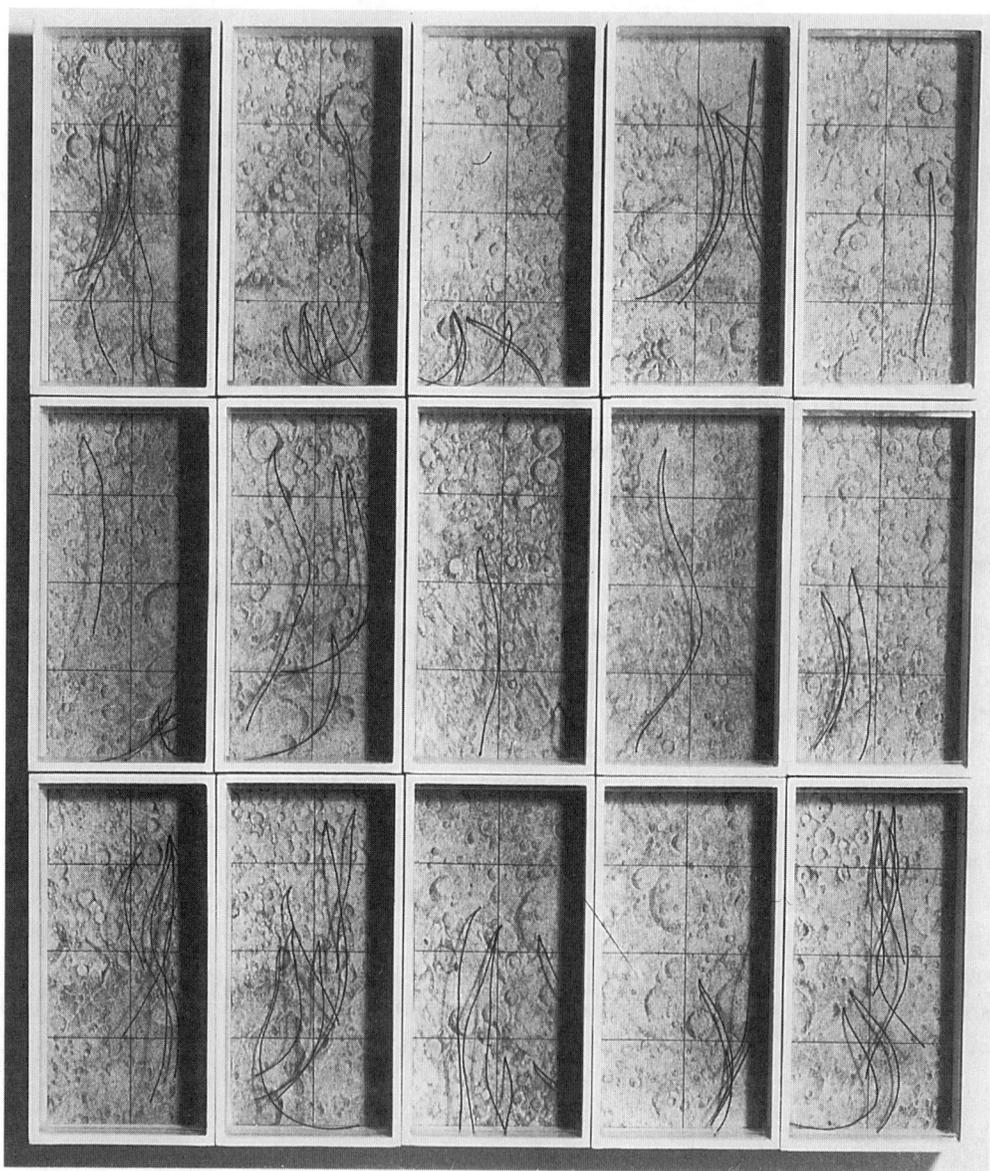

Figure 4.1. Michelle Stuart, *Mare 15* (1972). Paper, graphite, wood, and string construction, 25 × 22 × 3 inches.

dinary maps—have been removed; so have the vertical lines, or "meridians," that are essential to the location of things in global space. Gridded space has become striated space, as in the elegant exemplar illustrated in Figure 4.2. Despite the crisp punctuation provided by the sets of double lines, the real subject of the drawing is the surface of the paper as it bears the weight of the continuous application of graphite. Too regular to be lunar, this surface is like nothing so much as the surface of the earth in one of its more indeterminate stretches. This mottled surface emerges from beneath the parallels within which it is encased when it is subjected to geometric mapping operations. It is almost as if Stuart were bearing out Husserl's point, mentioned earlier, that geometry (which means "to measure earth") depends upon the very earth it transcends, since the basic geometric shapes can be seen as idealizations of natural landforms encountered in early land surveys in Egypt and Mesopotamia.[3]

Stuart's breakthrough works of this period suggest not only the dependence of geometry upon earth but also, more radically, the resistance of earth itself to explicit cartographic representation. Thus it is not surprising that other members of this same series of drawings eschew the quasi-latitude lines that remain in *No. 4.* Indeed, the first member of the new series, *No. 1,* is as unstriated as it is frameless. It asserts the earth by a remarkably intense rubbing of blocks of graphite and graphite powder into the absorptive surface of the rag paper. The paper itself is very large in size, 12 feet by 5 feet 2 inches, and it is meant not merely to hang downward on a wall but to extend onto the floor, where it greets the spectator as if it were a magic carpet capable of flying over the very earth it sets forth. But before any such flight can occur, the viewer's look is arrested on and at the dense surface, which is (in Lawrence Alloway's phrase) "a fabric of significations."[4] This surface is a highly tactile scene of visual traces, none of which is indexical, much less symbolic. The effect is almost that of a self-absorbed icon. I say "almost," for in fact there is an allusion to something else literally underneath the drawing, namely, the rugged mass of what is placed under the work, which the drawing traces out compulsively. This is rock or sand or some other hard substance—something that belongs to the natural world. Stuart rubs not only the surface of the rag paper on which she works but also *through* it to capture the raw texture of what lies below, which belongs to the earth (even in the case of metal, which she also employs).[5]

Rubbing It In

It is but a natural next step to abandon the artificiality of graphite and to begin to rub earth itself into the paper, as Stuart proceeds to do in a remarkable series of artworks that can be called *earth-mappings.*[6] What is most immediately striking about these works—which continue to be done on large sheets of rag paper that dangle down and curl up at their lower edge—is their brilliant, translucent color. Just as ordinary graphite shows itself to be unexpectedly rich in tonalities, so the

Figure 4.2. Michelle Stuart, *No. 4* of "Moon" series (1973). Graphite on canvas-backed paper, 111 × 62 inches.

earth is far from dull in its colorations! This becomes evident in a work such as *Sayreville Strata (Quartet)* (see Plate 10). Here reddish earth from an abandoned quarry near Sayreville, New Jersey, has been rubbed directly onto four striking sheets of rag paper. The effect is as numinously dazzling as certain late paintings by Rothko, yet these are not paintings in any received sense of the term. The colors are reminiscent of those used by Cézanne in his studies of the Bibemus quarry outside Aix, but the French master's colors are approximations of the natural hues of quarried rock, while Stuart's colors are *those of the earth itself.* If the graphite works of 1973 convey the palpable texture of the earth, these newer works (neither exactly paintings nor drawings) preserve the earth's visible colors, the native stains of its soil and minerals. The qualitative immediacy that characterizes color—in contrast with the delineative and depictive properties of line—is thematized, and all the more effectively thanks to the subtle variations in value manifest from panel to panel.

The hanging paper of these earth-maps reminds the viewer of scrolls, and it is only appropriate that Stuart begins to include stacks of sheaves that suggest books in works of the same period. Sometimes these "rock books" stand by themselves; sometimes they are juxtaposed with the scrolls, themselves at times supplemented by photographs, as in the instance illustrated in Figure 4.3. The rock-books seem to resemble the sun-dried bricks of the cliff dwellings and to allude to archaeological knowledge of early Native American life. The two photographs of these dwellings act to reinforce this knowledge by giving us accurate representations of them. In their two-dimensional exactitude, they edge toward cartography. But instead of being given a map, we are presented with three alternative and equally valid ways of ingressing into Mesa Verde: by icon, word, and matter. Each maps in its own way. The scrolls do so by "unfolding smoothly, sequentially, like maps . . . sections of a place held up for perusal rather than for implied handling."[7] The rock-books might well be full of geographic information, like ancient chorographies.[8] The photographs locate very precise parts of the dwelling place. Uniting all three constituents is the earth of the place, and more specifically the color of its substance, its patina.[9]

Perhaps the quintessential Stuart of this period, however, is an instance of what Heidegger might call "the two-fold" *(die Zweifach),* in this case, the combination of distinct image and indeterminate rubbing. This basic pairing takes two forms, closely related. In several early studies, topographical maps accompany rubbings of earth, as if to locate what would otherwise be unlocatable, for example, in *Blue Stone Quarry—Moray Hill Site* (1974). Or else, as in *Codex: Canyon de Chelly, Arizona* (1980), instead of maps a series of photographs accompanies a central area of earth *frottage* (see Plate 11). The photographs are of various parts of the fabled canyon, both at a grand scale and close-up. They are not maps in any readily recognizable sense, since they do not cover the entirety of the space of the place; but they do convey a precise pictographic record of some of its most important features,

Figure 4.3. Michelle Stuart, *Passages: Mesa Verde* (1977–79). Earth, paper, photographs (photographs are of Mesa Verde, Colorado, and earth is from that site); scroll, 108 × 59 inches; forty-five rock-books, 11 × 12 × 3 inches each, four feet from wall; photographs, 14 × 17 inches each.

and in this capacity they would qualify as chorography if not topography—where, by "chorography," I mean the tracing out *(graphos)* of a region, in Greek, a *chōra*. Topographic maps and photographs of a place share a common pictoriality; each gives an image of that place, whether by way of contour lines or by directly depictive representations. Both contrast with the indeterminacy of a rubbing, which though highly palpable and texturally rich is still not imagistic. The rubbing is not an image *of* something such as earth, but it is the bringing of earth itself into the work; rather than representation—the status of all pictographs, whether topographic or chorographic—it is a sheer *presentation*. In just this respect, however, representation and presentation complement each other: one gives us what the other cannot deliver, either the earth itself or an icon of this same earth.

This is not to say that the two parts of such works are altogether disparate. The common linguistic root of *photographic, pictographic, topographic,* and *chorographic* is the same word: *graphos*, "written," derived from *graphein*, "to write" qua tracing or marking, with both words being ultimately traceable to Indo-European *gerebh-*, "to scratch." Rubbing is akin to scratching, marking, and tracing alike, and it is hardly accidental that one basic form of rubbing—that first adopted by Stuart—employs *graphite,* which shares the same etymology. It follows that there is an inner, and often hidden, affinity between the rubbing of Stuart's paper works and the images that accompany or surround them. Both take place on a paper surface, whether by the direct pressure of hands on that surface or by the attaching of pictographic images to it. All that is required is "barely scratching the surface" for the depths of the earth to come forward into visibility. Once more, then, the depths appear on the very surface of the work.[10]

Land Works

By 1975, it had become apparent to Stuart that the relevant surface for the works she wanted to create could not be confined to muslin-mounted rag paper, invaluable as this had proved to be (and as it would continue to be, intermittently, for the next two decades). There is, after all, the *surface of the earth* to attend to, the very surface that she had traced in her first rubbings and from which she had extracted minerals and soil to rub into the surface of the paper. Instead of bringing the earth directly onto the paper's surface, why not put the paper (once colored with the earth) back onto the earth itself? In a bold move that is reminiscent of Smithson's large-scale earth works, Stuart did just this in *Niagara River Gorge Path Relocated* (1975) (see Figure 4.4).

Here the paper drapes down over the land as it dangles into the river below in "a Piranasi-like elongation of the scroll form."[11] It follows the original path of the falls before it was rerouted to its present location by the last glacier. Not only does the paper (rubbed with red earth and red shale from the gorge site) follow the path of the water as it first made its way downward into the gorge, but its own trajectory,

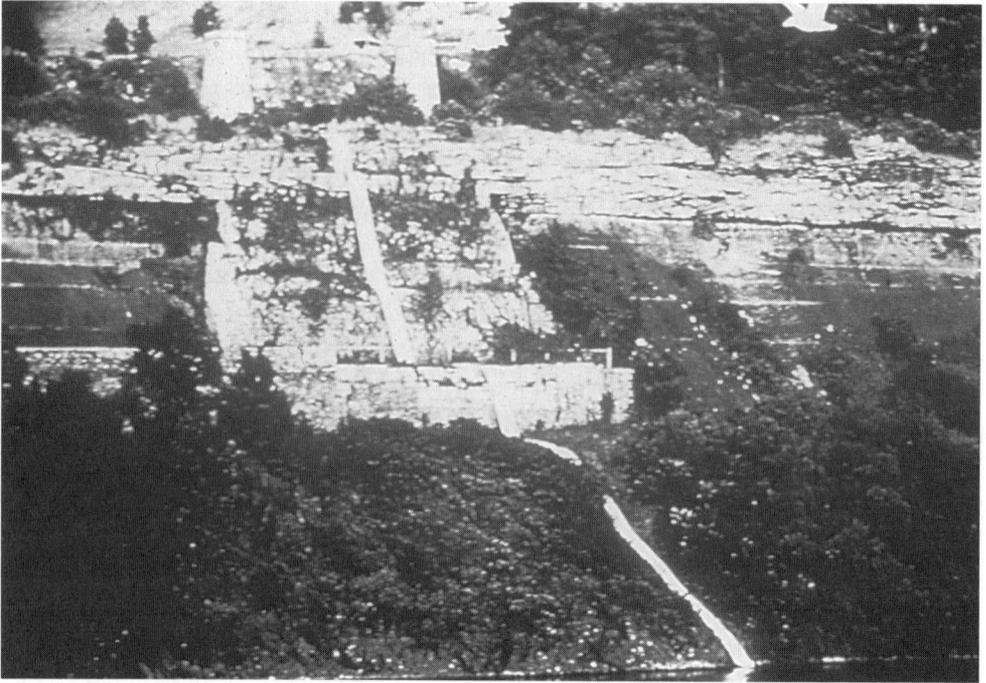

Figure 4.4. Michelle Stuart, *Niagara River Gorge Path Relocated* (1975). Earth and shale from site on muslin-backed paper, 460 feet × 62 inches. Artpark, Lewiston, New York.

free-falling and not pinned to the escarpment, evokes the flow of the now-absent water. The individual pieces of paper are sewn together to form a vast continuous ribbon, suggesting a single watercourse; but their constructed character, their very artificiality, also links them to the man-made pillars and sculpted palisades through and down which the paper is placed. Stuart has remarked that "the line of the piece [i.e., the long ribbon of paper] reiterates 'going from one point to another' geographically as well as geologically: repetition, relocation, and redefinition, then, each have their place in the work, as well as mapping."[12] The concatenated canvases trace out the shape of the escarpment, and in this way they map it.

Despite the similarity to Smithson at the level of gesture—and in anticipation of Christo's later wrapping of cloth over the landscape—Stuart calls this and other comparable efforts "land works" in distinction from "earth works." This is not a distinction without a difference. If *earth* signifies at once the entire planet as well as its topsoil—at once a three-dimensional planetary entity as well as its surface with a certain minimal depth—*land* implies mainly surface, as in the phrase "the surface of the land." Of course, land is a region or realm of the earth and is constituted by solid ground (of which topsoil is a main instance). But it also signifies property or estate (something owned) as well as nation (the territory of a whole people). In its origin (i.e., as *lendh-*), it means "open heath or prairie"—and, in a more civilized modality, "lawn."[13] The Niagara River Gorge land work suggests a lawn of the river,

half cultivated (in reshaped rock and sewn paper alike) and half wild (in the natural rock and the untended vegetation on its slope). This is a cultivated surface of the elemental earth that has become a coherent escarpment, thanks to the intervention of the stone mason in the nineteenth century and the land artist in our time.

Land work need not be temporary. Cut to the measure of Smithson's ambitions in his earth works, land works can create a lasting figure in the landscape. An example of this is Michelle Stuart's *Stone Alignments/Solstice Cairns,* constructed on the Rowena Plateau in the Columbia River Gorge in Oregon from thirty-two hundred boulders brought there from Mt. Hood. A main circle 100 feet in diameter is divided into six parts, with a rock pile at the center and three outlying cairns linked respectively to the moon, the sunrise, and the sunset (see Figure 4.5). The sunrise and sunset cairns were aligned for the summer solstice June 21, 1979. Certain fortuitous events occurred on that same day: the moon sank directly into the rising sun that morning, four killdeer were born on the plateau: "They emerged like Mithras himself."[14] Stuart describes the summer solstice as "this cycle in time patterned by time," and she regards the entire land work at Rowena as a "journey in time." The time at stake is triple: the prehistoric time of ancient peoples whose heliocentric culture is here reinstated, solar time proper (i.e., the rising and setting of the sun) as it impinges on seasonal time, and the present time of building and celebrating. But it is striking that in order to invoke and reflect this triple journey in time, *spatial*

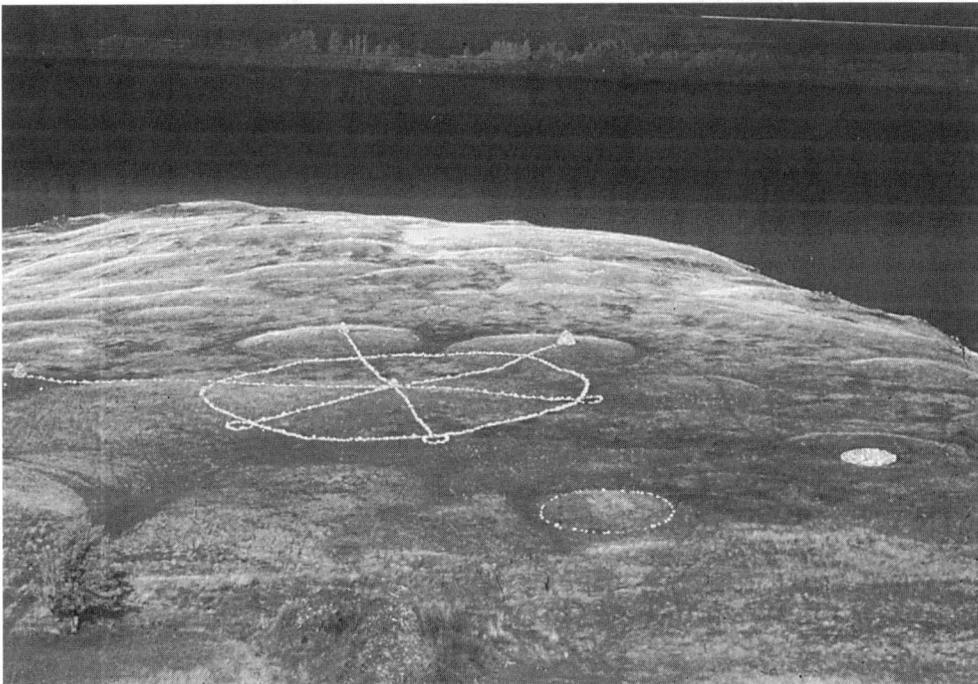

Figure 4.5. Michelle Stuart, *Stone Alignments/Solstice Cairns* (1979). Earth and stone, 1,000 × 800 feet. Rowena Plateau, Columbia River Gorge, Oregon.

means must be massively deployed: first, in the construction of the site itself, then in the intended effect as described by Stuart: "sensuous mounds . . . rounded earth base topped with cairns . . . flat stones . . . oval stones . . . shape matching shape . . . joined to link the dreamer to the horizon sealed by the sun." Here is another, vaster version of "viewing mounds"! The flat and ovoid shape of the stones, "chosen both to contrast with the dark indigenous basalt and to bring the mountain to the river," allows them to form cairns that draw the glance out from the center of the sacred circle to the horizon of the land work: they form at once a nearby horizon of perception and at the same time symbolize the larger horizon of the Klickitat Mountains.

The lesson is that any journey in time is equally a trip in space. The "day" at stake in a literal *journée* becomes manifest only on spatial surfaces on land or sea or in the air—in short, in the elemental matrix that makes up or surrounds the earth itself. It is noteworthy that yet another journey is at stake on the plateau of Rowena: this is the end of the Oregon Trail, land's end, and a place where the Lewis and Clark expedition camped for a while. Thanks to such historic events in such a space, the Rowena Plateau becomes an entire "place-world." Place alone can hold space and time together in one shared situation. The issue is not just that time calls for space as if for some mute and stubborn support, or conversely that space requires time to leaven its obduracy by letting something happen in it. Precisely in the case of journeys such as those of Lewis and Clark and more recently those of Stuart herself, *space and time collude in place*. Not only does every journey go from one place to another, but at every step along the way it is ineluctably bound to place, that is, the particular place it is passing through at the time. "At the time" goes together with "in the place."

Voyaging into Sacred Precincts

Michelle's Stuart's journeys—her "voyages" as she prefers to call them—are primarily movements in and through places, the places she travels to and from. Journeys, after all, are from one place to another, and they often mean taking a *long time* to get to a *distant place*: the longevity of the one answering to the remoteness of the other. Journeys are also simultaneously geological and cultural. Stuart is an artist in search of what she likes to term "cultural overlay," which she analogizes to "geological overlay."[15] Each earth formation, whether that of the palisades in the Niagara River Gorge or the Rowena Plateau above the Columbia River Gorge, constitutes a place of its own, distinctive of a region yet unique in its specificity. But human culture resides as well in utterly particular places: "Culture is made by the relationship between man and the place from which he springs."[16]

Referring to her travels in the South Pacific in search of ancestral origins, Stuart remarks astutely that such travels seek out "areas or places holding a collective memory etched by a ship's voyage across time."[17] That *places hold collective memories* is crucial to all of Stuart's later work, which Lawrence Alloway characterizes

as "discursive" in contrast with her earlier "synonymous" paper works.[18] Put otherwise, these later works are *diachronic,* that is, historically attuned, in contrast with the *synchronic* character of the monochromatic drawings that provide neither image nor word to the viewer. But Stuart's own statement just quoted points toward a place-based, and more specifically an earth-based, aesthetic in which the synchronic and the diachronic, like the geological and the cultural, come together in the place of the earth. It is not that she has moved from mute rubbing to explicit history and manifest word—any more than she has simply moved from geology to culture[19]— but that she has found a way, a quite complex way, to bring all these dimensions of her work to pivot on the particularity of place. For this reason, a more apt and encompassing term for her mature artworks would be *place works.* Place works include everything that Stuart intends under "land works" and Smithson under "earth works"—with the additional advantage of expressly signaling the locatory dimension of such works.

A clarion instance of a place work is *Sacred Precincts* (1984), whose very title is redolent of place: *precinct* is definable as "a place or enclosure marked off by definite limits." By enclosing this installation within three walls, each with its own presentation, Stuart has created an inner sanctum within the more encompassing walls of a museum. Even if this work would be a "non-site" in Smithson's lingo, it is no less place-specific. Place works do not have to be located in natural terrain, as *Niagara River Gorge Path Relocated* and *Stone Alignments/Solstice Cairns* were. Stuart here departs from Smithson, who preferred to keep his earth works, his "sites," in the open landscape wherever possible, with the undeniable implication that they belong there. By moving her work inside, Stuart gains an intensity and intimacy that are difficult to achieve outside. Instead of settling a composition into an already existing natural setting—over cliffs, on a plateau, or on the Great Salt Lake—the artist here *builds place.* She builds a temple,[20] a sacred space within which to enclose artifacts from distant cultures, ranging from Nantucket to the South Seas, as well as a temple-within-a-temple, the Mariners Temple (see Plate 12). This whole project derives from a dream in which the artist found a fur pouch that contained a diorama of ancient Maori life as well as a chart that showed a series of islands, fragments of artifacts, and a burial cache of a white whale. Throughout the dream, she was guarded by humpback whales. A sailor appeared to tell her that she was taking this voyage "to show the things of this place . . . cities built in white limestone with temples hiding idols below deep jungle vines . . . the ships that shape passages across the sea fixed by stars and hope."[21] Plaited reed maps were also present in the dream, along with a gold temple built by Chinese mariners as a refuge for the lotus and the dragon. A number of these dreamed-of elements made their way into the installation, in addition to tools created by Stuart, modeled on those that had been on the ill-fated whaler *Essex,* which sank in the South Seas, crushed by an angry whale. The entire work is done in homage to Herman Melville, who had been inspired to write *Moby Dick* after hearing of the fate of the *Essex.*[22]

Although the Mariners Temple is literally the central structure, of more interest to us is what is on the right and left walls: a series of constructed artifacts, some from the Nantucket Excavation and others from the Burial Cache of the White Whale. These imaginatively designed tools help to make *Sacred Precincts* an intimate space, thanks to the smallness of their scale, their fit with the human hand. The installation as a whole contains things of varying scale, just as any place does that shelters diverse contents. Moreover, as Smithson asserts, "size determines an object, but scale determines art."[23] Intrinsic to being a place work—an artwork that is *of place* and not just about it—is its capacity to hold items of different sizes and types, and in this respect *Sacred Precincts* can be considered a paradigm of aesthetic place.[24]

Let us look at the Mariners Chart, another part of the same work. Figure 4.6 gives a portion of the larger topographical map of islands and entire continents; in its entirety, the Mariners Chart contains dotted lines that trace out criss-crossing sea voyages and (on the right and left edges) names of ships and sailors who undertook such voyages, as well as whole constellations, represented near the top. The result is what Stuart calls a "network of all these places"[25]—a network that, despite being partly imaginary, matters greatly to the artist, since it represents the part of the world where her ancestors had once migrated. The ultimate subject matter of the Mariners Chart is a single coherent place-world, a nexus of particular places linked as part of a given region; it is chorography practiced in an imaginary mode.

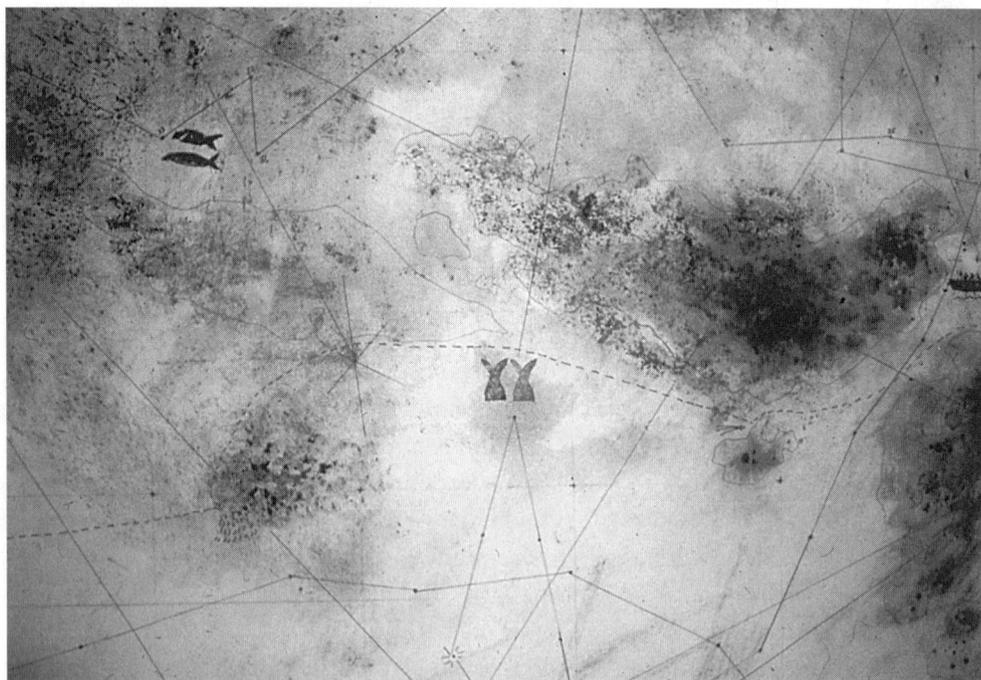

Figure 4.6. Mariners Chart (detail), from *Sacred Precincts* (1984). Pencil and graphite on rag paper, 48½ × 76 inches.

Taken as a whole, *Sacred Precincts* can be considered a *cosmographic chart*, given that it sets forth an entire world, a *cosmos*. This world is not confined to the South Pacific; it extends from Nantucket to that region and back again in one enormous circuit that is as much historical as geographical, as well as literary (via *Moby Dick*) and oneiric (as inspired by Stuart's initial dream). And I say "chart" and no longer just "map" in keeping with Stuart's own preferred word, since *chart* alludes to actions imagined and projected, before being actually pursued. We say that we "chart a course of action" or that we "chart out a line of conduct" (with the sense that we are undertaking something *possible*), whereas *map* connotes a representation of land or sea that is already in place and that we are attempting to delineate with cartographic fidelity. Hence, "chart" is most appropriate to journeys of the sort that the Nantucket whalers undertook—journeys into vaguely defined regions of open possibility—and that Stuart pursues in the wake of Melville and these men of the sea. She *charts out* her art much as she projects her voyages, just as she *maps down* the results in the form of artworks that serve as remainders/reminders of what she has done in light of where she has traveled.[26]

Going to the Stars

It is revealing that Stuart, following common usage, speaks of "star charts." While the earth in its massiveness is eminently mappable (hence my own preferred term, *earth-mapping*), the skies at night call for charting. For the stars, in their ever-changing positions, suggest possibilities of many kinds, ranging from astrological influences to barely discernible outlines of mythical animals and gods. Their very effervescence as twinkling "points of light" adds to the sense of emergent and intangible possibility. As aids to navigation, they tell us where we *might go*, and only rarely where we *must go*.

In a work entitled *Starchart: Constellations* (1992), Michelle Stuart captures this very experience of continuous alteration and oscillation. Filling an unlit medieval barn with thirty translucent fiberglass columns that are situated at odd intervals on the barn floor, she induces "a sense of wonder at the various constellations of stars suspended within the perimeters of the columns."[27] Within each column, 8 feet by 5 inches, are lights that suggest groups of stars and that, combined with lights in other columns, form literal "con-stellations" for the viewer. Or more exactly: *for the walker*. Stuart ingeniously suggests the kinetic character of stars that move every night by inviting the spectator to move among the columns, thereby precipitating the perception of motion among the fiberglass stars themselves. The fact that any walk through the columns is a more or less random walk—one is free to walk through in any of several pathways—only reinforces the factor of possibility that is intrinsic to charting.

By making the distinction between mapping and charting, I do not mean to suggest that the two modes of *graphēsis* (as we can call any kind of tracing out)

are incompatible, much less irreconcilable. On the contrary! They are not only congenial partners on many occasions but may urgently call for one another. Take, for instance, the major place work entitled *Nazca Lines Star Chart* (see Plate 13). Earth taken from the Nazca Plateau was rubbed into the fiber of muslin-backed rag paper, here cut into squares—ten tall and fourteen wide. Impressed into these same squares, assembled in one large canvas, are hard linear forms that resisted the earth staining; hence, they stand out in the final configuration. These lines were taken directly from the celebrated Nazca lines, geoglyphs traced into the Nazca Plateau, which are fully visible only from a plane overhead.[28] The exact meaning of these earth-glyphs has been a matter of controversy for a very long time. Stuart construes them as calendrical in character—as "earth to heaven time references on the matter of planting (and possibly ritual maps for planting) their crops. Thus astronomical seasonal calendars were in fact dug into the earth's surface."[29] In short, the lines are star charts that have been brought, quite literally, to earth, where, in the context of actual agricultural practices, they serve as maps for planting.

The painting overall captures both charting and mapping in one complex but coherent work. The square pieces of earth-embossed paper constitute a virtual grid, the template of a map of the earth with implicit meridians and parallels. This grid, whether in its original Chinese format or in its post-Ptolemaean modalities, is the basis for the cartographic inscription of earth-space, thanks to the regularity of its modules and its implied indication of east-west and north-south directionality. Not only is it the case that Stuart "takes the grid and positions it in the zone of history"[30]—here, ancient Peruvian agricultural history—but also she allows it to be the foil for the trapezoidal Nazca lines that overlie it. Not unlike Smithson's deliberate distortion of the grid, these latter constitute a "pale geometry" that in its very irregularity, its outright deviation from the equilateral shape and parallel edges of the earth-grid, intimate a far freer and more open future—a future of drifting and wandering, yet one still ruled by a vagrant geometry of the heavens and by a calendrical repetitiveness that is pertinent to agricultural cycles.[31] Set together, the gridded earth-map and the free-form star chart constitute an entire place-world, for which the encompassing term *cosmography* seems once again most suitable.

This magisterial work embodies another important theme of Stuart's multiform explorations in the last several decades. I call this *interelemental exchange*. It was already present in *Niagara River Gorge Path Relocated* (Figure 4.4), which in Stuart's own words "joins water and sky [across] strata or layers of earth that form the wall of the escarpment."[32] But it is even more manifest in later works. In *Navigating the Sea Reflecting the Stars* (1986), submerged flashlights beam illumination in the form of a constellation from under the water in Ship Creek, Cook Inlet, Alaska. Here the sky has been brought down into water, just as it is taken into rock in the case of *Starmarker* (1992), in which an obelisk (incised with the words *Memory, Change, Chance, Desire*) serves to mark the main star, Thuban, of the constellation Draco, whose other stars are represented by eleven white marble stars seen across Wanas Lake in Sweden.

All three works just mentioned, *Navigating the Sea Reflecting the Stars, Starmarker,* and *Starchart: Constellations,* follow the elemental directionality of *Nazca Lines Star Chart* insofar as in each case the heavens descend to the earth, whether coming down into water, onto stone, into Plexiglas columns, or in imposition onto the earth itself. Perhaps *Nazca Lines Star Chart* is the most dramatic instance of this stellar fall, since here the very shapes of constellations, not merely individual points of light, come to inhabit the earth, being etched into its very surface. They have become not just markers of practical value to farming—that is to say, indicative signs—but a species of symbolic figure incised into earth, as *geo-glyph* literally says.[33]

Sky and Water Down Under

Not that the directionality of interelemental exchange is one-way only: from the stars to the earth. In a recent work, *"Fish in the Sky, Whose Bottom is Pebbly with Stars,"* beeswax and pigments are applied to canvas mounted on wood in such a way as to suggest at once fish in the sky and stars in the water: a double exchange of elemental presences. Not only does the sky swoop down, but also the water goes back up into the sky, and the proper inhabitants of each thereby change position (see Figure 4.7). It is not incidental that this painting, and others closely related to it, derived from a journey Michelle Stuart made in late 1997 and early 1998 to New Zealand in search of her ancestral origins. The experience of being geographically "down under" inspired her to make paintings that show water up in the sky, which is in turn reflected down in the water.

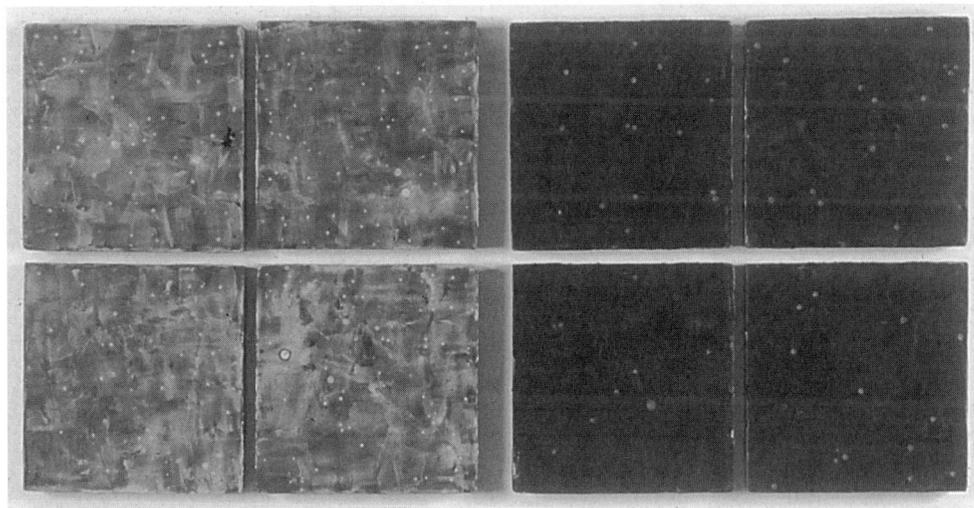

Figure 4.7. Michelle Stuart, *"Fish in the Sky, Whose Bottom Is Pebbly with Stars"* (from Henry David Thoreau, *Walden*) (1999). Encaustic (beeswax) with pigments, canvas mounted with wood panels; intervals of 1 inch between sets and 2 inches between dark and light sets; overall dimensions (eight units), 25 × 52 × 1¾ inches.

Air is the least palpable of the four ancient elements and the one most difficult to capture in painting—even more so than fire, which Stuart has rarely pursued as such. In the paintings to which I have just alluded, the artist sets herself the task of finding in the sky neither auguries nor agricultural directives but a place for reflection and contemplation: reflection of other elements (notably, water in the case of *"Fish in the Sky, Whose Bottom Is Pebbly with Stars"*), contemplation of the artist's genealogy.[34] Just as *re-flect* means to bend back—here, one element bending back through another—so *con-template* means to be with(in) a sacred place cut out of wood: a *templum*. In *Sheep's Milk and the Cosmos*, Stuart has in effect created a temple to commemorate her voyage of discovery to New Zealand (see Figure 4.8). The white substance in the votive dishes suggests sheep's milk and thus the meadow around the artist's great-grandmother's grave; the stone slab upholding the dishes, the headstone of the grave itself; and the dark painting behind, the nighttime sky of the Antipodes. In the presence of this serene work, one is invited to contemplate cosmic as well as personal origins.

In this way Stuart brings back the Antipodean skies to New York, and by a very different act of retrieval and redemption from what she usually undertakes. In many other instances, she returns with photographic images and literal remnants (typically, soil and stone) from the place re-created in the work, for example, as in *Passages: Mesa Verde*. But in the recent works here under discussion, she imports the sky as well as ancestral lines and memories—all intangibles. As Joseph Ruzicka has noted:

> The sky—home to the light and atmosphere peculiar to any given place—is
> the most formless aspect of any landscape and the one part of it that Stuart
> can possess only in her memory; she cannot bring samples back to the studio.
> For this reason, the sky paintings are singular in Stuart's oeuvre. They possess a distilled sensibility quite apart from the world of things.[35]

These sky paintings come after a period of making diminutive sculptural works—above all, elegantly modeled jars made of beeswax—which she set out, along with found objects from her travels, on tables and shelves she also made. These *choses intimes* help to scale down and make inhabitable the large-scale constructions and installations she made previously. They are present in the votive jars of *Sheep's Milk and the Cosmos*, but now they beckon toward the vast nighttime sky, to which they seem to pay homage. It is as if the sky were the ultimate locus of cosmic possibility. One is reminded of the title of Eugène Minkowski's book *Vers le cosmos*: so, too, the sheep's milk offerings are turned "toward the cosmos." In the cosmic dimensions of the sky, these offerings are distilled and sublimed, losing their concrete thinghood in order to rejoin universal forces of gravitation and light. This is to reenter the pool of cosmic possibility from which all discrete things, human and nonhuman, derive.

A journey for Stuart is the epitome of a pool of possibility here on earth. She confesses to liking the "free movement in all directions" that the ancient elements

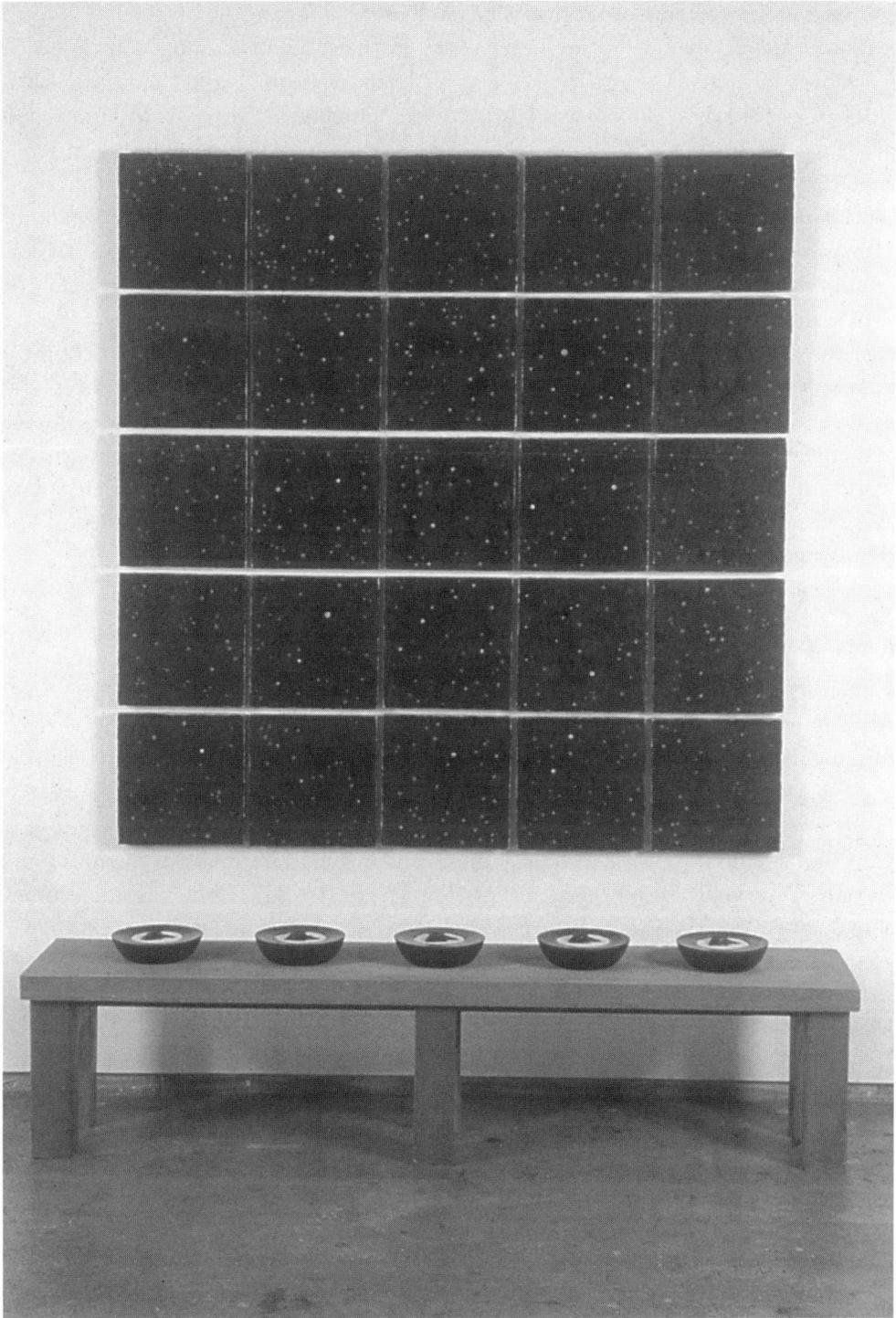

Figure 4.8. Michelle Stuart, *Sheep's Milk and the Cosmos* (1999). Panels: beeswax, pigments on canvas mounted on wood, 62½ × 62½ inches overall. Table: stone and wood, 15½ × 71¾ × 14 inches. Beeswax containers: 8 inches in diameter.

embody—above all, air—and that is enacted in traveling.[36] The homage in *Sheep's Milk and the Cosmos* is not only to the sky as the scene of cosmogenesis but also to the free movement of history, her own and her ancestors'—and Captain Cook's. Cook is for Stuart an emblematic world traveler, intelligent, intrepid, and interested in the natural history of the planet long before Darwin and Humboldt. He "discovered" Bream Bay and named it a century before Stuart's great-grandparents arrived there, and Cook Strait separates the North and South Islands of New Zealand. *Navigating the Sea Reflecting the Stars* is appropriately set in Cook Inlet in Alaska, reminding us that Captain Cook followed the lead of the stars in his explorations of the Pacific Ocean. Thus, in commemorating her ancestors in New Zealand, Stuart is at the same time commemorating the first European to set foot in that country, thereby opening it to emigration from the British Isles. And in both instances, she is celebrating the very idea of journeys into uncharted and unknown places in vast and distant regions. Such journeys culminate in acquaintance with new place-worlds, both cultural and geological, and in the creation of place works that reflect and reinstate these alien worlds elsewhere, typically in the original home world of the voyager.[37]

A New Vision of the Grid

If there is any single structural constant in Michelle Stuart's work it is the *grid*. Already present in the early drawings of the surface of the moon—where the rigor of the cartographic grid is relieved only by the tendrils of wires that fall aslant it (e.g., in *Mare 15*, Figure 4.1)—it continually resurfaces. The wall drawings of 1973 may forgo an explicit grid design, but they are in effect modules of a larger grid pattern made up of several such drawings, as is suggested strongly in the four panels of the *Sayreville Strata (Quartet)* of 1976 (Plate 10). This implicit grid becomes actual in a work such as *Copan I* (1978), wherein eighty-four units of rag paper are arranged as one enormous rectangle that is 112½ inches high and 167 inches wide. Each unit is rubbed with pulverized reddish soil from Copan, a Honduran Maya archaeological site. In the 1980s Stuart extended the grid into such diverse contexts as *Diffusion Center: Fort Ancient Site, Ohio* (1979–80), which displays a grid (composed of red strings) on which multiple tool forms are distributed freely (see Figure 4.10); *Nazca Lines Star Chart* (1981–82), in which we have seen the grid stand in for the Peruvian plateau on which the Nazca lines are inscribed; *Islas Encantadas: Seymour Island Cycle* (1982), in which six photographs of native fauna from the Galapagos Islands are set within a grid of ninety-four dark units that are surrounded by a band of lighter units of the same size and two deep; and in *Sacred Precincts* (1984), in which the Mariners Temple is built up from a gridded group of square units that vary in color and value (see Plate 12). The grid is everywhere employed, and one must wonder why this is so in view of the geometric severity of its formal composition: its origins lie, after all, in the regularizing pas-

sion of cartographic precision as well as in the planiformity effected by the perpendicular x and y axes posited in analytical geometry.

As if to defy these austere geometrizing roots—or rather, to capitalize on them—Stuart sets out to construct a grid that breathes life into an installation or painting: that frees it rather than confines it. In part, as Alloway remarks, this is to take the grid into history. But it is also to situate it in virtually every imaginable zone of human experience, including space, time, memory, and desire. As with Smithson but more insistently, Stuart's grids animate the subject matter of her artworks in all its diversity. The paradox is that they do so not despite their formality of shape and repetition of design but precisely *because of this shape and this design*. Where it was only the irregular grid that Smithson valorized, it is often the strict geometrism of the grid that enables the exuberant freedom of Stuart's compositions. As Patricia C. Phillips observes, "An imposed, invented, and unalterable order is the elementary condition for the comprehension of a more random and indeterminate set of principles. For Stuart, the grid is a device to introduce matter and symbol in a *more mutable* state."[38]

Far from indulging in what Minkowski calls "morbid geometrism,"[39] which devivifies its own content, Stuart manages to employ gridded patterns in an enlivening, life-endowing way. In part, this is due to the fact that she does not confine the grid, any more than she confines a map, to the representation of abstract space. The repetition of the modular units of the grid infuses a temporal, even a narrative, dimension into the work it undergirds: "The grid for Stuart is less a formal paradigm of [spatial] flatness than a symbol for time and connectedness. Its use in her art is strongly diaristic—the grid unreels narratively, like the squares of a calendar."[40] This observation of Stephen Westfall's works especially well for the paintings on which he focuses: *Paradisi: A Garden Mural* (1985–86) and especially *On Part of Memory Being Alaska: Black Star . . . Sky Dome of the North* (1985–86). In the latter, two of three large panels allude expressly to seasonal time (winter and summer), while the third refers to the nighttime Alaskan sky (in Stuart's own words: "in the night the great black star-swept sky so clear that dreaming in front of it one can be transported to the beginning of time").[41]

Secret Gardens

Once more, however, let us resist any strictly binary analysis into space and time, as if these provide the only pertinent parameters. Instead, the grid enables the presentation or representation of place more than of space or time per se. This is evident in *Paradisi: a Garden Mural* (1985–86), whose very name connotes a place of felicitous experience, whether this be theological or psychological. This enormous painting (16½ by 33 feet) is not only about a celebrated place but also creates *a place of its own*, as was evident when it was exhibited in the entry hall of the Brooklyn Museum, where it caused a sensation. It is made up of 628 panels, each 11 by 11 inches as a unit

of the overall grid, and is brightly colored in pigmented encaustic that also contains impressed plants, soil, and flowers from the New York City area. The overall effect is that of teeming floral life in "a dense palisade of leaves and blossoms."[42] Stuart has here created a garden in painted panels, reflecting the fact that *pairi-daeza,* the Avestan root of *paradise,* means "walled-in park" or "garden." And a garden in turn is a paradigm of a place between places, an "interplace" situated between the architectural and the uncultivated or wild.[43]

Two years later in 1988 Stuart created a number of striking works for exhibition at the Rose Art Museum at Brandeis University. Each is a place work. One of them, *Ashes in Arcadia,* was an elaborate installation within the museum. In it, walls constructed of grids of the familiar 11- by 11-inch muslin-backed rag paper surround a scene of devastation: on the ground are rocks, shells, dying plants and branches, rock books, sandpaper, metal, earth, slag, and rubbish, all covered with ashes. This is a dead place; here nothing blooms, nothing blossoms. The bucolic existence of verdant Arcadia has vanished: this is paradise lost. The plaintive song of the humpback whale, threatened with extinction and no longer in its element in the South Seas, plays in the background. Stuart appended this poem:

> Nothing left but the call of the whale
> All silent
> With our knowledge we let
> the planet die
> Instead of seeds
> We planted ashes in Arcadia.[44]

This grim and dispiriting tableau was exhibited at Brandeis at the same time as the major series "Silent Gardens: The American Landscape." The phrase "silent gardens" is a leitmotif throughout Stuart's artwork. It appears in an earlier poem—where she wrote, "Wombs nestled in the graveyard of the branches / A silent garden. Waiting for the sun"[45]—and it reflects Stuart's continuing delight in garden spaces. Silent gardens are explicitly thematized in the new group of large paintings (each is 99 by 198 inches) that opens with *In the Beginning . . . Yang-Na,* which alludes by title and image to cosmogenesis as well as to the Native American name for the valley of what we now call Los Angeles.[46] This painting acts as a prelude to seven others, each of which condenses and exfoliates the sense of particular places or regions: Alaska, New Mexico, Hawaii, the Northeast, the Deep South, Arizona, the California coastline.

Each of the 162 modular units that make up a given painting in the series "Silent Gardens" can be seen as an artwork on its own terms or as part of the series as a whole: a place within the place of the painting overall, a "frame of vision."[47] Every unit is multilayered, and its encaustic base (i.e., wax with resin) contains not only standard pigments but also fragments of earth, plants, bones, shells, flowers, and silver leaf. The rich commixture of diverse constituents reveals Stuart's continuing

fascination with the material world, which is for her the privileged point of access to a singular place: "In looking for the revelatory aspects of a place I [first] respond to the physical and material nature, and [then] research the roots of the culture, the indigenous structures, objects and patterns of thought."[48] Matter first: *prima materia*! There is indeed something alchemical in the dense mixture of material in any given module, for example, the one illustrated in Plate 14. The particular part shown here, acting as a frame of vision, manifests Stuart's investment not just in gardens but also in seeds—which form the basis of an entirely different set of works, "Natural Histories," featuring seeds at the center of haloes of diffuse paint, again arranged as a grid and sometimes situated above a table with beeswax objects created by the artist.[49] But in the larger work, *Woodland Garden Seeds the Eastern Wind,* from which Plate 14 is taken, the seeds are immersed in sheer materiality, as if to prove that the artist "loves material and matter—the tactile, observable, manipulable stuff of this earth."[50]

This is certainly true, but only on two conditions: first, that matter be seen as the basis of life, as animate from the start and not merely inertial; second, that matter be put into the service of place: acknowledged as coming from a particular place ("borrowed matter," as we might call it) or manifested as creating a place of its own, which is what all of her works do. Stuart speaks of her intention "to do a work about a place,"[51] but in fact she does more than this: she creates works that *are places*. They are entire place-worlds unto themselves. This is nowhere more evident than in the paintings that compose "Silent Gardens," each of which offers a place-world of its own: not a world of actuality (that would be the object of "a work *about* place"), but a world of possibility, a world charted out, a world in progress. Just as a seed is defined by its own set of possibilities,[52] so each silent garden harbors a world *in status nascendi*.

White . . . Moon Minister in the Marriage of Earth and Sea is something like a summa of Stuart's lifework (see Plate 15). It brings the moon, one of her first fascinations, into league with earth and sea, constituting the putative scene of the birth of life itself on this planet. The grid is here more explicit than in other members of "Silent Gardens," and as such it more directly suggests a map, with the darker areas serving as islands in a Sargasso Sea of diffuse matter (earth, stones, shells, and plants set in encaustic). Or let us say: serving as possible islands, islands possibly; but we can also see these deliberately ambiguous areas as germinating plants in partial bloom, or maybe even as ghosts of Captain Cook and other early explorers of the South Pacific, or perhaps the White Mountains of New Hampshire. No one interpretation will suffice; the work is overdetermined and polyvalent. But one thing is indisputable: this is a work that has created from matter an entire animated place-world.

In so doing, a work such as this has also expanded the idea of map beyond any usual limit. As Stuart says herself, this "means stretching the spatial and psychological map on one hand, and compressing it on the other."[53] Stretching it to include

the dynamics of journeying—thus extending mapping to charting—and compressing it to fit such dynamics into the grid of the work, that is to say, into the formal basis of the living place, the biotope toward which the work signals.[54]

Traveling in Place

The central nervure of Michelle Stuart's immense evolving oeuvre—the primary source of its undeniable force, beyond its sheer diversity, imaginativeness, and skillful realization—is to be found in her decided gift for plumbing paradoxical extremes of medium, presentation, and subject matter, thereby confounding her critics and delighting her devotees. Rubbing earth onto paper, even to the point of perforating its surface with pockmarks: can this be art? How can art be made by arranging thousands of tons of boulders in a pattern that mimics ancient rites? Can photographs of a place become part of an artwork that transforms that same place? How can beauty be accomplished when the detritus of the earth, its very dregs, is smeared onto the surface of a painting? Stuart not only inspires us with her inventiveness; she challenges our conventional ideas of what art can be. And she does so by playing off the unsuspected power of extremes, normally disjoined, to move us to places we have never been before.

We have already seen this power at work in a number of Stuart's works. It can be understood best in terms of a double transformation she effects. First, she transmutes ordinary matter into material for art: whether the matter be soil or shells, seeds or ashes, beeswax or bone, she incorporates it into the work in which she is engaged, so deeply and effectively that it becomes the equivalent of paint or crayon or pencil.[55] As if this were not already transformative enough, she then transmutes such worked-in and worked-through material into the charisma of living substance, in vivid works that reach their epitome in "Silent Gardens." Each of the paintings in this latter series offers to us a unique vision of "nature alive." From the rawest of raw matter—kept raw even as it becomes part of the materiality of the work—comes a sense of expansive, efflorescent life. And a sense of the beauty of life: the aesthetics of biogenesis.

The same paradoxical power is present in the idea of journey, which we have seen to be so central to Stuart's life and work. A journey is standardly a long voyage to a remote place, and Stuart is not one to refuse taking trips to exotic lands and seas: where Smithson traveled to American sites only, Stuart is much more drawn to journeys abroad. Nevertheless, with rare exceptions the effects of these journeys upon her work do not concern her private pleasures or problems in traveling; they are not autobiographical reportages of experiences undergone when on the road. Even a work as rooted in family history as *Sheep's Milk and the Cosmos* (Figure 4.8) is not *about* that history. Indeed, human presence of any kind is absent at the level of content, since animals and sky are the effective epicenters of the work.

The kind of journey that is at stake in Stuart's art is not an actual one: the issue

is rarely whether the artist has ever set foot in a place or whether the viewer has done so either, but rather what we can call *traveling in place*. By this I mean not just the representation of traveling to an actual place but more especially the sense of "moving in place," that is to say, moving one's body yet staying in the same place: getting somewhere and yet going nowhere at the same time. The latter situation, paradoxical in itself, is important for Stuart's purposes, since it means that neither the artist nor the viewer need necessarily go to a particular place to savor its special local qualities. Some of Stuart's journey places are outright imagined (e.g., those posited on the Mariners Chart in *Sacred Precincts*, Figure 4.6), and others are remembered (e.g., *On Part of Memory Being Alaska*). Indeed, the spectator will rarely have visited the particular places thematized in Stuart's works, and doing so is certainly not required to appreciate or understand the work. (I, for example, have visited Mesa Verde, but this does not put me in a privileged position when viewing Stuart's *Passages: Mesa Verde*, Figure 4.3; it only lends a certain air of familiarity, reinforced by the artist's photographs of these cliff dwellings in southwest Colorado.)

Therefore, the journey that matters most in Michelle Stuart's art of journeying cannot be confined to trips the artist or spectator has taken or is expected to take. If the two main modes of journeying are the actual trip and the voyage, it is the latter that bears most directly upon Stuart's art, as the artist herself indicates by choosing "Voyages" as the title for the retrospective of her work held in 1985.[56] A voyage has several ontic modes, none of which requires actualization (or reactualization): imagined, remembered, desired, and intended. Michelle Stuart's artworks take us on all kinds of voyages to all kinds of places, and we are the better travelers for it, whether we ever in fact visit these places or not.

A closely related paradox is that of place versus nonplace. Stuart plays between these poles as nimbly as she dances between trip and voyage in the context of journey. Just as she takes trips yet does not demand them—only voyages are mandatory—so she travels to sites but does not depend on them. Place is what finally matters in Stuart's work: not site, which (again in contradistinction from Smithson) I take to be designated or denoted, and often denuded and degraded, place. Site is place that does not move—and often does not move us either. One takes a photograph of a site or visits it as an archaeological or historical location; or else one specifies a site on a map: indeed, it is the primary unit of cartographic localization.[57] Like any tourist, Stuart does all of these latter things, and her art is, in this sense, "site-specific." But it is this only in part. Even in such highly localized works as *Niagara River Gorge Path Relocated* (Figure 4.4) or *Stone Alignments/Solstice Cairns* (Figure 4.5), what transpires is the transformation of site into something we remember *as a place*, for example, the historical site of the "first" Niagara Falls into a lively and celebratory land work.

Similarly, Stuart's use of photographs is never just for identificatory purposes: either they are part of a larger work, surrounding a central area having no specific

image (e.g., *Codex: Canyon de Chelly, Arizona,* Plate 11), or they are themselves surrounded by areas of indeterminacy (e.g., *Islas Encantadas: Materia Prima II* [1981]). If photographs are massively deployed throughout, as in *Stone/Tool Morphology* (1977–79), they are effective only as alternating modules of an overall grid pattern, in accordance with the grid-logic I have discussed just above.[58] In this way, site, or nonplace, becomes part of place itself, the place of the work or, more exactly, integral to the place-world that it sets forth from its own material base, its "earth."[59] Thanks to Stuart's agile hand and bold mind, *les extrêmes se touchent*: place and nonplace become congruent in the world of the work—a work that *takes us places* even as it ingeniously incorporates nonplace into its own midst. A land or place work by Stuart offers us the prospect of a journey, moves us somewhere on earth, and it often does so by means that include the representations of static sites.

The paradox of place/nonplace can be considered as a particular instance of a still more general paradoxical relationship: that between representation and nonrepresentation. Although Michelle Stuart's art would not be categorized as abstract in any usual sense (e.g., as part of abstract expressionism, formalism, etc.), it is also not simply representational either. What is representational in it is supplied by explicit photographs and by the occasional inclusion of maps of actual regions on earth. Landscapes and archaeological sites are certainly represented, as are animals, for instance in works inspired by the Galapagos Islands, such as *Islas Encantadas: Seymour Island Cycle* (1982). On the other hand, the human figure almost never appears as such, even though human beings are often present by implication: as benevolent presences in the elegant tables and votive jars created in the mid-1990s or as malevolent forces in the devastation of *Ashes in Arcadia.* Just this ambiguous sense of being indirectly represented—if not represented as such, then present by proxy—is characteristic of Stuart's whole approach to representation. Another telling case of highly ambiguous representation is found in the sense of sublimity that inhabits so many of Stuart's works, subtly so in the hand-rubbed drawings of the early 1970s, more flamboyantly in later works such as *In the Beginning . . . Yang-na* (1984). One could say that the sublime, like the human beings who are its witness, is *neither represented (as such) nor not represented (at all).* To represent the sublime per se would be to tie it down to something altogether too specific; not to represent it in any sense whatsoever would be to let it elude the work altogether. Stuart situates herself in the uneasy no-man's-land between these extremes, profiting precisely from an unsettled state that challenges our usual modes of looking and interpreting.

Still other avatars of the ambiguous representation/nonrepresentation test to which Stuart so willingly submits include the tension that her work exhibits between the sculptural and the painterly and between color and black and white. In both cases, Stuart characteristically refuses to choose; or more exactly, she refuses to let the choice itself be an easy one, either for herself or for her viewer. For example,

she will take black-and-white photographs of the sites to which I have referred, yet embed these same colorless images in highly pigmented material. In these cases, the chiaroscuro effects of the photographs contribute to representation, while the colored parts of the works are often not representational at all; still, both coexist in congenial and constructive ways, as we can see in a work from the Nazca series (see Figure 4.9). Black-and-white photographs of the Nazca lines as seen from far above the earth are set within a dark earth-rubbed central rectangle, which is in turn situated inside a lighter earth-stained border of larger squares that decoratively display Nazca lines. The result is a work that is as nonrepresentational as it is representational—the two in elegant equipoise.

The sculptural is coeval with the painterly in equally effective ways in Stuart's work. By "sculptural" I mean anything that displays its three-dimensionality overtly; by "painterly" I mean whatever draws us to focus on a painted surface qua surface. Much as one might expect these different modes of realization to fight each other off—the former contributing directly to the felt tactility of the work in its

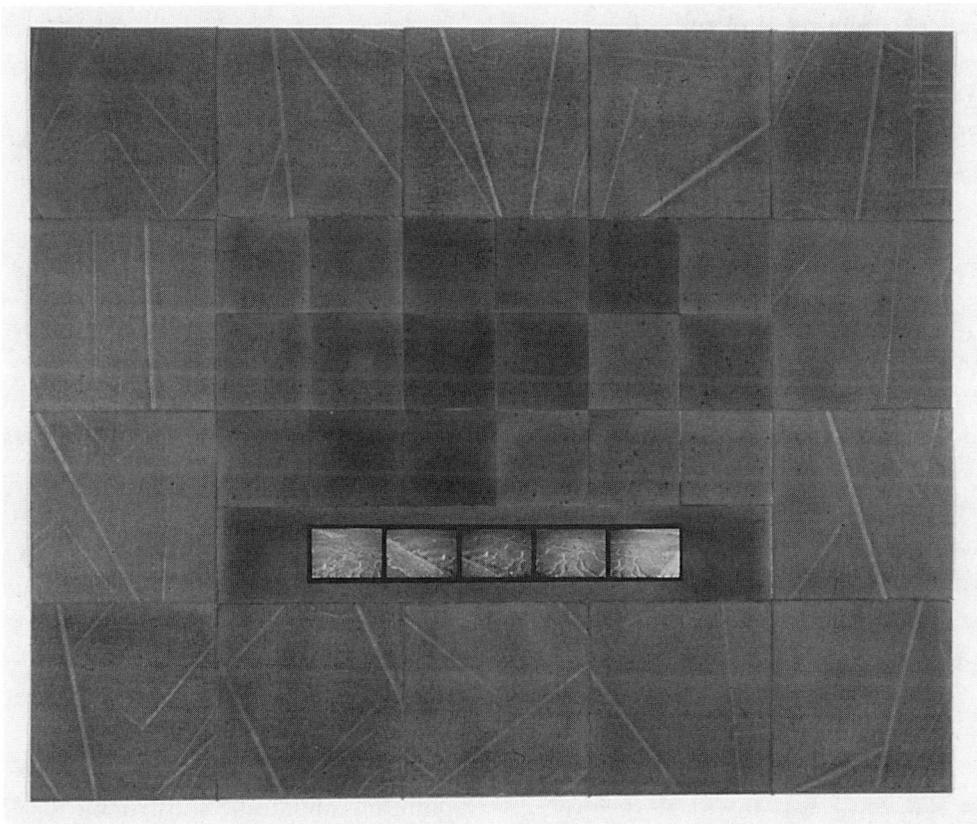

Figure 4.9. Michelle Stuart, *Southern Hemisphere Star Chart II* (1981). Earth from site (Nazca Plateau, Peru); black-and-white photographs from site (by artist); graphite, muslin-mounted rag paper, 32 × 40 inches. Destroyed by flood in Helsinki, Finland.

sheer physicality, the latter to its representational prowess—the two collude grace-
fully under Stuart's careful eye. Nowhere is this more evident than in a painting
such as *Woodland Garden Seeds the Eastern Wind* (Plate 14), which is remarkably
palpable in its felt presence, since its surface sports seeds, blossoms, husks, and
earth compiled in a delightful disarray that cannot be considered figurative. Yet
as part of the total artwork, the part here reproduced contributes to a totality that
is highly suggestive of blooming flowers set within dense woods. The full work is
as representational as the individual part is not; yet neither is simply one or the
other: as a frame of vision, a given panel conveys to us a schematic sense of plant
life, while the overall work is not a purely pictorial representation of a "woodland
garden" but (true to the rest of its title) gives us instead the gist of such a garden
in the form of "seeds [blown by] the eastern wind" (see Plate 16). Now this same
painting illustrates a still further paradoxical dimension of Stuart's artworks, one
that escapes the representational/nonrepresentational cycle: their capacity to be
read both *close-up* and *far away*. One and the same painting calls both for close
scrutiny—the viewer is drawn powerfully to examine what is happening at the very
surface of the work, to see the intricacies of its texture—and for standing back in
order to appraise and appreciate the whole. We know this double draw from other
painters, such as Goya and Soutine and Van Gogh, and we encountered it in Margot
McLean's *Virginia* (Plate 2), but it is rarely so distinctly present throughout an
entire oeuvre as in Stuart's case: her early earth-rubbings evince the same double
fascination as her mature encaustic works do.[60] What is going on here?

The Double Take

Stuart adroitly sets up situations in which there are two epicenters competing for
our attention, yet without conflict or contradiction. We are attracted twice over,
from afar as well as close in. The effect is that of a *continual double take,* wherein
we take in a given work simultaneously at two removes. Each remove implicates
our active body as it moves back and forth before the work. Thanks to this double
action, we are drawn more fully into the drama of the work than were we to main-
tain the same critical distance throughout—the "aesthetic distance" that is some-
times presumed to obtain for viewing paintings.[61] Stuart contests any such single
standard distance, as if she were exemplifying in her art Aristotle's dictum that
"the minimal number, strictly speaking, is two."[62]

In Stuart's two-step dialectic there is no third stage—no stage of synthesis that
would, as in Hegelian thought, reconcile and sublate the first two stages. Here as
elsewhere she refuses any easy compromise. There is no middle distance, or *via
media,* much less any ideal distance. Either paintings should be construable at *all
distances* (as Cézanne is reputed to have claimed), or they should be viewed at
just *two distances*. Stuart opts for the latter, more practicable model; she consid-
ers herself successful when her artworks fascinate us from two privileged viewing

places—that is, two distances that are not themselves strictly quantifiable but simply as close as we can comfortably get *and* as far as we need to be in order to take in the whole work.

This seemingly schizoid strategy makes perfect sense for an artist who lives from paradox and pursues it wherever possible. Indeed, the two-way take carries out the very idea of paradox in its literal sense of *para-doxa,* "belief alongside" or "next to." Each taking of a Stuart work, near or far, is a grasping of it as there to be believed—posited as an object of epistemic certitude. But more than credence is at stake in the paradoxical double take: the work demands assent, calling us to acknowledge it. In other words, if the work is to work, it must work on us and work for us. "The truth is what works," in William James's pragmatic axiom, and this is nowhere more so than in the case of artistic truth.

For Stuart, such truth works at two levels, at once near and far. The "at once" is crucial; it is the temporal equivalent of the spatial juxtaposition implicit in "alongside" or "next to." It would not be good enough for an artwork to be effective at one remove only. It must work *at both at once.* The aesthetic situation is not such that in some simple succession I admire a Stuart work from afar *and then* close-up, or vice versa. This may be true at the level of overt behavior, as I step forward and back in relation to the work. But in phenomenological fact I take in the work nearby *in view of how it looks from farther away*; and I see it from afar only *by keeping in mind how it appears from close-up.* The heart of aesthetic paradox is just this: to have two different views *of one and the same artwork at the same time.* Anything else, either mere sequence or dialectical synthesis, weakens the point of such a paradox, which confutes both empiricism (and its many offshoots, e.g., behaviorism) and rationalism (overcoming contradiction in a system of reason). The point of paradox is to undermine any stable or accepted binary pair of terms—terms that exist equably side by side, thanks to the sanction of some supervenient system or theory. The point is to deconstruct the false equipoise of these apportioned terms: to break them up, to show their differences, yet still to insist that they occur together.

This is not to say that Stuart proposes to us "two distinct discourses,"[63] as if there were no relationship whatsoever between the two terms in question. The paradoxical logic of close and far as practiced by Stuart resists both submersion in system *and* any claim to strict dis-relation, as in the idea of two disparate discourses, or for that matter two unrelated ways of moving the body (e.g., arbitrary moving forward and then back in random succession). Rather, her work has the resources to deal with the very paradoxes it raises, not so as to resolve them but rather to make them aesthetically attractive.

There are at least three such resources. The first is the most sensuously specific: the close-up view favors tactility; the longer view encourages vision. The first tempts us to touch; the second to look. These are compossible and complementary; in Stuart's renderings, they are even coessential. For example, were I not to sense the palpability of the work close-up, I might mistakenly judge the portion of the

surface to which I'm drawn to be an entire work in itself; the palpable is locally effective but less compelling at the level of the work as a whole: I can touch only one partial surface at a time. Vision, on the other hand, takes in the whole all at once, without having to build up this whole from single units. Such is the comprehensive power of the look: the merest glance can sweep into our view the work in its entirety.

This is not to say, however, that the part of the work to which I attend is merely a disconnected fragment. A second resource of Stuart's is her capacity for convincing the viewer that every part of a work, no matter how seemingly disparate or trivial or peripheral, bears the imprint or import of the work as a whole—that it is a microcosm of the macrocosmic totality. Or rather, it detotalizes this totality even as it constitutes an emblematic and condensed version of it. This is precisely what happens in the case of a single panel of *Woodland Garden Seeds the Eastern Wind,* which conveys, even as separately reproduced in Plate 14, the sense of the larger work from which it is extracted. When it is perceived as an integral part of this work, it is as if it were a monad expressing and reflecting the entire work, so much so that it is difficult to isolate as a discrete module in the detotalized totality. What Emerson calls "the unity in variety which meets us everywhere" is here realized by the organic ties effected by this microcosmic-macrocosmic relationship.[64] Not only is the part part of the whole, but the whole is part of the part. As Phillips puts it, "[Stuart's] work is both microscopic and macroscopic, tactile and abstract, singular and multiple."[65]

A third manner of achieving "the sense of connectedness" that the divisive force of paradox threatens to undermine is found in Stuart's use of the grid, to which we here return.[66] This use is threefold: First, it sets up the units of close-up looking, allowing us a multiple choice in effect: our eye is free to select any given unit for scrutiny. Second, regarded as a sum of squares, the totality of units can be seen as one sizable but coherent rectangle—coherent enough, in any case, to take in with one comprehensive look when we regard the work from far enough away. But the grid is also operative in a third way: precisely because it is perceived as both a single set of squares *and* a group of separate squares, it enables us to relate one to the other in a complex, interactive matrix. This last feature of the grid is best specified as its inherent *scannability*: not just being able to see it as a single massive rectangle but also as a whole that our restless look continually runs through. In such scanning, both part and whole are included *totum simul*. This phrase, meaning "all at once," was first applied by Thomas Aquinas to God's perception of time, in which past, present, and future are co-apprehended in one cosmic embrace. But it also applies to the delimited but essential activity solicited by those many of Stuart's works that are explicitly gridded. Phillips astutely observes that "it is the small incisions made by the squares of paper within the overall work that urge the viewer to both close examination *and* the general, scanning overview from afar, establishing the reciprocal relationship of the small piece and the big picture."[67] In being spontane-

ously scannable, a grid actively enables the viewer to connect the divergent with the coherent, the heterogeneous with the unitary, the many with the one.

As we have seen in Smithson's otherwise very different case, whenever one is presented with a grid one is never far from a map. This is all the more the case when the grid is as regular as that employed by Stuart. In the end, both the grid and the map embody ways of articulating her conviction that the near and the far can exchange positions, thus are much more intimately related than we normally like to believe. She has written recently of Alaska as

> representing something to all of us not unlike Melville's South Seas—a place far away topographically, but close metaphorically. A distance so far that it can become near—a part of our psyche. A place so outside common history that we can make it part of our history.[68]

Both maps and grids—the two being in close collusion when it comes to the facilitation of scaled representation—bring the far and the near together in one planiform *tabula*: typically, the distant and the close in geographic actuality (so that the Marshall Islands now appear under our eyes as a map), but also in imagination, or more generally "psyche," as when vignettes from life in a distant place fill out the edges of a map as if they were scenes from that place viewed from a cosmic telescope.

Grid and map exhibit a virtually irresistible tie: to think grid is to consider a possible map, and to think map is to evoke grid. No wonder there is considerable "cultural overlay" between the two. This overlay belongs not just to the history of cartography but also to contemporary artists' use of the grid. For Stuart, maps can be considered highly acculturated overlays on a base level established by regular grids; for Smithson, irregular grids alone take us into a new sense of mapping. For both, there can be no mapping without gridding and vice versa.

But there is this important difference between the two artists: if Smithson considered all of his work as mapping, Stuart thinks of her work as mapping only in part, albeit a very significant part. Her work consciously combines mapping with nonmapping techniques. By this I do not mean merely that actual maps, or fragments thereof, are displayed alongside drawings or paintings or rubbings. As we have seen, this certainly does occur, literally so—whether the map is imaginary, as in the Mariners Chart of *Sacred Precincts* (Figure 4.6), or altogether authentic, as in the early "Moon" studies or in *Blue Stone Quarry—Moray Hill Site* (1974), which juxtaposes a graphite rubbing, a black-and-white photograph of a quarry site seen from above, and a detail of a map, all superimposed onto a faint background composed of a single large map. In *Diffusion Center: Fort Ancient Site, Ohio*, a "site map" is set next to an enormous field of tool forms exhibited on a grid of red strings (see Figure 4.10). The smaller work at the left is made up of color photographs of the Fort Ancient Site that ring around a carefully drawn gridded map of the digging sites themselves as seen from the air. In a case such as this, Stuart merges map or

maplike elements with drawn or painterly parts—with photographs often playing an intermediary role, at once locatory and imagistic. (And the trialectic between the three is often played out in accordance within the dyadic logic of the near and the far, for example, the photographs in the Fort Ancient Site map bringing close what is seen from a considerable distance above in the drawn map. This is yet another form of double take.)

Charting It Out

While all of this (or some significant variation) is happening at the level of the actual composition of Stuart's works, something else is often going on at a less literal level. This is a tensional struggle between mapping and nonmapping. Or rather: a refusal to make that choice itself in any simple binary fashion. For Stuart does not set out to map or not to map; nevertheless, she manages to map and to map otherwise than in certain easily recognizable ways. If most of the artists considered in this first part of the book employ standard cartography at times, this is in the service of something much more elusive than the accurate depiction or reliable direction-giving that is the aim of most established models. This something else is *earth-mapping*

Figure 4.10. Michelle Stuart, *Diffusion Center: Fort Ancient Site, Ohio* (1979–80). Site map with color photographs, gouache, and graphite on rag paper; tools made with muslin-backed rag paper rubbed with earth from site and powdered graphite, 35 × 46 inches. Installation at National Museum of Modern Art, Kyoto, Japan.

in the generic sense at stake throughout this book. In fact, each artist I take up, in both parts of the book, does such mapping in her or his own distinctive way.

What is distinctive about Stuart's way can be captured by drawing a distinction between plotting and charting. *Plotting* is the conscientious tracing out of a path between several points. In plotting a course, I draw a continuous line between these points, which stand for places on earth or sea through which I plan to pass. In mathematics, to plot is to locate points on a graph by means of coordinates; it is to pin them down, and at the same time it is to draw a curve or other line between these same points or figures. Thus both localization and shape are at stake; and they are at stake in mapping with the additional consideration that they relate to a "plot," that is, a piece of ground or other measured area. (*Plot* itself is related to *plat*, flat country or surface—think of *plateau*—and, ultimately, "a small portion of any surface; a patch, spot, mark.")[69] To plot, then, is to trace a course between existing points on a portion of the earth (or surface of the sea). Both the points and the ground/sea are regarded as actual, as existing somewhere on an equally actual surface. One cannot plot a path through an imaginary region, for it does not possess the requisite density of soil or buoyancy of water to support movement in its midst—just as one cannot "plot" in thin air when it comes to the more sinister sense of devising a scheme to hurt or murder someone: any such plot, to have credibility, must be based in the actualities of the circumstance and, much like plotting a trip, it must proceed step by step if it is to be effective.

Charting, in contrast, concerns the possible more than the actual. To chart a voyage is to project what may happen on that journey; it is to sketch out the arc of possibilities, the trajectory of *what might be the case*. Hence, charting is not bound by the actualities of the earth; it may skip over points instead of having to connect all of them in one continuous curve. No subtending piece of ground, not even an entire region, dictates its course; it can move freely over the surface of what we traverse at its own pace and with its own direction. For this same reason, it relies as much on memory as on perception to guide it—and even more on fantasy.

It is not surprising, then, that we speak of "sea charts" and "star charts" rather than of "land charts." For the sea and sky (especially the nighttime sky, so prominent in Stuart's New Zealand work) offer scenes of possibility: in their open embrace, anything can happen; on the high seas, a ship is "blown off course" by sudden winds that seem to come from nowhere; looking up into the sky at night, I can imagine myself moving in almost any direction upward, toward this star, then that galaxy, then the moon. It is not for nothing that Stuart gives to her works such labels as "Mariners Chart," "Starchart: Constellations," and "Starmarker."

Nor is it surprising that "charters," which are linguistic cousins of charts, have to do with granting certain freedoms in the form of privileges and rights: "exemptions from [customary] law" in Hobbes's phrase. What Hobbes considers to be the essence of human freedom (i.e., deliverance from external hindrances: "negative freedom") fits the case of charts, which indicate possible lines of action that are

free from earthly obstacles. For this reason there are no land charts; for land is constituted by obdurate masses, such as rocks and hills, trees and ground. To go over land we normally plot our way; to sail over the sea or fly into the air we can afford to chart our course, given the fluidity or ethereality of the medium and the comparative absence of obstacles; here freedom is positive: we are *free to* do any number of things.

True to her own complex and paradoxical sensibility, Stuart manages to map in *both* modalities in the course of her work. Sometimes she maps in a plotting sort of way, as in *Passages: Mesa Verde* (Figure 4.3) and *Diffusion Center: Fort Ancient Site, Ohio* (Figure. 4.10). In each of these works, the viewer knows exactly where the subject of the work is located, thanks to photographs and explicit maps. But one also knows the exact location at stake in *Sayreville Strata (Quartet)* (Plate 10), since the quarries at Sayreville are evoked both by the place-name of the title and by the earth colors of the four panels—colors from a particular patch, a plot, of earth near the quarries at Sayreville, New Jersey. In contrast stand frankly chartist works that map by way of imaginary charts (again the Mariners Chart in *Sacred Precincts*, Figure 4.6) or by cosmic night sky charts (e.g., *Sheep's Milk and the Cosmos*, Figure 4.8, or the encaustic painting *Black Star . . . Sky Dome of the North*, which served as the central panel in *On Part of Memory Being Alaska* and then became part of "Silent Gardens").

There is a parallel to be drawn between the distinction I have just made between plotting and charting as two forms of mapping and my earlier discernment of trip and voyage as the two main kinds of journey. Just as trips are from one determinate point to another and always concern the details of the actual world, so plotting bears on actualities as well; both are primarily earthbound (even an airplane trip takes us from one spot on earth to another). So, too, voyages are either imaginary or inspired by imaginative possibilities and in this respect rejoin charting, which projects the possible in comparative independence of terrestrial realities. It is tempting to sum up this double parallelism in the following tabular way:

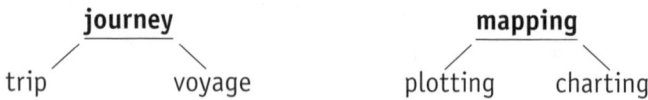

```
        journey                      mapping
       /       \                    /        \
  trip          voyage       plotting          charting
```

Or more completely stated:

	actuality	possibility
journey	trip	voyage
mapping	plotting	charting

But we should not rest content with any such tidy tables. Stuart herself teaches us to be suspicious of them. In a true tour de force, Stuart manages to *chart the earth itself,* for example, in most of the paintings belonging to "Silent Gardens."[70] This reversal trespasses on the categorical boundaries delineated just above. Doing so is characteristic not just of Stuart's verve but of her irreverence before her own earlier efforts—and thus in relation to what she has led us to expect. Not only does she chart the earth, but, by the same token, she also plots the moon's face—and this from the start (e.g., in *Mare 15,* Figure 4.1). We can see such unexpected moves as akin to reversal in the strategy of deconstruction: this is a crucial step before the more chaotic stage of dissemination sets in.[71]

For all of her artistic life, Michelle Stuart has been reversing conventional and expected categorical distinctions—especially those that fall into neat binary pairs. We have witnessed her agile and artful dismantling of established pairs of terms whose relationship is inherently paradoxical: representation/nonrepresentation, black and white/color, place/nonplace, close/far, mapping/nonmapping. We have seen her refusing to submit to any easy choice of one term over the other in any given pair, as well as resisting any amalgamation of both terms in some supposed conceptual synthesis. Her logic, discovered by gift of artistic genius and dint of labor, is very close to that of deconstruction as described by Derrida: "neither/nor, that is, *simultaneously* either *or.*"[72] Or, as she says herself in the epigraph to this chapter, "I like the idea of putting boundaries on the chaos that is there." If so, these boundaries are always subject to reversal and to a dispersal into the Chaos that is the other side of Cosmos.

Concluding Reflections to Part I

Each time you put down a work, even though it is caught up in a non-objective process, there is still the vicinity of that activity going on.—Robert Smithson, "Interview with Robert Smithson" (1970)

The four artists discussed in this first half of the book share some striking things. Three of them (Gellis, Stuart, and Smithson) enclosed their early work in carefully constructed boxes. These boxes not only take the place of traditional frames around paintings; they also serve to demarcate a sense of interior location: not just in a gallery but in a protected place within the gallery itself. They act to relocate twice over: from the surrounding world (the "site," in Smithson's language) to the public space of the gallery, then from this space of exposure to a place of containment (both amounting to the "non-site"). The contents of the boxes are quite different, ranging from careful drawings of the moon's surface based on NASA photographs (Stuart) to miniature landscapes seen from an aerial view (Gellis) to rocks collected at quarries (Smithson). But in each instance materials (or representations of such materials) are taken from the natural world, earthen or lunar, brought inside, and subjected to *emboîtement*. Something similar occurs in the case of the fourth artist as well: Margot McLean also gathered natural materials in the field (i.e., her childhood home) and put these into containers, plastic bags instead of boxes, keeping these containers in her studio. The basic move is comparable to the other three earth artists; none relies exclusively on manufactured paint or other traditional media, and all go outside the studio not just to paint or sketch but to obtain materials (or images of them) that belong to nature and to make these materials the substance, the very subject matter, of their artworks. For each artist invests the eventual artwork with such material, either as its sole content (as often with Gellis and Smithson) or as part of its full manifestation (as when collected leaves end up in McLean's finished paintings or earth is rubbed into the surface of Stuart's early drawings).

A second area of significant overlap concerns the incursion of cartography into the artists' lives. Stuart, it will be recalled, was deeply immersed in maps as a child and young adult when she worked as a topographer with the Army Corps of Engineers. No

wonder she did not hesitate to bring existing cartographic maps directly into her work, early and late, and that she has created her own semi-imaginary maps—"charts," in my nomenclature. Similarly, Smithson made conventional maps an explicit part of his work, both early (e.g., the *Dallas–Fort Worth Regional Airport Layout Plan* and the *Negative Map Showing Region of the Monuments along the Passaic River*)[1] and late (e.g., *Map for Double Non-site, California and Nevada,* Figure 1.10). He, too, was led to invent his own sense of mapping, that of the non-site as an "abstract" and "three-dimensional" map of the site from which its material content derived. Both he and Stuart came to be preoccupied with the grid, which (as we have seen) structures a great deal of their later production. In contrast, neither Gellis nor McLean employs cartographic maps directly in her work; nevertheless, each devises a distinctive sense of mapping of her own: a mapping of water and earth that is at once geographic and meteorological in Gellis's case, an earth- and sky-mapping in recent paintings of McLean. Moreover, both artists at least allude to the grid, whether by means of taut strings that cross at right angles (e.g., in *Condensed Spaces: Iron, Sand, String,* Figure 3.1) or by bare adumbration in paint (e.g., in *Blackbirds,* Plate 7).

For all four artists, the grid is an issue because mapping is an issue. At one level, this pays homage to Western modes of mapping, which after the demise of T-maps and portolan charts became committed to the grid system of Ptolemy and the great Dutch mapmakers. But this gesture to the history of the subject conceals a deeper level of concern that must be faced by anyone who takes maps seriously enough to create them on his or her own. This level bears on questions of location and distance, size and mass. The grid is able to answer these questions because of its combination of extremely regular modular units (i.e., the squares or rectangles of the grid system itself) with a virtually unlimited concatenation of these same units. Thanks to this double aspect of the grid, it is able to effect an economy of scalar representation. As Smithson points out, the word *scale* comes from the Latin *scala,* meaning "ladder" (the plural *scalae* signifies "stairs").[2] In scaled representation, one climbs the ladder or stairs of comparative size and distance: one moves one's body along regular intervals in an effort to get somewhere. This is closely akin to *scanning* the earth: *skand-,* "to leap, climb," is the common Indo-European root of *scale* and *scan* alike. Smithson insists on the necessity of scanning as preliminary to the creation of mapping. He finds the site he is looking for, often by serendipity, and then proceeds to map. In his laconic description: "First I find the sites. Then I draw the squares. I'm scanning the physical material before I start to set up the plan; in other words, the map layout is following after the scanning."[3] From this statement, which we have encountered before, it becomes clear that the grid of a map (and almost every map, considered as a "layout," involves the inscription of square units) depends on a basic act of scanning that precedes its creation. Although such scanning can occur in two modalities (i.e., visually, from above; kinesthetically, by walking), it is striking that Gellis and Smithson both begin by preferring the "aerial view" or "aerial map," and both end by scanning

earth or water on foot: Smithson walking out onto the Spiral Jetty, Gellis wading into the Hudson River to collect samples.

For none of the artists treated so far in this book is the map or its implicit or explicit grid independent of the earth that it represents at one remove and by projection. Whatever momentary autonomy an expressly gridded map may appear to accomplish is precarious; the map sinks back into the element from which it comes. The metaphor is Smithson's, but the three others under discussion would agree with him that "after a point, measurable steps . . . descend from logic to the 'surd state.'"[4] In other words, the scale, the regulated steps, of the grid give way to the earth's resistance to the rationality of number and perfect shape. *A-logos* triumphs over *logos*. Not only in the Spiral Jetty but also in various works of McLean, Stuart, and Gellis "the surd takes over and leads one into a world that cannot be expressed by number or rationality."[5] We see this surdity, this alogicality, in the glass jars of Gellis, each with its own local content; in the strange intimacy of the insets in McLean's paintings (what are these animals doing here?); and in the streaming of a long strip of rag paper over the earth in Stuart's *Niagara River Gorge Path Relocated* (Figure 4.4), where the paper mocks even as it retraces the steps of the enormous escarpment over which it is draped: here is the literal construction of scale in (and not just about) the natural world!

Maps, then, far from being mere representations of the earth, can become part of the earth itself. Gellis, Stuart, McLean, and Smithson make maps of earth and its elements—where the *of* is not the *of* of depiction but that of constitution. However differently, they all create earth-maps.

Does this mean that we have left the domain of art? Certainly not. The earth works that each of these four artists creates are at the same time works of art. In their ingenious hands, earth becomes map, but the map that results is also an artwork. There is no incompatibility between art and map, not just because both can be pictographic, or both constructed from elements of the earth, but also because even the formal elements of maps can assume artistic allure. Recall Smithson's statement that "size determines an object, but scale determines art."[6] Scale as an effect of the grid, scale as steps within an artwork: there is deep affinity here, allowing art to be scalar and maps to be artistic—and earth, the basis of all grids and steps, to be their common basis.

But wait! Are we not moving into conceptual confusion here, mixing art with maps and earth with both? Have we not moved into the absurd as well as into the surd? Do not maps of every sort serve to locate, at the very least? Do not Smithson and Stuart explicitly, and Gellis and McLean by implication, depend on the locatory properties of maps? And do not these same artists supplement maps with photographs in order to gain further locatory precision? All this is undeniably true.[7] The value of such locatory indices, whether cartographic or photographic, cannot be gainsaid. They point to certain particular places of origin—sources of earthen materials as of intense experiences. They act to remind the viewer of the highly specific

character of the earth in its local configurations, its exact topography, the way the surface of the earth bends and breaks off, smoothes out and falls away. Given these locatory and visual virtues, conventional maps and precise photographs retain a valid role in the construction of artworks that bear on the earth and its destiny. Nor are they incompatible with the extended forms of mapping that we have witnessed in the more adventuresome work of the four artists under discussion. Both versions of mapping, carto-photographic (relying on pictographically conveyed isomorphism of detail) and all those that are no longer concerned with exact representation, can be incorporated into the same artwork and even become its very basis. Indeed, such double-track mapping in two ways at once is itself an effective device for bringing the work back to earth with redoubled testimonial power.

Common to all of the artists considered in part I is a refusal to stay put—a *rejection of simple location*. In contrast with earlier ideals of creating a perfect object (a painting, a piece of sculpture, a building) that is meant to subsist statically in a single place (typically, a museum or gallery), the very different ideals of *movement* and *multiple location* are the commitments of each of these artists. Smithson is perhaps the most concerted critic of simple location, that is, the idea that the identity of something (e.g., a work of art) is at once satisfied and established by its location in just one place—a "site" in my nomenclature, a "non-site" in Smithson's. According to this doctrine, which is pervasive in early modernist thought, an object is just where it is and nowhere else.[8] Smithson and other critics of modernism in art could not tolerate such a restrictive sense of location, which in effect reduces place to position. His form of rebellion was to move out from the gallery to the quarry or the barrens—and only then to return from these open places to the constrained spaces, the "non-sites" of the gallery. He brought to the non-site—which is at the same time a *non-sight*: a place where the natural world is not in sight—material belonging to the outer place. Putting this material in boxes was meant to underline the confining character of the exhibition space, which contains such material twice over (first in a box, then in a room). By breaking out of the box in his later works, he managed to relocate what had already been relocated once in the non-site of the exhibition: the answer to double containment is double relocation!

The others we have treated also practice relocation, each in her own way. Margot McLean relocates animals from their natural habitats to the artificial (but aesthetically effective) shelter of her paintings: she gives them another place to be (safe, themselves, different). She also relocates whole continents into the haven of her work (as in *Virginia* [Plate 2] and in *Blackbirds* [Plate 7]). By the same token, Sandy Gellis relocates water and soil and rock by placing it in glass containers or recording traces of it on prepared plates. These containers and traces are themselves relocated through exhibition together in a regroupment that is the condensed equivalent of an entire world (a space-world in the case of the jars that collect items from around the earth, a time-world in the case of the plates that record rainfall for one year). Traveling the world, Michelle Stuart relocates *herself* as well as the mat-

ter that she transports back from the places she visits: this matter, rendered tractable by rubbing or other means of incorporation, is effectively re-implaced into the work. At the same time, Stuart practices what we might call *co-location* by virtue of her technique of presenting photographs and maps together with the materials from a place, all in one and the same work. Gellis and Smithson also participate in this co-locatory move by means of their use of photographs and/or maps of a given place of origin.

The relocation realized by these artists is itself diverse. It is not only double but sometimes triple or more: Stuart's *Sacred Precincts* relocates the historical wreck of the *Essex*, as first relocated in the prose of *Moby Dick*, into her own relocatory Mariners Chart. In the full installation, the Chart is in turn co-located with the Mariners Temple, the Nantucket Excavation, and the Burial Cache of the White Whale (another allusion to *Moby Dick*). No simple location here! Even as set up in the Neuberger Museum in Purchase, New York, this complex work belies the very idea of "in-stallation." Nothing is here installed if this means fixed in place, pinioned, positioned. This is a most moving show, as mobile in its own way as Stuart's land works (e.g., *Stone Alignments/Solstice Cairns*, Figure 4.5) or Smithson's earth works (e.g., *Spiral Jetty*, Figure 1.6). It is telling that Stuart's first major land work is titled *Niagara River Gorge Path Relocated* (Figure 4.4; my emphasis). The re-location is not just the literal re-location (i.e., location back to the original locus) of the path of the river gorge, however; it also inheres in the different sense of place that emerges when the same place is reconfigured significantly: relocation by dint of changing the character of the surface of the place. This can be considered relocation within one and the same location: where the *re-* no longer looks back to a previous location but forward to a *renewed* sense of place.

Relocation and co-location are, then, modes of multiple location. Each of them contests the very idea of simple location. True to their mission, each is itself multiple: we can relocate in several ways (e.g., by literal transfer of content, representation in maps and photographs, insets in a painting, containment in vessels, etc.), just as we can co-locate variously (by different modes of representing the same place, as in the photo-cartography that is pursued by most of the artists we are discussing; or by the simultaneous presentation of items that stem from, or reflect, the same place, e.g., the audio accompaniment employed by Stuart in *Correspondences* [1981] and *Ashes in Arcadia* [1988]).

The major mystery remains this: how can such differential locating, such diverse movement, occur in the midst of something as massive and unmoving as the earth? Does not the very notion of "earth work" or "earth-map" render all such enterprises dubious from the start? The fascination with earth works and the earth-maps to which they give rise—or that they directly embody—is not only with moving out of the gallery or studio to seek inspiration outside: the late nineteenth-century plein air painters had already done that. Nor is it just to work with raw matter, either in its natural habitat (as in land works and earth works proper) or as transported back

to the studio (as McLean and Gellis do) or to the gallery (as with Smithson and Stuart and, again, Gellis). This path of development is powerfully motivating, and it has shaken up the art world while making its mark in art history. Yet this restless relocatory passion does not fully exhaust what is very special about the direction that Smithson, in league with Heizer and Oppenheim and others, inaugurated in the middle 1960s and that is still ongoing today.

The specialness has to do with the paradoxical possibility that matter, in its very obduracy and substantiality, can yield movement that is of intense artistic interest. The elemental and unworked, what exists in nature and is not yet reshaped, appears at first glance to be very unlikely as material for art. Earth is too heavy and dense, water too viscous and dependent on what contains it, air too ethereal, fire too lambent and destructive to be fit subjects for aesthetic exploration. Leaving air and fire aside—they are difficult to consider as *matter*[9]—how can earth and water figure into artworks? Especially when "artwork" connotes the agile fingers and quick eye of the artist or craftsperson, ever poised to work skillfully and rapidly with the materials at hand. But how to move *through* such stubborn substance as earth? How to *hold fast* the ever-moving waters, as wayward as the raw earth is stolid?

Every one of the four artists featured in this part of the book manages not just to work with earth and water but to move nimbly in their presence. Or more exactly: to get *them* to move with an unaccustomed suppleness and to shape them in a way that bespeaks the force of art. It is a question of the metamorphosis of matter itself. But how does this happen? And what does it have to do with mapping?

Each of the four artists engages with both earth and water, though in varying degrees and distinctively different ways, and each of them accomplishes mapping on the basis of this very engagement. How is this so? Stuart and Smithson engage primarily with earth, whether as the source of intensely rubbed rag paper or as the contents of non-site boxes; but water figures as well in their work, especially their more ambitious earth or land works, as in Smithson's *Spiral Jetty* and in his *Broken Circle/Spiral Hill* (1971) at Emmen, Holland, in both of which an earthen structure is built out into the water, and in Stuart's land works on the edge of bodies of water (the Niagara River Gorge, the Columbia River). Gellis bottles water and earth alike, and she literally walks into the Hudson River for samples of its substance; McLean brings back samples of personally meaningful soil and leaves, and she travels to a distant river, the Orinoco, in search of its aqueous essence.

Not only do all four artists make use of earth and water—the actual element, not just its representation—they render it ductile and mobile for their purposes. Clumsy clods of earth and clumps of rocks are pulverized by Stuart into a refined and colorful medium that is pounded or ground into the rough surface of rag paper. McLean mixes leaves and soil with acrylic paint; Gellis lets the pattern of raindrops determine the course of an etching. For Smithson, earth is something he moves and removes; and if water is part of the work, it is as a moving medium that may even (as at the Great Salt Lake) come to cover the work itself as its level rises. A yard in

Virginia full of the most miscellaneous debris, rainy days in Manhattan, dirt from open fields, rock from quarries, a briny seething salt lake: all of these seem very unpromising as furnishing materials for art. But in every case, an almost alchemical transmutation of such *prima materia* takes place, yielding artworks notable for their subtlety and sinuousness. From the detritus and dross of the earth and its waters, each artist has created "not objects, but fields, subdued being, non-thetic being, being before being."[10]

But this subtlization of matter has not arisen without very special efforts on the part of these earth artists. If matter has become dynamic—if it has been put to work with such agility—this is only because the artist himself or herself has been so mobile and agile. Earth and water begin to move because the artist is a moving force who has put his or her own body to work.

A first way in which this happens with this quartet of artists is by actual travel to particular places. Smithson says explicitly about his *Nine Mirror Displacements in Yucatan* (1969) that "it is a piece that involves travel. A lot of my pieces come out of the idea of covering distances."[11] In this instance, Smithson had traveled to Yucatán and set up sites with mirrors in the earth, photographed them, then dismantled them. Travel is required if one wants to work in situ. Smithson continues:

> I'm more interested in the terrain dictating the condition of the art. The pieces I just did in the Yucatán were mirror displacements. The actual contour of the ground determined the placement of the twelve mirrors. The first site was a burnt-out field which consisted of ashes, small heaps of earth and charred stumps; I picked a place and then stuck the mirrors directly into the ground so that they reflected the sky. I was dealing with actual light as opposed to paint.[12]

Beyond describing the conjunction of air with earth here, through the medium of mirrors and light, Smithson articulates a crucial fact about doing earth works: they require the artist to travel to a specific place of work. "I very often travel," says Smithson, "to a particular area; that's the primary phase. I began in a very primitive way by going from one point to another. I started taking trips to specific sites in 1965: certain sites would appeal to me more. . . ."[13] Others have followed suit. Richard Long, for example, travels to a place, walks back and forth in a field long enough to form a discernible path, and leaves: the earth work has been created by the movement of his body at that place.[14] This is to reduce the artwork to two events: travel and bodily motion on the earth. Smithson himself insists on disrupting the earth to some extent, "denaturalizing" it, even if he sometimes smoothes over his intervention.[15] In short, he insists on creating something *from,* and not just *at,* the place. So too with others we have considered: Stuart travels even farther than Smithson did in order to create something on the spot (e.g., *Navigating the Sea/Reflecting the Stars* in Cook Inlet), or she takes back materials with which she creates something in her New York studio (e.g., various rock books such as *Puerto*

de la Luna History Book [1979]). The travel is in the service of the work, wherever that work is to be located.

If travel is a first and most literal way in which the body moves in creating an earth work—the "first actuality" in Scholastic nomenclature—it does not begin to exhaust this mode of movement. As a *trip* in the sense discussed above, it is tied to the actualities of time and distance, since it is indeed a matter of "going from one point to another." The trip that is the modular unit of travel involves changing positions on earth (or at sea); it is a question of *phora,* in the Greek word that is equivalent to literal "transposition." Hence, it is properly *plotted* in the sense I have discussed: staked out in terms of successive movement between determinate positions already designated on an existing map. Everyone, not only the artists here under consideration, takes carefully plotted trips, traveling more or less on schedule and through more or less securely situated spaces.

But for artists who take their primary inspiration from an active engagement with the earth, a more challenging journey is at stake. Their task is to move with(in) matter itself—to move in its terms, to follow its terrain. This means not just getting to a place where the matter is located and where the "selection of the site" can occur but also, more significantly, getting bodily immersed in that matter, feeling its density, touching its texture, smelling its aroma. In other words: coming to terms with it, not *idealiter,* but *materialiter,* that is, *on its own explicitly material terms.*

Examples of this engagement include Smithson's practice of concerted *scanning* (the Salt Lake), McLean's *foraging* (the lawn of her Virginia home), Gellis's *wading* (into the Hudson), Stuart's *camping out* (under the New Zealand sky). Each of these is a specific way in which the artist's body comes to terms with the materiality of the landscape from which the earth work takes its origin. Each is "a very primitive way" of being on earth—more primitive than any scheduled trip can ever be. Each is prehistoric: before any specific narrative history is told, preceding any definite succession of events. We are at the level of "causal efficacy" (Whitehead) in which the body is so deeply enmeshed in matter that no clear distinction between the two is any longer possible. What belongs to *my* body and what to *that* matter cannot be determined easily, if at all. My body, that of the artist, is not just a "lived body" in Husserl's sense; it is a material body that is continuous with matter itself, with earth and water (and air, given that we are breathing creatures). By the same token, matter is bodylike; the world is fleshlike.[16] Stuart considers rock as "bone under the flesh of soil in the body of the earth. . . . The earth lives as we do, elastic, plastic, vulnerable. . . . Stone is self."[17]

This is not to say that we are mired in matter. Being at one with the material world at this inchoate and primitive level (and it with us), the artist can move more freely and effectively within it. This movement constitutes the earth artist's odyssey, a journey that can no longer be designated as a mere trip. Nor even as a voyage, if this implies free motion through the possible and *over* the elemental (as in a sea voyage that is taken over the ocean). Instead, it is a matter of a literally en-grossed movement in and with matter that continually touches base with water and earth.

It is not unlike the ancient notion of *periplus,* a circumnavigation that goes from one port to another by clinging to the coast. Not precisely plannable (because at the mercy of the elements), this kind of journey occurs as a continual movement between two material modalities: being in the water, being on the land. The ship, like the artist's body, is engaged in both kinds of places—fully so, never being idle, not even in port (where it must be *held* still). So, too, the Spiral Jetty offers to the walker's body a scene of circumambulation, of moving around (*circum-,* like *peri-,* signifies "around") a spatial vortex in which this body is engaged with the landfill under foot and the saltwater at its edge, thereby realizing a miniaturized *periplus.* In both cases, the body is linked to two kinds of matter *at their common edge.*

The result is the postmodern equivalent of the premodern *costaggiere,* the journey along the coast of the Mediterranean. The earth artist puts his or her body at risk in a perilous *periplus,* which may lack the rigors of ancient sailing on the surface of the open seas but which is no less dangerous in terms of an unplotted and unchartable course. This is an adventure that takes place between at least two elements. It is a truly medi-terranean voyage, in the midst of the earth, in the middle between earth and water, amid them, along the edges where they meet. The body is the indispensable mediatrix of this extraordinary voyage: the middle of its middle. It is the alembic in which occurs the transmutation from crude to subtle matter. This transmutation manifests not *l'alchimie du verbe* but *l'alchimie du corps.*

Such a voyage in and through matter is risky in the extreme. It is also dangerous in another, more ontological sense. For it puts into question the comfortable distinction between the possible and the actual on which I have so far been relying, a distinction that most human beings take for granted most of the time. The material factor at stake in earth works is not simply actual in the sense of *physical.* Just as the ideas of simple location and planned trip fail to capture the peregrinations of an open voyage, so the matter through which he or she moves is not physical, where *physical* means extended substance that is inert, rigid, and three-dimensional, in short *res extensa* in the Cartesian sense. Nor is the matter in question something purely possible—the *idea* of matter, what matter *might be.* Instead, the matter at issue is animated matter, dynamic if not literally alive and breathing in the manner of McLean's animals bristling with movement. This is matter that is animated by what Leibniz called *vis activa,* an "active force," to which the alert earth artist responds with his or her own active body. Such a force was felt by Smithson at the moment of his discovery of the site for the Spiral Jetty. Let us look again at his description of this remarkable moment:

> As I looked at the site, it reverberated out to the horizons only to suggest an immobile cyclone while flickering light made the entire landscape appear to quake. . . . My dialectics of site and nonsite whirled into an indeterminate state, where solid and liquid lost themselves in each other. It was as if the mainland oscillated with waves and pulsations.[18]

In this exhilarating situation, there is "no sense wondering about classifications and categories,"[19] because the bodily immersion in matter is such that a concept like "extension" (which keeps bodies entirely separate) is rendered irrelevant. Even the conceptual distinction between site and non-site, on which Smithson himself had relied so heavily in earlier work, melts away, as does the seemingly irrecusable difference between solid and liquid, that is, earth and water, on which everyone relies in ordinary waking experience. Taking the place of this static difference is a dynamics of matter that reverberates and trembles and oscillates. Instead of the empty and dead space of *res extensa,* the space of analytical geometry and the formal grid, there is now the "gyrating space" of the emergent Spiral Jetty.[20]

The "indeterminate state" thereby reached is indeterminate with respect to an entire series of binary choices: not just liquid versus solid, but physical versus mental, actual versus possible, trip versus voyage, plotting versus charting. Earth work is deconstructive work. We have seen this happening in the work of Michelle Stuart. Now it becomes clear that it arises in many kinds of earth work, from Robert Smithson's inaugural efforts to Sandy Gellis's ingenious experiments. (Do these experiments concern weather? place? water? Clearly, all of these, among which a definitive choice cannot be made.)

Another way to grasp the deconstructive indeterminacy of earth works is to see them as so thoroughly multilayered as to refuse reduction to any single privileged layer. This is certainly the case with Margot McLean's treatment of depth in *Blackbirds* (Plate 7), a painting that we saw to involve at least four kinds of depth, none of which is predominant over the others. Other artists navigate between horizontal and vertical depths (Gellis, Smithson), cosmic depths of various sorts (McLean, Stuart), close-up and far away (Stuart, McLean). None is willing to choose in an exclusive way between these variants: all are affirmed, however much at odds they may seem to be with one another.

Their works are also multilayered with respect to temporality. This may appear surprising, since at first glance they seem to share a "predilection for the prehistoric" (in Freud's memorable phrase). Think only of Stuart's fascination with ancient burial mounds and their contents—and of her *Stone Alignments/Solstice Cairns* (Figure 4.5), which evokes similar prehistoric sites in the British Isles and elsewhere. Smithson was fascinated with the geologically prehistoric that is laid bare in abandoned stone quarries, and near the site of the Spiral Jetty he spotted a dilapidated shack: "a hut mounted in pilings [that] could have been the habitation of 'the missing link.'"[21] We have seen McLean's penchant for the *souvenir,* and her preoccupation with animals concerns the literally prehistoric. Gellis composes *records* of what has transpired during a *past* year with materials that are outside history and human temporality.

Nevertheless, none of these artists is interested in the past for its own sake. Not only this, but their tie to the temporal is such that the past, far from being isolated from the present and future, is continuous with them, making it difficult in the end

to distinguish between the three modalities of time. Indeed, there is free movement back and forth across past, present, and future. Smithson says explicitly that "our future tends to be prehistoric."[22] Otherwise put, the present of art must "explore the pre- and post-historic mind; it must go into places where remote futures meet remote pasts."[23] This is a virtual credo that would be endorsed by each of the artists under discussion in part I. While earth art certainly draws much of its inspiration from the prehistoric and even the precultural (e.g., the purely biological or geological), it must also speak to our postmodern time, in which history is as much under question as the individuated subject is. Earth works put into a commanding present format the intertwining of ancient roots and contemporary sensibility. (These ancient roots include cosmic origins, the specific concern of Stuart and McLean and Gellis.) The earth artist must refuse any forced choice between past and future, instead showing them to be bound up with each other in the imbroglio of the present. Just as any decision between the actual and the possible (and the other dyads mentioned above) is contested by earth art, so any comparable choice in the domain of time must be resisted: "The deeper an artist sinks into the time stream the more it becomes *oblivion*."[24] In each case, the artist endorses the indeterminacy of non-choice, a fog of indistinct direction, in this way reflecting the merging of body and matter, which is the central action of earth art.

And earth-maps? To do earth work in the manner just discussed is never to be far from mapping the earth that one selects and shapes, pounds or photographs, transports or transmutes. As Smithson says in the epigraph to these concluding remarks, to do an earth work is to be engaged with "the *vicinity* of that activity going on."[25] "Vicinity" names a place that is neither a pinpointed position nor an empty space; it is a concrete area, a neighborhood, that calls out to be mapped in its specific topography.[26] This is why Smithson, in the same interview from which the epigraph was taken, spontaneously reverts to the term *earth-map*: "I've done other things [i.e., other than setting up non-sites in a gallery] that are on the landscape, usually in the sites that the non-sites point to, like the 'earth maps,' but there is still a form that I use, mainly pre-historic land masses."[27] What are these maps? How do they differ from other kinds of maps?

Short of the further treatment to be found in the epilogue, in closing these reflections, we can usefully distinguish among the following five forms of map:

(i) *cartographic*: This mode of standard mapping is frankly representational and concerned with the accurate depiction of position and distance in accordance with a precise metric and regular grid. Its roots are in early modern mapping in the West, and much further back in China, but it presents itself mainly today in the form of the road map or the atlas. Such maps are essential to travel in the sense of making a trip; everyone who takes a trip from one particular place to another employs them, including all four artists with whom we are now familiar. Smithson himself used a map of Yucatán to guide him on his project of nine mirror displacements, and he alerts his interviewer that the sites of these displacements "could be reconstructed

by following the map."[28] In fact, he supplies just such a map in his own essay on this project—a highly conventional map in which the numbers 1 through 9 indicate on the map just where his displacements are to be found.[29] Like any such map, it is at once aerial and "objective" (i.e., planiform, isometric, and strictly gridded). But this does not prevent Smithson from ironizing on such a straightforward cartographic representation: he titles the map *Vicinities of the Nine Mirror Displacements*, and he makes it clear that the original sites would be very difficult to locate given that he removed the mirrors and smoothed over the earth soon after he created and photographed the displacement. Such irony is also at play in Gellis's "Condensed Spaces," which takes what should be open-ended views having expansive horizons and puts them *into boxes*—boxes gridded with wires and other devices. So too with Stuart's early "Moon" works, which combine the deadly accuracy of NASA photographs with the artist's chosen complications (drawings, strings, etc.).

(ii) *quasi-cartographic*: By this term (to be explored further in part II) I mean merely a map that *resembles* something cartographic yet in the end is not cartographic at all. The apparent continents in McLean's *Blackbirds* (Plate 7) or *Virginia* (Plate 2) and (to a lesser extent) in *Flying Bird* are only maps *as it were*: they present *something like* continents, like Smithson's "mainly pre-historic land masses," that cannot be strictly identified with cartographically represented continents such as Africa, South America, and so forth. One would probably not recommend them to a child learning world geography, much less refer to them as a basis for one's own adult travels. They are imaginary geographic presences that trade upon accurate depiction while departing from it freely. In the same spirit, Stuart's Mariners Chart of *Sacred Precincts* is more fictive than factual; it is the representation of a possible group of South Sea islands crisscrossed by imaginary voyages. The same artist's quasi-topographic "site map" attached to *Diffusion Center: Fort Ancient Site, Ohio* (Figure 4.10), which ostensibly shows dwelling places and the locations of archaeological remains, is concocted from the artist's fertile imagination, not from geographic fact. The detail and apparent accuracy of this work easily mislead one into believing that it is indeed a precise representation of archaeological digs. This is a case not of *trompe l'oeil* but of *trompe l'esprit*: only the photographs that frame the map on all sides are trustworthy representations of the actual site. The issue in quasi cartography is not, however, that of deception per se; it is, rather, *ostensible versus reliable representation*.

(iii) *abstract*: This refers to the ineluctable selectiveness of maps, their necessarily partial representations as well as the distance they take from what they represent in scaled formats.[30] I also use the term with reference to Smithson, for whom *abstract* meant at least two things: lacking a world; and abstracted *from* in such a way as to be relocated elsewhere (e.g., in a non-site, considered as an abstract three-dimensional map).[31] The two traits fit closely with each other: a representation will be worldless if its material medium is incapable of constituting or even suggesting a coherent set of places: a place-world in short. Such abstraction obtains in the case

of the earliest known maps of the Mediterranean world: Egyptian cadastres that survey land in a protogeometric manner. I have referred to Husserl's claim that the rudimentary geometric shapes are parasitic on existing landforms—once more, on "mainly pre-historic land masses." As Merleau-Ponty, commenting on Husserl, says, in such elementary abstract maps we witness "the homogenization of every exterior transformed into an object . . . all of this constructed on ([in such a way that] one cannot efface) my bodily implantation in a Being-Father-Land, all of this being idealization, superstructure, of the earthly relation to the ground *(sol)* and to terrestrial co-existence."[32] The abstraction, then, is not just from earth but from the body-on-earth: it is this entire latter complex that is spirited away, idealized, in those maps that leave out the double-groundedness provided by earth and body.[33]

(iv) *concrete.* Concrete maps expressly acknowledge the role of the mapmaker's body as it engages itself with the materiality of the land (or sea) that it helps to map. More than helps—rather, *brings into existence.* For the body is not just an instrument, a point of application. It is the basis of my "implantation" on the earth: Merleau-Ponty's metaphor draws on the biological world by suggesting that the human body grows out of the earth and is sustained by it. Since *plantare,* the root of *implant,* means "to drive in with the sole of the foot," the dynamic motion of the body in relation to the earth is signified as well. If the body is implanted in the world, this is because it presses itself into the surface of the world's body, into its very flesh. This is the basic action I described above when I spoke of the body's moving in the material realm and alleviating its bulk, loosening and leavening it by its dynamic motions. Just such an action is at stake in the creation of earth-maps, which derive from the body's intimate interaction with the surface of the earth.

Concrete maps are of two kinds. In a first avatar, they are created on paper. Instead of the body's action being concealed as in cartographic and quasi-cartographic maps, it is evident in the very lines and shadings of the map, in such salient items as decorative cartouches and emblems and signatures as well as in subtler ways, such as the style of contour lines, the coloration of the map, the selection and representation of specific topographic features. These features not only personalize maps by rendering them idiosyncratic; they also show the cartographer's body at work, being the traces of this body's gestures, its psychokinetic offspring.

In a second instantiation, concrete maps are not just the display of the body's formative work on paper; they are created from the very material they are supposedly about. I say "supposedly" about, for they are not *about* anything other than themselves. But since they are made of elemental materials, they nevertheless bear on something quite significant, the ultimate "basis-body" (Husserl) for all the animate and inanimate bodies that live on it, that is, the earth. They are not about the earth but *of it,* and precisely in Smithson's sense of *of:* "The pieces I do on a landscape are maps of material, as opposed to maps of paper."[34] Maps of material: not just maps made *from* material (i.e., matter, not distinguished from material by Smithson), but maps that manifest the very earth from which they are made.

(v) *earth-maps*. With the second kind of concrete map we have reached the level of earth-maps proper. Such material maps are utterly concrete in the sense that they do not point away from themselves as conventional cartographic maps do; rather than being indicative in status, they are adumbrative or exhibitive. They show themselves from themselves, and are thus phenomena in Heidegger's sense of "phenomenology": "to let that which shows itself be seen from itself in the very way in which it shows itself from itself."[35] What is here shown is the earth—in the very way it shows itself from its own ground. Or rather: from the surface of its ground that reveals the depths of this ground on the surface itself.

But to be exhibitive of earth in this strong sense of being concrete qua material is not just to set forth the earth as if it were an independent entity calling for disclosure. Essential to the concreteness is the body's action on earth, and this action is that of journeying amid matter, making its way in the material world, mapping not only materially but kinetically. For the body's action, corporeal journeying, is a matter of *kinēsis,* not of *phora.* Kinetic action means not just change of position, literal transportation, but an implantation that changes the very matter in which it moves, opening up the soil with the soles of its fast-moving feet. The matter is not just marked, much less represented; it is altered in its very identity. Not just physically extended, it is dynamically charged with bodily motion.

This motion is the mapping of body on earth. No longer a question of following a map, the map is made by the movement itself, step by step. The basic action of walking across a field—and "everything is a field or maze"[36]—is already, and fully, mapping. Richard Long's walk works are primal earth-maps, since they trace a trajectory in the earth over which they move. Indeed, each artist I have treated elaborates the enterprise of the earth-map, whether by building on or with earth (Smithson, Stuart), pounding it into powder as a basis for rubbing a surface (Stuart), collecting its residual traces (Gellis), or including it outright in the painted surface (McLean, Stuart). But these elaborations cannot conceal that each artist begins by walking on the surface of the earth, finding its depths there. Such walking is the basis for the "absorptive" mapping to be discussed in the next part. For now, let us agree that walking is the most telling way in which our moving body is in kinetic connection with the earth, another moving body. Whether we walk to scan or survey, to ruminate or relocate, this basic action puts us in touch with the earth's surface where, like Antaeus, we gain renewed strength every time we touch base. Not just strength to do particular tasks, but strength to map the earth by our very perambulation on it.

No wonder that earth-maps are "left on the sites."[37] Where else could they be left? Not imposed on the earth but fashioned from it, they are left to sink down into the earth of which they are made and from which they are shaped by the magico-mediatorial action of the living body moving in its midst. Concrete and material, they expose the very earth to which they make return, for in the end "there is no escape from matter."[38]

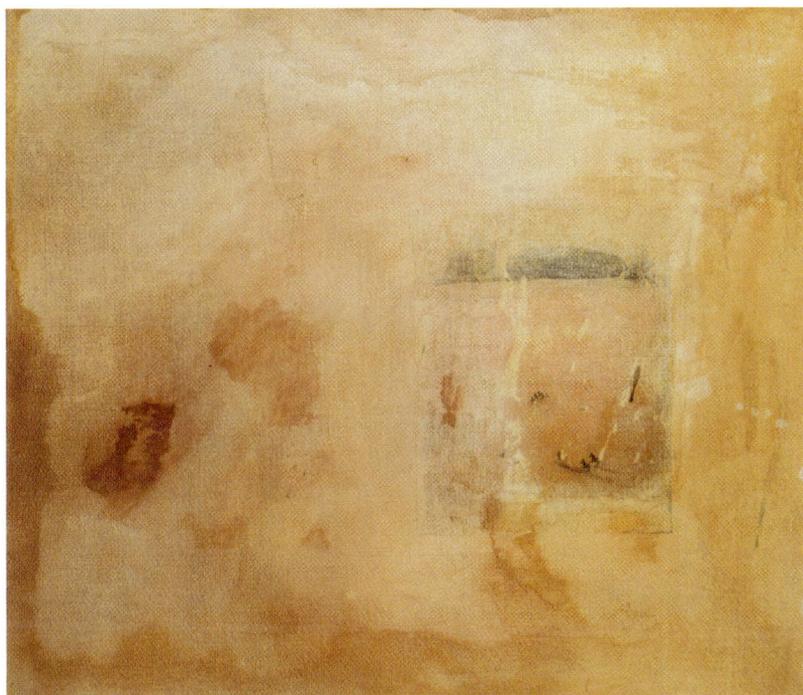

Plate 1.
Margot McLean,
*Sphenoidal
Fissure* (1992).
Mixed media
on linen,
24 × 28 inches.

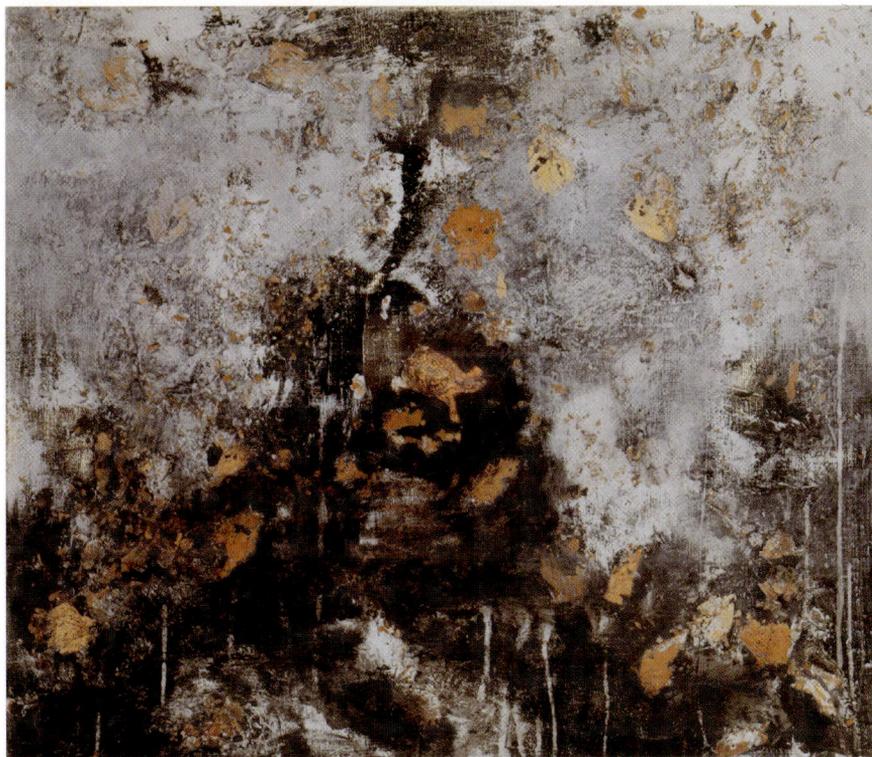

Plate 2. Margot McLean, *Virginia* (1993). Mixed media on canvas: soil, leaves, acrylic; 24 × 28 inches.

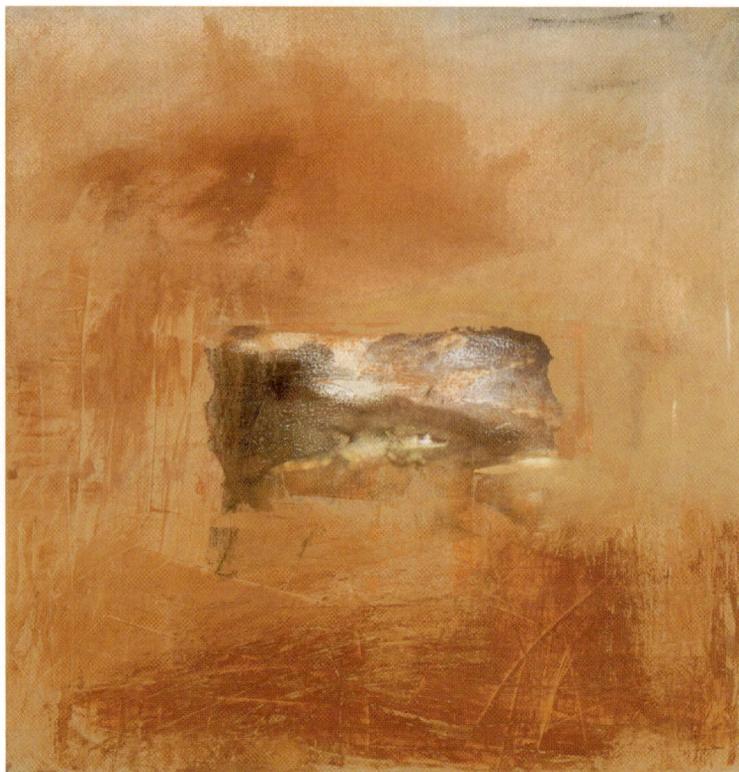

Plate 3. Margot McLean, *Orinoco* (1994). Mixed media on canvas, 30 × 30 inches.

Plate 4. Margot McLean, *Wyoming* (1990). Mixed media on paper, 8 × 10¾ inches.

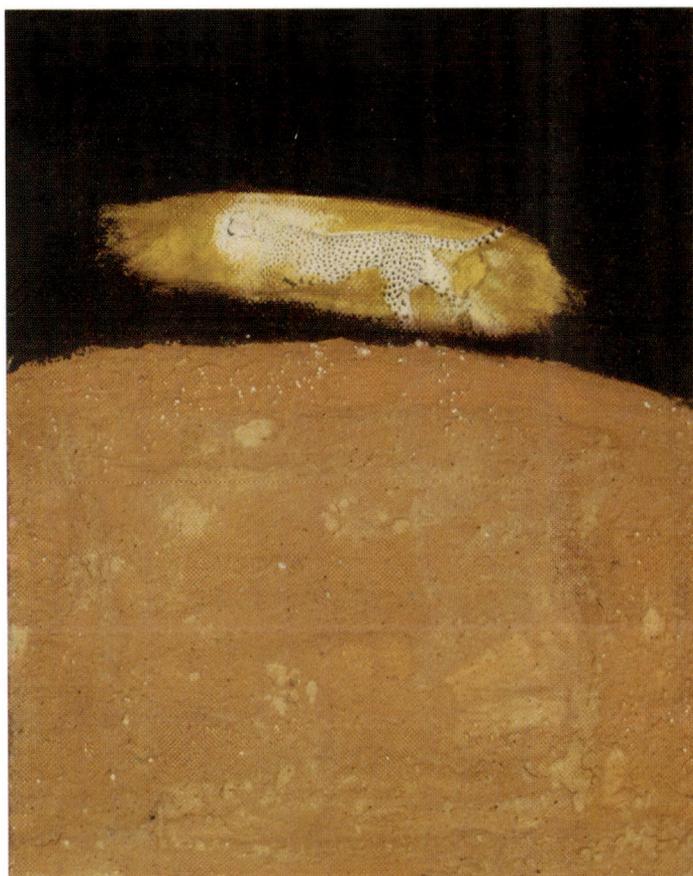

Plate 5. Margot McLean, *Muscles of Inspiration* (1989). Mixed media on board, 10 × 8 inches.

Plate 6. Margot McLean, *Pons Varolii* (1992). Mixed media on canvas, 36½ × 48 inches.

Plate 7.
Margot McLean,
Blackbirds
(2001). Mixed
media on canvas,
60 × 72 inches.

Plate 8. Sandy Gellis, *Cygnus A*
(1994). Concrete, bedrock, glass,
steel, phosphorescent paint;
2,000 square feet × 4 feet high.
A dimensional map with three
layers: bedrock, the earth's
surface, and the galaxy Cygnus A.
Project realized for Sedgwick
Branch Library, New York.

Plate 9. Sandy Gellis, *Viewing Mounds* (1988). Mounds coated with different amounts of powdered iron that forms a crust when wet, 100 × 40 × 4 feet. Located in Ancramdale, New York, on a hilltop overlooking the Catskill Mountains.

Plate 10. Michelle Stuart, *Sayreville Strata (Quartet)* (1976). Earth rubbed into muslin-mounted rag paper; each unit, 144 × 62 inches. Earth from site at Sayreville, New Jersey.

Plate 11. Michelle Stuart, *Codex: Canyon de Chelly, Arizona* (1980). Color photographs (by artist), earth from site, muslin-mounted rag paper placed on archival board, 25⅜ × 25⅜ inches. Collection of Honeywell, Inc.

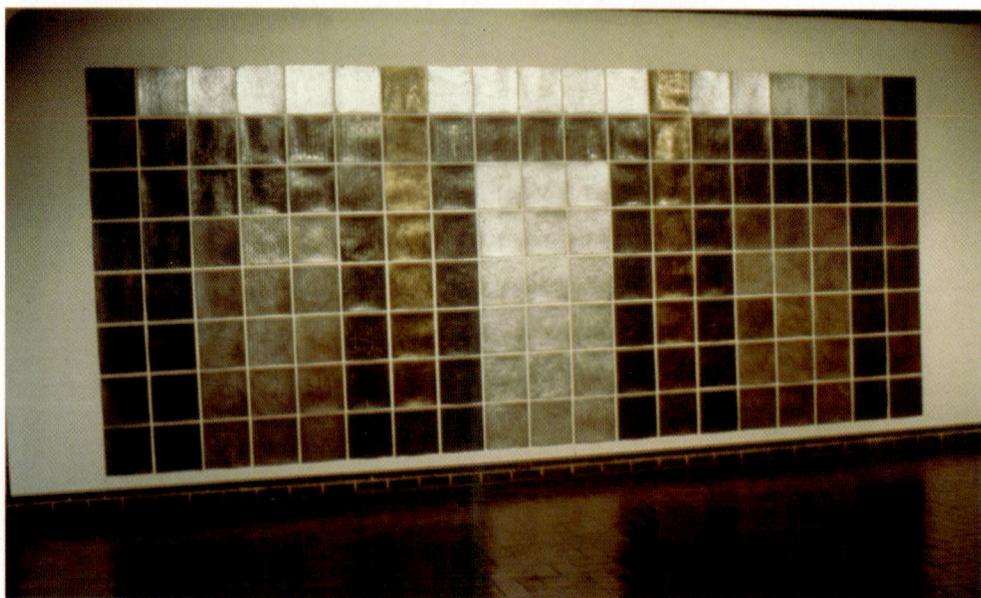

Plate 12. Michelle Stuart, Mariners Temple from *Sacred Precincts: From Dreamtime to the South China Sea . . . with the Addition of the Nantucket Excavation . . . the Mariners Temple and Burial Cache of the White Whale. For Herman Melville* (1984). Encaustic (beeswax) with pigments, aluminum powder, graphite on muslin-mounted rag paper, 91½ × 218 inches. Installation at Neuberger Museum, Purchase, New York.

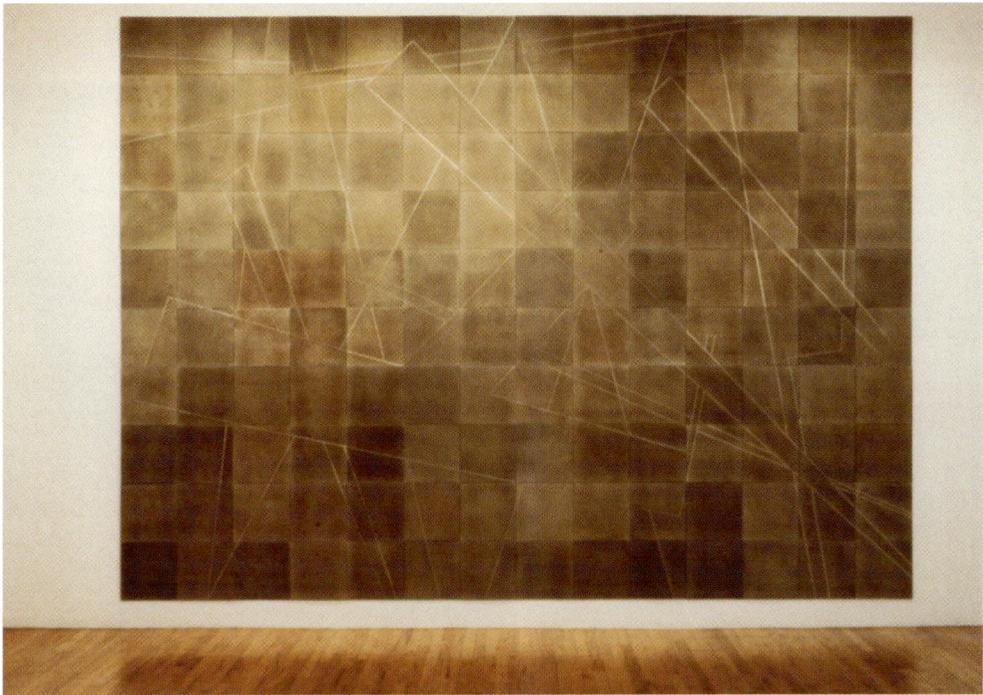

Plate 13. Michelle Stuart, *Nazca Lines Star Chart* (1981–82). Earth on muslin-backed rag paper, 120 × 168 inches. From Nazca Plateau, Peru. Collection of the Museum of Modern Art, New York.

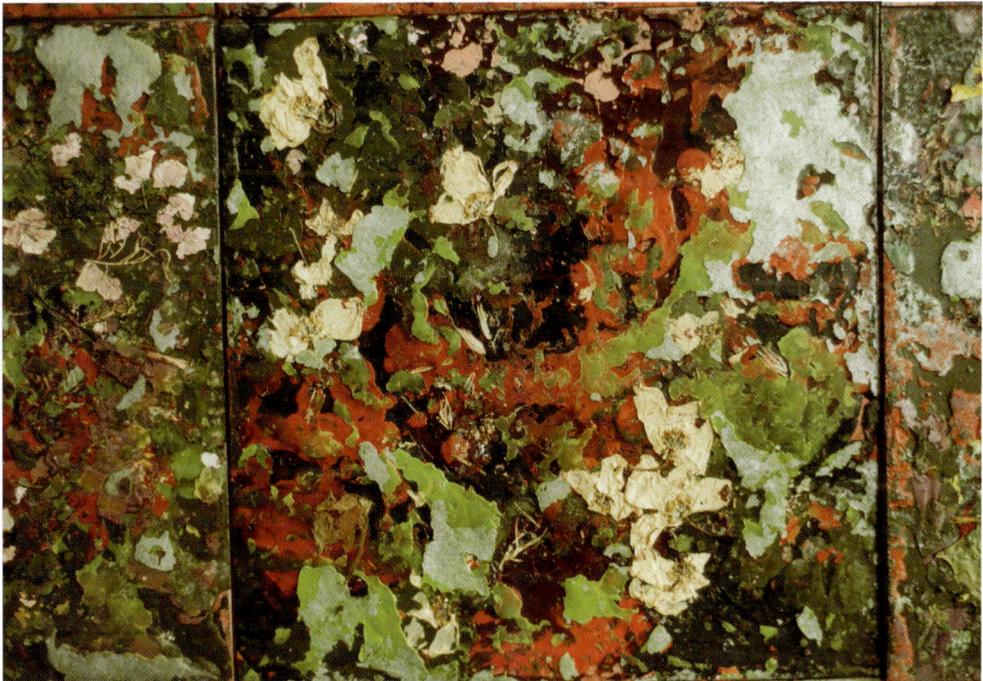

Plate 14. Michelle Stuart, *Woodland Garden Seeds the Eastern Wind* (detail) (1987). Earth, plants, flowers, and encaustic; overall work, 99 × 198 inches.

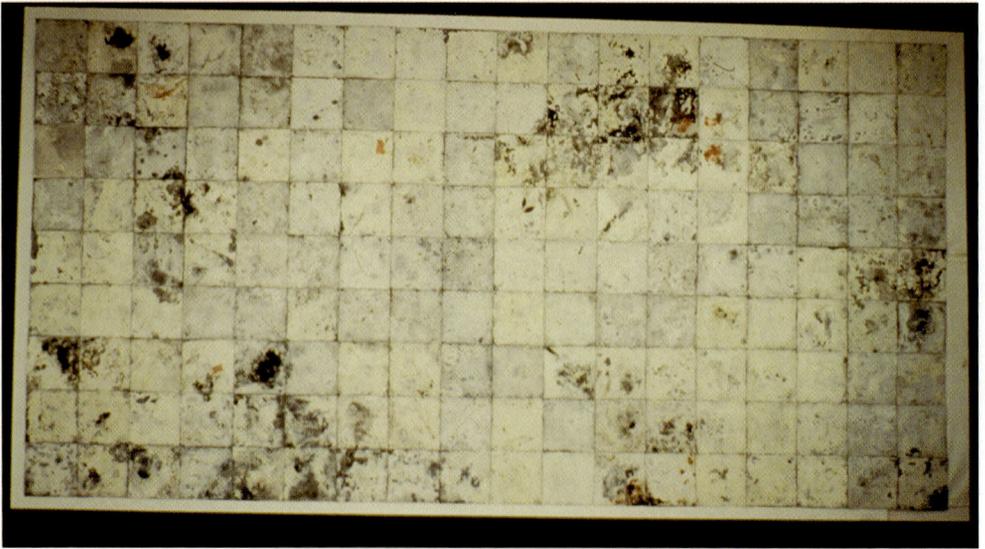

Plate 15. Michelle Stuart, *White . . . Moon Minister in the Marriage of Earth and Sea* (1985). Earth, stones, shells, plants, and encaustic, 99 × 198 inches.

Plate 16. Michelle Stuart, *Woodland Garden Seeds the Eastern Wind* (entire work) (1987). Earth, plants, flowers, and encaustic, 99 × 198 inches.

Plate 17. Eve Ingalls,
Sherds (1974).
Acrylic on canvas,
63 × 54 inches.

Plate 18. Eve Ingalls,
Folded Field (1987).
Ink and acrylic on
canvas, 85 × 84 inches.

Plate 19. Eve Ingalls, *As Light as Possible* (1995). Oil and acrylic on canvas, 62 × 204 inches.

Plate 20. Jasper Johns, *Map* (1961). Oil on canvas, 78 × 123⅛ inches. Collection of the Museum of Modern Art, New York.

Plate 21. Jasper Johns, *Map* (1963). Encaustic and collage on canvas, 60 × 93 inches.

Plate 22. Jasper Johns, *Corpse and Mirror* (1974). Oil, encaustic, and collage on canvas, 50 × 68½ inches.

Plate 23.
Richard Diebenkorn,
Ocean Park No. 31
(1970–72). Oil on canvas,
43⅓ × 49⅔ inches.

Plate 24.
Willem de Kooning,
Montauk Highway
(1958). Oil on canvas,
59 × 48 inches.

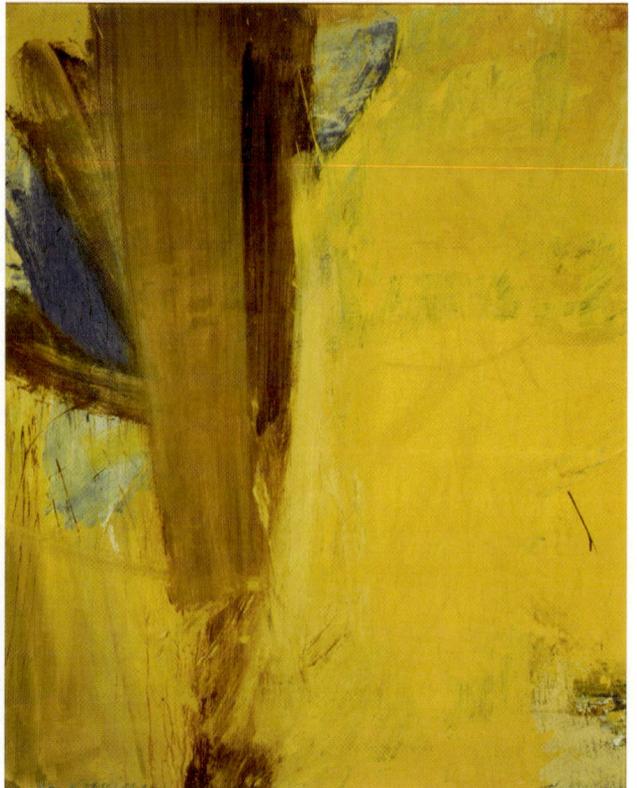

Plate 25.
Willem
de Kooning,
*Two Figures in
a Landscape*
(1967).
Oil on canvas,
70 × 80 inches.

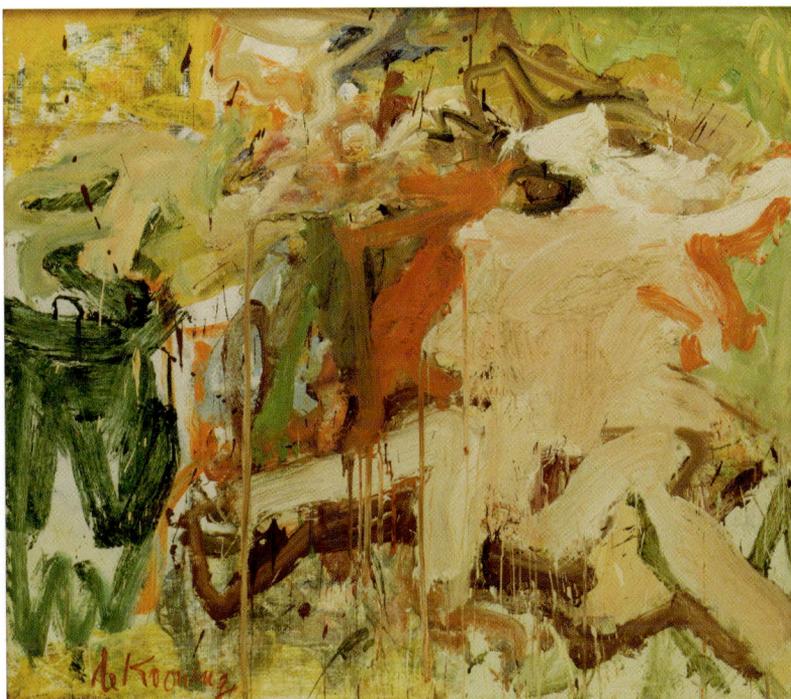

Plate 26.
Willem de Kooning,
Untitled III (1981).
Oil on canvas,
88 × 77$\frac{1}{16}$ inches.

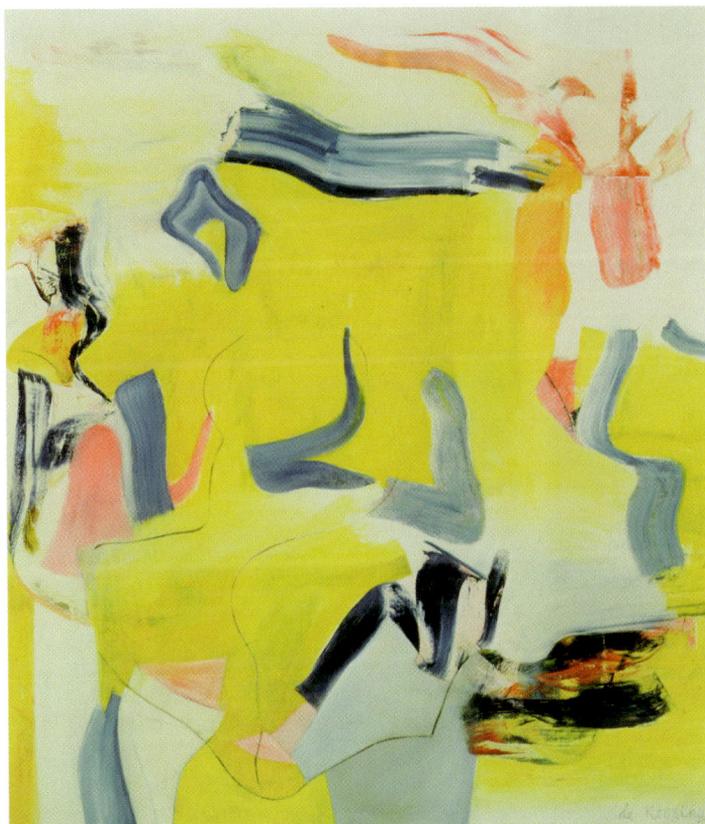

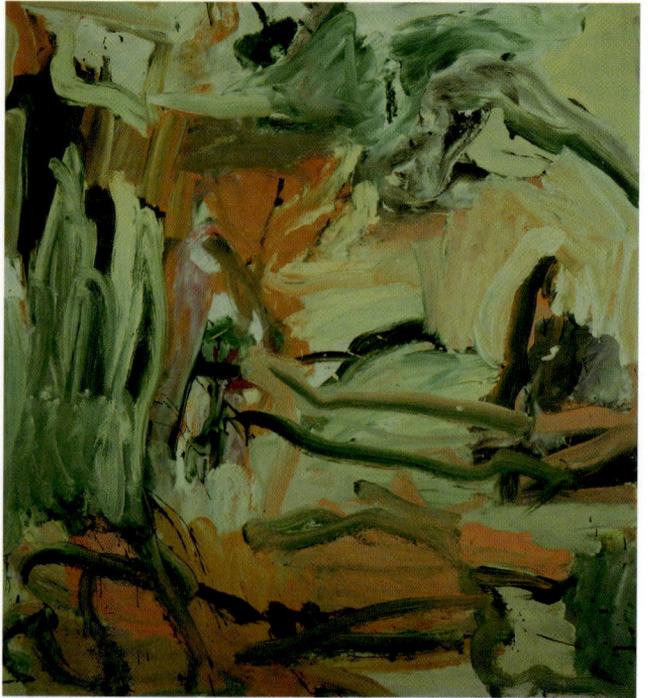

Plate 27.
Willem de Kooning,
Untitled X (1977).
Oil on canvas,
59 × 55 inches.

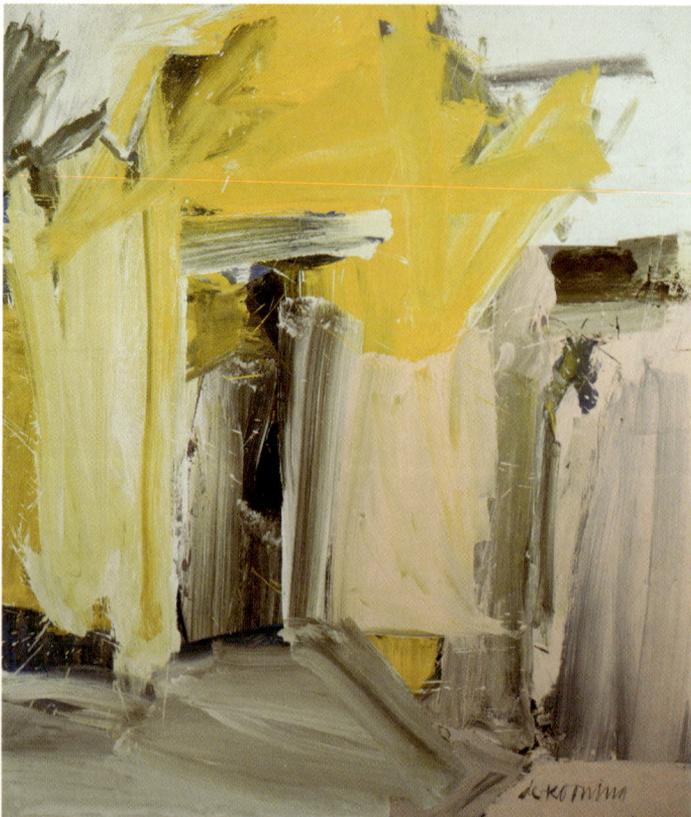

Plate 28.
Willem de Kooning,
Door to the River
(1960).
Oil on canvas,
80 × 70 inches.

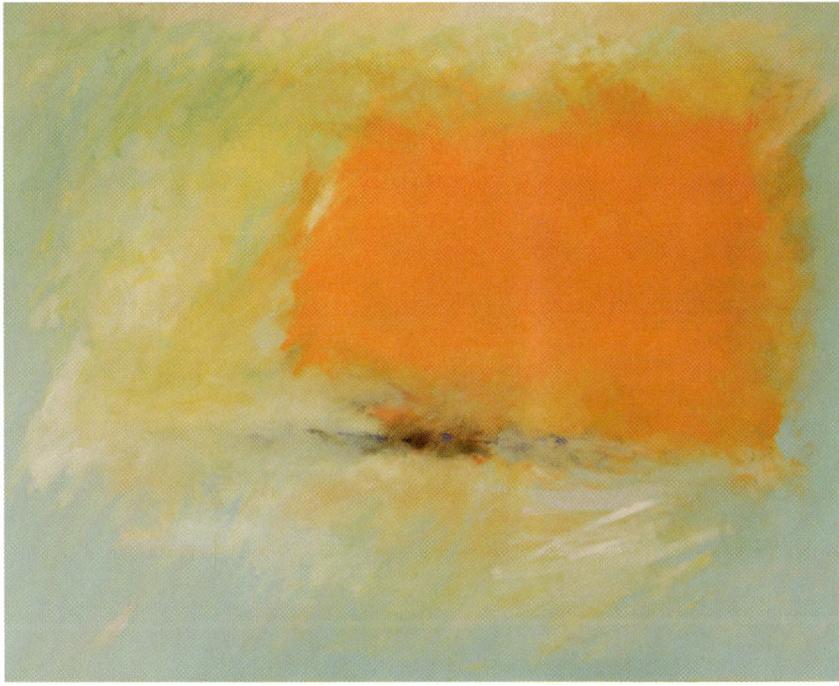

Plate 29. Dan Rice, *Land's End, N.E.* (1976–97). Oil on canvas, 56 × 70 inches.

Plate 30. Dan Rice, *Evening Marsh* (1988–97). Oil on canvas, 50 × 63 inches.

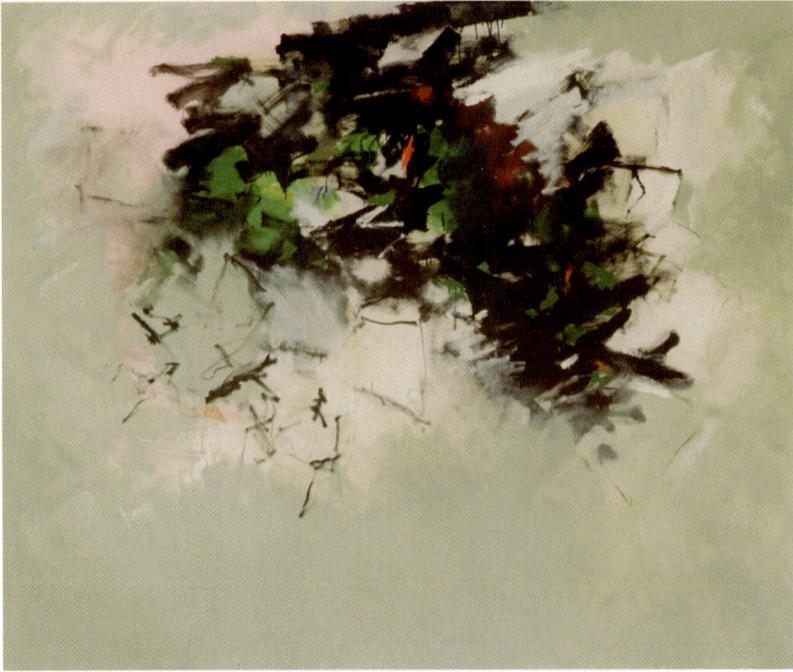

Plate 31.
Dan Rice,
Salt Marsh Woods, Sunset
(1998).
Oil on canvas,
58 × 70 inches.

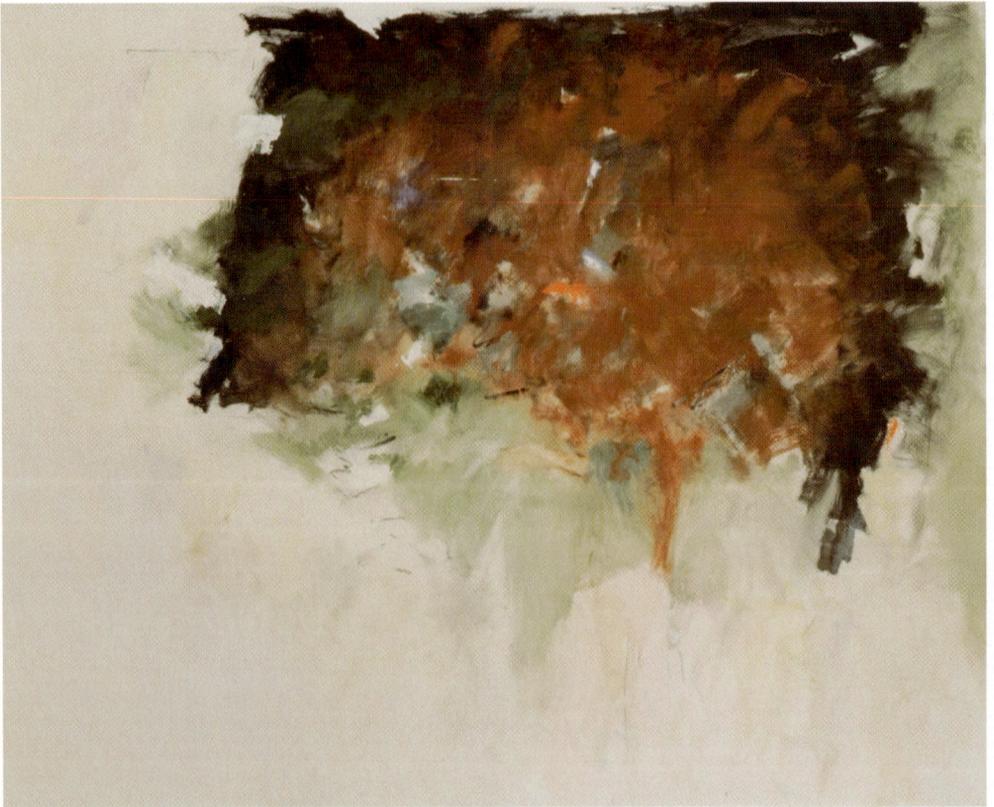

Plate 32. Dan Rice, *Woods to the North, Nightfall* (1997). Oil on canvas, 56 × 69 inches.

PART II

MAPPING THE LANDSCAPE IN PAINTINGS

Chapter 5

GETTING ORIENTED TO THE EARTH
EVE INGALLS BRINGING LINE AND PAINT TO BEAR

> I'm constantly constructing maps in my mind which I cast onto
> the land to orient myself.—*Eve Ingalls, "Nudging the Sublime,"*
> *interview with Sharon Olds*

Of the five artists to be considered in this second part, at least four are known for doing landscape painting in some distinctive form, but all *map landscapes* in some significant sense. Two of the five literally incorporate cartographic elements into their paintings (Johns, Ingalls), while the others map in decidedly noncartographic ways (de Kooning, Diebenkorn, Rice). Moreover, Johns and Ingalls are very differently cartographic: where Johns at once celebrates and mocks the standard map of America, deliberately blurring geographical detail and barely delineating state boundaries, Ingalls makes selected use of certain basic cartographic techniques in creating works that are as much maps as paintings, indeed, both at once. De Kooning, Diebenkorn, and Rice, in contrast, never provide what would be recognized as a map in any conventional sense, not even a parodic version of a map such as Johns offers. But they map the landscape in their own singular ways. De Kooning transmutes a given scene or place that he has only glimpsed into a complex composition, usually to the point of complete unrecognizability. (Who could recognize in any strictly pictorial sense the town of Asheville, North Carolina, in de Kooning's 1949 painting entitled *Asheville*? And yet, somehow, the town is *in the painting,* relocated there.) Rice, on the other hand, *simplifies* a particular scene, thanks to his dedicated search for its essence; the baroque contortions, the flamboyant twists and turns of de Kooning, here give way to a deeply serene sense of place. Serenity and simplicity are also evident in Diebenkorn's "Ocean Park" paintings, but these are realized in a quasi-geometric order and austere spirit that are foreign to de Kooning and Ingalls and Rice alike.[1]

Five painters, each of whom maps the land in an enlarged sense of the term, are here to be considered, even though (indeed, precisely because) each accomplishes such mapping in an instructively different way.

Remapping in Space and Time

Eve Ingalls is a landscape painter and sculptor currently based in Princeton, New Jersey. She attests that all her work "is about mapping—if mapping is primarily about humans orienting themselves in the natural world."[2] Her work is also about *remapping,* a term we first met in chapter 3: where the *re-* signifies not only *again* but also *otherwise.* Ingalls maps differently—differently from conventional mapping certainly, but differently as well from our ordinary expectations as viewers of artworks. She distinguishes between physical and conceptual mapping—roughly, environmental and personal mapping, respectively—but insists that both are at play at all times, in art as in everyday life. A painting for Ingalls is a two-dimensional surface on which the painter maps; it is a unique set of energies bounded only (and then not always) by the edges of the canvas or paper. Mapping occurs whenever the painter realizes a topic (i.e., "the thing you're making") in a work. For Ingalls, the point of painting is to map out the landscape in any of several ways—to map everything of concern there. (Everything, that is, except the painter herself, who is conspicuously absent from her later landscapes: the very converse of Cole's insistence on including himself as a diminutive but distinct figure in *The Oxbow.*)

The evolution of mapping in Ingalls's work is telling. Early paintings from the mid-1960s to the mid-1970s had for their theme "mapping the female body" (in her own phrase). Such body-mapping took several forms: straightforward paintings of women, paintings of Ingalls's own body, and female figures dramatically wrapped around globes. The globes signify solitary planets to which women cling in desperate isolation: each woman encircles her own private planet, each "wanders" (in keeping with the literal meaning of *planet*), enclosed in her own fragmentary experience. Even without the depiction of a globe, the female body is seen as twisted in space, as if emerging from a cosmic chrysalis (see Plate 17). It was only a short step from there to ensconce the female body fully in the landscape of the earth, as began to happen in drawings at the end of this same period: the planet became the planet Earth. The female body became an earth-body; and her rendering, an earth-map (see Figure 7.1, below).[3]

By the middle 1970s, Ingalls was creating a group of remarkably subtle works in which the primary theme is the disorientation wrought by depicting objects at the very limits of an outstretched body, extended as far as possible into space. Only the distended body links together the disparate objects, which are otherwise disconnected and displaced from their original settings, as when fragments of a past civilization become widely scattered. In addition to such scenes of spatial disruption, Ingalls also began to examine circumstances of radical temporal dislocation: her paintings began to allude expressly to archaeological excavations, which unearth things that stem from *different times*—disparate times that challenge the self-assured plenitude of the present. Plan views of digs seen from above were intercalated with images of layers of the earth peeled back and held by giant pins. Emerson remarks somewhere, she

has recalled, that "human beings cannot endure the geological chaos they encounter under the soil of their own gardens."[4] The nineteenth-century fascination with geology—already a decisive influence in the Hudson River School[5]—signifies for Ingalls the way in which vast and unsuspected spatial and temporal frames outside habitual human experience can perturb people at a very deep level. She likes to quote Ruskin: "Geologists' neat little hammers broke up our complacent civilized sense of time."[6] They did so not just by uncovering an archaic past but also by suggesting that there is no last layer on which we can count—that we could keep digging forever without finding a first fact, a single form of ancestor, the primeval stage of the earth, and so forth. The situation is vertiginous—and complex. The myth of simple origins is smashed by these geological hammers, anticipating Nietzsche's philosophical hammering at the same myth. Moreover, the rigors of digging in opaque earth demonstrate that it is sometimes difficult to distinguish between the soil and the object sought, with the result that the object may be destroyed by the digging itself. Likewise, the represented object in a painting is subject to continual dissolution in the acid test of human perception, itself deeply historical in character. Just as an archaeological object is dependent on the digging techniques by which it is unearthed, so the representational status of an object in a painting is a function of the ways we organize it in our perception—ways that are socially shaped and shared and thus always subject to change.

For Eve Ingalls, painting is about achieving orientation in the face of the kind of radical disorientation that archaeology and geology embody (in the case of time) and that disjunctive positionings of things in the visual environment exemplify (in the case of space). This is not an arcane proposal on Ingalls's part; it is meant only to reflect that "disruption is what life is about."[7] Just as we must reorient ourselves continually in the face of confusing everyday circumstances in space and time—"problematic situations," as John Dewey liked to call them—so we should expect from the painter a comparable effort to reestablish (or at least to suggest) equilibria that are disturbed within the painting itself, especially when taken in at first glance. And just insofar as this is the case, painting is inherently like mapping, given that "mapping is an orienting effort that creates an orienting and oriented place."[8] For Ingalls, then, the point of painting is to "explore the difficulties of orientation that occur within the territory defined by the edges of the canvas and to resolve them by means of the dynamism of what happens on the taut surface."[9] This concerted project of accomplishing orientation from within an initial disorientation was first pursued in a group of works executed in the late 1970s tellingly titled "Earth Watch."

Broken Coordinates

Shortly after completing "Earth Watch," the artist created another series of paintings, "Broken Coordinates." These were attempts to contest a forced choice between two traditional modes of pictorial organization. On the one hand, there is

world-making; this depends on a hierarchical structuring of space into a center, edges, and dynamic lines of forces that converge on the center; in such space, things are given differential locations with respect to the overall world thereby constituted.[10] On the other hand, there is *grid-making,* in which the enclosure of a world is replaced by parallel lines that proceed into infinite distance; there is no certain center of such space, and edges are nonexistent. Ingalls became fascinated with the disarming prospect of a space that is neither exclusively gridded nor simply world-like. Her aim (here close to Smithson's) was to disrupt the grid by "letting it fly around."[11] Its posited coordinates—for example, as determined by the x and y axes in Cartesian analytical geometry—were broken by being displaced and set at odd, nonperpendicular angles. Nor is any coherent world presented; nothing gathers together the strewn-about objects of such works into a centered whole: "Lines, mark systems, and random flecks probe the rough terrain of raw canvas and reweave its linear structure into fragmented structures of diagrams, artifacts, and earth formations."[12] An exemplary instance is the painting at the right, which has the same title as the series as a whole (see Figure 5.1).

Notice, to begin with, the sheer variety of forms in this work, so diverse at first blush as to defy any ready categorization as to object-type. One is reminded of Borges's description of a Chinese encyclopedia in which animals are classified as "(a) belonging to the Emperor, (b) embalmed, (c) tame, (d) sucking pigs, (e) sirens, (f) fabulous, (g) stray dogs," and so forth.[13] A first moment of confusion soon gives way, however, to the identification of several definitely recognizable items in Ingalls's painting: the half-delineated jar in the upper right-hand corner, a jug on its side in the lower left-hand corner. And one begins to glimpse sketches of archaeological sites, for example, the settlement at the middle left, which includes several buildings and (probably) a wall, as well as a small image (overlaid by crossed axes) of what appear to be boulders and stones just below the center of the canvas. Also present are fragments of cartographic mapping: a shadowy grid in the center, a faded map to the right and just above the center. Three quasi-organic shapes emerge at the lower right: earth-kidneys as it were. Some shapes are altogether unrecognizable: the complex and darkly outlined mass at the left and just above center (although a contrastingly realistic elevation view of a building having several windows is part of this same obscure mass). The overall effect is that of an almost bewildering diversity of detail bordering on mystery overall. No single theme is paramount, not even that of the archaeological digs that show through and to which the jar, jug, and partial maps seem somehow to belong. There is, however, a lurking sense of a massive earth-body buried in the scene—an echo of the immediately preceding works in which recognizable female bodies are discernible on the earth's surface.

Not only are there significant ambiguities as to object recognition, but there is also a disquieting alteration of scale at work in the painting. The jar and jug are seen close-up; the excavations are viewed from a considerable distance; the geometric elements have an indeterminate size befitting their eidetic nature. If this is to be

Figure 5.1. Eve Ingalls, *Broken Coordinates* (1978). Ink and graphite on raw canvas, 80 × 55 inches.

considered a map, it is a map that constantly changes the scale by which its contents are to be seen and measured. It is also a map that changes direction at many points, as is signified by the variously tilted axial lines; in addition, it is continually altered in its point of view (ranging from plan to elevation to axonometric perspective) as well as the comparative velocity of presentation (i.e., the implicit speed with which one is led to look at various parts of the work, e.g., rapidly for the three organic shapes, longer for the dense palimpsest of forms above the center and to the left). As Ingalls herself writes, "The once unified surface of the canvas is drawn into discontinuities of time, space, and scale."[14]

These clues lead us to ask: Is this not only a painting that maps but also a painting *about mapping*—mapping of several sorts? These would include the mapping (qua drawing) of particular objects (the jar and jug), the mapping of archaeological sites, the mapping of shadows, the mapping of body parts, the mapping of mapping techniques (i.e., the contour and hatch lines), even the mapping of a map itself. By the last-named possibility I refer to the faint cartographic fragment in the center of the work; it reads like a map even though it is not a map of any given place or territory: it is an ostensible map *of* something that is not in fact a map of anything in the actual geographic world.

The same ambiguous status holds for the "big map" that is the graphic work as a whole.[15] Perhaps we could say that this constitutes a *map for looking at maps,* for considering certain imaginative and historical possibilities of mapping. It would thus be a map to the second power: a map that represents and sustains other kinds of mapping. This is made possible by the manipulation of what Ingalls calls "memory surfaces": surfaces whose spatial and temporal complexity is such as to call for the orientation that maps provide.[16] Ingalls affirms, "I draw to orient myself on the earth's surface,"[17] and this sort of drawing is certainly a form of mapping. Such drawing-mapping constitutes a smooth space that defies striation even as it employs remnants of it. This is a space of "the smallest deviation," since visual episodes are elicited by the barest wisps of detail and adumbrated by lines that twist and turn and disappear without leaving a trace, including shadow lines that act as the projected images of forms that are not themselves represented (I refer to the shadowed shapes at the center left).[18]

This drawn map is neither cartography nor topography, since there is no single place or region that it represents, yet it is not simply, either, a map of a single fictitious territory (e.g., the Land of Oz). The small central map appears to be a map of a delimited imaginary region, and the buildings of the depicted dig may well be real, for all we know, but we cannot determine what truly obtains in either case: without further information (here strictly foreclosed: the work is complete as it stands), they must remain indeterminate in status. Much the same indeterminacy holds for the jar and jug, which look very much as if they had been sketched from two actual objects—except that, in a literally sur-real touch, contour maps are drawn on their outer surfaces. The very uncertainty of the ultimate provenance of

buildings and vessels alike is part of the perplexing character of the work, its sense of intrigue, and is integral to its disorienting effect.

Nevertheless, the work is not simply disorganized. It achieves orientation amid disorientation. The orientation is not supplied by the customary cartographic means, for example, regularity of distance and scale (as set out by a formal grid), much less by sameness of geographic layout, and still less by consistency of depictive means. Rather, it is furnished by the complicated coexistence of all that is here given form by the artist. Just as duration in Bergson's view encompasses qualitative multiplicity precisely because it *is* such multiplicity in its very becoming, so the smooth space of "Broken Coordinates" contains and presents a pictorial multiplicity just insofar as *it is itself such a multiplicity*: it gives itself to the viewer as nothing other than its own manifest heterogeneity of motif and method.[19] The artist not only allows decidedly incongruous items to be cast together in random assemblage—as a strictly surrealist approach might dictate—but also creates the very space of their togetherness, a continuity for their discontinuity.

How is this smooth and heterogeneous space constituted? It is constituted by a subtle concatenation of regions within the work: regions that, not unlike the regions in Plato's *Timaeus,* collect certain characteristic forms (e.g., shadows, organic bodies, earthen jars, bird's-eye views of digs, etc.) in their own places, yet without imposing any strict borders upon these porous regions. Thus the viewer's glance is encouraged to roam freely among the contents of the work in such a way as to realize whatever minimal order is required to see the work *as a work,* as a single but complex offering that embraces its many inconsistencies. The center may not hold (in fact, the exact center of the work is obscured beneath the oblique line coming in from the left), and the usual coordinates of orientation (i.e., rigorous verticals and horizontals) are certainly broken, but the work as a whole holds our fascinated attention, not just *despite* the effects of disorientation, but *through* them. Our basic need to become oriented triumphs in the very face of extreme perceptual disruption; the painting maps us out of our confusion. Such mapping out is in effect a remapping of what would otherwise be sheer disparity, with the result that a work such as *Broken Coordinates* can be said to seize orientation from the very jaws of disorientation. This is what Ingalls signals when she says strikingly, "I map and diagram the faulted landscape."[20]

In the Fold of Wilderness

By the mid-1980s Eve Ingalls had turned away from works done exclusively in ink and pencil so that she could achieve more complete and increasingly colorful renditions of nature. Typically, the scene depicted was a single place, whether viewed from afar or from close-up. No longer composed of a set of disjunctive items stitched together by a mapping of disconnected regions, these paintings are formally unified by a single motif throughout: one and the same landscape provides

the focus and theme. If there is any sense of initial disorientation, it is now given by the sheer detail of the scene, not by questions of identity or origin. This is evident in *Folded Field,* an exemplary work that forms part of a new series entitled "Nudging the Sublime" (see Plate 18).

This painting is not cartographic in any usual sense—no conventional mapping elements are here displayed, not even in fragments—and yet it maps the landscape it depicts. This is so at two levels. At a microlevel, it maps the weave of the canvas, its thin paint allowing the perpendicular threads of this weave to show through as a form of quasi-gridded space. At the level of representation, a smooth space is constituted that is at once chorographic and topographic. It is *chorographic* insofar as it sets forth a particular region of highly mountainous Idaho terrain, that of the River of No Return (*chōra* signifies "region" or "countryside" in ancient Greek), and it conveys to us its qualitative material essence. (It does so just as effectively as do John Constable's chorographies of East Anglia, one of the flattest parts of the Western world!) It is *topographic* inasmuch as it closely follows the layout of the land, delineating the contours and the flora of a particular place in the River of No Return region in Idaho. (*Topos* signifies a particular place.) Indeed, the topography of the land is rendered in exquisite detail, almost to the point of photorealism. Yet it is not reducible to the latter, since many of the brushstrokes (e.g., those in the upper left-hand corner) are readable *as brushstrokes,* in contrast with the finer modeling that depicts the trees throughout and the crevice just to the right of center. In such modeling, individual strokes are perceptible only upon very close inspection—an inspection that is discouraged by the considerable apparent distance of the landscape from the viewer's imputed position, located perilously high above the ground (as high as the front range of mountains). These strokes are, as it were, the small deviations, the steps by which the painting has been created and that are the visual equivalent of footsteps up the mountains.

The mountains themselves are tilted slightly forward, as if offering an open embrace to the perilously placed viewer—an embrace further reinforced by the way in which the main mountain range spreads downward and outward to the left and right, like two enormous outstretched arms. A place of reception is thereby created in the form of the generous, gentle arc that subtends the lower portion of the work, creating a central open field in which one can easily imagine oneself standing or moving (in contrast with the more treacherous slopes of the mountains). The apparent size of the trees on this lower field is invitingly human and is further reinforced by the shadow each makes, suggesting standing bodies caught in a bright sun. Although this is a work in which no human bodies are explicitly represented, for this very reason it invites our own bodily investment: "The surface tugs more now on the viewer's body," remarks Ingalls, "because there is no painted figure as intermediary."[21]

The title, *Folded Field,* refers to the capacious field that is coextensive with the canvas itself—in fact, two canvases that together form a closely compacted diptych.

The fold in the center that conjoins and separates the two parts is perceived as a not altogether continuous line that clearly bisects the open field below and the lower part of the mountains before disappearing into the dense rock of the cirque above (i.e., the scooped-out area formed by a former glacier). By saying "folded," moreover, Ingalls suggests that the two halves of the painting can be imagined as *folding over on each other*, not unlike a folding mirror. This is so even though the two sides are by no means identical in content or structure; they are not literal mirror images of each other, nor even incongruent counterparts. As if to underline this ultimate asymmetry of the two sides, the darkened crevice that depicts the cirque is located almost entirely in the upper right panel, echoed only by a faintly depicted but structurally comparable geological formation at the center of the left panel. Nevertheless, the two panels mimic one another in the manifest similarity of cool coloration and value variation, not to mention the basic character of the terrain and vegetation: these last clearly belong together in the same landscape, even if they are physically bifurcated by the two panels and are disparate in detail. Much of the power and allure of this painting reside in the intimate connection of the panels; indeed they are inseparable, even as they are distinctly divided.

A painting like *Broken Coordinates* proffers a brittle surface on which a species of writing that can be considered *quasi-cartographic* is set down. From this fragile surface, "nothing emerges totally."[22] The shadows and mappings of the complicated excavations keep the viewer guessing; no single object or stable set of objects comes forward, with the result that the viewer's glance lingers at the surface qua surface. In contrast, *Folded Field* is less surface-intensive and surface-bound; even if its surface "tugs" on the spectator's body, from its detailed infrastructure something at once coherent and massive emerges: entire mountains! Indeed, a painting such as this is about emergence as such: *emergence of the earth from the earth*: the genesis of the earth, its very becoming.

Where there is earth, body is never far away. In *Folded Field* body figures in two major ways. On the one hand, the mountains that emerge in this painting constitute a megabody, an earth-body. I have alluded to their proffered embrace—hence, to their open arms (*brace* derives from *bracchium*, "arm"). Ingalls herself analogizes the line dividing the two canvases to a vertical axis that suggests an upright posture for the work as a whole, thus a basis for the viewer's upright body to align with the work.[23] The flanking mountains can be seen not just as arms but also as legs, and the cirque/crevice as an enormous vagina. This concrete sense of earth-body is far more pronounced than the dimly limned phantom body of *Broken Coordinates*. On the other hand, there is a sense that my own body as viewer is not only situated at a considerable distance from the beckoning earth-body but is also capable of returning its embrace by reaching out and putting its virtual arms around this "basis body."[24] The earth's enormity paradoxically provides me with an opportunity to become its colossal partner in phantasy. The fragmented body of Ingalls's earlier work—its *corps morcelé*, as Lacan would put it[25]—gives way to the expansive body

of the outreaching aesthetic subject. Just as the earth's body is enfolded within its re-presentation in painting, so my own body as viewer of *Folded Field* is enclosed in turn within the work; as the work folds over upon my body, so my body folds over onto it.[26] The field thereby doubly enfolded belongs as much to the human body as to the earth.

Mapping is still at stake in the artwork that results, this time in each of the four basic ways I have distinguished in the prologue. *Folded Field* is a quasi-corporeal chorographic-cum-topographic map *of* a certain mountainous terrain in Idaho (where Ingalls spends summers painting), a map that can even be construed as a map *for* finding our way in that rugged space. Finding our way visually and, by implication, by foot as well: not to direct our hiking in this mountainscape but rather to facilitate feeling how it would be to move in such a scene. Most crucially, the painting maps being *with/in* this particular landscape; its inviting embrace brings us forcefully within its circumambience, dramatizing human thrownness in a wild world. And it maps *out* the painter's own experience in the vast Idaho wilderness, her own exposure in that undomesticated world, her committed (and sometimes dangerous) being-there. The painting remaps her experience so that our own experience as viewers who may never have been to this part of the earth rejoins hers in painted space—her actual experience concretizing our possible experience. A doubly implaced experience of wildscape has taken place in the fold of a work of art, indeed *as* this fold: as a "folded field."

Elemental Creation

Eve Ingalls's paintings of the next decade are ever deeper and more forceful ingressions into the natural world. The elegant, measured sublimity of a painting such as *Folded Field* gives way to a much more visceral sense of involvement with natural places. Even if the mountains of *Folded Field* are meant to fold over onto the viewer, they do so as self-contained entities; their emergence, awesome as it is, remains restrained: they are colossal but gentle presences. The embrace they extend comes with less than a complete engagement. Ingalls remarks that such a painting "take[s] things across a surface so as to release them,"[27] but the release is limited to what the viewer can take in with a single sweeping glance or confront with a single movement of the chest. For all that emerges from it, this is a painting of the appearing of nature, not of its hidden depths.

We can no longer say this of Ingalls's more recent paintings, which thrust the viewer bodily into the natural environment. If her earlier works *tell* us about various complex ways of being in the world—whether by undermining established coordinates or by edging toward a coherent natural sublime[28]—these new paintings *take* us bodily into nature, encouraging us to feel close to natural things and events: *Closer Than Here,* to cite a revealing title of another painting from this later period. No longer a matter of "measured fall" or "intricacies of the edge" (both

phrases serving as titles of paintings from the 1980s), these new works are neither measured nor intricate. They are bold experiments in involvement that reach out and wrap themselves around the viewer. If the flanking mountains of *Folded Field* suggest the experience of being embraced, they do so only from their vast distance and settled serenity. In the subsequent work, the viewer senses himself or herself to be actively *surrounded* by the place at stake in the painting—taken in by that place. The more closely the viewer's body is implicated in the painted scene, the more that scene becomes a particular place and no longer a remote vista or set of fragmentary views. Indeed, as the full body is drawn into the drama, the primacy of viewing itself comes into question. It becomes a matter of "looking with one's eyes but seeing with one's body."[29] This is tantamount to getting down on all fours, feeling the landscape from below, getting into the thick of it with the heft of one's earth-bound body.[30]

Other new directions include an extending and enriching of the palette, along with more dramatic effects of depth, modulation, and light. These go hand in hand with a diminution of the value of pictoriality per se in favor of a complex presentation of the elemental constituents of a place. The high pitch of the pictorial so splendidly rendered in *Folded Field* gives way to a deliberate deconstruction of coherence as such and thus a new fragmentation, not now of time or point of view (as in *Broken Coordinates*), but of the material elements out of which everything arises, including those "life pockets" in which flora and fauna flourish in oases of wilderness: "cocoons of intimate intensity."[31] The step taken here is strongly reminiscent of Pre-Socratic thought, and in fact Ingalls has entitled a painting of 1992 *Being in Plato's Timaeus,* a remarkable work composed of an intimate juxtaposition of three triangular canvases on which the ancient elements of air, fire, earth, and water are given lively copresence, creating a turbulent scene of genesis. Just as the elements cluster by a violent shaking motion into the four great regions of the emerging cosmos in Plato's parable, so Ingalls now gathers the same elements into regions of a complicated landscape seen alternately close-up and far away.[32]

Let us take a look at a representative painting of this later phase of Ingalls's oeuvre, *As Light as Possible* (see Plate 19). One of the first things one notices here is the radical difference in scale between the portion of the painting on the left, with its near view of marshland, and the dark red vista on the right, which is seen at a significantly greater distance. Between these two scenes (whose direct juxtaposition would not make visual sense) is a mysterious area of swirling forces that mediates not just between the flanking scenes on the horizontal plane but also between earth, water, and sky in a vertical dimension. This visual *tourbillon* is in the middle not only spatially but also by virtue of the very ambiguity of its identity: Is it a representation of land, as its central part suggests, being continuous at one point with the land on the left; or is it a matter of water, as the wavelike shapes within it seem to indicate? Is it a stretch of desert with upraised lamellae (as expressly occurs in another recent painting of Ingalls's, *Shadow and Shining*)? Or is it a question of air,

a small cyclone perhaps (note that the upper part resembles the cloud structures on the extreme right)? Any and all of these interpretations are plausible, given the fatefully open ambiguity of the region here presented. By bearing all such interpretations, this region shows itself to be a place of elemental interfusion, a swirling mass of all the elements (even fire is signaled in the flamelike reds of its lower part) gathering before their eventual dispersion into settled places and recognizable scenes of the very sort that are depicted to the far left and the far right.

Thus, for all its focus and particularity, *As Light as Possible* is a scene of cosmic genesis (as is also suggested by the presence of marshland, where various forms of life were first generated, and by the fetuslike area in the upper central part of the swirl). This is a painting about the becoming of the world—specifically, a place-world that is evolving out of an originary elemental con-fusion. "One is offered a world," Ingalls has said, "a world which alternates between being bounded and unbounded, between being mediated and immediate."[33]

A movement from disorientation to orientation is still operative here. But where in the paintings of the 1970s, the movement is from a kaleidoscopic disarray to a smooth space whose loosely assembled unity is supplied by the mere copositioning of discoordinated items on the same canvas, now it is from discrepancy of scale (between the two pictorially specific vistas) and unknown identity (with respect to the indefinite mass in the middle) to the creation of an increasingly coherent place-world. Moreover, if *Broken Coordinates* is largely about disruption in time, *As Light as Possible* concerns disruption in space. And if smooth space resolves the prior disruption, rough-edged *place* moderates the new disruption by suggesting that chaos as an unidentifiable place gives way to a fully created, explicitly identifiable place. Ingalls intimates as much in her remark that a painting like *As Light as Possible* immediately poses to the viewer these questions: "Where would I go? Where will I find shelter? Where am I going to be exposed? Is there a place for humans in wilderness? It's a matter of place."[34] (To these we should add Emerson's celebrated question at the opening of "Experience": "Where do we find ourselves?")[35] "Place," adds Ingalls, "is the whole thing but also all the parts of it; the painting brings various places together, yet is itself a place where you have to experience all the discrete places at once."[36] This goes to show that once again we are operating in accordance with a distinctly Timaean cosmo-logic: in the tale told by Plato, the four indeterminate elemental regions (the *chōrai*) give rise to determinate places *(topoi)*. So too in this painting particular places emerge from the central generative mass: the farther one moves from this spiral nebula of aboriginal creation, the more definite the identity and pictoriality of the scene.

Among created things are also *bodies,* and it is notable that very few physical bodies are depicted in this painterly cosmogony: only a few trees and various clumps of marsh grass. Conspicuously absent are any human bodies, including the body of the artist, which had been so prominent in her earliest works. This is a deliberate choice: the void of that primal lived body is the place of *our* experience as

viewers.[37] The painter withdraws as a seen presence at the very moment when she becomes the pivot of the painting that wraps around her and forcibly includes her, but this is possible only insofar as she (and the viewer by identification with her) is a displaced center of the work, outside it yet taking it in. The withdrawal is reflective of the artist's conviction that less and less of the natural environment accrues to our bodies as we become increasingly alienated from it and continue to destroy it—a downward spiral symbolizing our escape from nature, our evasion of it.[38] At the same time, this withdrawal can be taken as a sign of respect: the painter becomes a sheer witness, someone who does not leave a trace in the wilderness to which she is paying homage. From being dragged on all fours into the forest, she has withdrawn to a position of contemplation. But the contemplation remains active and committed: it is the concerned look of someone who cares deeply about the fate of the very wilderness from which she is led to draw back.

Pathways into Place-Worlds

Another of Ingalls's later works is entitled *Take Only Pictures*. In it, an idyllic view of a mountain stream—reminiscent of Asher B. Durand of the Hudson School in its painstaking realism and harmonious balance—is suddenly complicated at its far edges by brush strokes that signify the celerity of the human glance and the sense of being suddenly surrounded by trees on the banks as one looks downstream. Here the wraparound effect mentioned earlier is dramatized to an extreme, and it becomes unmistakably clear that it is the viewing body that is thereby encircled. The felt paradox is that the landscape wraps itself around a body that is not represented at all—that is present in its very absence. The blurry strokes at the edges, which are as numinous as the central mass in *As Light as Possible*, signify a proximity of the landscape so great as to render it invisible. As Ingalls says, "The landscape is so close to the body [i.e., at the edges of the painting] that you cannot look at it anymore, but you can feel it."[39] The extremity of vision is blindness—blind immersion in a wild world.

Thus does landscape, a paradigm of resplendent visibility when seen at the right remove (e.g., that of *Folded Field*), itself become invisible, not because it is too far removed to be seen, but precisely because it has become too near to be viewed: "closer than here." Erwin Straus says that "landscape is invisible, because the more we absorb it, the more we lose ourselves in it."[40] This is very much the sense of a painting like *As Light as Possible*, except that what becomes strictly invisible is the body of the artist and (via identification) that of the viewer, who are so profoundly enmeshed in the natural scene as to vanish from it as separate entities. In Straus's word, they are "sacrificed" in this scene.[41]

Sacrificed to what end? So that a world will be born. If our bodies carry less and less of nature (and care less and less about its fate), we have to ask, insists Ingalls, "What gestures would the body [have to] make to restore the world"?[42] Among

these gestures are those of the painter—or the poet or the philosopher. In the instance just above (Plate 19), the world that is born from a painting is a place-world, the very place of creation as well as its implaced product. This is a world that is indeed *as light as possible,* having only the weight of acrylic and oil on canvas, yet creating a single luminous whole. Light as it is—in both senses of this word—it is more of a world than we get in *Folded Field,* which gives us at most a region, and certainly more than we find in *Broken Coordinates,* which presents no world at all, only an acosmic dispersion.[43]

Such an unponderous but portentous world as we perceive in *As Light as Possible* is a mappable world. "Anything that is a world, or a journey, can be mapped."[44] *World,* however, does not here mean a centered space but a place-world. In a painting such as this, Ingalls is mapping the genesis of the place-world of nature. She is tracing its progress, showing its paths, indicating its ways. She does so by giving us two particular places that have been generated out of the elemental confusion that lies between them as their common origin. It is a matter of mapping the topogenesis of this natural place-world—indeed, remapping it in the wake of the *Timaeus.* The resulting map, like any truly topo-graphic map, must point out the ways by which places are discovered and made. These ways are laid before us in manifest vision: in this painting, mainly water ways, first on the left as we enter the marshland from below, then on the right as we reach the distant red mountains from the sea they encircle from afar. But way is also provided by the ambiguous mass in the middle, a mass that takes us from the baseline of cosmogonic creation to the heights of artistic creation: in both cases, a matter of creating a place-world.

A painter who maps place-worlds creates as well as follows "pathways." Where *routes* are designated as such—typically by lines construed as cartographic symbols—*pathways* are the spontaneous and suggestive ways by which a body moves into a certain part of the place-world: *a pathway puts us on the way to place.*[45] A viewer of Ingalls's later paintings follows pathways through their surfaces rather than gaining knowledge of established routes. Even those routes that are explicitly represented in Ingalls's early quasi-cartographic works are not there as items of knowledge. They disappear altogether in recent works—to be replaced by pathways that take the viewer into a given region (e.g., a group of Idaho mountains in *Folded Field*) or into particular places (as in *As Light as Possible*). Just as a cartographically constructed, or practically orienting, map must contain all known routes, not just those by which one may reach one's stated destination, but also those leading to other possible destinations—routes being the skeletal in-lines of every map *of* and map *for*—so a chorographic/topographic landscape painting ought to present, or at least suggest, the most relevant pathways: out-lines, which take the viewer *with/in* the landscape there set forth, drawing *out* his or her body therein. In this way, the viewer's body is drawn to enter the scene of painting as if it were a new territory; the older habitual routes known by this body are suspended in favor of learning new ways to enter new place-

worlds. As Stanley Cavell observes, "The 'routes of initiation' are never closed."[46] These routes are pathways to new places.

Even if it is true that disorientation calls for orientation—in painting as in life—one should not settle for more accurate or comprehensive knowledge or for becoming merely more efficiently or reliably directed. Beyond orientation as such, beyond its coordination and reassurance, is the struggle to get close to the land, to enter the earth, to bring one's own body down into intimate touch with the earth's body: a struggle we shall encounter again in the work of de Kooning and Rice. For her part, Ingalls emphasizes that the painter "has to fight like crazy" not to allow a too easy recognition of landscape to occur.[47] Orientation ought to lead not just to improved knowledge or to finding better literal routes in cartographic space but to discovering more open and nuanced pathways into unknown worlds: to pursue these pathways is to paint what one does *not* know. It is to follow out ways into the mysteries of genesis, apocalypse, or the sublime. All these are ultimate matters—as ultimate as matter itself. They are the true topics, the final places, of landscape painting as practiced persistently and resourcefully by a painter such as Eve Ingalls.

Chapter 6

MAPS AND FIELDS
JASPER JOHNS AND RICHARD DIEBENKORN ON ICONS
AND THE LAND

*He absorbed the aura of a place.—William Brice, speaking of
Richard Diebenkorn*

The Art of the Familiar

By the early 1950s, the art scene in New York had come to be dominated by abstract expressionism—most notably, by Jackson Pollock, Franz Kline, and Willem de Kooning. This most American of directions had grown out of the surrealist movement as it had been transplanted to New York during World War II and just after (Arshile Gorky being the crucial bridge figure). The lyricism and transcendentalism of abstract expressionism, along with its subjectivity and sheer romanticism, were well suited for landscape painting, as we shall see. In its very intensity, it failed to reflect the realities of the cold war except quite indirectly (e.g., in a certain tone of apocalypticism), and it was not concerned at all with the concrete daily life of Middle America. A number of younger painters, Larry Rivers, Robert Rauschenberg, Jasper Johns, and later on Andy Warhol, felt that painting should be more inclusive of the particularities of everyday life in America. Thus was born "pop art," construed as the art of what is popular, that is, common to the people rather than to a rarified retinue of artists and art critics. A return to ordinary objects did not mean a glorification of the ordinary, such as in the manner of Norman Rockwell (whose own brand of popular art reached a zenith in the 1950s, thanks to its unabashed portrayal of basic American virtues). But it did mean a rescue of the banal from a closeted and even prohibited position outside painting and its return as a primary subject matter of painting itself: the aim was not to effect "the transfiguration of the commonplace" (in the words of the title of a book by Arthur Danto, one of whose main inspirations had been Warhol's *Brillo Boxes*) but to capture the aesthetic possibilities inherent in the commonplace itself. Strikingly, the publication

of Ludwig Wittgenstein's *Philosophical Investigations*—a book that represented a reconsideration of the philosophical significance of the everyday in the guise of what Stanley Cavell calls "the quest of the ordinary"[1]—occurred in 1953, the same year in which Larry Rivers painted his version of *Washington Crossing the Delaware*, arguably the first major step in the resuscitation of the familiar: here in the form of an ironic repainting of an archetypal event of American history.[2]

It was but a short step from Rivers's inaugural work to Jasper Johns's famous flag series, the first member of which was painted in 1954–55 in response to a dream Johns had of painting just such an object. At that historical moment, the flag was an especially charged symbol, since it stood for the American way of life that was being threatened by Russian communism and particularly by the very real threat of nuclear holocaust. Johns chose to paint something imbued with pervasive everyday presence, something that was an integral part of contemporary culture and not invented by him, yet to do so in a way that emphasized its aesthetic properties rather than anything expressly cultural or political. The result was (as Robert Hughes remarks) that "his flags had a beautiful and troubling muteness. They were cooler than the culture wanted them to be, in the midst of the Cold War."[3] Not the larger cultural sense—the transcendental signified, as it were—but the *surface* of the painted flag was what counted the most for Johns: "The very finesse of the surface detracts from the flag's political meanings, makes it more autonomous as a painting."[4]

Displaying a proleptic mixture of motifs that would soon sort themselves into pop art and minimal art, Johns's paintings of this period share with Marcel Duchamp's earlier prophetic "ready-mades" a passion for *found* objects rather than *invented* ones.[5] But instead of simply exhibiting the material objects actually found—hence Duchamp's original term, *objets trouvés*—Johns's operative principle was to take something found in culture at large and to paint a representation of that object so as to display certain aspects not altogether evident in the physical exemplar itself (sometimes, too, he would paint this exemplar as such by applying a coat of paint to its physical surface). Thus he sought to paint something that was (in his own maxim) "so well known that it was not well seen."[6] He wanted, in short, to improve upon the seeing of something altogether familiar in the general culture by dint of painting many versions of it, each of which brings out different features of the same object. Beyond the American flag, there was also for Johns the bull's-eye target that belongs to the bar scene and to shooting practice in America, and then there was (it now seems inevitable) the map of America itself, with which Johns engaged himself assiduously in the early 1960s.

Painting (Out) the Map

The map of the United States—the most conventional such map imaginable, the kind one finds in the most ordinary Rand McNally atlas—is what fascinated Johns. Why this particular artifact? Perhaps because it is an icon of the land of public

icons, the representation of America as a single geographic region whose cities and states exude multifarious mass culture. Certainly Johns was not interested in the map as a cartographic representation, any more than he was concerned earlier with the American flag as a symbol of patriotism. His interest lay, rather, in what Smithson called a "mapscape."[7] That is to say, not in landscape as such—Johns is not a landscape painter in any usual sense of the term—but in the way that maps, which already allude to landscape as the implicit content of their represented sites, can themselves be transformed into the equivalent of a landscape painting. In this case, a landscape becomes a mapscape. But the term *mapscape* is still not specific enough to capture what distinguishes Johns's efforts from those of any mapmaker who wishes to embellish an ordinary map by adding topographic vignettes to what is otherwise abstract cartography. In order to capture what is distinctive about Johns's work, let us have a close look at his first major map painting (see Plate 20). At first sight, this looks like a deconstruction of a map, the dismantling of it as a pristine cartographical object. But it is more accurate to say that Johns has here *painted out the map*: painted it out not in the sense of converting a map into a painting (as if the map were somehow perfected by becoming a painting) or in the sense of reaching full articulation of expression (i.e., in accordance with the artist's subjective intentions).[8] Instead, this painting paints out, or paints over, details that would render the map useful to someone in need of conventional cartographic representation.

Granted, the present painted-out image *could,* in a pinch, be employed as a map: the names of virtually all states are set forth in varying degrees of visibility, and the state borders are for the most part retained and sometimes even reinforced by painted strokes. Still, despite its ironically blatant title, *Map*, it remains a rudimentary representation at best, that is, if *map* signifies either "map *of*" or "map *for*" in the meanings discussed earlier. What would have been a useful and representational work before the action of being painted out (supposing that there is a meaningful sense of "before" here) has been changed into a work of art. What now matters is not the accuracy of the representation—the relation to a given geographic reality—or the utility of the result but, instead, what happens at the painting's surface. As in the case of the flag series, our attention as viewers is riveted on what Johns has done in and on and with this surface: its full-throated coloration, the patterns formed by the blues and clusters of red, orange, and yellow, the dialectic of lines throughout, the curious gray blotch in the center (where Kansas is located), the quality and tenor and direction of the brushstrokes. These are not just "surface effects"; they constitute the surface itself as what D. W. Prall calls an "aesthetic surface."[9] What might otherwise be a matter of factual information or practical orientation has become something of sheer sensuous delight in the vividly painted surface of the canvas. That is to say, one kind of representation has become another but in such a way as to complicate what it means to be a map or a painting in the first place. If this is a *painting of a map,* the status of the *of* is very much in question.

If a map is already an abstraction—an abstraction from a lived or remembered experience of landscape—what happens to this abstraction when it is painted out in the manner of Johns? And if this painting out is itself a form of abstraction (i.e., an abstraction from the cartographic regularity of the original Rand McNally map), do we then have to do with an abstraction of an abstraction? Not exactly: the matter is not so purely transitive as this, given that the two senses of abstraction are different in character. Here we can ask with Robert Hughes: "Is a painting of an abstraction a representation?"[10] Hughes refers us to Magritte's piquant painting of a pipe that includes the arch inscription: "Ceci n'est pas une pipe." But this analysis does not take us very far: of course, the painting is not a pipe; it is a representation of a pipe. So, too, Johns's painting of a map is not a map but a representation of a map. The more difficult and pertinent question is: What kind of *representation* is here at stake? Johns's *Map* puts the very idea of representation, presumed to be coherent and even irrefrangible, into question.[11]

It is *not* a matter of "representation" if by this we mean what happens to an experience/perception/memory of an actual landscape as it becomes the subject matter of a given landscape painting: its literal re-presentation. Nor is it a matter of "representation" if this signifies strictly *pictorial* representation, that is, *re*presentation whose exclusive criterion is isomorphic resemblance to an original or exemplary landscape. The matter is more complex: by virtue of offering a *re-presentation of a map,* which is itself a form of representation, any cartographic pretense is suspended—that is to say, any strict sense of being a map *of.* The *of* is literally bracketed, yielding: (of). This is the modified *of* that arises when a map is painted rather than constructed or consulted. And when it is painted, it is indeed *represented*—that is, it has recognizable representational content—but such that the artist is free to tamper with the way he or she treats the map. In Johns's case, this way includes the various ways of painting out mentioned just above, in particular, the use of free and bold brushstrokes while, nevertheless, preserving enough of the basic structure of the cartographic map to be recognizable as a modification of that map. Thus, a painting such as Johns's *Map* of 1961 (and any other *Map* painting or graphic work of his during the next few years) can be defined as *a [painted out] representation of a map (of) the United States,* where the square brackets indicate the specific modality of representation and the parentheses point to the skewed or suspended state of the representational force of the map from which the painting takes its initial inspiration. The "mapscape"—or perhaps we could say better, *mapscene*—is what results from this rather sinuous representational relation: such a scape or scene is the painting taken as an augmentation of mapping, an aesthetically significant modification that ensues from Johns's peculiarly free-form, yet not entirely unconstrained, painting technique. Johns compresses and conceals this complexity within his deliberately laconic, flatly parodic titles: *Map, Flag, White Flag, Target,* and so forth.

The Painted Map as Theater

We can see much the same indirect representational relation at work in another major map painting completed two years later (see Plate 21). Here the artist's active painting out is even more pronounced; the map of the United States, regarded as an accurate cartographic representation, is now massively obliterated by the large bold strokes of gray and black and blue (California, for example, is literally "wiped off the map"). Dysfunctional as a map *of* (the United States) or a map *for* (various forms of practical use), the painting also approaches the limit of being a map (of); the tenuous tie signaled by the parenthetical *of* is itself in danger of nullification. Yet some significant form of reference survives this threat—a reference that is not merely geographic but also historical. The exuberance and comparative intactness of the 1961 *Map* (1961 being the first year of John Kennedy's presidency, a time of high hopes) here give way to a darker vision of America in 1963, the year of Kennedy's death (Texas, the state of the assassination, is painted out in a particularly aggressive and stormy manner). If this tragic event is indeed alluded to, then the referent at stake in the way the [painted out] map is a map (of) has historical as well as geographical meaning. As if to underline this complexity of reference, the painting is made from strips of paper pasted onto the canvas, and the medium is encaustic, that is, wax-based in such a way as to facilitate thick overpainting throughout.

The effect overall is to *theatricalize* the map. If the referent is indeed both spatial and temporal, then it is something that can be *staged*. A stage is a spatiotemporal scene, and what is presented there—a play or opera—is spatial and temporal by virtue of its episodic character. Indeed, one can readily imagine the 1963 *Map* (Plate 21), suitably enlarged, as a theater curtain for a play that would dramatize the major public events of that fateful year.[12] Even as it stands, as the painting it is, this *Map* has a quite theatrical aspect. In this spirit, it can be regarded as the staging of a map icon, making it into a scene of presentation (and not merely of literal re-presentation, much less of pictorial likeness). It is as if the various states of America have been released from their confederation, each state being given a role in the drama of the painted map as a whole. The ordinary map loses its banality by being staged in this fashion; no longer confined to the atlas, it has been liberated to realize its unsuspected artistic potential. The aesthetic surface of the painted-out map has become a scene of agitated motion, with individual states appearing as actors who improvise rather than follow a set script.

In another sense, too, this *Map* has the character of an animated docudrama. Just as in the theater each actor is perceived in concert with the others—the drama being taken in all at once—so in Johns's extraordinary map we are treated to a spectacle that is grasped *totum simul*. The scene is complex yet invites being taken in by a single glance. This follows from the manner of composition. John Cage reports having observed Johns creating one of the *Map* paintings:

He had found a printed map of the United States that represented only the boundaries between them. . . . Over this he had ruled a geometry [i.e., a grid], which he copied enlarged on a canvas. This done, freehand he copied the printed map, carefully preserving its proportions. Then with a change of tempo he began painting quickly, *all at once as it were*, here and there with the same brush, changing brushes and colors, and working *everywhere at the same time* rather than starting at one point, finishing it and going on to another. It seemed that he was going over the whole canvas accomplishing nothing, and, having done that, going over it again, and again incompletely. And so on and on. Every now and then using stencils he put in the name of a state or the abbreviation for it, but having done this represented in no sense an achievement, for as he continued working he often had to do again what he had already done. . . . I asked how many processes he was involved in. He concentrated to reply and speaking sincerely said: It is all one process.[13]

"All at once as it were," "everywhere at the same time": these adverbial phrases can be applied equally to Johns's canvas and to a theatrical production—and, for that matter, to an ordinary map, whose conterminous regions are also grasped in one sweeping look. What all three have in common is a continuous display or layout whose parts are either similar enough or sufficiently connected to be read together. Johns's painting out here appears in a different, less destructive light: as a way of ensuring the togetherness of the different states of America, forging a multiplicity in unity (*e pluribus unum*!), making it "all one process." Whether by brushstroke or by color, Johns's active painting technique as described by Cage has for its effect the aesthetic gathering of what would otherwise be self-contained cartographic fragments: one region merely juxtaposed with another. The coloration of maps that became an established practice in the West, starting in the eighteenth century with the circumspect tinting of engraved maps with watercolor, has much the same aim: to overcome the sheer separateness that strictly linear demarcation brings with it. In this light, Johns can be said to take the technique of cartographic coloration to an extreme that is reminiscent of the romantic rebellion against the cautious and confining neoclassical ideals of the eighteenth century.[14]

And if this is so, we return to the matter of landscape. A romantic sensibility finds landscape everywhere wherein Nature's "haunting presences" are to be felt: an early nineteenth-century romantic poem like Wordsworth's *The Prelude* can be considered a Theater of Nature.[15] In contrast, a Jasper Johns *Map* amounts to a Theater of the Everyday insofar as it makes use of standard maps (projected by a grid system onto the canvas), reconstituting them on the surface of the painting, indeed *as* this surface itself. But this placing of a map on the stage of art is such that the painted-out map becomes transformed into a special kind of landscape— once more, a "mapscape" or "mapscene." Recall that the "scene" of an ancient pro*scen*ium was the "background" of a dramatic production (and even earlier, the

tent or booth in which the actors dressed).[16] Thus the very first stage was itself a dramatic landscape, a stagescape with its own landscapelike features, horizon, sky, and the like.

A Johns *Map* is the painterly equivalent of such a stage. Here the background, the literal *skēnē*, is formed by the Atlantic and Pacific oceans on the right and left margins, respectively, and by the presence of Canada and Mexico on the top and bottom of the map. Given this scene-setting backdrop, the drama of the map is played out on the stage of the states themselves: a stage that unites the individual states into the United States, thanks to the apparently casual but visually shrewd brushwork that concatenates them "all at once as it were." The *as it were* in this phrase of Cage's can be construed as alluding cannily to the as-if character, the "illusory" nature of any dramatic production, its imaginative remove from literal reality. Just as a drama is at second remove from this reality—through its script first, then its enactment—so a Johns *Map* is also twice removed from the actual (geographical, historical, political) United States: first in the guise of the conventional map with which Johns begins, then as its projected and painted-out transform. (As Johns likes to describe this indefinitely iterable process: "Take an object / Do something to it /Do something else to it / " " " "."))[17]

The result is a distinctive kind of dramatic landscape, at once a map and a painting—and the two together in a format that, like any given landscape, has its own integrity, being readable as one coherent, albeit complex, work. The fact that such a mapped/painted landscape emerges only at two removes—and, correspondingly, contains two levels of representation—does not undermine our perception of this mapscape as a singular work of art, a work with its own credible internal dynamics, a work that catches our attention and keeps it. Without recourse to "invention," but building instead on the manifest structure of an ordinary map, Johns has created a unique kind of landscape in which painting and mapping play equally important and deeply intermixed roles, each drawing the other into dramatic action.[18]

Pursuing Paradox

As with other artists, Jasper Johns proceeds by paradox in his painting. The major paradox in the case of Johns is the sheer fact that he yokes painting and mapping together in one vivid complex work, playing one off against the other so that the intrinsic virtues of each are highlighted by ironic contrast with those of the other, for example, a mapmaker's concern with consistency and accuracy in contradistinction to a painter's nonchalance with regard to such ideals of verisimilitude. The isomorphic pretensions of a cartographic map—its claim to offer an unbiased and impersonal view of parts of the earth, a view endlessly reproduced in its printed versions—are set over against the free handwork of a painting that embodies aesthetic ideals of pleasingness or innovation or surprise. Where an official map such as that of the United States embodies centuries of conscientious surveying,

exploring, recording, geometrizing, and printing, Johns's painterly modulation of this map occurs spontaneously and freely within a matter of minutes. As Max Kozloff notes:

> With one movement of the wrist [Johns] can slide from Oklahoma through Kansas into Missouri. And with merely a few strokes, he obliterates most of California, Arizona, Utah, and all of Nevada. [Johns] is playing with the notion of measurement, in which the locked-in, diagrammatic "in scale" dimensions of map images are contrasted with the virtually gratuitous dimensions of painterly gestures, the two being mutually usurped.[19]

What makes this contrast all the more effective is that in the final painting the measured and the gratuitous, the mapped and the painted, the recognizable and the abstract, though stemming from wholly different histories and temporalities of production, coexist on the same picture plane: one is intercalated into the other so deftly and completely that the two together form one more or less coherent scene of perception. What is utterly disparate in time is reunited in space, thereby conjoining two otherwise divergent enterprises and intentionalities.[20] Johns puts this literally para-doxical situation in his characteristically succinct way: "One thing made of another. One thing used as another."[21]

From this primary paradox follow various combinations of extremes, some of which we have already encountered: theater with image, landscape with bare surface (the one bearing a background, the other exclusively emphasizing foreground), respect for geographic form with an investment in free-form shapes (combining further an indulgence in color with precise linearity), stress on sheer surface yet inclusion of signified content (a content both spatial and historical), laconic titles with florid painted masses, painting out (definite forms) with painting in (i.e., filling in the forms of certain American states with intense colors), lack of invention with innovation (i.e., taking over an existing design and creatively complicating it), merging the givens of popular culture with the contingencies of personal nuance, and so forth.[22] Beyond these avatars of the primary paradox are three other para-doxical matters that characterize Johns's work.

(i) *finding depth in the flat.* This is paradoxical only because of Johns's evident obsession with "flat, mundane imagery" and with "extending his repertoire of or-dinary flat imagery."[23] Virtually all of Johns's chosen subject matters in the first decade of his professional life as a painter are literally flat in their dimensions: not just maps and flags and targets but also numbers and letters. In each case, he finds an ingenious way in which to discover or render a peculiar depth *in the flatness itself.* For example, certain of his number paintings represent the digits 0 through 9 all together in *one* complex image in which one can read 0, 1, 2, 3, 4, 5, 6, 7, 8, and 9. These numbers are read *directly on top of one another,* thereby introducing a special number-depth that is no less effective for being phantasmatic. Similarly, a series of alphabetic letters is presented in such a way that each letter has its own

depth. In the case of American flag paintings, the field of stars provides depth to the stars as separate entities. The targets of the target paintings are often painted as on a neutral ground that provides depth for them. As for the map paintings, we have just seen that the United States is set forth as a stage seen against the background of the two oceans and of Canada and Mexico, all of which furnish depth for the fore-grounded nation. In this last case, moreover, any given portion of the painting has its own depth effects, shallow and tenuous as these may be. These effects are especially evident in the *Map* of 1963 (see Plate 21), in which considerable vicissitudes of value and hue act to suggest a continually varying depth of the picture plane, while yet another kind of depth is contributed by the presence of collage: a paper-thin depth, yet depth nonetheless. Everywhere one looks in this painting, there are new depths to behold, and this is true even though it is a painting of something (i.e., a map) that could not be more flat in physical fact.

(ii) *finding self-identity in the impersonal image.* It might be thought that Johns, in choosing quotidian images, would efface himself before or in them. Moreover, the publicly accessible status of a map of the United States might seem to eliminate anything personal from its representation. Far from it! Johns takes the familiar and public as frameworks within which to innovate technically *and* to discover his own identity as painter. To start from a preexisting design as he so often does is to allow more, not less, self-exploration. Much as Stravinsky claimed in *The Poetics of Music* that it is only within certain formal constraints that the artist can find the freedom to create something new, so Johns takes the ordinary image as an occasion for his most creative moments, moments that respond to the question posed by Michael Crichton: "In what way can a familiar, reproducible image become something that is to be looked at freshly?"[24] Speaking of his emblematic flag paintings, Johns says expressly, "It was something I could do that would be *mine*."[25] It is a matter of appropriating—literally "making one's own"—what belongs to everyone. Thus Johns asks: "How can a young artist believe that he has found himself in painting an image that nobody owns, that is not uniquely identified with anyone (except perhaps Betsy Ross), and that possesses a meaning, or an emotional content, which is obscure to say the least?"[26] It is this meaning or emotional content that the artist makes his own, on which he puts his unique signature. Hence our sense that Johns's flags and maps and numbers are somehow *his* flags, maps, and numbers. "A *Johns* flag," we say to ourselves when espying a reproduction of one of his flag paintings; so, too, we say, "a *Johns* map," even though neither flag nor map belongs to Johns in any legal or historical sense: belonging to everybody, they belong to nobody. Nevertheless, Jasper Johns has made a commonly consulted map of America *his own map,* not in the stark sense of literally possessing it, but as having painted it in a manner that is instantly recognizable as something *painted in his style* (that is, his characteristic style of the early 1960s). And as having painted it in such a way as to have found out something about himself as a painter: that he can paint, and paint well, in this very way, and in so doing find out what the map of

America means and feels to him: its initial indifference now becoming charged with a new significance for himself (and presumably for us as its appreciators).

(iii) *putting word with image*. We have seen Eve Ingalls infuse numbers into her early quasi-cartographic paintings—numbers that appear to be unrelated to the other contents of these works. Johns imbues many of his own early works not just with numbers (when these are present, they tend to be the unique subject matter) but also with letters and more especially with whole words. On one canvas the word *cup* is painted in, along with an arrow pointing to a painted cup hanging in pictorial space. In a painting of a fork and spoon dangling vertically on a wire, the words "Fork should be 7″ long" are written. Another painting has "Tennyson" written out in its bottom part. A lithograph of 1963–65 reprints a Frank O'Hara poem alongside Johns's hand prints and a vague face print. Still another has fragments of words as well as words upside down inscribed on its surface.[27] Many paintings of the years 1958–68 have words for basic colors painted into the presented image: *yellow, red,* and so forth. These last works are notable for the fact that the color words are often painted in the "wrong" color: for example, *gray* in red, *orange* in white, *blue* in yellow.[28] This seems to signify the arbitrariness of the sign, or so it is tempting to think.

Any such arbitrariness is considerably reduced in the map paintings, since in these the names of the states (and countries and oceans) are indeed appropriately affixed to the geographical entities depicted there, however sketchily. Nevertheless, place-names, however well established, are themselves ultimately arbitrary vis-à-vis the territories they designate ("Texas" has no natural resemblance to the state of that name). As Johns put it himself, "Time does not pass. Words pass. . . . Things slip away from the intentions [and words] that have located them. Abuses and unexpected uses are found."[29] He heightens the basic arbitrariness of the verbal sign by varying the stencil size and sometimes the designation itself from one work to another: "NORTH DAKOTA" in the 1961 painting becomes "N.D." in the 1963 version; "MO." in the latter was "MISSOURI" in the former; and so on. Conspicuously missing in all such paintings is the designation "UNITED STATES." This notable absence of a master signifier reflects the empty and open title *Map* for all the members of the series. It is as if the obviousness of the subject of the map as a whole *calls for no name,* just as the obviousness of the topic of these paintings calls for only the blandest designation. This means that the basic image—the United States in both cases—*speaks for itself,* requiring no explicit (de)nomination. Elsewhere, in all the particular parts of such paintings, images of states exist in equipoise with names of states, as if to say that each is an equally valid representation of the geographic region.[30] Image and word, those ancient rivals, here cohabit a peaceable kingdom.

What is the overall effect of all these paradoxes—and paradoxes propounded upon paradoxes? A sense of calm bemusement and wry detachment that radiates from these works, along with a puckish sense of humor, of parody, of play: "puns on intentions," as Johns puts it himself.[31] This comic distancing is evident in Johns's

claim that his paintings are meant to convey information[32]—surely an ironic remark, given that the information at stake is so minimal as hardly to count as informative. The states of the union, the American flag, ordinary numbers, the letters of the alphabet: these are all things that we *already know,* not things we learn in the form of new information about the world. No more than Ingalls's wilderness paintings of the mid-1980s are meant to give detailed information about a particular stretch of mountains (even if they contain much that is true about this stretch) is Johns's map series meant to provide special information about the United States: nothing in any case that is not already part of the most readily available map. Equally, these map paintings proffer no expressive outcry of the artist: even if he discovers himself in these elaborations of *res publicae,* he does not *express himself,* much less expose his private feelings; what he discovers is his style, his technique: "the way the image is made,"[33] *not* his inner thoughts, his own subjectivity.

Neither informative nor expressive, Johns's paintings are parodic or satiric expansions of items of popular culture; they are the *painting out* of these items in every sense of this richly ambiguous phrase that is so aptly descriptive of Johns's artistic project as a whole. Lacking the gravitas of the sublime toward which Eve Ingalls's work is always nudging, Jaspers Johns's paintings are desublimated renderings of items of American popular culture at midcentury, light-handed and quasi-literal representations of its most accessible icons. They dramatize the ordinariness of that culture even as they deflate it by their caustic detachment from it.

Moving Mapping to a Minimum

Jaspers Johns had this to say in a 1978 interview:

> My experience of life is that it's very fragmented. In one place, certain kinds
> of things occur, and in another place, a different kind of thing occurs. I would
> like my work to have some vivid indication of those differences. I guess, in
> painting, it would amount to different kinds of space being represented in it.[34]

This statement, which actively espouses the idea of painting as place work, can also be taken as a description of what happens in a *map,* wherein different kinds of space are represented so as to suggest that different sorts of things can happen in one place compared with another. Indeed, Johns's celebrated "Crosshatch" paintings of the 1970s and early 1980s are highly maplike: they borrow a technique commonly employed in mapmaking (i.e., hatch lines) and make this into the major motif (see Plate 22).[35] The left panel of this diptych could be a plan (i.e., bird's-eye) view of low hills as modeled and represented by the hatch lines; the right, "mirrored" panel might be another map of similar territory seen through fog—painted out, literally—with a particular destination (or perhaps the site of a burial?) marked by the large X in its upper part. The work is not representational, even if the appearance of possible representation is given by techniques similar to those used in actual

mapping techniques in the West. The parenthetical (of) in the relation of a putative map to what it represents here becomes so attenuated as to disappear; the last link to actual cartographic representation is severed. Reflecting its own title, *Corpse and Mirror* is like an abstraction abstractly representing an abstraction, or rather, it is an abstraction that *does not represent anything in particular*; yet it has the feel of being somehow a map of *something*: some *possible* landscape, itself abstract because wholly speculative and projected. Once again, Johns leads us to the edge of paradox: at the very moment when, thanks to the extreme nonobjectivism of the work, any resemblance to a map has reached its nadir.

Such minimal mapping by way of painting need not, however, be ironic or parodic or paradoxical. It can be done with a studied serenity that is the reverse side of the frantic. Such is the case with Richard Diebenkorn's "Ocean Park" paintings, most of which were executed during the very same years in which Johns painted his "Crosshatch" works (i.e., from the early 1970s to the early 1980s). No trace of comic or ironic relief is found in these lean and elegant works; instead, they exemplify dignity and high seriousness: they are "reflective, stately, intellectually rigorous."[36] Nor is there any concession to popular culture here (despite the playful series of painted cigar box lids Diebenkorn created in the late 1970s). Rather than drawing on banal icons of current culture in a spirit of bemusement or satire, Diebenkorn conveys to his viewer an assured sense of commitment to the rigors of visual abstraction. The result is quasi-cartographic painting that is at once demanding and sophisticated. Take for example, *Ocean Park No. 31* (see Plate 23). Most conspicuous at first glance are the frontality and severe geometry of this painting, in which everything seems to appear on the same utterly flat picture plane. It is as if the planiformity that is so often a virtue of mapping has been transferred to painting—here to the distinct advantage of the latter! Each distinct area, perceived as flat in itself, fits neatly together with every other area to form a single planar region that constitutes the canvas as a whole.[37] The picture plane is literally striated, though the striations are not equally well marked, some seeming to be drawn with a ruler and others improvised by hand—the latter apparently to remind us that this is, after all, a quite painterly organization of space. Closer inspection, however, reveals a tension between the clearly delineated, brownish, and earthlike area in the right half of the work and the several leaner shapes on the left. The truncated rectangle, on the right, which is almost cartographic in its suggestion of a field below, is here flanked by a complex region of different dimensions and identities that lie at the limit of cartographic representation, a limbo of heterogeneous flows that strikingly suggest the nomad space at stake in *A Thousand Plateaus*.[38] The contrast is not just that between the terrestrial and the aqueous, the browns and greens and yellows versus the blues—a contrast reinforced by the ambi-valent title "Ocean/ Park"—but, more generally, between striated and smooth space, here brought together in one continuous if complex canvas, not wholly unlike Ingalls's graphic commixture of both kinds of space in her *Broken Coordinates* (Figure 5.1).

I call such a work *quasi-cartographic* because of the exquisite balance that is struck between what could be construed as an aerial view of a quasi-rectilinear field below—a hawk's-eye view assumed by Diebenkorn on helicopter flights he took over the California landscape[39]—and a set of skewed and variant shapes whose perception does not suggest any such overview. Diebenkorn's inveterate tendency to revise his works allowed him to conjoin what might otherwise be antithetical in purely spatial terms.[40] Indeed, only by being continually reworked could his "Ocean Park" paintings succeed in bridging the gap between striated and smooth space, earth and water, park and ocean on the one hand and, on the other, the artist's ongoing struggle between an intense pleasure in improvisation and an "agonizing discipline" to achieve what he liked to call "rightness" in the work.[41] One critic has characterized this struggle in terms of a contrast between Diebenkorn's "maplike habit of construction" and his "infrequent, and somehow always arresting, introductions of aleatory drips and splatters on the [painting's] surface."[42]

Convergence in the Face of Divergence

The task of a painter such as Diebenkorn is to see again as together what has been severed in pictorial space—to make one world out of what would otherwise be a schizoid situation. This requires an effort at resynthesis, which Ingalls (especially in her early work) also had to face, as does any artist who introduces cartographic or quasi-cartographic elements into a painting. No such effort is demanded when painting is frankly chorographic or topographic—as in paintings from Ingalls's series "Nudging the Sublime" (e.g., Plate 18) or in works of the Hudson River School—or when its subject matter is a single central cultural icon, such as the map of America. In all these cases, the work is unified from the start and does not call for reunification. In contrast, Ingalls and Diebenkorn, especially in their quasi-cartographic works, must strive to bring together the smooth and the striated, the painterly and the linear, in one more or less coherent work.

But the two painters part ways at just this point. *Broken Coordinates* (Figure 5.1) is certainly a coherent work, but its various incongruities do not constitute a single coherent world: it remains irredeemably heterogeneous in its "holey space."[43] *Ocean Park No. 31* (Plate 23), in contrast, "creates its own self-contained chromatic universe, and each [element] functions within that universe in a structurally self-sufficient way."[44] This universe is best understood as what Mikel Dufrenne calls "the world of the work"—where *world* connotes a spatiotemporal whole that is both inwardly consistent and able to embrace a considerable diversity of content.[45] In Diebenkorn's case, the world of the work is *placialized*; if it is not *about* a particular place—not even about the Ocean Park area of Venice Beach, where Diebenkorn lived when he painted the series—it nevertheless *reflects* that place. This is what distinguishes Diebenkorn's work from that of Johns's "Crosshatch" paintings, which though quasi-cartographic in form do not reflect a given place,

much less represent that place concretely. As we have seen, Johns's later works are abstract to the second power, abstractly representing something that is itself abstract. As a result, it is difficult to impute a sense of world to these paintings; they are more decorative than worldlike, more pictorial than mundane.[46] But the world of a resynthesized work such as *Ocean Park No. 31*—and of virtually every member of the extensive "Ocean Park" series as a whole—is a place-world. Thus we are not surprised to hear of Diebenkorn's extreme sensitivity to his local environment. As a fellow painter has remarked:

> I don't know of any artist who was more responsive to his physical environment than Dick. If he moves down the block, it changes everything. He absorbed the aura of a place.[47]

The aura of a place is what transmutes its local details into a place-*world* of the sort that we experience in an "Ocean Park" painting. In Diebenkorn's work, the radiant world of a place is primarily captured by color. When the artist moved from Albuquerque to Urbana, it was mainly his palette that changed, as he testified himself: "In Urbana the color [change] kind of came forth. In Albuquerque [my color] was subdued, austere, black, gray and white. . . . [The Urbana color] is something that a very different kind of environment produced."[48] So too with the "Ocean Park" paintings: their "high-pitched chromatic lyricism"[49] is notable for a tendency to emphasize either yellows and yellow-golds (evoking the color of sun-bleached grass on California hills) or various blues and greens (suggestive of ocean and sky)—and often the two together, as in *Ocean Park No. 31*. Here, the elemental force, its sheer differential, is conveyed more directly by color than by line, which is why this work is ultimately more a painting than a map—if we are forced to choose—and why smooth space triumphs in the end over its striated counterpart.

Yet this particular painting (and virtually any other in the same series) is a painting that maps place despite its cool abstraction. The world of the work reflects the place-world of the region. The painting is a map by its very indirection. Not by dictating directions but by *showing* them—that is, by adumbrating and embodying them—it helps the viewer to find directions out in the landscape it reinstates. Diebenkorn underlines the inherent placiality of his work by bestowing on each major series of his paintings a single place-name that designates the geographical place in which he created the series: "Albuquerque," "Urbana," "Berkeley," "Ocean Park." It is all the more significant that the title of a given work gives the name of the place first of all, followed by the number it occupies in a series, as if to suggest that the place is more basic than the work regarded as a discrete entity: *Berkeley, No. 3, Albuquerque No. 5, Ocean Park No. 43*. But more than naming or numbering is at stake here. A place-world is set forth by the indirection of abstraction and reflection—a world that, if not mapped in its detailed infrastructure, is nevertheless given maplike representation.[50]

By the early 1980s the work of painters such as Johns and Diebenkorn had moved

to a level of nonfigurativeness that was comparable to that of the abstract expressionism regnant twenty-five years earlier. The elimination of familiar icons and images on the part of Johns, and of any trace of explicit topography on the part of Diebenkorn, brought both painters remarkably close to a position of high abstractionism. (This is especially ironic in the case of Johns, whose self-professed expressiveness in his later abstract works takes him still closer to painters whom his own early work, more effectively than that of any other artist, served to repudiate.)[51]

Since the later paintings of Diebenkorn and Johns alike invite interpretation as a form of mapping, however attenuated such mapping may seem to be, their unexpected affinity with abstract expressionism suggests that we may find within this movement mapping tendencies that are not usually detected or even suspected. These tendencies will be very different from anything we have witnessed in the early works of Ingalls or Johns—works that make explicit use of conventional maps, however fragmentary their use may be—or even in the later paintings of these two artists as well as Diebenkorn: paintings that, despite their manifest differences from one another, continue to map in subtle and significant ways.

Chapter 7

ABSORPTIVE VERSUS CARTOGRAPHIC MAPPING
WILLEM DE KOONING ON BODIES MOVING
IN THE LANDSCAPE

> Whatever I see becomes my shapes and my condition.—*Willem de Kooning (cited by Diane Waldman,* Willem de Kooning*)*

View versus Scene

Willem de Kooning maps in his paintings without ever passing through a phase in which mapping as such is a self-evident presence. There is no early phase of his work in which fragments of maps, or bare allusions to maps, can be found; nor are there any chorographic or topographic sequelae.[1] Instead of looking for such fragments or allusions or sequelae, we need to consider de Kooning's painting as containing its own mode of mapping: in short, as a form of mapping that does not present itself as mapping in any obvious sense. Hence the new paradox to be explored: painting as nonmaplike mapping. To help resolve this paradox, we must begin by making a basic distinction between *view* and *scene*.

In conventional mapping, the operative cartographic unit is the view. This is so whether a given map is constructed in accordance with a formally determined "plan" view (i.e., from above), or an "elevation" view (from the side), or an "axonometric" view (obliquely). In many topographic maps, the views are simply those assumed by the imputed observer, who is sometimes located on the earth looking at a particular landscape but who more often floats freely above the earth. "The view from nowhere"—that is, the maximally comprehensive perception of the earth as a whole—is still a view. The position of the observer is intrinsic to the determination of a given view: *no view without a viewpoint*. Thanks to the viewpoint, every view is directed and focal and thus yields a more or less determinate perception. The presumption is that the viewer is stationed somewhere in particular and looks out from his or her position along a determinate "line of sight" toward what is viewed. Given this basic setup, theories of monolinear perspective become tempting to espouse as

explanatory of such a thing as recession in depth. Many maps, especially those with pretensions to cartographic accuracy, presume such perspective and its accompanying theoretical justification.[2] So do numerous paintings: witness *The Oxbow* of Thomas Cole and countless other works in the wake of Renaissance painting. But this is not necessarily the case: the point of view in a given painting can be multiple, deeply diffuse, or merely implied. So too the view itself need not be focused and unidirectional; it may not involve anything like a line of sight directed at a definite object. (Johns's target paintings can be seen as a sarcastic comment on the very idea of aiming one's attention at something altogether determinate.)

If view belongs to maps and paintings alike, scene pertains more exclusively to painting; it is where the action takes place, the central drama of a painting (*drama* derives from the Greek *dran,* "to do, act, or perform"). In this respect, it is the equivalent of an *episode* in recollective memory. Both scenes and episodes have the character of coming forward to meet us; they literally *stand out* (*epi-* signifies being *upon* something, as in "on the road": the literal etymological meaning of *episode*). As Ian Hacking remarks apropos of memory, "I suggest that our common conception of remembering, as encoded in grammar, is remembering of scenes, a remembering that is presented, often, by narrating but is nevertheless *a memory of scenes and episodes.*"[3] This analogy between memory and painting is not a merely contingent one, especially not in de Kooning's case. For this painter often regarded his later paintings, particularly those that can be considered landscapes, as stemming from intense experiences that he suddenly remembered: flashback memories as it were. This is not surprising if it is indeed true that "the flashback is no more than an unusually jolting scene."[4] The jolt comes from the rapid and unanticipated recall of a given scene, rendered all the more surprising and suggestive for not having been the object of a mnemonic search. In the instance of de Kooning, scenes merely glimpsed returned as flashback images in his paintings by means of spontaneous retrieval; what was seemingly meaningless as an actual event became intensely meaningful as a remembered episode and painted scene—an episode that was the very core of the scene in question. Freud would call this an instance of *Nachträglichkeit,* "deferred action" that yields a meaning or insight not accessible upon first encounter.[5]

Unlike Johns's *Map* paintings or his later "Crosshatch" works—and just as unlike Diebenkorn's "Ocean Park" series—de Kooning's paintings, early and late, provide scenes of action, places of dramatic presentation. A scene, whether remembered or painted or painted-as-remembered, is a place of aesthetic action—and of the viewer's reaction. To this extent, a de Kooning painting is as theatrical as a Johns's painting. Rather than the Theater of the Everyday, however, we witness in de Kooning's work a Theater of the Extraordinary.[6] The extraordinary is evident at the ground level of the *experience* that his paintings reflect and inspire: often, an ecstatic experience replete with lyricism, for example, in a painting such as *Ruth's Zowie* (1957), in which explosive forces are released through very broad power-

ful brush strokes as well as by sharply etched whiplash lines that act as poignant vectors. The effect is that of staging a sudden detonation from within central dark masses. But the extraordinary is also felt in the *object* of this experience, that is, in the character of the work itself or, more exactly, in its sublimity. The sublime is here felt both as "mathematical," that is, as immeasurably great, and as "dynamic," that is, as overpowering in its bursting-forth. Either way, the sublime is not merely the fantastic or the ethereal. There is always something concretely engaged, thrown, *down to earth* about a de Kooning painting, which locates the extraordinary *in* the ordinary, the sublime *in* the mundane, the sapphire in the mud. One factor in this insistent *im*manence of his work is its rooting in flashback memories. Another potent factor is the mapping accomplished by this exhilarating work. What kind of mapping is this?

Woman in/as Landscape

Before being able to answer this question, we must step back a moment and consider a crucial sequence of events in the artist's life in the years 1961–63, the very same years during which Johns created his *Map* paintings. Distraught with the intense New York art scene that had lionized him, de Kooning decided to move to Springs (East Hampton), Long Island. Earlier drives to East Hampton from the city had been inspirational for his art; it was while he was literally on the road that many of the glimpsing incidents alluded to above occurred. Speeding along the Long Island Expressway, de Kooning glanced out the window at the rapidly passing scenery; later, while painting a new work, images gleaned from these bare glances informed the subject matter and structure of the emergent work. In later years, de Kooning, who did not drive himself, would ask friends to drive him around in the vicinity of Springs; during the ride, he would continue this practice of being (in his own words) a "slipping glimpster."[7] At the end of such a ride, he would briefly review, in no particular order, what had been seen. He once said revealingly to his driver, "I was relieved that I did not get a full view of anything."[8]

One of the several works that came out of his early rides in the country is the richly colored *Palisade*, painted in 1957; another is *Montauk Highway* of the next year (see Plate 24). This astonishing work captures vividly the sense of having glimpsed a landscape on a very sunny day, as if to embody Mallarmé's famous line: "le vierge, le vivace, le bel aujourd'hui." Beyond the brilliant colors, barely modulated and full-throated so as to maximize their impact, there is a remarkable lability of scale in this work. It can be seen as landscape viewed from afar (say, a great canyon or river looked at from above in the manner of the "Ocean Park" paintings), as a female body (looking straight into the groin, with the suggestion of a male organ being thrust into a vagina), as bleached underbrush and grass in late summer, or even as afterimages produced after exposure to a dazzling sun. Here is an exemplary instance of the plasticity of viewing to which I alluded earlier, though

it is rarely realized in such dramatic extremity. *Montauk Highway* is a painting literally *on the way* to de Kooning's new residence; it is an episode of his journey to the place where he will paint the epochal landscapes of the 1960s and 1970s.

De Kooning moved to Springs, says Diane Waldman, "to be near his friends, and also because he liked the light, the underbrush, and the water, as well as the flatness of the potato fields in the area. While it did not occur to him [at first] that the landscape is reminiscent of Holland, he later acknowledged the similarity."[9] Notice the elemental character of the various things that attracted him to Long Island: light, vegetation (the underbrush), water, earth (the potato fields). This constitutes a virtual litany of the ancient elements, if we allow that light stands in for air and fire. I take the great mass of high-keyed yellow in *Montauk Highway* to be equivalent to the combination of air and fire that is found, for example, in the Greek conception of *aithēr,* the purest form of *aer* and fiery by nature. The small patches of deep blue give glimpses of something like sky, and the dark brown hints at earth.[10] Other, later paintings will be even more insistently elemental (see *Untitled X,* 1977, Plate 27).

Montauk Highway was preceded by a series of paintings that were at once figurative and landscapelike. De Kooning's investment in the human figure, especially that of women, goes back to his fledgling work in the 1930s. Set aside in favor of the abstract landscapes that were his hallmark in the late 1940s—for example, *Asheville* and *Attic* (both 1949)—women returned with a vengeance in his celebrated, ferocious *Woman I* (1950–52) and in five others of this same series, along with a large set of drawings of women that continued into the 1960s. Of particular interest to us are the works in which de Kooning combined his passionate interest in painting women with his equally passionate interest in painting landscape: a double passion he shared with Diebenkorn.[11] These range from *Woman as Landscape* (1955)—in which a colossal woman's body is almost coextensive with the landscape she dominates and defines, for example, by the fact that her shoulders are not only aligned with the horizon, they *are* the horizon—to *Two Figures in a Landscape* (1967), which displays two abstract but quite fleshy bodies situated in the midst of what appears to be a field of scrubby vegetation (see Plate 25). The two figures—or perhaps one and a half!—are so deeply immersed in the land as to be part of its very topsoil. They form the earth's endoskeleton, as it were. The meltdown of their flesh is such that they have become part of the earth's elementality, like stretches of sand in the land: flesh of its flesh. The bodies are as much glimpsed as the landscape in *Montauk Highway*: de Kooning's roving eye moves rapidly amid these bodies-in-place-on-earth, sliding over their sensuous surfaces as his glance slid over the edges of the land seen from a racing car. As Waldman remarks, the female figures in such a scene are

> integrated into their surroundings. . . . they merge with the landscape.
> Severe frontality, the direct confrontation of figures and spectator [i.e., as

in "Woman I–VI"], gives way as the women recline, complacent and at ease in the countryside. The mood is pastoral. Ultimately the figures become so distorted that it is virtually impossible to disentangle torsos and limbs from the background. . . . [Here] de Kooning makes Woman a landscape.[12]

Indeed, de Kooning entitled one of the most important paintings of this period *Pastorale*, the last painting he finished in his New York studio before moving permanently to Springs in 1963. The pastoral motif remains evident in a number of later paintings such as *Untitled III* (see Plate 26). Bodily presence here becomes virtually indistinguishable from the overall landscape. The high yellow mass in the center of the canvas *could* be a standing female body with blue legs moving off the lower edge of the canvas, with a linear crotch between them, and a possible left arm (also in blue) above and to the right. But we are not encouraged, much less impelled, to read the image this literally; truer to the spirit of the work is the vaguely hairlike horizontal blue band above this putative body, behind which a pale red suggests rosy-fingered dawn. In paintings such as *Untitled III* and *Two Figures in a Landscape*, we see de Kooning in the process of *double abstraction*: of body and landscape at once and together.[13] At once, insofar as instantly abstracted from anything easily recognizable; together, insofar as equally transmuted and occurring strictly in concert. In the case of *Untitled III*, the effect of joyous lyricism is reminiscent of Matisse figures merging with Monet landscapes.

The theme of body, especially the female body, in relation to the earth is hardly new, but de Kooning's treatment of it is freshly realized. Rarely has such a degree of interfusion of one with the other been achieved. Eve Ingalls's early works take up this theme, but in them distinctly recognizable female forms emerge from a carefully mapped landscape, for example, in *Working to a Level*, a drawing in which a primal figure arises directly from a quasi-cartographically delineated earth (see Figure 7.1).

Consider in contrast the Tibetan wall painting entitled *Supine Demoness* (see Figure 7.2). The demoness's body is here identified with the land of Tibet, whose detailed landscape makes up her body surface. The body itself remains distinct, in terms of both its crisp outline, which contrasts with the ancient sea around it, and the landscape that makes up the demoness's body. The body may be identical with Tibet, but Tibet is clearly depicted over against the sea on which the body is set and the mountains that encircle it.[14]

Both Ingalls's work and the Tibetan mural incorporate mapping factors: Ingalls inserts details of the precise lay of the land her drawing represents, and the anonymous Tibetan painter includes icons of actual places (e.g., Samye monastery as the enclosed group of buildings positioned near the demoness's heart) in an effort to depict the "sacred geography" of Tibet. Each work is both an earth-map and a body-map in equal measure. But in Ingalls's drawing, woman emerges intact from the reductions of cartography, while in the Tibetan mural woman is at one with the

Figure 7.1. Eve Ingalls, *Working to a Level* (1975). Ink and pencil on raw canvas, 66 × 56¼ inches.

very topography that constitutes her body surface. The emergence and the identity evident in these two works respectively situate the body-earth relation somewhere between the fierce dominance of woman over landscape at stake in de Kooning's "Woman I–VI" series and the deep commixture of woman and landscape at play in *Two Figures in a Landscape* and *Untitled III*.

Just as woman becomes indistinguishable from landscape in de Kooning's paintings of the 1960s—leading us to ask in regard to de Kooning's later works: where

Figure 7.2. *Supine Demoness* (1990s). Tibetan wall painting mural on the Yak Hotel, Lhasa.

exactly has the female form gone?—so we also need to ask: where is the mapping factor in his later paintings? It is evident from Ingalls's drawing and the Tibetan wall painting that the intimate tie between woman and earth may be placed in the service of a cartographic or a topographic impulse. Not surprisingly so, given that the female body is a source of such profound orientation and reorientation in human experience. But de Kooning, who brings this body closer to earth than any other painter of the last century, seems to refuse the mapping relation that may ensue from this proximity.

A New Kind of Mapping

Or does he? Here we must consider a new sense of mapping that his engaging and intense paintings propose. To disentangle this sense, we need to look beneath the more or less obvious landscape allusions of a painting such as *Montauk Highway*—which, thanks to the title, is all too tempting to construe as merely a painting about taking a drive to eastern Long Island—in order to find a different mode of mapping than we have so far encountered: a mode that is inseparable from the place of the body in the landscape.

A body that is shown sinking into the earth and becoming one with it suggests a modality of mapping by which the human body, proceeding without any instrumental technology, *finds its way on earth*. Here *Two Figures in a Landscape* (Plate 25) is

again important. Notice that the figure at the right, beyond being splayed and spread out on earth, seems to be groping her way across its surface. It is as if she/it (the term *figure* in the title is deliberately ambiguous as to gender) is getting to know the peculiar topography of this surface; hence, de Kooning has supplied extra legs, just as the even more abstract figure at the left seems to have extra arms. The figure at the right is not just down on all fours—in the expression used by Ingalls in descriptions of her later work—but down on $n + 1$ appendages! Thanks to such supplemental *disjecta membra,* the human figure gains increasingly intimate contact with the earth as basis body, partly taking additional strength from it (like Antaeus touching the earth to be renewed) and partly figuring out what its contour is like. Its Dionysian dismemberment serves this figure well, allowing it to get to places an ordinary rigid body could not reach.[15]

The figural presence on the right seems, then, to be *drawing herself/itself across the earth,* pressing her/its body against the earth to come to know it better from close-up, not just on all fours, but with all major body parts. It is as if she/it is not just making contact with the earth but forming a *contract* with it—a contract to map it in a distinctly corporeal mode. She/it is contracting herself on and with the earth so as to get to know it more fully at first hand (and first foot and chest and belly) and thus to generate an extraordinary earth-map, a map that exists not on the printed page of any atlas but as an ingredient in the body's inherent knowledge of the earth. This contractual body does not *have* a map; rather, it *is* the map by which it proceeds, since it actively embodies the knowledge it gains by its own exploration. This is a literally *grounded* knowledge—knowledge of the earth gained from the ground up by the body that moves upon it.

De Kooning provides us with an exemplary instance, a concrete scenography, of embodied orientational know-how—that is, knowing how to move around on earth without recourse to any conventional form of charting. The scene created in *Two Figures in a Landscape* is a spectacle of mapping without a map. The primary figure in this painting does the mapping solely on the basis of its bodily experience. This figure maps by drawing its body over the landscape, where *drawing* signifies both tracing and dragging. Its contract with the earth means, literally, "drawing/with" the earth, hence mapping with/in it, tracing out a map by dragging a body over it.

During the same period in which the woman-in-the-landscape paintings were being created, de Kooning was also drawing sketches of female figures in close relation to the landscape. These were not just preliminary studies for major paintings such as *Woman as Landscape* or *Two Figures in a Landscape.* They were attempts to explore the outer limits of drawing itself, as if the artist were asking himself: What is it to *draw* a pencil or a piece of charcoal across paper, where this basic activity is preliminary to *drawing figures* on a surface? What can we learn from such a primitive drawing action? One answer is this: to know the surface of anything—not just paper, but the earth itself as a geo*graphic* surface—we must drag a physical body directly over that surface in such a way as to trace a path there, make a trail.

In my earlier nomenclature, this trail is a pathway and not a route. It constitutes the protoaction of mapping and is the minimal unit of what anthropologists tellingly call a sketch map, that is, the most rudimentary form of mapping known to human beings. The sketching is normally done by a sharp-pointed instrument, a *stylus,* typically a pen or pencil; but it can equally well be done by a body that moves itself over a portion of the earth's surface with its own style of movement and its own pointed edges. When the body does the tracing, it constitutes mapping as a corporeal earth chart. Consider a sketch of 1966–67, *Untitled (Figures in Landscape)* (created at the same time as the composition of *Two Figures in a Landscape*). Here two figures (at least) awkwardly occupy a portion of the landscape, seeming to palpate its traits with legs and arms, being drawn down into its embrace (and perhaps into each other's as well) (see Figure 7.3).

It is a short step from de Kooning's exploration in such drawings to developed

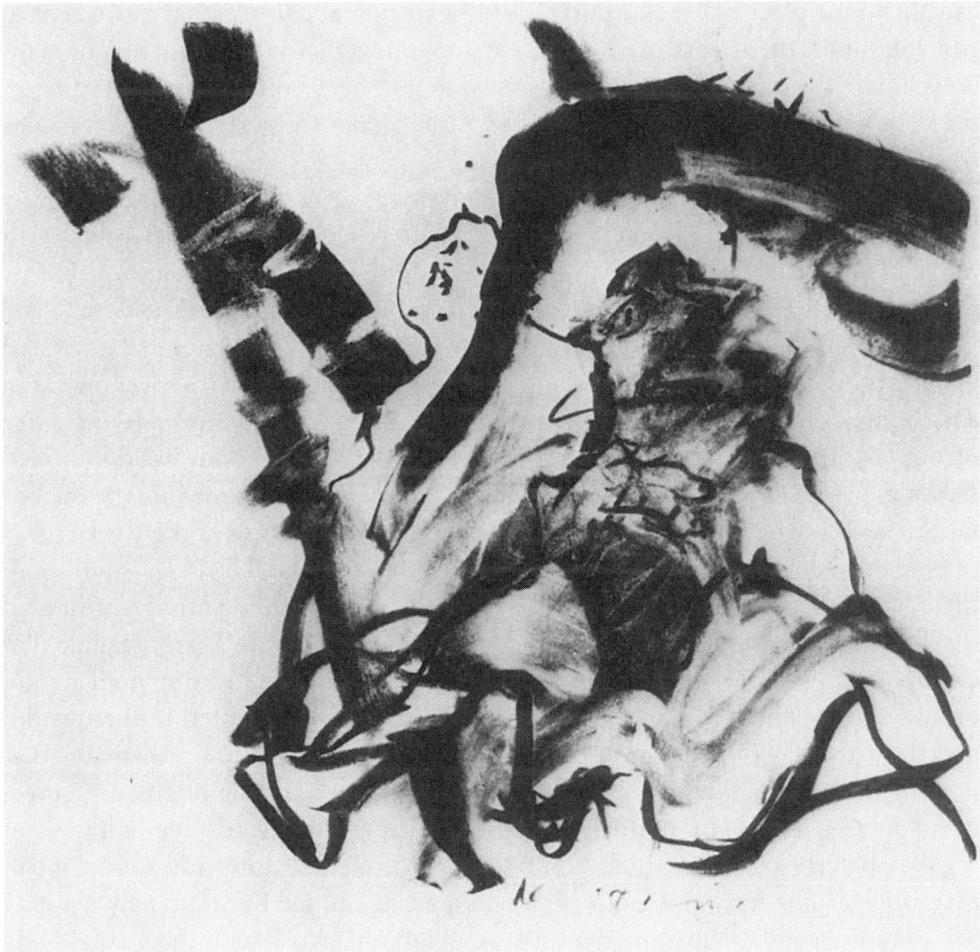

Figure 7.3. Willem de Kooning, *Untitled (Figures in Landscape)* (1966–67). Charcoal on paper, 18⅝ × 24 inches.

paintings in which bodily motion in the landscape is tantamount to mapping that landscape. He has said himself, "There is a time when you just take a walk; and you just walk in your own landscape."[16] The artist maps the landscape by moving in it by the proxy of the bodies he paints—bodies that draw themselves out in the landscape, if not walking in it, then crawling and dragging themselves through it, and thereby tracing its topography. *Draw* and *drag* are both derived from the Indo-European root *tragh-*, "to draw, drag, move." Via the Latin derivative *trahere,* we arrive at words such as *traction, contract, trail, trait,* all of which are very much at stake in the intense bodily mapping in which de Kooning became engaged in the mid-1960s. *Abstract* and *portray* are other descendants of *tragh-*, intimating that de Kooning's concerted, concurrent abstraction of body and landscape is not just another step in the history of modern art but something essential to the very notion of earth-mapping. Abstraction is here at one with the body's trail-making on the surface of the landscape: creating pathways on which actual or virtual walking can then take place. This is a portrayal of a corporeal con-tractual movement in which both partners, earth and body, are drawn together in the ur-action of mapping, finding their common place there. Mapping here becomes the recording of the body's unique way of being on earth by tracing out the path of its spontaneous trajectory thereon, its protraction as it were.

Mapping as drawing/dragging the human body across the landscape gives way in other paintings of de Kooning to an intimate close-up of the traced-out earth (or sea). The scale changes accordingly, furnishing the viewer a stance very near the scene itself. Take, for example, the remarkable painting *Untitled X* (see Plate 27). The painting thrusts us directly into the earth, with its adumbrated grass and underbrush—the very earth, grass, and underbrush glimpsed from a speeding car in a painting such as *Montauk Highway* and then felt under the body in *Two Figures in a Landscape.* Even more dramatically, it is as if our viewing body has diminished radically in size, leaving us denizens of low-lying vegetation, inhabitants of the botanical world, which we touch as much as see (the lush texture of the strokes asks to be palpated as much as observed). The immersion, though intense, is not total: there is an allusive sense of a far horizon at the center of the painting, glimpsed through the dense undergrowth. By and large, however, we are led to imagine that our body is at the level of the ground and that we have become a Lilliputian animal or insect in the midst of luxuriant plant life. We need guidance in this microworld, and the artist has provided it in the form of bold and dramatic brushstrokes that literally trace out pathways through the flora. This is a mapping of possible movements in a scene that cannot help but disorient us at first glance, reminding us of Ingalls's precept that a painting should be disorienting to begin with, so that it can then offer means for finding our direction once again. De Kooning may leave us less than perfectly oriented by the time we inhabit his work with the virtual body that belongs to us as viewers, but he does indicate various ways to find our way in the labyrinth of his work: this is the mapping that he does for us or, more exactly,

that he encourages us to do for ourselves once we start to follow the pathways he has staked out.

The abstraction of de Kooning's paintings is therefore not only that of abstract expressionism in the sense in which this term is often construed. Rather than expressing a particular emotion or thought—rather than stemming from a singular subject who has that emotion or thought—it is at once an *abstraction from* the natural world and an *attraction to* that world: *attraction* (at/traction) being another word derived from *tragh-*, intensified by the locative *at*. A painting such as *Door to the River* (1960), for example, is a painting about attraction as such: the "door" (probably not originally intended as such but, once having been painted, accepted as a found object within the completed work) beckons us to the unseen river beyond the door, directing our gaze into a water world that will become a central presence in de Kooning's paintings after his move to Springs (see Plate 28). There is nobody here in this painting, just an open *invitation au voyage,* a glimpse into a realm of sheer being at one with the becoming of nature, a domain where the extraordinary is in close collusion with the ordinary. The door to the river indicates a pathway into a wild world, which de Kooning's paintings for the next three decades will map in their uniquely concrete, body-bound manner. Everything will take place beyond this door construed as an aegis and a threshold (i.e., a *limen*). The painting is just below it *(sub-limen),* thus literally *sublime.* It takes us to the very threshold of the natural world and asks us to join it.

Such mapping as de Kooning realizes in his mature landscapes is an extravagant mapping with/in nature as sublimely inviting. His intensely opulent paintings take our body with them into the dense underworld of the elemental, sometimes furnishing a "figure" as a guide through the tropics of an abstracted landscape, but more frequently offering no figure at all, just trails toward possible places to go by slithering bodily motions within a wildly particolored and feverishly stroked scenography.

Absorptive Mapping

De Kooning's brilliantly tortuous work has helped us to grasp another form of mapping than is usually recognized. What is conventionally sanctioned, and almost always expected, in the West is *cartographic mapping.* In such mapping, the primary strategy is to gain a *view* of a place or a region: a view that claims to be at once comprehensive and objective. This is normally an upright view, typically from above and from afar, hence a view that favors long-distance vision rather than anything involving the other senses, much less the body as a whole. Many cultures and periods, notably the medieval Chinese and the early modern era in the West, have favored cartographic mapping conceived in this way, as we can see from the privileged position of the global map, still very much an ideal even today. Such mapping is at once bodiless (the eye standing in for the rest of the body) and horizonless

(horizons accrue to landscapes, which are excluded from cartographic representation). The rigor of cartographic mapping—its bracketing of body and horizon in favor of a gridded space of latitude and longitude—is such that there have been numerous efforts to diminish its severities. I have termed such efforts chorographic and more generally topographic, since they are concerned with the representation of a particular place *(topos)* or region *(chōra)*.[17] Their shared aim is to set forth the peculiar features of the surface of a given place as these are perceived and remembered. But the result is almost always a compromise of sorts: a discrete place or region is represented in terms of its most prominent local traits, yet only by means of signs (e.g., contour lines or hatch marks) that are rendered in iconic or isomorphic terms that are necessarily arbitrary, that is, established by convention rather than reflecting the actual experience of the lay of the land. Cartography abstracts from this experience, and to this extent it literally mis-represents it in its very effort to attain verisimilitude in representation.

In contrast with cartographic mapping and its chorographic and topographic mutations stands *absorptive mapping.* This is mapping that aims to capture the sense, the feeling, of a certain place or region, not in terms of its precise configurations, much less its position in striated world-space, but in terms of how it is concretely experienced by those who live there. Such an experiential level is altogether elided in cartographic mapping, and it is only marginally present in most choro- or topographic representations. The means and standards of cartography run athwart any ambition to glean the singular material essence of a place or region. Painters, however, are often concerned with detecting and conveying just such an essence. John Constable attempted to do this with regard to particular parts of East Anglia; Thomas Cole did the same for the Catskills in his early works; Albert Bierstadt aimed at the regional essence of the American Far West; Frederick Edwin Church sought the equivalent essence of Central America. These nineteenth-century English and American painters were already practicing prescient versions of absorptive mapping. So were the painters of the Northern Sung era in ancient China.[18] All these artists were acutely aware of the importance of such things as the horizon and the position of the painter's/observer's body in relation to what was painted. And what was painted was not just a view but a *scene,* a place where eventful action occurred: action that was at once bodily and historical, specific and placial. Not what is seen, but what is scene was what mattered.

In distinction from the distance and rectitude of cartography—its studied remoteness—absorptive mapping is a matter of setting forth how it feels to be in a place, and more especially how it feels to be on the surface of the earth: to be with/in its immediate ambience. The feeling here in question belongs to the lived body as it finds its way in a given landscape: how it moves there, senses itself there, inhabits it. It is above all a question of *the contraction of the body on the land* and of *the attraction of things and events for that body.* The lived body is all over the place—spread throughout a given place, as is overtly indicated by de Kooning's

awkwardly extended figures that sprout extra legs and arms so as to be equal to the task of feeling their way on the earth. This is not the view from above but *the scene from the ground.* So immersed in that ground is the human figure that it cannot even get a view; it does not look around, much less over, the whole landscape, so deeply absorbed is it in the immediate place. The absorption is with what is experientially elemental—with fire and air (for de Kooning the two together), earth, and water.[19]

In relation to this elementality, the basic bodily action is that of taking in the sensuously felt features of a landscape. The painter's initial experience—whether this is part of settled life, as in the case of Constable, or whether it occurs in the quick glancing of de Kooning—*draws in* the landscape, makes it part of an inherent bodily knowledge (*connaissance du corps,* in Merleau-Ponty's phrase) and then *draws out* this bodily knowledge in a work of art and, more particularly, *maps it out.* Drawing-in is the receptive moment of this process; at this level, as Emerson remarks, "All I know is reception."[20] Such receptive drawing-in usually takes the form of perception in its several sensory modalities. The drawing-out is the moment of articulation and expansion whereby the bodily experience of land or sea is transmuted into a mapped-out painting. As de Kooning puts it in the epigraph to this chapter, "Whatever I see becomes my shapes and my condition."[21] This bespeaks the logic of absorption, and his later paintings are absorptive mappings of the Long Island landscape that proceed in accordance with this logic, realizing a contractual relationship with the earth as the basis of the painter's experience there. Thus is accomplished, in one of its most fully realized forms, a primal earth-mapping.

In comparison, Ingalls and Johns are quasi-cartographic artists, unabashedly employing contour lines and hatch marks in certain paintings and yet never aiming at the exact representation of any given landscape. Their otherwise different work is intermediary between professional cartographers and those who map absorptively. Not committed to cartography as such (indeed, defying it, e.g., by painting it out in Johns's case and fragmenting it in Ingalls's), they feel free to borrow conventional symbols so as to put them to unconventional uses. Their work stops short of a complete corporeal immersion in the earth in the manner of de Kooning.[22]

Ingalls and Johns are in company with such other intermediate painters as Kandinsky and Klee, Mondrian and Diebenkorn. Kandinsky and Klee and Mondrian convey a vivid sense of landscape by the use of their own private systems of topographic symbols, while Diebenkorn (in his "Ocean Park" series) clings to a quasi-cartographic planiform surface, a surface structured by more or less regular rectilinear shapes that recall determinate regions on an ordinary atlas map, say, of the Middle West. Rather than de Kooning's intense biomorphic forms with all their profusion and indeterminacy, in Diebenkorn one encounters a detached geometric normality, within which innovation proceeds in the manner of a controlled artistic experiment. The effect is that of a distant aerial view of a very flat portion of the earth whose delineated parts display an animated dialectic between horizontals

and verticals: rectangularity and truth! This is quasi cartography raised to the level of the felt chorography of a region.

The divergent instances of Johns, Ingalls, and Diebenkorn, preceded by Klee and Kandinsky and Mondrian, demonstrate that there are many variations possible in maplike painting that lies between the extremes of cartographic objectivity and absorptive expressivity. One striking variation, for instance, is provided by McLean's paintings of animals who are at once situated in their natural habitat—which *could* be mapped cartographically—and yet are also relocated in the new bodily-felt habitat of the artwork. Indeed, the extremes themselves rarely exist in a pure state, each often incorporating some factor of another strain, as is evident in the wind-blowing cherubs and fanciful cartouches that bedeck even the most accurate early modern maps. Nonetheless, the American land surveys of 1785, instigated by Thomas Jefferson—bona fide cartographic maps that are echoed in many of the "Ocean Park" paintings—are about as distant in sensibility as one can imagine from the later work of Willem de Kooning: a survey map is as disembodied and conceptual and deadpan as a de Kooning landscape painting is embodied and empathic and expressive.

Chapter 8

Locating the General in the Earth Itself
Dan Rice on Biding Time in Place

I absorb the landscape within me.—Dan Rice, in conversation

Getting General

Another painter of absorptive bent is Dan Rice, who resided in Madison, Connecticut, in the later part of his career and who was significantly influenced, personally and professionally, by de Kooning (as well as by Franz Kline and Mark Rothko). Rice pursued his own version of mapping absorptively. The paintings that resulted are at once more pacific and more subtle than de Kooning's agitated incursions into the landscape. They exemplify a lyrical sublimity that is unique in contemporary painting, a vision of patient adherence to the natural world that is in no way to be regarded as its pictorial representation. This is evident in a painting such as *Land's End, N.E.*, from Rice's "Marsh" series (as he calls his works executed between 1975 and 1997) (see Plate 29).

Here is a high-spirited scene of atmospheric incandescence, the large cadmium red light (orangish) "cloud" standing in for the sun as well as for the investment of its rays in a luminous hovering mass of *aithēr*. This "ether" is no longer that which surrounds a nearby highway or what is caught in the glimmer of a glance. It is an enormous presence that lingers over the land like a brooding but benevolent host. The land itself is nothing but a blurred line in dark cobalt blue, slightly smudged with gray, yet forming an unmistakable horizon line that distinguishes the nebulous mass overhead from water underneath. Neither water nor sky is painted in traditional ultramarine blue but in a sparkling thalo/viridian green-blue, which, along with the mediating role of various yellows and whites, links all parts of the painting together into one luminous whole. We are reminded of Turner and of Monet, but we are more deeply reminded of the way a certain seascape feels when we are in its midst, when we *receive* it and *take it in*.

Rice himself spoke of "taking in a landscape and existing with it."[1] His paintings reflect many years of living on the Connecticut shoreline, not just momentary

passing experiences of being in a particular place (as in de Kooning's case), but a continuous pattern of inhabitation in a group of places in close proximity to one another: a pond on a farm, a marsh, a certain beach. Rice did not paint discrete events in such a landscape, not even spectacular ones (as the above painting might lead one to believe were one to construe it as a single remarkable sunset). Rather, his paintings were the product of the *longue durée* of dwelling in a certain region, observing it continually, patiently absorbing it. Rice constantly looked into his immediate environment, not for the sake of noting special visual effects within it, but so as to build up an immense repertoire of experiences on which he drew spontaneously as he painted. I say "experiences" and not "memories": it is not a matter of reproducing a given impression or event but of bringing back the way something has been experienced again and again. Instead of recollecting it as a unique occurrence, Rice allowed an experience to mingle with other experiences of a like kind, thereby forming a dense mass. A composite of experiences led to the composition of a work. The commonalities of these experiences, their inherently overlapping character, underlie the shared regional essence of paintings that draw upon them.

Land's End, N.E. is therefore not a representation of something that happened to Rice, *an* experience he once had in datable historical time. It is a painting of *many* of the experiences he had looking out from his studio on the edge of a marsh, where *many* does not signify a totalizable sum but an indefinite yet inclusive grouping of like experiences. By calling it a *marsh painting,* he signified an especially fuzzy set whereby the subject matter, the topic, of any such painting is generic, not singular. This is a painting of luminosity-over-marsh—how light surrounds and subsumes land to the point of dissolving the land into its barest residue, a mere spit of earth. It is also a painting of how water and sky—each taken as sheer massive presences—dissolve into each other and become one (as symbolized by their sharing of the same viridian green-blue).

In other words: the painting's defiance of the particular, its engagement with the elemental at an almost archetypal level, reflects the painter's reliance on a repertoire of internalized, nondiscrete experiences. The generality of the one answers to the generality of the other, where generality must not be confused with anything like universality. The painting is not a painting of *everyone's* or just *anyone's* experience; it draws only on the experiences of one painter in one region, yet it draws on them in terms of what they connect and interfuse, not what they distinguish. The undeniable particularity of each experience as such contributes not to its universalization but to the generality of all such experiences when amassed within the mind and body of the painter. Rice's painting relays, indeed repeats, the mass of his experiences; it does not reproduce any one of them. Such repetition, as Gilles Deleuze puts it, "echoes, for its own part, a more secret vibration which animates it, a more profound, internal repetition."[2] Each experience of a given place such as a marsh repeats all others, not because it is a mere reiteration of previous experiences of that

place, but because it repeats them as collected into an indefinite series that yields its own generality; and a painting repeats that generality in turn: it *generalizes the generality,* making it available to others as something to which their own experiences of similar places closely relate. This is why any one of Monet's water lily paintings can be said to repeat, by condensation, his many experiences of this particular flower and to convey to us its general essence. "Generality," adds Deleuze, "as generality of the particular, thus stands opposed to repetition as universality of the singular. The repetition of a work of art is like a singularity without concept."[3] It is also a generality that does not depend on isomorphism (i.e., "resemblance" in Deleuze's term) or identity ("equivalence") for its constitution.[4]

Thus *Land's End, N.E.* is a painting neither of *a* marsh nor of *the* marsh; it is a painting *of marsh.* "Marsh" in a sense capacious enough to include almost any marsh ("many marshes") *and* the particular marsh on which the painter resides ("my marsh"), with space left over for imagined marshes and remembered marshes, not to mention marshes painted by other painters as well.[5] The painting repeats a great many marshes, not so as to elicit their formal essence (that would be a universal), but so as to distill and instill their material or regional essence (this is a general).[6] The most vivid sense of this material regional generality comes from looking at a second painting of Rice's, *Evening Marsh* (see Plate 30).

This painting can be said to *repeat* the first painting in certain important ways. The "cloud" mass, though distended and differently colored, still hovers directly over the water; and there is a comparable horizon line, though delineated in a cerulean rather than a cobalt blue and without any black or gray. Again, too, sky and water are amalgamated by color alone: here by subtle grays, e.g., a bluish gray, and a piquant pink. Conspicuously missing from the second painting is the yellow/white that the sheer intensity of the cadmium red light/orange of the first painting requires as a bridge to the thalo/viridian blue-green. In short, we witness two paintings that are certainly *like* each other, yet without anything like exact resemblance, much less strict identity, being present. Such paintings form a spontaneous series, of which there can be (and in fact are) numerous other members. The particularity of each painting—itself reflecting (but not representing) the uniqueness of a certain *kind* of experience (e.g., marsh-as-misty, marsh-at-sunset)—is repeated in the particularity of the next, the result of which is a generative order of the Same that should not be confused with the eidetic order of the Identical. Such a series has the *same* subject matter—"marsh"—without our being able to say that it provides insight into Marsh as such (i.e., the universal marsh). And in precisely this regard, the series is the painterly equivalent of a set of experiences of a particular place: experiences that are the same in a sense that allows for differences among them from occasion to occasion, differences among kinds of experience. As Heidegger has insisted, the logic of the Same is such as to include the different within its scope—in contrast with the logic of the Identical, which excludes any significant sense of difference.[7]

The Right Repetition

It follows that whenever the distinct identity of a place or region, its topographic specificity, intrudes into the artist's work, it plays a distorting and distracting role. Rice once related a case in point. When painting a work some years ago, the place-expression "the Upper Cape" began to come repeatedly to his mind. Such was its force that it led him to start inserting beachlike areas into a work for which that degree of detail was inappropriate. He soon realized that a concern for local topography was ruining the painting, which was fast becoming a depiction of a particular geographic region, that is, the upper part of the peninsula called Cape Cod. The work was failing to attain the general; it could not *contain* difference (i.e., in the manner in which the two marsh paintings just above contain differences between themselves) but extruded difference outside itself: it was a question of depicting the Upper Cape *and nowhere else* (where *else* signifies differences existing *outside* this work, between this work and other works, etc.). To proceed further, Rice had to bracket the all-too-specific identity that was intruding itself into his mind as he painted. He had to dis-identify the work, that is, remove its discrete identity, so that its proper generality could come forth. Within the embrace of that generality, the Upper Cape could indeed figure as one possible region among others; but the sameness of the resulting work was not restricted to this particular region: the painting included this region and others like it within the artist's experience, but it was not exclusively *of* this region.[8]

"The artist's experience": what is this? This, too, is generic in character—a matter of the com-position of many moments, each exceptional as a single occasion but general in status when all moments of like content are considered as integral parts of one continuous durational whole. Experience in this sense is what I have referred to above as of a certain *kind* or better as *amassed*. Amassed of what, by what? Of and by bodily sensings. Or more exactly, *with* these sensings. Hume, echoed by Whitehead, spoke of perceiving the world *with the body*. This does not mean merely *by means of the body*. It means more crucially counting on the body as a continually present level of all experience, its basso profundo as it were. The body bears this experience, registers it, keeps it within its orbit, and thus forms the reservoir from which painting can take its rise. My body is with me not as a companion, a partner, but as what holds in reserve my "myriad experiences" (in Dan Rice's own phrase).[9] Only something as amorphous as the lived body—which, in Merleau-Ponty's words, "is not where it is or what it is"[10]—could effect this kind of holding action by which an indefinite reservoir of experiences is amalgamated. Prior even to holding experiences in reserve, the lived body must *undergo* them, and this signifies that it must be exceedingly porous and receptive in relation to them: standing or moving under them and with them so as to receive them. Thus occurs the moment I have called *taking in*. It is the moment—the ever-repeated moment—of inhabiting a given landscape and drawing it into oneself, making it part of one's bodily being and temporal becoming, so that it becomes a resource for future use.

At the same time that I take in experiences in this deeply corporeal way, I also *exist with* the world to which they belong. The relation of withness cuts both ways: it implicates my body as always with me, but it also implicates the world I sense with my body. Both at once, moreover: only because my body is always with me do I exist with a world at all times. This is the double-edged truth of absorptive mapping, of which Rice's "Marsh" series offers an exemplary case, albeit quite different from that of de Kooning. Rather than reflecting the world as glanced-at—the world instantaneously glimpsed in what Whitehead calls "the immediate rush of transition"[11]—here the painter's long-suffering experience reflects a patient residence in one and the same place or region. The deeply infused body-with of the painter is imbued with the deeply suffused with-world of the work.

What is absorbed is not merely visual information, or even the with-world as such (i.e., the immediately circumambient world), but instead the painter's polysensorial experiences of this world. Only such experiences have sufficient depth and ramification to underlie subsequent actions of painting that are not merely pictographic. Instead of stressing *finding*—as in the tradition of the found object on which Johns draws or the sudden gleaning of images that so inspired de Kooning—Rice's model of painting emphasizes *funding*. I take funding in Dewey's sense of furnishing an ongoing and open resource for subsequent action. Funding is not to be confused with *founding*, the most conspicuous alternative to finding in philosophical discourse. No issue of secure establishment—no "quest for certainty" in Dewey's phrase—is here at stake.[12] The experiences absorbed and compiled by a painter of patience do not necessarily provide a basis for a new style or form of art: nothing programmatic, much less systematic, is here expressly intended. The funding of past experiences makes possible the open-ended discovery of newly configured and newly directed experiences. If Rice is right that "you must paint discovery,"[13] this is because one paints *what one does not know one knows*. Franz Kline is reported to have remarked that "if you paint what you know, you will bore yourself; if you paint what other people know, you will bore them."[14] But it remains that you can paint what you already know—know at a pre-reflective level—and then in such a way that you will not bore yourself or others.

The discovery pertinent to painting is therefore not of something altogether new; if anything, it is of something *re*newed, shown to have new guises, new directions. Freud maintained that every discovery is a rediscovery.[15] This comes close to describing the situation of the painter who paints in Rice's way: thanks to the rich funding from prior experiences, the artist can find various new ways to paint what he or she has absorbed. This is not painting what you know consciously (it is of this that Kline is critical in the above statement) but painting what you know unconsciously—know from the sheer amassment of prior experiences. Because you know it in this deeply amassed way, to paint from it as from an ever renewable (re)source is to feel consciously that you are painting something different, something new, each time: it is to innovate from what you know and do not know.

But the different and new and innovative remain part of the Same; they extend, in free variation, the same experiences that have made painting in this manner possible in the first place. The artist creates what he or she is in fact re-recreating; however, the re-creation is not of the identical—that would be mere "reproduction" or "recording" (in Rice's words)—but of that which is essentially the same, materially like, regionally similar, experientially of a like kind. This is a matter of repetition in Deleuze's strong sense, a sense that builds on Kierkegaard's idea of "repetition forwards" (i.e., in contrast with "recollection backwards").[16]

Painting that repeats in the weak sense is painting that merely depicts what is before it: before it both temporally (i.e., in the history of art) and spatially (i.e., as the merely observed view before one). Either way, there is only "reproduction in the old manner," as Freud liked to call memory that aims at perfect recall.[17] In painting, it eventuates as representationalist art that strives for recognizability of (present) object and view rather than for reflection of the scene of (past) experience. It is painting as snapshot—as *instantané*, in the revealing French term.

Letting It Last

For Dan Rice, painting was anything but instantaneous. Eschewing the model of the glance that is so crucial for de Kooning—and that resonates so closely with the idea of *Augenblick* cultivated by Kierkegaard and Heidegger: the "moment of authentic decision" that is at the same time a "moment of vision"—Rice painted from a sense of the abiding. For him, what matters in painting, its very subject matter, is what abides in experience, is funded there, so as to be found (again) in the finished work. This is the very converse of how de Kooning proceeded, that is, making what the artist finds in immediate experience to be what emerges in a painting as the spontaneously realized image.

Rice's method of absorptive mapping is therefore crucially different from that of de Kooning: the absorption is not so quick as to produce a painted image as "a sudden salience on the surface of [the painting]" but so slow in happening as to distill in painting what is lasting, that is, what is essential, in experience.[18] Moreover, the Ricean absorption is less carnal than the de Kooningian mode. In the late 1950s and early 1960s Rice painted human figures in the landscape, incorporating faces and other body parts into the painted scenes, but (not unlike Ingalls in this regard) he soon abandoned this direction for the sake of painting landscape as such. Figures became relegated to figure drawing, a form of sketching; important as this can be for developing a sense of free form—and for overcoming a sense of the drawing instrument as an impediment—it cannot take the place of painting, any more than sketching a landscape can be equated with painting that landscape.

Nevertheless, to sketch is to add concretely to one's repertoire of known scenes; it is to reinforce memory by a reconstructive action in Piaget's sense.[19] It is to lay down experiences in quite specific forms, that is, as actual if momentary views—to

lay them down so that painting can draw upon them later on; this is another instance of the close relationship between drawing-in (here as sketching) and drawing-out (in the eventual painting). Drawing-out in painting is thus a case of deferred action. Rice reported that visual experiences of being in a studio in Vermont dazzling with reflected light from snow outside showed up in paintings in New York many years later: "Out popped these crinkly light paintings: I knew these were a residue of the Vermont experiences that had lived and percolated inside me for a long time."[20]

In short, "I absorb the landscape within me. . . . an experience has been internalized and I can paint directly from that experience."[21] By "paint directly," however, Rice did not mean paint mimetically; he did not mean painting a particular view he once beheld looking out from his studio in Vermont; again, a sketch would come closer to preserving this view. Rather, it is a matter of "something composite" in which various scenes, real and imagined, have merged in the final composition. This is not to deny that one *could* paint something as particular as a sketch represents, and there is certainly a constant "war or tension between painting specifically or figuratively and [painting] abstractly." We can even admit that "the original impulse is figurative—an impulse to reproduce and a pleasure in doing so."[22] But this impulse must be resisted if one is to be true to oneself and to the history of modern painting. In Rice's case, it is a matter of continually *reducing* the complexity of the original experience so as to get at the regional essence of his subject matter. This experience "could very well be used specifically within a painting [i.e., as a detail that suddenly returns], but a painting is not about *that*—specifically."[23]

The deeper the absorption, the greater the internalization, and the more lasting will be the experiential stock on which the painter draws. Painting is a waiting game, a matter of playing patience. Seen in this light, the *lasting* is a primary category in the evolution of a painting. What Cavell says of philosophy can also be said of painting:

> The *last* . . . is an instruction about philosophical patience or suffering or reception or passion or power. It speaks of lasting as enduring, and specifically of enduring as on a track, of following on, as a succession of steps (which bears on why a shoemaker's form is a last).[24]

A landscape painter such as Dan Rice draws patiently on the lastingness of an immeasurable reserve of prior experiences. These experiences, stemming from the past, last into the present of painting; they constitute his "succession of steps" or (as Cavell adds) his "knowing how to go on," his "being on the way, onward and onward."[25] Such drawn-out know-how means *outlasting* the various initial experiences that inspired the evolving work; or we can say that it means *letting them last*: letting them come forward at the appropriate moment, letting them become present again, not as they *were* (that is the path of recollective memory and reproductive painting) but as they are *still becoming*. This line of thought rejoins Heidegger's:

To presence means to last. But we are too quickly content to conceive lasting as mere duration, and to conceive duration in terms of the customary representation of time as a span of time from one now to a subsequent now. To talk of presencing, however, requires that we perceive biding and abiding in lasting as lasting in present being. What is present concerns us, the present, that is: what, lasting, comes toward us, us human beings.[26]

The Nearing of Nearness

A painter such as Dan Rice *bides his time*. He did not paint out of the passing moment, the "now." He painted from his experience of "being with the marsh: becoming it, and its becoming me."[27] He would agree with Heidegger that "the present in the sense of presence differs so vastly from the present in the sense of the now that the present as presence can in no way be determined in terms of the present as the now."[28] A painting stems from a past present that was never merely a now—not something that could have been encapsulated in an episode or captured in a glance—and that gives itself to its viewer as a present present, that is, what lasts in a present being that is again not just a now: it is a re-presence of the present of a past presence, where "presence" is precisely what has sufficient force and depth to last over time and to survive, relocated, in a painting. Such presence cannot be contained within a simple or single view; thanks to absorptive internalization, it is an amalgam of many experiences that gain persisting re-presence in a painted scene. Their return is not as (reproductive) representation but as (productive) re-presencing in the work.

In this way the painter does not lose the intimacy of first-hand and first-time experience, as is inevitably the case according to models of depictive representation in painting. Thanks to the reinstated presence accomplished by a re-presencing work, the painter comes closer to his or her subject matter than would otherwise be possible; indeed, even nearer to the material essence of the landscape thereby renewed than on the first perception of it. Such aesthetic augmentation over lasting time is evident in a very late phase of Rice's painting, a phase he designated as that of the "Black" paintings.

Take, for example, *Salt Marsh Woods, Sunset* (see Plate 31). At first glance, this striking painting seems completely abstract, especially in comparison with the "Marsh" paintings, which retain aspects of recognizable land- and seascape. But on longer looking, this work appears increasingly landscapelike: does it not allude to the rugged rockface of a hill or perhaps to pine trees? One thing is clear: the scale has changed drastically from the earlier works; here we are thrust very close to the painted subject matter, thrown forcefully into its midst, thanks to the powerful dark values of this matter. No longer is there the feeling of serenity so evident in *Evening Marsh* (Plate 30); instead, an intense aura of involvement captivates our look.

Rice regarded this painting, and others in the same series, as articulating his experiences of looking *away from* the marsh on which his studio was perched. When

he gazed in this contrary direction, he looked into a darkly forested area just beyond the studio. He gazed into this area for considerable stretches of time, finding solace there and focusing on the "negative spaces" created by the low-hanging tree boughs. These almost meditative experiences, deeply absorbed within the artist, gained re-presence in his work: his paintings were about none of these experiences in particular; rather, they encompassed all of them as collective copresences. At the same time, earlier experiences of being in a heavily wooded state park near Penobscot, Maine, were also present; they too returned, not in pictorial detail, but as ghostly *revenants* from another era of the artist's life. The result is an absorptive mapping of at least two layers of this life—a mapping onto this particular canvas of these previous times ("times," I say, not isolated moments).

The mapping is absorptive in two regards: as drawing on the artist's own immersions in experience and as drawing us into its special spatiality: his absorption calls for ours. Much as de Kooning brought us close to the Long Island landscape in his later works—closer than he was willing to come in the paintings that reflected his initial approach on the highway to a new life there—so Rice brings us into a more intimate space than is accessible in his "Marsh" paintings. He brings us into the painterly equivalent of the "near sphere": that world of proximal presence in which everything is within actual or potential reach of our body.[29] Here things are not just objectively close but "more closed in and more intimate,"[30] indeed, *immeasurably close*. It is a region of sensation in which nearness itself becomes ever nearer, thus a matter of "the nearing of nearness."[31] We sense this acutely in *Salt Marsh Woods, Sunset,* in which we are enjoined to enter alveoli of nearness—pockets of intimate space that are the transmuted residues of the negative spaces perceived by the artist as he stared into the dense trees near his house. Everything conspires to intensify the effect of proximity: the chrome oxide green warmly encloses the central black mass, which we enter through pink and white border areas. Once our look is captured by the dark region, it is drawn further in by the brilliant viridian greens and the touches of Venetian red and dark umber. It is like entering a visual labyrinth from which there is little or no exit—to our delight, however, not our dread. We are embraced by this work, enfolded with/in it, attracted to it and drawn into it.

Despite the fact that both de Kooning and Rice radically reduce the scale (if not the actual size) of their later works, they part company in regard to one basic matter: the submersion in the near sphere to which Rice invites us is much less corporeal than that of his friend and fellow painter. Paintings such as de Kooning's *Untitled X* (Plate 27) and *Whose Name Was Writ in Water* (1975) engage a spastic body that is disjunctive and dismembered, a body of polymorphous perversity, a "fragmented body" (again in Lacan's term).[32] Rice's call into near space is not spiritual but bodily; yet the body that is beckoned remains a mainly reflective body that does not seek or savor the disarray that is so prominent in de Kooning's later landscapes. If this body is not as cerebral as that which is at stake in Diebenkorn's "Ocean Park" paintings, it is nevertheless a *psychical body*—the body of someone who thinks and

remembers as much as he actually moves, a sensuous body in search of serenity even if this has not yet been found. The experience that is solicited is resolutely "psychosomatic," in Rice's own preferred word for the kind of experience here at stake.[33] Thus it is not surprising that his paintings are as much about "state of mind" as they are about the landscape from which they arise: indeed, both at once, since the landscape has become him and he it, a literally psychosomatic process.

Attaining Lyrical Sublimity

The state of mind Rice's paintings induce and exemplify is lyrical in character, given that the lyrical is more a quality of mind than of physical sound: at once quiescent and lively, bemused and dynamic. Attaining a new version of what I have called the contemplative sublime, as this was realized in the work of the Hudson River School, especially in its luminist phase, Rice's painting instantiates a new version of the lyrical sublime.[34] Its most significant predecessors are found not just in luminism but also in Turner's later seascapes and in Northern Sung mountainscapes.

And what do such paintings have to do with mapping? I have already hinted that they offer us a special mode of absorptive mapping, not de Kooning's mode (frenetic, somatic, and a matter of the moment), but Rice's own brand: contemplative, patient, and exhibiting the lasting. The master of action painting expresses explosive moments of being, epiphanies of the concrete senses; the master of the lyrical sublime sets out presences garnered in long periods of becoming, presences that are genuinely visionary in scope. Rice's painting is both luminous and numinous: luminous because of his self-professed "engagement with what [he] see[s] out there in terms of light, and the play of light in terms of colors through the seasons";[35] numinous in the original sense of the word: having to do with "the presiding divinity or spirit (of a place)."[36] The spirit of a place, once internalized, becomes the guiding daimon of the artist. The absorption is thus finally of the genius loci that orients a painter, gives him or her a sense of direction, inspires a new kind of mapping that is more like an announcement than a statement (*announcement* derives from the same root as *numinous* does: i.e., *numen*, "nod" or "command"). Such mapping is not the detached declaration of the cartographer, or even of such comparatively detached painters as Diebenkorn and Johns. It is an engaged commitment of an artist whose major daily practice was that of reflective awareness: an awareness of what is numinous in a landscape's luminosity. The awareness is not only of the phenomenal manifestations of the landscape—for example, its actual light—but also of its noumenal basis. (The "noumenon," as Kant reminds us, is the thing in itself, the unknowable aspect of anything; it is thus the ultimate source of that unknownness that is the necessary condition of discovery in painting.)

Rice's absorptive mapping reaches further; it also bears on the *dimensionality* of human experience. By this term I mean the openness with which any given spatial situation is structured in terms of basic vectors of up and down, right and left, back

and front—and also, even more basically, horizontal and vertical. As Heidegger puts it, dimension is "here thought not only as the area of possible measurement, but rather as reaching throughout, as giving and opening up. Only the latter enables us to represent and delimit an area of measurement."[37] Rice's paintings, early and late, convey and constitute dimensionality in this broad meaning of the term; they give and open up in a manner that allows his lyricism to precede, and to survive, any attempt to reduce landscape to its cartographically measurable properties. How many miles is it to the spit of land evident in *Land's End, N.E.* (Plate 29)? How far from us is the dark mass presented in *Salt Marsh Woods, Sunset* (Plate 31)? It is impossible to tell in either case, in contrast with pictorially precise paintings that aim at visual exactitude by the employment of perspective and recessive gridding. Absorptive mapping absorbs such exactitude itself, *dissolves* it, in the interest of letting us see the numinously anexact aspects of land or sea.[38]

Another late work of Dan Rice's, *Woods to the North, Nightfall,* has to do with dimensionality, now in a very special way (see Plate 32). This painting moves underground, moves from the surface of the earth into its rich interior. It is a painting about telluric depth: about getting more fully into that depth, yet in such a way as to preserve its sense of intimacy and proximity. Not depth as distancing but depth as *fathoming* is at stake here. As in the ancient Greek conception, the downward movement from the earth's crust goes through at least two layers, *gē* and *chthōn,* before reaching the underworld.[39] The earth-red not only suggests such earth penetration; it embodies it, as if it were the blood of the earth, part of its vital viscera. But this movement in depth is possible *only from the horizontal surface* at the very top, suggesting that when it comes to the element called earth, the vertical is possible only in relation to a preestablished horizontal. Even a mythical *axis mundi* rising far into the sky makes sense only in relation to the flatness of the earth from which this axis arises.

The horizontal axis is concretized and made available to human perception in the *horizon* of any given landscape. As I have already suggested, there is no landscape without horizon: it forms, in collusion with the body of the person perceiving or moving in the landscape, the epicenter of any landscape scene, the opening of the far sphere. The horizon is the single most powerful orienting factor in a landscape: it pulls our body toward it while also actively alluding to the gravity to which the same body must submit when on earth. As Erwin Straus remarks,

> In a landscape we are enclosed by a horizon; no matter how far we go, the horizon constantly goes with us. Geographical space has no horizon. When we . . . use a map, then we establish our here in a place of horizonless space.[40]

In my own vocabulary, cartographic mapping gives only views, none of which has a horizon, whereas absorptive mapping construed as mapping our being-on-earth in scenes cannot do *without* a horizon. We have observed hints of this close imbrication between absorptive mapping and horizon in de Kooning's work, for example, his *Woman as Landscape,* which as I have noted makes the woman's shoulders count

as the horizon. Yet de Kooning does not emphasize horizon as such, and it is often only implicit or imputed, as in *Two Figures in a Landscape* (Plate 25) or *Untitled X* (Plate 27). In Diebenkorn's later works (e.g., *Ocean Park No. 31,* Plate 23), it vanishes altogether, which is why these works are quasi-cartographic in character, adhering more to the space of geography than to the place of landscape.

In Dan Rice's paintings, by contrast, the horizon is an integral and felt presence; it is never wholly absent from his landscape works. In the "Marsh" series, it is often a conspicuous item; as Rice himself has said, it forms "their one commonality." More generally, "horizon seems to be a foundation in my life, a fundament of some power, thanks to my having been born on the edge of the Pacific Ocean and being on this ocean during the war."[41] To be in a landscape without horizon, for example, in the interior of a mountain range in Montana, is to be in a place where Rice feels something is "missing." Such a landscape is acutely disorienting; it lacks the major axis of orientation, the basic dimensionality of giving and opening up, which we expect to find in any complete landscape scene and for which the horizon is essential.

The paradoxical fact is that cartographic maps, though having no actually perceived horizons (or even, usually, any representation of them), are used precisely for purposes of orientation. But this is a matter of strictly measurable orientation, and the statement from Heidegger cited just above warns us that the dimensionality that counts is not measurable. The horizon of a landscape (whether perceived or painted) is a leading case in point: we can never say just how far a horizon is when we are situated in a perceived landscape (much less when we view a painted landscape), yet its presence is essential to our being oriented there—to "knowing how to go on," indeed, to the most basic human movement of all, walking. Rice's painting acknowledges the necessity of a horizon, and in so doing it inspires the quietude of mind that this painter wishes to instill in the painting and induce in us as viewers. He draws on the fact that nothing in an actual landscape is as reassuring as a horizon, especially when we have lost our way in mist or fog.

The later, "Black" paintings of Dan Rice do not have discrete or precise horizons. Yet in each case something horizonal is felt. This is certainly true of the two works reproduced in Plates 31 and 32. The dark strokes at the top of each work certainly *act as* horizons even if they lack any claim to represent perceived horizon lines. If anything, they are horizon *slopes* that reflect the curvature of the earth. They are readily construable as standing in for the surface of the earth, thus as a basis for seeing the horizons of any given landscape of which they may be part. They are certainly indispensable to the absorptive mapping accomplished by both of these paintings by Rice and just as certainly part of their sublimity. Indeed, they embody the literal sense of "*sub*lime": *under* and more especially *up to* the threshold. *Woods to the North, Nightfall* (Plate 32) in particular presents itself as a painting about being beneath the threshold of the earth's surface: both moving up to that threshold and coming down from it into the depth of the earth, two modes of intimate spatiality just under the crust of the earth. Thus it stands in contrast with

de Kooning's *Door to the River* (Plate 28), which takes us beyond the threshold of a door into an aqueous world situated on, not under, the earth's surface.

The horizon, though not represented as such in either of the late paintings of Rice's, remains a potent stabilizing force. It controls our orientation to these paintings, and it directs the shape of the forms that fall under it in each case. It is notable that in the case of *Woods to the North, Nightfall*, as in the two paintings from the "Marsh" series (Plates 29 and 30), a free-form but recognizable rectangle derives from the horizon: either moving down from it, as in the later painting, or towering above it, as in the earlier works. The rectangle, one of most stable of the basic geometric figures, is here a creature of the horizon, and it is precisely because the horizon is not itself a geometric entity (just as it is not a geographic entity either) that the rectangles in these paintings are free from any constraint to be perfect exemplars of their ideal formal shape. Unlike Mondrian or Johns or Diebenkorn—instead, closer in spirit to Rothko—Rice does not have to rely on the perpendicularity and symmetry of these figures to mine their deeper painterly significance. Thanks to the felt but unstated presence of the horizon, these delightfully irregular rectangles possess a truth of their own that does not depend on the regularities and normalities of geometry or geography—much less on cartography, the measured mapping of these two modes of earth measurement. Such unreconstructed rectangles are as immeasurable and as sublime as the horizons from which they take their rise.

Dan Rice's paintings are extraordinary in their accomplishment, but the final paradoxical truth they teach is that the extraordinary itself flourishes in the context of the daily, the ongoing. These are paintings of the extraordinary dimensions of repetitive phenomena: phenomena such as living in one place or region for a long while (having *been there*) and sensing each day and nightfall the light and color that this brings with it, not to mention the patient probing of such elementary things as horizon and ground and negative spaces, or for that matter such elemental things as air and clouds, sea and earth. There is nothing theatrical here: neither the Theater of the Ordinary essayed by Johns (no cultural icons clutter these paintings) nor the Theater of the Extraordinary as in Ingalls and de Kooning (no majestic mountains here or any ecstatic moments of being). Instead, there is drama without melodrama, action without a frenetic edge, ending without apocalypse, nearness without coincidence, absorption without fragmentation—just as there is also scene without view, region without site, sameness without identity, the general without the universal, repetition without reproduction, re-presencing without representation, dimensionality without measurement.

The landscape paintings of Dan Rice constitute mapping without cartography: mapping with/in the earth, mapping it out, yet not a mere mapping of it, much less mapping it for any practical purpose. This is absorptive mapping at its most lyrical and serene, scene made splendid and sublime, the phenomenal in its noumenal luminescence. It is the ordinary become extraordinary in painting that is mapping that is painting.

LAST THOUGHTS ON PART II

Underlying the last two modes of mapping as set forth in the prologue—that is, mapping with/in and mapping out—is a pair of further factors: "diachronic density" and the "body as a basis." I would like to address each of these briefly and then to suggest a more general model of the process underlying painting that maps absorptively.

(i) *diachronic density.* By this I mean that the experience pertinent to mapping the land (whether that of the mapmaker or the mapviewer) is never simply a unique or single experience, no matter how convincing this may be. The mapping that counts in painting—that does not merely reproduce or record—does not concern a discrete unrepeatable experience. A painting such as *Twilight in the Wilderness* may have been inspired by a certain datable sunset actually perceived by Frederick Edwin Church (this is a question of historical fact), but it is not a painting *of* this experience as such: that way lies autobiography and history. Spectacular it is, but the spectacularity does not entail a discrete event in world-historical time or space.[1] This is a painting arising from a series of sunset experiences in the wild; it is not the strict summation of these experiences (what could such a summation consist in?) but their condensation insofar as they form a nondiscrete, nontotalizable whole: it is their concrete emblem.

This whole is diachronically dense in that its beginning and ending cannot be located as such and also because it consists in a great deal of overlapping and outright merging. It is a matter of experiential *amassment.* The mapping painter paints on the basis of this amassment as much as from any given sensuously perceived landscape, since parts of previous experiences can return at any time to insinuate themselves into a current painting of a recently experienced landscape. The return is from a depository of past experiences—a reservoir that acts as an effective repertoire—on which the painter draws. The deposited knowledge is of prior places and regions as these have been experienced over time, often for many years.

(ii) *the body as a basis.* Where is this reservoir located? It is found in what Merleau-Ponty calls the "customary body," the body of deep habitual knowledge that is to be contrasted with the merely "momentary body" that reacts to the distractions of the day.[2] The customary body is the practical operator of the more profound

167

discernment that is tantamount to knowing one's way around a given region—a matter of *auskennen*, "to know one's way about" (a city, a park, a landscape). It is therefore a question of a basic familiarity with the place-world, knowing how to orient oneself in, and navigate skillfully through, that world, often wholly without self-consciousness.[3]

Mapping with/in a landscape and mapping it out in a painting both depend upon the customary body, not merely as an instrument, but as the receptacle of the tacit discernment to which I have just pointed. Only such a body can effect this double-edged mapping, because only such a body is equal to the task of containing, and selecting from, the diachronic density of the painter's experience. The long duration of many comparable experiences has its proper locus in the customary body: where else could such density reside? The amassment of experience calls for the myriad habitual body memories that carry forward that experience into a present and future in which there occurs the making of paintings that map the landscape as it is re-membered and re-implaced in a completed work.

Indications of such a bodily basis of painting-maps are to be found in Eve Ingalls's early paintings of female bodies that emerge directly from the earth's landscape: bodily features here being continuous, and sometimes even identical, with landscape features (e.g., *Working to a Level,* Figure 7.1; *Sherds,* Plate 17). Other indications are manifest in some of de Kooning's paintings of women who are at one with the landscape they reconfigure (see *Two Figures in a Landscape,* Plate 25). Consider also the kind of figure drawing in which the model moves every few minutes and thereby constitutes an experience in which the usual distinctions between the body of the other and one's own body are suspended as one's hand and whole upper body move in synchrony with the body of the model.[4] Here my customarily moving skillful hand stands in for the model's continually moving body, *stands in its stead*—my hand seeming to belong equally to the model and to me as I trace the outlines and inlines of the momentarily poised body. I map out this body even as I map with/in it.

Something like this is happening in landscape painting of the sort under investigation in this last part of the book. Here, too, even if in a considerably more complex way than in figure sketching, and albeit often to a quite attenuated degree, the painter's body stands in(the)stead of the landscape, becoming part of its "real estate." Itself composed of enduring matter, this body reinstates the durable parts of the landscape, including the earth that persists beneath it. The durability of the painter's customary body captures and incorporates the enduring features of the landscape: the amassed diachrony of the one answers to the equally massive placiality of the other. Through the lived body, time and space reconnect in place, just as by the services of this same body the human subject knows itself to be a creature of the earth around it and a creator of landscape paintings in which this same earth is re-presented anew, this time in earth-maps that are located outside the subject yet trace the complex history of its experiences on earth.

To sum up: we can pick out three stages in the generative process of mapping the land:

(i) The first stage is that of *assimilation*: this is a matter of *taking in the land-scape* only to the degree that it *takes the viewer in* as well. This is very close to what Rice means by speaking of absorption. Such two-way assimilation is not limited to Western painters such as Rice or de Kooning. The "wandering" so crucial to Northern Sung painters concerns much the same double action of taking in and being taken in: internalizing a world of which oneself is also an integral part.[5]

(ii) The direct result is the slow formation of a reservoir of experiences of land-scapes of many sorts, clustered into groupings of roughly similar kinds (often with a common regional tenor) on which one can draw, spontaneously or by intention, in the future. This amounts to an informal compilation of landscape experiences bearing family resemblances to one another. The status of this reservoir is that of the *tacit*, a matter of what Husserl (and Deleuze after Husserl) would call "passive synthesis"[6]—the passive synthesis of tacitly held knowledge of how to find one's way, and to secure one's place, in a given landscape world. Thanks to the body's orientational and navigational powers, such synthesis is realized as one's own map-ping with/in this world and is the antithesis of the mapping of this world for liter-ally locatory purposes.

(iii) From this basis in "taking in and existing with,"[7] the painter—here unlike the viewer, who feels no such compunction—*takes out* his or her experiences and re-invests them in a work of art: maps them out. Having gotten (back) into place by way of immersion, the painter gets place out of himself or herself, deposits it, as it were, into a drawn or painted earth-map. Such a map does not record, much less repro-duce; it does not even describe; instead, it transmutes all relevant prior experiences into the work. Not transportation of detail but transmutation of material essence is operative here, sometimes to the point of unrecognizability. The aim is not to delin-eate, much less to preserve, the identical; it is to carry forward what has been held back and within as the *same*: a same that allows difference to flourish in its midst.

Such nonreproductive mapping is accomplished by reinstating the primal sense of "ex-perience," *trying something out* in a created work, endowing the work with the embodied knowledge one has gained of the landscape in question, extending that knowledge into an earth-map that captures even as it alters the sensed and remembered landscape, re-implacing this landscape in and with its own map. Thus one maps what one knows, yet in such a way as to discover it for the first time. Such is the case with all the artists under consideration in this book: they find what they fund, and they fund what they find in turn. The dialectic of finding and funding continues indefinitely.

I am not claiming that the painters I have examined in this last part are explicitly or even primarily engaged in mapmaking activities. As with the earth artists dis-cussed in part I, mapping is only part of what is accomplished by any given artist—and then sometimes only in certain works from certain periods of his or her career.

It would be exaggerated to claim, for example, that de Kooning had the explicit intention of mapping land or water in his later work; in fact, he was preoccupied with making good paintings, hence, with questions of color and composition. But I have been exercised to show that a significant strand of his and other artists' work concerns, intentionally or not, the creation of maps or maplike elements. In some instances, this concern is conspicuous, as with the early work of Ingalls or Johns; in others, notably de Kooning as well as Rice, Diebenkorn, and the later work of Ingalls, it is much less evident.

In order to make it more evident, so as to see what is truly of the character of mapping in the less than obvious cases, I have had recourse to a renewed consideration of what mapping itself consists in. This has had the double advantage of allowing us to discern what is maplike in the more recalcitrant instances and expanding the usual horizon within which mapping in general is understood, thereby extending the scope of the concept as a whole. That painters rather than cartographers have inspired this extension is itself remarkable. It is one thing to point to painterly aspects of traditional maps such as certain chorographic representations and topographic inscriptions. But it is something very different to realize how mapping can be accomplished in and by painting itself, including painting that does not look like mapping at all in any accustomed sense.

To grasp the larger sense of mapping that is conveyed to us by the painters under discussion in previous chapters, we must distinguish between two fundamental forms of mapping activity: *cartographic* and *absorptive*. Cartographic mapping purports to be objective, that is, to be uninfluenced by personal or historical circumstances.[8] In order to attain objectivity, such mapping takes a detached view from a determinate position (typically a view from above) so as to make a representation as accurate as possible within the available technology of a given culture. This representation is as horizonless as it is disembodied. The cartography of the modern era in the West is a paradigm of this kind of mapping, but it is not the only such paradigm: portolan charts are cartographic in their own colorful way; indeed, even prehistoric maps with bare petroglyphic inscriptions may be considered cartographic in spirit.[9]

Absorptive mapping, in contrast, is mapping that is done from the lived body's standpoint, which is to say, from its concrete experience of existing and moving on the earth, being extended in traction there, tracing out its trajectory, thus literally choro-graphic and topo-graphic; rather than detachment and view, engagement and scene are what matters; instead of an undelimited infinity of space being posited, horizons here enclose a finite landscape; the assuming of discrete and stationary positions gives way to the intense lateral inhabitation of places; instead of the veridical representation of a region, the guiding principle is the lived sense of how it feels to be part of that region and in extreme proximity to it, relating to it in diachronic density—what it is like to be "landed" or to have "sea legs": a matter of "legwork" in Deleuze and Guattari's term.[10]

The distinction between cartographic and absorptive mapping is not so much literal as projective, by which I mean that these two generic forms of mapping act as poles between which other kinds of mapping fall, including the four major kinds to which I have pointed on various occasions.[11] Given the great diversity of maps, such a distinction is a signal virtue and something of value beyond its immediate application to landscape painting. When Herman Melville said famously in *Moby Dick* that "it is not down in any map; true places never are," he was alluding to something akin to such a difference. The distinction between cartographic and absorptive mapping is pertinent to a historical narrative that trades on the difference between the official, state-sanctioned map of a region in which the plot unfolds and the embroiled experience of actually being in that region—an experience that calls for absorptive mapping. I am proposing in turn that certain sorts of painting require this distinction if we are to do full justice to their interpretive horizon. Without this distinction, we would not be able to understand the inner and often concealed relationship of mapping and painting; with it, we can determine more completely what this relationship consists in.

The painters considered in this part can be understood in terms of this same distinction. Thus the painting of Ingalls, Johns, and Diebenkorn is largely (if diversely and idiosyncratically) cartographic in inspiration, while de Kooning and Rice are mainly absorptive mappers. Within this major classificatory difference, each painter creates her or his own unique brand of work, thereby proliferating possibilities. We have seen that the early paintings of Ingalls exhibit their own type of quasi cartography, in which various contour lines and hatch marks become part of a larger pictorial medley. These cartographic shards are meant to disorient and unsettle, partly by their spatial discontinuity, but primarily by their reference to an ancient past that lies far below, and exists longs before, the popular culture of the contemporary world. Built on deconstructed coordinates that are at once historical and spatial, the mapped parts of these paintings take us both elsewhere and elsewhen, while other wholly abstract factors (e.g., lines and numbers) bring us back abruptly to the literal surface of the canvas, where a drama of heterogeneous images plays itself out. Here the *quasi* in "quasi cartography" refers to the fact that these disparate images coexist *as it were* within the work as a whole: it is *as if* they were, in the world of the work, associate members of the same pictorial kingdom.

In striking contrast, Johns's use of cartography is homogeneous and occurs all at once: now the map is coextensive with the painting as a whole, being its exclusive subject matter. The effect is entertaining, not disorienting. There is no spatial or temporal depth as in Ingalls; instead, there is fetishization of the surface qua surface: the surface of the map of America is at one with the picture plane, since it is depicted as the sole inhabitant of this plane and as something whose flatness merges with the flatness of the canvas. History is literally pushed off the map, which is presented as a sheer and simple icon of contemporary, ahistorical American culture. Where Ingalls's *Broken Coordinates* (Figure 5.1) refers us to a disconnected,

unshareable prehistoric past—as disconnected as the mute boulders that bear petroglyphic maps of the Late Bronze Age in northern Italy—the temporal frame of a Johns's *Map* (e.g., Plates 20 and 21) is exclusively that of the present moment shared by everyone. It is from within this shallow but clearly defined frame that Johns feels free to ironize and to parody cartography as well as American culture as a whole: the painting-map stands in a *pars pro toto* relation to the common culture from which it stems. This is not so much quasi cartography as cartography taken to an almost comic extreme.

In a sudden development some fifteen years later, however, Johns begins to engage in quasi cartography—in his own distinctive way. His "Crosshatch" paintings give us abstracted symbols of a wholly abstract landscape: wholly abstract insofar as the landscape is entirely imaginary or imputed, unlike the landscape at stake in the map of America or in Ingalls's paintings early and late. The crazy-quilt design of many of Johns's works from 1974 to 1982 gives us the ghost of cartography, its abstracted essence: what cartography becomes when it is shorn of any actual or even imaginary geographic reference. This is a radical de-geographizing, more extreme than anything we find in Diebenkorn's "Ocean Park" paintings. These latter are grave in emotional tenor and imperious in design, and they display no more interest in the past than Johns's paintings do. Diebenkorn's work offers us indirect chorographic adumbration by way of apparent aerial views, color (evoking the region in which they were painted), and title (which names the scene of painting itself). In both of these last respects, his paintings rejoin the Long Island landscapes of de Kooning, painted only a decade before. In the end, however, the two painters go their separate ways, since de Kooning maps absorptively by means of embodied engagement while Diebenkorn disdains any such engagement.

A painter's relationship to various modes of mapping is often quite complex. The complexity is most evident in a succession of styles of mapping over a lifetime of painting. Diebenkorn and Ingalls, for example, both move through at least three significantly different phases in their work: in Diebenkorn's case, from an early abstract phase of biomorphic forms (the "Albuquerque" and "Urbana" paintings), through a period of recognizable landscape (i.e., the "Berkeley" works), and finally to a last, quite different abstract phase that is geometric rather than biomorphic in its formal properties. Ingalls moves from the quasi cartography of early closely delineated works such as *Working to a Level* (Figure 7.1), through a chorographic and topographic phase that is notable for its pictorial realism (e.g., *Folded Field*, Plate 18), and then into a complex final period that combines representational with gestural motifs in works that are at once depictive and absorptive (e.g., *As Light as Possible*, Plate 19). Rarely, however, do we observe a mixture of cartographic and absorptive mapping within one and the same work—just as we might expect, given the extremities they exemplify.[12]

If Diebenkorn (in his "Ocean Park" series), Johns (in his *Map* paintings), and Ingalls (in her early linear works) each pursue a different species of cartography—

indeed, even a different species of quasi cartography when we include Johns's "Cross-hatch" paintings—de Kooning and Rice provide us with different species of the genus of the absorptive mapping that I have taken to be their hallmark. De Kooning realizes an absorptive painting-mapping that is characterized by its emphasis on the present moment of the glance and by an ecstasy of experiential intensity that borders on the frenetic: the bodies that crawl through his East Hampton landscapes evince a sense of desperation in never being able to find their way home—as in Plate 25, *Two Figures in a Landscape,* and Figure 7.3, *Untitled (Figures in a Landscape).* Rice, on the other hand, engages in an absorptive mapping in which bodies are more conspicuous by their absence than by their presence, while attaining a sublime lyricism that is neither as austere as that of Diebenkorn nor as agitated as that of de Kooning. Both de Kooning and Rice take us finally into the earth—they drive us into the ground!—but the former does so by forcible bodily immersion and the latter by gentle and numinous psychosomatic connection. The inelegant, grappling bodies on display in de Kooning's paintings bespeak a process of literal absorption in the earth and proclaim a new apocalyptic sublime; the psychical body implicit in the work of Rice edges toward a contemplative and serene sublimity. Both painters map absorptively in seeking a new version of the natural sublime, even if their manner of attaining sublimity differs tellingly.[13]

In such absorptive painting-mapping the viewer is thrust into the scenographic place-world of the work, thanks to the deeply immersed and immersing character of its content, its felt ingredient in land or sea or sky, its overall unrefusable attraction. Indeed, the ecstasy and serenity of paintings by de Kooning and Rice can be said to constitute the converse of Johns's map paintings. In these latter, there is a decisive reinstatement of an icon that, even as painted out, symbolizes a cultural world in which the individual person, His Majesty the Ego (in Freud's words), is regarded as supreme. In the paintings of Rice and de Kooning alike, the viewing subject is invited to leave his or her egocentricity behind so as to rejoin the greater natural world without and to realize an animated alliance between immanence and transcendence, psyche and soma—all this sublimed to the very threshold of human experience. At this threshold and beyond it, painting and mapping stage one of their most intimate and evocative scenarios of collaboration.

Epilogue

WHEREFORE EARTH-MAPPING?

What distinguishes the map from the tracing is that it is entirely oriented toward an experimentation in contact with the real. . . . It fosters connections between fields, the removal of blockages on bodies without organs. . . . The map has to do with *performance*, whereas the tracing always involves an "alleged competence."—*Gilles Deleuze and Félix Guattari,* A Thousand Plateaus

Spatial concepts can only effectively predict these results by becoming active themselves, by operating on physical objects, and not simply [by] evoking memory images of them.—*Jean Piaget and Bärbel Inhelder,* The Child's Conception of Space

The Many Avatars of Earth-Mapping

If maps and paintings are considered as ways of representing the world in images drawn or painted on flat paper or canvas, they seem very different from each other, without common ground. It is tempting to think that a painting is a colorful rendering of the world as we perceive it, capturing it in a tableau that, however dynamic it may be in its coloration or movement, fixes the painter's vision in a lasting way. Hence we "hang" paintings on walls, as if they were just so much dead weight; we put them, thus immobilized, into living rooms and museums as if they were so many embalmed objects to be preserved just as they are—or rather *were*: were at the moment of being finished in the artist's eye or by her hand. Maps, too, we regard as mere objects, completed once and for all, then deposited in printed atlases or, sometimes, hung on walls for decorative purposes. On this view, maps are quite literally stillborn: once published, they are taken as definitive representations of the known world; they stand as authoritative renditions of this world—until corrected by other maps (or later editions of the same map) that claim even greater representational authority. Construed thus, a map is a statement about the way the world is. It is a literally object-ive claim in linear form about a supposedly settled state of affairs (e.g., a route system, a group of mountains, etc.).

Regarded as objects to be hung on walls or included in books and seen as alternative modes of representing the world, maps and paintings have strong affinities to each other. But it is precisely in the domain of objective representation that they also part ways in a definitive manner. For maps trump paintings when it comes to accuracy of representation; their formidable armamentarium of metrically exact techniques for measuring and reproducing the lay of the land keep them a step ahead of paintings when it comes to the depiction of space.

This was not always so: before the eighteenth century in the West, what were called landskips and other topographic paintings (including those painted by J. M. W. Turner in his early career) were as much prized as maps for their delineation of particular landscape features. The advent of modern mapping techniques, along with the rise of romantic sensibilities in painting (to which Turner's later paintings contributed so significantly), changed all this. From that point onward (e.g., the middle of the nineteenth century), paintings and maps went their separate ways as two diverse means of representing the earth and its many landforms. The scientific status of the one came to be seen as increasingly antithetical to the inspired direction of the other. (I return here to themes first broached in the prologue.)

Curiously, it was when painters turned away from earlier aims of representing the natural world in some recognizable and reliable way that they cleared the way for a renewed convergence with mapmakers. In part, this was due to their willingness to acknowledge that maps, and more particularly photographs employed as maps, were bound to win out in any contest for verisimilitude of representation. In part, it was due to an increasing interest in eclecticism in art, breaking down traditional boundaries of what is art and what is not and importing into art what did not traditionally belong there, including *objets trouvés* as well as poetry and political comment and philosophy (Dada, surrealism, conceptual art), not to mention photographs and maps themselves. In the rising experimental spirit of a specifically "modern" art, the doors were flung open to former rivals or supposed enemies of painting and new forms of collaboration arose, for example, the extensive use of photography by artists as diverse as Man Ray, Robert Rauschenberg, Chuck Close, and Andy Warhol.

This collusion between artwork of many sorts (most notably, painting and earth works) and mapwork has been comparatively recent, a creature of the past several decades. Without purporting to be a comprehensive survey of such collusion, this book has considered several of those in the conspicuous forefront of this collaboration, most notably, Robert Smithson and Michelle Stuart, Eve Ingalls and Jasper Johns. Each of these artists makes express use of maps in his or her work. Others I have considered may not make use of recognizable cartographic inscriptions, but they nonetheless employ mapping techniques such as aerial views, grids (including parallels and meridians), projections, and the like. They are mapping even if they are not importing or displaying conventional maps. As Margot McLean remarks in reference to her work, "I don't like to talk of maps but of *mapping*."[1]

This statement of McLean's is telling. It points to something at stake throughout this book, namely, the crucial importance of mapping regarded as an activity of certain artists who refuse to stay within established bounds of painting. We have seen evidence of this activity at every turn and in many different forms. Sometimes, it has occurred in the specific form of remembering places and bringing their presence to bear in the artwork. This obtains for McLean herself: memories of her adolescent home in Virginia were sustained by the materials she brought back to her New York studio from that home-place. These *souvenirs*, preserved in transparent plastic bags on the walls of the studio, constituted a first level of mapping—a concrete synedochal relation to her past in the workplace of her present life. A second level was achieved when the same materials were incorporated into paintings of the early 1990s, such as *Virginia* (Plate 2), which brings soil and leaves from her former home-place into its very constitution. These materials allude to a past and a place without designating them in any strict sense. This is memorial mapping in which a painting does not represent something but commemorates it.

In an equal but opposite move, Michelle Stuart maps in an imaginary mode. Her Mariners Chart (part of the larger installation *Sacred Precincts*: see Figure 4.6) projects possible South Sea islands and dotted lines of imaginary voyages between them. There is a commemorative edge to this chart insofar as it alludes to the part of the Pacific where the ill-fated *Essex* was stove by the whale that became the inspiration for Melville's *Moby Dick*. But unlike *Virginia,* Stuart's work does not look back primarily; it looks out onto an entire imaginative world that rejoins the literary world, where virtually anything is possible. It maps by charting in the special sense I have given to this term (in contrast with plotting, which is tied to the actualities of land or sea): it maps out an open future of possible happenings in which earthbound actualities no longer constrict the imagination. Much the same sensibility (though conveyed by a very different way of working) is found in de Kooning's paintings of the beach and ocean on the southern shore of Long Island, for example, *Montauk Highway* and *Door to the River* (Plates 24 and 28). Here, too, the realm of the possible beckons: the vividly colored land- or seascape invites movements as free as those laid out in Mariners Chart.

All such movements, whether oriented to the past or the future or linked to the actual or the possible, can be considered "psycho-kinetic." By this term I mean motions of the mind taken in the expansive sense of psychical outreach. This outreach, which occurs at the level of feeling rather than of intellect, is not only into temporal modalities such as past or future. It also extends into spatial situations that involve direction and distance, near sphere and far sphere, the earth under foot and the horizon out there. Into each of these parameters of place the psyche feels its way and gains orientation. Feeling at the level of psyche—not to be confused with emotion—is able to enter into the particularity of place in the midst of open stretches of space. It has a genius for sensing what is special to a place and for moving itself, on the wings of memory or desire, into that place. Psycho-kinetic motion,

then, is any such movement that occurs by the amplification of psychically based feeling. This is a movement that, true to its name of origin *(kinēsis)*, does not merely move through space without effect but *changes* what it moves through—changes it from within, alters its very character. Artworks are the testimonials of such change. They map out what happens to paint and other materials such as dirt or rock when they are invested with the psycho-kinetic motions of the artist.

To talk of mapping is thus to talk of motion, and to begin with the feelingful ingression of the artist's imaging psyche into his or her chosen or found materials.[2] But the more complete activity of mapping in paintings and other artworks requires the commensurate motions of the artist's body. To paraphrase Paul Valéry once again, the artist "lends his body" to the painting he creates.[3] Here, lending is not just loaning for a certain period of time, say, that of the creation of the work; it is more like a permanent donation in which the body's active contribution remains evident as long as the work itself lasts. This contribution is that of animating matter. The active gerund locution, "mapp*ing*," alludes to such animative motion, a somato-kinetic power that prevails in paint or stone, soil or glass, earth or water.

In part I, we looked closely at the literal movement of the artist's body out of the studio or gallery. Robert Smithson led the exodus with his excursions into abandoned quarries and industrial wastelands in New Jersey—another world in comparison with the sophisticated spaces of New York City. He went in search of a "site," a real place where the body could interact directly with matter, whether natural (e.g., stone) or man-made (e.g., slag).[4] So too Michelle Stuart has traveled to exotic places far from her studio—to the Galapagos Islands, to New Zealand, to Alaska, to Sweden. Ingalls lives in the wilderness of Idaho each summer, and McLean has visited the Orinoco region. Other artists may have traveled less far, but they too sought the *other place* that would inform their work back in the known place of the studio: de Kooning bicycled to the ocean in Springs, Long Island, only a few miles away, while Gellis walks across Manhattan to the Hudson River.

What matters, however, is not the literal trip, the displacement of the artist's body in geographic space: that way lies the transportational essence of *phora*, the other Greek word for "locomotion." Travel is important not merely as "going from one point to another" or for the sake of the exotic—or even as a way to obtain materials, important as this collection may be—but for the opportunities it offers to *immerse oneself more thoroughly in matter.*[5] And that immersion can occur just as well in one's own home-place: on the Madison marshes where Dan Rice lived, or even pacing back and forth in one's studio (as has been the habit of many artists, including de Kooning and Johns). What matters is to move in the midst of matter, to become attuned to it and to enter into intimate embrace with it. This embrace need not be as ecstatic as that of Robert Smithson's in his discovery of the site for the Spiral Jetty in Utah. Just as literal transportation to a faraway place is

not required, so such psychical transport before matter as Smithson experienced it is not necessary either. What is needed for the bodily engagement that is at play in active mapping is something more modest, yet of decisive importance: to feel oneself, bodily as well as psychically, at one with the materiality of one's immediate environs: to bring one's own body into synchronous relation with the world's body, to be the world in which you walk.[6] This can happen at the edge of the Great Salt Lake or in the Cook Inlet in Alaska, but it may also take place just outside your own apartment, where, like Sandy Gellis, you collect the daily results of rain. It can occur anywhere, even where you are just now sitting. As long as the experience is intense and intimate enough, mapping will occur.

The body at stake in mapping, then, is not the vehicle of meta-phoric motion or literal transference but the lived body engaged in matter. But this does not mean that the body is passively merged with matter, regarded merely as an obdurate mass. Instead, it is matter's animator, converting it from something lying before oneself ("dross") to material for art ("subtlized matter"). Such a body is the subject of mapping in the second sense of "concrete mapping," as discussed in the concluding remarks to part I. It is also the body of "absorptive mapping," as set forth in part II. The bestraddling of earth found in de Kooning's painted figures constitutes a unique way of becoming immersed in the earth, becoming part of the depth of its surface. No proud walking here—no striding over the earth with Promethean prowess. Not even an ordinary upright posture. Instead, a leveling with the earth is presented, coming to terms with its materiality at *its* level, getting down on all fours and "getting dirty." This impressing of the body into the earth has its counterpart in Ingalls's recent body sculptures, made from soft but fast-drying material into which she presses parts of her body. Just as these body parts are absorbed into the plasticene substance, so de Kooning's writhing bodies are absorbed into the earth over which they crawl so awkwardly yet with such resolve.

Such concrete, absorptive bodily movements are frankly inelegant. They contrast with the deft and highly skilled movements of the cartographer's hand, which traces out pregiven shapes with such unerring precision. The extraordinary hand-eye coordination of the professional mapper gives way to the loose and unwieldy motions of the corpulent body, its uncontrollable flesh arrayed against the equally unmannered flesh of the earth. And yet, mapping is going on in such motions. Even if not recognized by cartographic officialdom, this is a mapping that every/body—everyone in his or her fleshly existence—knows to be happening all the time in human experience. Every time we make our way across the merest plot of earth, our bodies map out the movement, tell us the way to go, report to us the "coefficient of adversity" we encounter therein.[7]

Since cartographers take no interest in this unofficial and often inefficient course of action, and since most human beings take it for granted, it remains for artists to underscore its importance. Contemporary artists in particular are sensitive to its potentialities for mapping. For them, mapping is anything that pushes out the limits

of their chosen medium while retaining an allusion to the earth. Such mapping "permits a kind of excavation (downward) and extension (outward) to expose, reveal, and construct latent possibilities within a greater *milieu*."[8] For the artists considered in this book, this greater milieu is the earth, and they see their own activities as speleological soundings into its depths by means of their own bodies—depths that are to be found on the earth's surface.[9] At least four of the artists with whom we have become acquainted literally dig into the earth (Smithson, Stuart, Gellis, McLean), and the others do so in effect.[10] Any mapping they do in this bodily excavation into the earth is meant to manifest its true depths, not to demonstrate cartographic correctness on the paper surface of a map: "One does not *impose*, but rather *exposes* the site," says Smithson.[11]

These same artists suggest that mapping, fully considered, is at once psychical and somatic—and in both ways, kinetic. Just as it changes the surface of the artwork (e.g., as when Stuart pounds and perforates the surface of rag paper, making it into something itself earthlike), so it changes its bulk and shape, its heft. Earth works in particular are hefty amassments of soil or rock, grass or trees, that reconfigure already existing things on earth. Sometimes the reconfiguring is very slight, as in Richard Long's creation of walking paths across open fields by repeated walking back and forth or in Andy Goldsworthy's delicate and ephemeral arrays of flowers set out on rivers and streams. Sometimes it is massive, as in *Spiral Jetty*, where earth has been moved and removed to create a lithic vortex rising from the water. As the two-dimensional surfaces of paper and canvas are left behind, we move closer to sculpture as well as architecture.[12] Despite their departure from the domesticity of flat processed surfaces, the aim of earth (and land) artists is not to alter the surface of the earth in any permanent way. Indeed, an earth work is meant to subside with time, to be taken away (as in Christo's cloth fence in Sonoma and Marin counties in northern California),[13] to sink back into the earth, or even to be allowed to fall under water (as in the case of *Spiral Jetty*). What matters is that matter has been reanimated and redirected in such a way that "maps of material, as opposed to maps of paper,"[14] have been set forth on earth, whatever their lastingness and without regard to questions of accurate representation.

These quasi-sculptural or semi-architectural productions are three-dimensional earth-maps. But in fact every artist we have considered, painter or earth artist, creates earth-maps, whether on paper or canvas or straight on the rude earth itself. These artists, despite their diversity, share at least four basic attitudes: (i) respect for the earth and its surface formations; (ii) willingness to immerse oneself kinetically in the earth, whether by way of psychical insinuation or bodily insertion (often, by both modes of ingression into matter); (iii) a commitment to creating material maps, whether from canvas, paper, rock, soil, or water; (iv) a passion for performance, not in the sense of "performance art" (in which the artist's body and/or others' is theatricalized), but as entailing an active engagement with the materials at hand and the earth under foot.

Performing Matter Productively

I take "performance" in Deleuze and Guattari's sense of an activity that exceeds any mere tracing of a prior or underlying reality and that has a life and directionality of its own. As James Corner reformulates the claim cited as the first epigraph to this epilogue:

> Mapping is neither secondary nor representational but doubly operative: digging, finding, and exposing on the one hand, and relating, connecting, and structuring on the other. . . . In this sense, mapping is returned to its origins as a process of exploration, discovery, and enablement. . . . Like a nomadic grazer, the exploratory mapper detours around the obvious so as to engage what remains hidden.[15]

Tracing is tied to an existing object—to its edge and shape, to what is literally superficial, the *superficies*, the outer surface that does not contain depths of its own. The line that does the tracing is bound to the configuration of the surface construed in this delimited sense. Plato claimed that form or shape *(eidos)* is "the outer limit of a solid object."[16] Tracing is eidetic replay. It is the basis of much standard cartographic mapping, which hews to what is already known—and known for sure—about the collocation of a given group of sites. Its epitome is the contour map, which traces out the exact shapes (via the comparative heights) of land masses by a series of continuous lines.

Performance, in contrast, is finding the form *through (per-)* experimental action. Instead of seeking to copy an existing shape, it discovers and creates new shapes by its own activity. This activity is that of the whole body, not just the hand and eye, which are the exclusive implements of tracing. Even in its ordinary acceptation, *performance* implies getting the lived and moving body fully into the act: making it *operative* and not just *operational*. When Michelle Stuart rubs soil into rag paper, she sometimes puts the paper over an object such as a stone or even a piece of metal. These objects exert their influence, they make their presence felt; yet they are not simply traced out. Stuart does not seek to reproduce their outline as if this were a detachable property that her skillful hand could lift off the object and transfer to the surface of the paper: as in the fantasy of perfect replication that underlies so much of scientific cartography as well as hyperrealism in painting. Instead, her entire body is engaged in the arduous procedure of rubbing, which consists of pummeling and pounding with her whole arm (not just the hand), bestriding and straddling the paper with her body, and many other concerted movements of her lived body. This body elicits new forms from its total engagement with the matters at hand—paper and soil. These matters are as indeterminate as matter is for Aristotle: in his view, matter is the very potentiality *(dynamis)* for form. Hence it solicits activities that invite form to join up with it, to give it shape. Bodily engagement is per*form*ative in the very sense intended by Deleuze and Guattari: "an experimentation in contact with the real."

Mapping is performative in another, closely related sense. It is *productive*. A map regarded as a tracing is reproductive of existing objects and structures; experiment has little or no part in its sober creation. This is doubtless why Borges lampoons such tedious sobriety with his fable of a map that had a scale of 1:1 and thus covered an entire region point by point, rendering it otiose to begin with.[17] A productive map, on the other hand, does not suffer from any such strict mimetism; it is more economic and selective; most important, it elicits new forms, even entire new worlds, from the region it maps:

> The distinction here [i.e., Deleuze and Guattari's distinction between tracing and mapping] is between mapping as equal to what is ("tracing") and mapping as equal to what is *and* what is not yet. In other words, the unfolding agency of mapping is most effective when its capacity for description also sets the conditions for new eidetic and physical worlds to emerge. Unlike tracings, which propagate redundancies, mappings discover new worlds within past and present ones; they inaugurate new grounds upon the hidden traces of a living context. The capacity to reformulate what already exists is the important step.[18]

Reproductive mapping, then, is the tracing of *what is already the case* and is bound to existing shapes and surfaces—a matter of formal eidetics. Active or productive mapping brings out *what is not yet the case,* thanks to its experimental and performative spirit. But production is not of the new in detachment from the known; as the word *pro-duction* itself says, it "draws out" new directions from the known, "new grounds," whole new realms. Hence, it is a matter of a material eidetics that "re*form*ulates" what already exists, drawing new forms out of extant matter. In contrast with abstraction, which literally "pushes away," production *leads out*. In the case of mapping, it leads novel shapes (contours, boundaries, etc.) out from the actual landscape, thus from within the immanence of earth. Productive mapping *reshapes the earthscape.* The productive process here at stake is neither that of the free-floating imaginary of pure possibility nor the sheer virtuality posited by cyber-technology. This is a deliberately primitive productivity that finds the unexpected within the expected, for example, in new ways to map the same old terrain: an unprecedented spiral structure in an ancient salt lake.

Mapping that is more than mere tracing is productive in three major ways. (i) First, it manages to *re-present* its subject matter in innovative and unanticipated ways instead of merely representing it as it is and has been. This is effected by such steps as literally including earthen material in the mapwork, giving it a new and second life there: rocks from open quarries in specially made boxes, water from the Hudson River in jars, leaves from a special place that are incorporated into paint. (ii) Such mapping *re-implaces* parts of the landscape in strikingly new manners. The marshlands of the Connecticut shore, certain mountains in Idaho, the land at Ocean Park, a house lot in Virginia, a remote farm in New Zealand: all of these

are relocated in artworks we have considered. These works offer new places for perceived or remembered landscapes—new scenes in which they can be relocated. Just as they do not merely represent them according to criteria of comparative likeness, they also do not reposition them either. They create new aesthetic and eidetic worlds in which previously encountered domains of experience can find new significance. (iii) By the same token and in the same productive process, the artworks under examination in this book, whether paintings or outright earth works, effectively *re-embody* their artists and viewers. Given their power to solicit full engagement, at once psychical and somatic, they provide new senses of being. As these senses are in effect potentialities of the lived body, we have to do with the dynamics of matter, the potentialities it holds within itself that are liberated in the productions of art. Such potentialities contrast with the habitualities of routinized bodily conduct that concern overt behavior, thus the manifest actions and external surfaces of the already consolidated body.

We can sum up the contrast between productive and reproductive mapping—and their analogous formations in artworks that map—in this schematic way:

Productive Mapping	Reproductive Mapping
Re-presentation	*Re*presentation (i.e., replication)
Re-implacement	Repositioning
Re-embodiment	Repetition of form

Creative Conjugations of Art and Maps

This book has been an extended meditation on the mixing of art and maps; we have savored the uncertain but ongoing promise of this commixture as well as the actual achievements of those who create artworks and who map at the same time. Not only have we witnessed the dissolution of any dogmatic binarism between making art and making maps, as if the two were antithetical or incompatible enterprises, but we have also seen each enhanced by the other. Gadamer claims that all significant art brings with it an "augmentation of being" *(Seinszuwachs),* and if this is so it is especially true for art that brings mapping into its domain. This has happened before, in Northern Sung scroll paintings that are in effect maps, in nineteenth-century Japanese mapping that is equally an art form, in Vermeer's remarkable employment of maps in his paintings (most notably, *The Art of Painting*).[19] But in the last thirty years in America there has been a virtual explosion of experimentation in the creation of earth works and paintings that map. But just how has there been mutual enrichment between such very different activities as making art and making maps?

If painting is not to be utterly self-absorbed—as it almost became in the middle 1960s in the more extreme forms of abstract art—it needs to have a certain quasi indexicality. Not indexicality as such, as would befit topographical realism in

Canaletto's paintings of Venice or Turner's early renditions of the Alps or Cole's view of an oxbow in the Connecticut River. This way lie the snares of isomorphic *re*presentation, repositioning, and formal repetition: visual reproduction, in short. But *quasi* indexicality is something else again; this amounts to a gesture toward accurate representation and exact reproduction, yet no more than this, and even so often an ironic or self-undermining gesture. When Smithson presents rocks from Franklin, New Jersey, in trapezoidal wood bins that correspond to sections of an aerial photo-map of the site from which the rocks were taken, this is not in the interest of establishing simple location, not even if the size of each rock bin is in fact proportional to the size of one of the areas shown in the photograph. If we consider a work such as *Non-site, Franklin, New Jersey* (Figure 1.2), it is clear that its quasi exactitude does not serve the interests of geographic truth. Despite the actuality of the rocks, the naming of their place of origin, and the reliable cartographic representation of this origin, something else is happening in their re-presentation in the gallery space. The non-site in the gallery is not a straightforward index of a preexisting site; no such one-way indexical relation obtains between the artificiality of the non-site and the naturality of the site. Instead, there is (in Smithson's own preferred word) a "dialectics" between the two in which both are caught up. The non-site indeed includes a "map" of the site, but it is a strange map, since it is cut up in trapezoidal shapes that mimic the forms of the boxes of rocks below it. The result is a double containment that closes off non-site from site. Mapping here thrives as much on difference as on similarity: the original site in New Jersey is not composed of trapezoids! Neither indexicality nor iconicity in any strict sense is present. Yet mapping is going on, and the viewer is intrigued and moved by the irreverent and indeterminate combination of site and non-site.[20] In particular, what would otherwise be mere boxes of rocks gain from their quasi-indexical reference to the site—thanks very much to the presence of the map—while the map itself gains allure and intrigue from the unconventionality and ingenuity of the boxed-in installation. Artwork and mapwork are both augmented in their ironic interchange.

What does mapping gain more generally from its association with earth works and paintings? In earlier times, one would have said: pictoriality and coloration and figuration. (I refer to eighteenth-century English and French maps that were enlivened by color tinting, not to mention sixteenth- and seventeenth-century maps that displayed "topographic views" of cities and other notable locales along their edges.) But today? I would suggest such very different gains as the texture of the medium and the expressiveness of the image. Johns's painting-maps of America are cases in point (Plates 20 and 21). These embellish a conventional atlas map of the United States with freely applied thick paint whose very surface tempts the viewer to touch it; and the blurring and slashing of state boundaries, their painting out, gives to the overall image an intensity and energy altogether missing from the Rand McNally original. The result is not just an expressive painting but also a map that has been significantly transformed in the process: what was once a map in an ordinary road atlas has

become an instance of *mapping* in the strong performative sense discussed above. Much the same can be said of the would-be continents in McLean's *Blackbirds* (Plate 7): these have become painterly presences with a life of their own that exceeds their delimited geographic origin.

In the end, the quasi indexicality that such mapping and remapping techniques lend to paintings or earth works and the aesthetic aura that imaginative art adds to maps conjoin and collaborate closely in the most convincing cases. These include not only such salient instances as those of Johns and McLean and Smithson but many others as well. The use of photographs of sites by many contemporary artists, for example, brings about a comparable effect of mutual aggrandizement: as we see in Stuart's *Passages: Mesa Verde* (Figure 4.3), where the photographic images of prehistoric cliff dwellings lend geographic specificity to the utterly indeterminate rubbed paper situated between them as well as the unlabeled rock books below. The paper and the books alike extend the subject matter of the photographs beyond their literal pictorial identity—beyond into the work as a whole. This is not an installation of photos *plus* indeterminate objects but a *Gesamtkunstwerk* ("total work of art") with several conjointly animating parts.

Even when there is no obvious maplike presence at all, not even in the form of photographs that survey a given scene, we may witness a significant interanimation of painting and mapping. This is surely the case with Rice's contemplative paintings of the marshland surrounding his studio: these map as much as they paint (see Plates 29–32). Not merely tracing whereabouts, they reveal the dynamics of engagement that belongs to the performance of mapping. They put the actual body of the painter and the virtual body of the viewer into an intimate cont(r)act with the inert matter of paint and the living materiality of the marsh. The mapping and the painting converge in an experience of landscape that is absorptive and not abstractive. Such absorption, which belongs to all truly concrete mapping, is also evident in de Kooning's landscape paintings, in which barely recognizable human figures guide us toward a deep absorption in the earth.

Four Remaining Questions

Certain basic questions remain. Who is the subject of such intertanglements of earth works, paintings, and maps? What is being worked or painted or mapped? How does this happen? Where is it happening? Here, I can only sketch out brief responses to these four quandaries.

The question of *who* is the question of the human subject who creates a map as an artwork and vice versa. This is any artist who chooses to invest himself or herself in the earth through creative work—to do *earth art* in a sense broad enough to encompass painting as well as "earth works" in the narrower meaning familiar to admirers of Smithson, Heizer, Oppenheim, Holt, De Maria, Goldsworthy, and others. *To find oneself in the earth*: that is an insistent aim of an earth-oriented artist.

This means in turn: *finding the earth as oneself,* that is, finding that one's own deeper identity and interests are held in a common trust with the identity and interests of the earth. Several artists under scrutiny in this book have contributed directly to the cause of environmental activism—Smithson, Gellis, McLean, Ingalls, and Stuart—while the others are deeply sympathetic to the goals of this movement. But what is significant here is not political action as such but the profound link between the artist's self, the ultimate *who* who he or she is, and a sense of the earth as an organic entity with distinctive vulnerabilities that must be heeded. When Smithson planted mirrors in the ground in the Yucatán, he removed them immediately afterward, restoring the ground to the condition in which he first found it. Gellis is determined not to tamper with the course of events on earth; hence, her water works stem from the sheer reception of rain or the bottling of limited samplings of the Hudson River. The Idaho landscape is left intact by Ingalls as she walks through it in search of scenes to paint. Animals and plants are co-denizens with humans on earth and are the subject of special attention on the part of McLean and Stuart, who make generous space for them in their work. In all such forms of earth awareness, these artists expand their subjectivity to reach out to the material identity of the earth and its inhabitants. The ultimate subject of their work is not limited to discrete objects positioned on earth, much less to their own isolated personality and its reactions, but extends to an encompassing self that is continuous with the earth on which it lives. The subjectivity of the viewer who is moved by this work undergoes a comparable enlargement into a larger sense of self that is sensitive to all that exists on earth—and to all that is above or below it.

What is being mapped or painted? Nothing other than the very same expansive sense of earth just discussed. But this "what" is no more reducible to a determinate substance than is the subject who creates (or views) the work. It is closer to Aristotle's notion of "prime matter": a matter that precedes any specification into the discrete identity of substance. This is a level of matter that borders on chaos yet is always part of some cosmos; it is matter as "chaosmos," in Joyce's jubilant term. We have seen how Stuart's later work brings us to this very point: a work such as *White . . . Moon Minister in the Marriage of Earth and Sea* (Plate 15) is situated on the very border between the ordered (these paintings being composed from an enormous rectangle made up of many smaller squares) and the disordered (as suggested by the wildly changing patterns, as seen close-up as well as farther away). Indeed, one and the same basic figure, the grid, provides both pattern and the basis for innovation.[21] This means that the ultimate *what* at stake is indeterminate with respect to this very choice—and to other dyads that tempt us to reduce the complexity of earth art to a binary description: form versus matter, self versus earth, close-up versus faraway, and above all painting versus mapping. A continuing theme of this book has been the undecidability of such bifurcated descriptions and the need to undo their stranglehold on our collective conceptual imaginations.

And *how* are earth works and paintings that map constructed? In no single way,

not even in a definite set of ways. If we have learned nothing else, we have seen that earth-mapping can occur with extreme variety. It ranges from traditional painting techniques (e.g., as employed by Ingalls and Rice, Diebenkorn and Johns, in their otherwise very different forms of landscape painting) to modifications thereof (e.g., the use of natural debris by McLean and Stuart). But it also includes the direct moving and reshaping of the earth independently of anything painted on canvas, transforming it into a three-dimensional earth work in the stricter sense (Smithson, Stuart, Gellis). Given such differences of material production, it is perhaps surprising that the nine artists we have examined in this book have so much in common. But they are deeply affiliated by virtue of their shared commitment to put art back in touch with the earth and to present a lively record of this reconnection in diverse modes of mapping.

Where, then, do such mappings occur? It is too easy to say "on the earth." This is certainly the case, but the same is true of much sculpture and virtually all architecture. Let us say instead that the earth works and paintings I have discussed find their place *in relation to the earth's surface,* a surface that has its own depths stirring just under its outer pellicle, whether this pellicle occurs in the form of topsoil or a rock-bound exterior or as the shimmering surface of seas and rivers. For each artist, the surface of the artwork—whether that of canvas or paper, or that belonging to a group of rocks or a jar of water—relates to the surface of the earth by means of a spontaneous mimesis that is an embodiment of a genuinely material eidetics. This mimesis is not to be reduced to the isomorphic projections of representational artworks, much less to the tracings of extant structures of the earth. It is a psychokinetic connection between work and world in which both are at stake—and in which both are changed by the interaction. The *place-world* is the larger scene of this interaction, the ultimate wherein of the mapping that artworks (paintings as well as earth works) realize in the bodily performances of artists such as those I have treated in this book. In the spatiality of this capacious world, new directions emerge from already known dimensions of experience: new worlds emerge, new works are created, a new vision of the earth itself arises. The familiar earth comes forth as if seen for the first time.

Fourfold Mapping Revisited

From the prologue onward, I have pointed to the differences among four kinds of mapping: mapping of, mapping for, mapping with/in, and mapping out. These modes of mapping remain relevant at this concluding point, even if they now call for modification and expansion in the light of the journeys we have taken in parts I and II.

(i) *mapping of.* This is mapping that attempts to delineate the precise lay of the land in terms of such specifiable parameters as shape and distance. As institutionalized, it is "cartographic" in the rigorous sense of being a tracing of territory, its exact extent and definite traits. Almost always it furnishes a view *in plan,* that is, a

view from above that purports to give the fullest and most objective picture of the land or sea below. Thus it implies both *taking distance,* in order to be as neutral as possible in visual assessment, and *determining distance,* that is, measuring the spatial interval between points. These points are preestablished and possess simple location; they represent determinate land- or seascape features (e.g., mountains, shoals) or human habitations such as cities or towns. Hence, their practical value as the basis for "trips" in the special sense I developed in discussing Michelle Stuart, that is, travel between known actualities in a known landscape. No wonder that travelers consult atlases and road maps for such information; they offer the most assured basis for deciding the best route to follow and how long it will take. Their reliable and steady character allows us to plot our way, where, once again, *plot* implies planning a trip from one definite place to another.

It is revealing that while we speak easily in English of a "map of X," we rarely say that we are engaged in a "mapping of X" unless we mean the cartographer's practice of creating a particular map. The objective genitive *of* fits best with a discrete object, a fully constituted map, rather than with the activity or performance of mapping—which we have seen to be what is most directly at stake in earth works and paintings that map. Since such works and paintings are at best quasi-indexical, they do not serve as objects that direct us to definite locations. Or if they do, it is only by an ironic gesture, as in Smithson's use of photo-maps in Figures 1.1 and 1.2 and of maps in other "non-site" works (e.g., Figure 1.4). Even if not intended ironically, however, the role of a map or photograph in an artwork is not locatory or orientational; nor does it offer geographical information for its own sake. At the most, it may serve as an acknowledgment of the source of materials or as designating the place of inspiration (as in Stuart's *Passages: Mesa Verde* [Figure 4.3], where both of these criteria obtain).[22] Even so, in the instances in which a recognizable map (or a photograph intended as a map) is employed, it does not direct us to leave the artwork or suggest that we should go somewhere else. It is part of the art itself.

(ii) *mapping for.* The last remark obtains all the more strongly for maps that are designed to tell you where to go in a delimited local setting—typically, maps that simplify (and even deliberately distort) the representation of the landscape in order to indicate more clearly the most effective single route from X to Y. In the case of an ordinary road map, all significant features are presented, including all viable routes; it is up to the map reader to decide which is the most expeditious to follow. In the case of the kind of map that is posted in the center of a city or on a college campus, only a few possible routes are displayed and these only to the most obvious destinations (e.g., the campus library, a hospital, the town hall). Such maps, then, are wholly utilitarian; they display information not for its own sake but so that it can be acted on in a very practical way in a given locale. Once an official cartographic map has been completed and printed in an atlas, its destiny is complete, whether it is subsequently used or not; in contrast, the aim of an orientational map is attained in its actual employment, its essence is wholly pragmatic, its meaning is its use.

Such maps are at the furthest remove from the work of the artists we have considered. Whatever mapping these artists do is not for the sake of telling viewers how to find a particular location. If a point of origin of materials or a locus of creation (e.g., Cook's Inlet, Alaska, the Great Salt Lake, Utah) is specified, this is not meant to suggest that the viewer should travel to this point or locus. Far from it! The earth-map itself is the destination of the viewer's visual voyage; it is an "intransitive object"[23] that is designed to attract and keep the viewer's attention throughout his or her engagement with it. It is not a matter of going from Here (the place of the work) to There (some other place, another destination in relation to Here). Instead, the viewer's look is meant to be invested just Here, in the work itself. This is true even if the work is in fact located in an open landscape, as in the case of many earth works. In that event, I go there in order to experience the work in its sheer Hereness, its unyielding otherness, its implacable implacement. This is not wayfaring, much less finding my way; it is the very fulfillment of any such finding or faring. I go to the Niagara River Gorge to see just how Stuart's ribbon of linked rag papers fits into that landscape, how it falls down over an escarpment that is partly natural and partly sculpted. Once there, I have found the only Here that matters; I need not go elsewhere but can remain with the work itself. The earth work has become a final stop in my journey as a beholder (see Figure 4.4).

(iii) *mapping with/in*. This third kind of mapping comes much closer to capturing what is happening in the earth works and paintings we have considered in this book. For these artworks map by way of exhibition rather than indication. Even the quasi-indexical character that obtains for some of these works operates by indirection; it does not really point us to a source or origin; or if it does, it is only by a gesture that falls away as soon as it is made; it does not persist as a pointer, as is required to be a genuine indicative sign, which possesses a consistent reality (*Bestand*, in Husserl's term) that motivates a steady belief in the existence of something else. We have to do, rather, with adumbration—literally, shadowing forth—in a situation of indirect signage.

When mapping that is genuinely *with/in* occurs, we encounter a situation very like what I have been calling immersion in matter. The *in* of mapping with/in concerns the way in which such mapping refuses to assume a detached position (e.g., the privileged bird's-eye view of the cartographer) but moves down into the very material it maps. The map is immanent in what is mapped; it sinks into the very matter it projects so as to reflect it better from within. This requires accepting matter on its own terms rather than those brought by prior or exterior considerations, such as accurate depiction or practical usefulness. Instead of imposing a map on the landscape, the artist-mapper exposes the landscape itself: shows it to be itself a map or maplike.

Such is the direction of what I have come to call *absorptive mapping*. In this kind of mapping, what matters most is the way the body of the mapper—and by invitation and identification, that of the viewer—is drawn into the mapwork, finding

his or her bodily bearings there. This is the corporeal analogue of Michelle Stuart's rubbings: just as the soil is absorbed by the muslin-backed rag paper as she presses it into the surface, so the experience of the artist becomes absorbed in the work. So much so that the separate identity of the artist melts down into the earth that is worked and reworked, mapped and remapped. As Smithson described his experience at the moment of first conceiving *Spiral Jetty*:

> All existence seemed tentative and stagnant. Was I but a shadow in a plastic bubble hovering in a place outside mind and body? *Et in Utah ego.* I was slipping out of myself again, dissolving into a unicellular beginning, trying to locate the nucleus at the end of the spiral.[24]

This kind of absorptive immersion, in which the mind and body of the artist (and, by projective identification, those of the viewer) become one with the body of the matter of the work, is also signified by the *with* of with/in. The human subject feels herself or himself to be very much with the work: at its level, living its way, feeling its textures and shapes. I as witness of the work become intimately close to it—and it to me. The critical withness is two-way in character: I-with-it, it-with-me. An indicative relation, by contrast, is always only one-way, from the index to the indicatum; thus the directionality entailed in "going in" signifies a movement of entering something from one area (typically designated as "outside") in such a way as to penetrate the area into which I am moving: a single directionality is at stake here. But when I am with something or someone in an immersed mode, each entity is qualified by the *with*: each is with the other and on equal terms in an engaged reciprocity.

Such bilateral withness lies at the core of earth-mapping. Body and work coexist with each other in an interdynamic manner: each bringing out the potentiality in the other. The two form an intimate dyad of inseparable partners who, in their very interaction with one another, realize mapping of a special intensity. Each sets the other to work—the work of earth-mapping.

(iv) *mapping out*. Each also draws the other out. This at-traction is an extending beyond the usual limits within which bodies and matter operate: limits of substance (metaphysically regarded), limits of physicality (materially considered). To map out is to reach out beyond these limits, to move into another, unaccustomed order. It is the emergence of this new order—this novel cosmos—out of ordinary materials (mud, rock, sand, etc.) that is of such moment in the works of the earth artists here discussed. They have not merely built something striking that stands out on the land or in the sea. What they have really done is to transmute matter in its most mundane forms into works that rise organically and not artificially from certain natural milieux: an ingenious circle of sand set out in the pond of an old quarry in Holland, lights beaming upward through dark waters to suggest a constellation thereby brought down upon earth, rainwater that has engendered richly diverse etchings on plates onto which it has fallen day by day, leaves and soil

brought bodily onto the very surface of the painting. These works map *out* in the precise sense that they take matter to its outer boundaries, where as transmogrified by the earth artist's active body it becomes an artwork. Much the same happens, albeit less dramatically, in the transformation of line or paint into an order of expression that is no less earth-rich in its significance. Mapping out here occurs by painterly means, as we see in the landscape works of Ingalls and Diebenkorn, de Kooning and Rice.

Mapping out in this expanded sense is not reducible to the tracing out of preexisting masses or structures. Such tracing out is merely a following of already determinate shapes, reproducing them as they stand, instead of experimenting with them, finding new forms within them, reconfiguring them. The settled habit of formulation, sticking to the given form, restricts "the capacity to reformulate what already exists." The redundancies of tracing foreclose the newness of mapping out different directions and discovering new worlds within the old. To retrace is to make a map *of* something already given and already known rather than traveling into the unknown.

To map out in a positive and productive sense means to undertake a voyage into the dark side of matter, into its potentialities—a voyage into what is not yet the case. It is to chart out one's course over uncertain waters. I here use *voyage* and *chart* in the meanings to which we are now accustomed; both signify moving into the possible rather than clinging to the actual. By the same token, mapping out is moving out into yet uncharted realms. It is to move with/in matter so as to move out of culturally confining or physically given limits. Instead of reiterating or reinforcing these limits, it is to re-implace and re-embody them in such a way as to extend or exceed them—and sometimes to undermine them: to call the limits themselves into question. It is to take them out of the arena of the commonplace and into new domains of possible experience.

This is walking on bulldozed rocks set out into a salt lake in the pattern of a spiral jetty (see Figure E.1). It is to move from the reassuring presence of the shore to a genuinely new place that calls for a new sensibility: not just a new way of walking, but a new way of feeling oneself, psychically and bodily, to be on earth.

> A dormant earthquake spread into the fluttering stillness, into a spinning sensation without movement. This site was a rotary that enclosed itself in an immense roundness. From that gyrating space emerged the possibility of the Spiral Jetty. . . . the flaming reflection suggested the ion source of a cyclotron that extended into a spiral of collapsed matter. All sense of energy acceleration expired into a rippling stillness of reflected heat. A withering light swallowed the rocky particles of the spiral.[25]

Here the earth work maps out stellar regions that exceed the limits of earth itself, even as they remain bound to these same limits as their "earth-basis."[26]

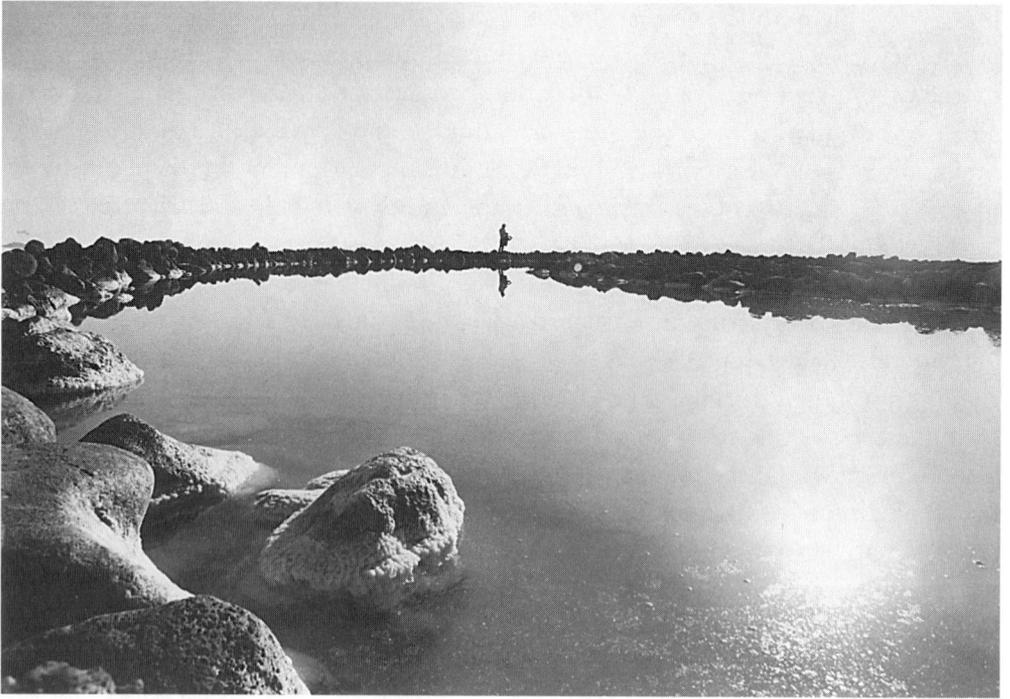

Figure E.1. Robert Smithson walking on the Spiral Jetty. Photograph by Gianfranco Gorgoni.

This brings us back to Robert Smithson's searching question: "Was I but a shadow in a plastic bubble hovering in a place outside mind and body?" In the end, Smithson answers his own question by his experiment of mapping out in a work entitled *Spiral Jetty,* which is situated in the Great Salt Lake. Far from being a mere shadow projected somewhere outside mind and body, in creating such a work Smithson was in a very particular place, Utah, and he was there body and mind in an experience that was nothing other than an *ecstasis*. The artist "stands out" from himself (i.e., in the literal sense of *ecstasy*) with/in his own production and by his own performance: he stands out in an unprecedented earth work that maps out land and sea in a new collaboration that brings about a new artwork, a new world for art. He is out there walking and mapping—feeling and savoring the world he has brought into being in an immensely expansive yet also most intense and intimate way.

NOTES

Prologue

1. For a more complete analysis of *The Oxbow,* see Edward S. Casey, *Representing Place: Landscape Painting and Maps* (Minneapolis: University of Minnesota Press, 2002), chapter 4.

2. "The earth is essentially self-secluding" (Martin Heidegger, "The Origin of the Work of Art," in his *Poetry, Language, Thought,* trans. A. Hofstadter [New York: Harper, 1971], 47). On the inside-out relation as obtaining for bodily immersion in the world, see M. Merleau-Ponty, *The Visible and the Invisible,* trans. A. Lingis (Evanston, IL: Northwestern University Press, 1968), 143: "For the first time, the seeing that I am is for me really visible; for the first time I appear to myself completely turned inside out under my own eyes."

3. Rilke's words occur in the celebrated letter of 1925 to his Polish translator: "the earth has no other refuge except to become invisible: in us, who, through one part of our nature, have a share in the Invisible" (see Rainer Maria Rilke, *Duino Elegies,* trans. J. B. Leishman and S. Spender [New York: Norton, 1963], 129). In a remark to which we shall have occasion to return, James Hillman says, "The invisible is as important as the visible. And I see [Margot McLean's] paintings as . . . about what I call the invisibles. The invisibles that have been forgotten and passed by" (James Hillman and Margot McLean, *Dream Animals* [San Francisco: Chronicle Books, 1997], 6). See also Véronique Fóti, *Vision's Invisibles: Philosophical Explorations* (Albany, NY: State University of New York Press, 2003), especially part 3.

4. Gilles Deleuze and Félix Guattari, *A Thousand Plateaus,* trans. B. Massumi (Minneapolis: University of Minnesota Press, 1987), 371. The authors add: "Homogeneous space is in no way a smooth space; on the contrary, it is a form of striated space. The space of pillars. It is striated by the fall of bodies, the verticals of gravity, the distribution of matter into parallel layers, the lamellar and laminar movement of flows. These parallel verticals have formed an independent dimension capable of spreading everywhere, of formalizing all the other dimensions, of striating all of space in all of its directions, so as to render it homogeneous" (370). The deep link between dimensionality and the concept of an absolute, infinite space is traced in Edward S. Casey, *The Fate of Place* (Berkeley: University of California Press, 1997), chapters 4 and 5. The more abstract and all-encompassing the idea of dimensionality becomes, the more the notion of an infinite empty space is called for, and the more the characteristically early modern paradigm of site is approximated.

5. The nomad "distributes himself in a smooth space; he occupies, inhabits, holds that space; that is his territorial principle. It is therefore false to define the nomad by movement. Toynbee is profoundly right to suggest that the nomad is on the contrary *he who does not move.* . . . Of course, the nomad moves, but while seated, and he is only seated while moving" (Deleuze and Guattari, *A Thousand Plateaus,* 381; their italics).

6. The *relative global* is "limited in its parts, which are assigned constant directions, are oriented in relation to one another, divisible by boundaries, and can interlink." The *local absolute,* in contrast, is "an absolute that is manifested locally, and engendered in a series of local operations of varying orientations: desert, steppe, ice, sea." (Both citations from ibid., 382.)

7. On this distinction, see ibid., 381. Concerning the relationship of speed to art, consider the remark of Richard Tuttle to the effect that "art is about differences of speed; otherwise, it would be advertising" (quoted by Eve Ingalls in conversation, June 28, 1999, New Haven, Connecticut).

8. Heidegger, "The Origin of the Work of Art," 46. He adds that "to set forth the earth [in a work of art] means to bring it into the Open as the self-secluding" (47).

9. I here allude to the close tie between thrownness *(Geworfenheit)* and mood (*Stimmung*: with connotations of attunement) as these are discussed in part 1 of Martin Heidegger's *Being and Time,* trans. J. Macquarrie and C. Robinson (New York: Harper and Row, 1962), sections 28–38. *Thrownness* reappears in "The Origin of the Work of Art": "Truth is never gathered from objects that are present and ordinary. Rather, the opening up of the Open, and the clearing of what is, happens only as the openness is projected, sketched out, that makes its advent in thrownness" (71). On the flesh of the world, see Merleau-Ponty, *The Visible and the Invisible,* chapter 4 and Working Notes from the same volume (especially that of May 1960).

10. On the intimate dyad of body/place, wherein each calls for the other, see my *Getting Back into Place: Toward a Renewed Understanding of the Place-World* (Bloomington: Indiana University Press, 1993), 150–55.

11. *Part* here does not mean a detachable "piece" but an integral element or "moment" of a perceived whole. For this distinction, see Edmund Husserl, *Logical Investigations,* trans. J. Findlay (New York: Humanities Press, 1970), Third Investigation, "The Logic of Wholes and Parts."

12. Indeed, there are signs that this openness is now occurring in fertile discussions among cultural geographers. See, for example, D. Cosgrove, *Social Formation and Symbolic Landscape* (London: Croom Helm, 1984); J. Nicholas Entrikin, *The Betweenness of Place: Towards a Geography of Modernity* (Baltimore: Johns Hopkins University Press, 1991); R. D. Sack, *Homo Geographicus* (Baltimore: Johns Hopkins University Press, 1997); and my unpublished paper, "Between Geography and Philosophy: What Does It Mean to Be in the Place-World?" (invited address to the Association of American Geographers, Boston, 1998; revised version published in *Annals of American Geography,* December 2001).

13. John Marin is exceptional in having produced genuinely cubist renditions of particular places, for example, Deer Isle, New York City, and the mountains of New Mexico, without indulging in the temptation of telling a story. The same is true for Monet's late impressionist paintings of a single place, such as Giverny.

14. See Casey, *Representing Place,* part 1.

15. For a parallel, but not precisely the same, set of distinctions, see my discussion of place at, place of, and place for, ibid., 30–31.

16. Edmund Husserl, "The Origin of Geometry," appendix to *The Crisis of European Sciences and Transcendental Phenomenology,* trans. D. Carr (Evanston, IL: Northwestern University Press, 1970), 353–78. See also ibid., section 9, "Galileo's Mathematization of Nature."

17. See Marvin Levine's various studies of such maps and their paradoxes: M. Levine, "You-Are-Here Maps: Psychological Considerations," *Environment and Behavior* 14 (1982): 221–37; M. Levine, I. Marchon, and G. Hanley, "The Placement and Misplacement of You-Are-Here Maps," *Environment and Behavior* 15 (1984): 139–57.

18. I here give in effect Husserl's definition of an indicative sign, namely, a sign such that "certain objects or states of affairs of whose reality *(Bestand)* someone has actual knowledge indicate to him the reality of certain other objects or states of affairs, in the sense that his belief in the reality of the one is experienced . . . as motivating a belief or surmise in the reality of the other" (Husserl, *Logical Investigations,* I: 270; mostly in italics in the original).

19. See Alfred North Whitehead, *Process and Reality: An Essay in Cosmology,* ed. D. R. Griffin and D. W. Sherburne (New York: Free Press, 1978), 62–64, 81, 170, 173, 311–12, 333.

20. As Erwin Straus says, "In the landscape I am somewhere"—that is, in a particular place in that landscape (Erwin Straus, *The Primary World of Senses,* trans. J. Needleman [Glencoe, IL: Free Press, 1963], 321; see also: "In a landscape we always get to one place from another place," 319).

21. On "major science," that is, "royal" or "state" science, see Deleuze and Guattari, *A Thousand Plateaus,* 108–9, 361–74. Such science contrasts with minor or "nomadic" sciences such as hydraulics or metallurgy in the early modern era.

22. The van Linschoten and Keisai maps are Plates 15 and 16, respectively, in *Representing Place.*

1. Mapping with Earth Works

1. For a treatment of various metaphorical depths, including the chthonian, see James Hillman, *The Dream and the Underworld* (New York: Harper, 1979), 23ff.

2. See Smithson's own survey of his contemporaries in his essay "Sedimentations of the Mind: Earth Projects" (1968), reprinted in Robert Smithson, *The Collected Writings,* ed. Jack Flam (Berkeley: University of California Press, 1996), 100–113.

3. See Gary Shapiro's remarkable study *Earthwards: Robert Smithson and Art after Babel* (Berkeley: University of California Press, 1995).

4. From Smithson, "The Spiral Jetty," in Smithson, *Collected Writings,* 150: "Back in New York [from Utah], the urban desert, I contacted . . ."

5. See Smithson's discussion of the picturesque in Uvedale Price and William Gilpin, regarded as predecessors of Frederick Law Olmsted, in his essay "Frederick Law Olmsted and the Dialectical Landscape" (1973), in Smithson, *Collected Writings,* 159–60.

6. See Smithson's revealing early essay, "A Tour of the Monuments of Passaic, New Jersey" (1967), in Smithson, *Collected Writings,* especially 70–73.

7. Smithson, "A Sedimentation of the Mind: Earth Projects" (1968), in Smithson, *Collected Writings*, 102; his italics.

8. Cited ibid.

9. As examples from this early period, see Smithson's *Line of Wreckage* (1968), Bayonne, New Jersey, featuring broken concrete pieces inside an aluminum box (photo-documentation, with map, of this same piece, as reproduced in Smithson, *Collected Writings*, 205); and of piles of matter set off by mirrors, *Rock Salt and Mirror Installation*, White Museum, Cornell University, February 1969 (photographs in Smithson, *Collected Writings*, 178–79).

10. Smithson, "Earth" (1969), statement at a symposium at White Museum, Cornell University, in Smithson, *Collected Writings*, 178. A more coy definition of *site* is this: "a place where a piece should be but isn't" ("Discussions with Heizer, Oppenheim, Smithson," in Smithson, *Collected Writings*, 250). *Non-site* is defined thus: "The non-site is an abstraction that represents the site" ("Four Conversations between Dennis Wheeler and Robert Smithson" [1969–70], in Smithson, *Collected Writings*, 199).

11. In one striking passage, Smithson concedes that *site* may bring with it a misleading dimension of objectification: "The naturalism of seventeenth-, eighteenth- and nineteenth-century art is replaced by [a] non-objective sense of site. The landscape begins to look more like a three dimensional map than a rustic garden" (Smithson, "Aerial Art" [1969], in Smithson, *Collected Writings*, 116). By qualifying sites as "non-objective," Smithson in effect holds that such sites are equivalent to *places*—which in my view are resistant to objectification of any kind.

12. Smithson, "A Tour of the Monuments of Passaic, New Jersey," 71. Smithson intends this sentence to apply to anything he finds in the suburban landscape, but it is more apt as a description of natural material.

13. "Four Conversations between Dennis Wheeler and Robert Smithson," 204.

14. Smithson, "Fragments of an Interview with P. A. [Patsy] Norvell" (1969), in Smithson, *Collected Writings*, 192.

15. "You are presented with a nonworld, or what I call a nonsite" (ibid., 193).

16. Smithson, "Earth," 178.

17. "There is this dialectic between inner and outer, closed and open, center and peripheral. It just goes on constantly permuting itself into this endless doubling, so that you have the nonsite functioning as a mirror and the site functioning as a reflection" (Smithson, "Fragments of an Interview with P. A. Norvell," 193). A still more complete statement concerning the use of mirrors occurs in "Fragments of a Conversation": "I'm using a mirror because the mirror in a sense is both the physical mirror and the reflection. . . . But still the bi-polar unity between the two places is kept. Here the site/non-site becomes encompassed by mirror as a concept—mirroring, the mirror being a dialectic. The mirror is a displacement, as an abstraction absorbing, reflecting the site in a very physical way" (in Smithson, *Collected Writings*, 190).

18. See Smithson's account, "Incidents of Mirror-Travel in the Yucatán" (1969), in Smithson, *Collected Writings*, 119–33.

19. Smithson, "Earth," 182.

20. Ibid., 187; my italics. For further on this sense of dialectic, see Smithson's essay, "Frederick Law Olmsted and the Dialectical Landscape."

21. These contrasting terms, and several other such pairs, are set forth in a footnote to Smithson, "The Spiral Jetty," 152–53.

22. "Fragments of a Conversation," 188; my italics.

23. Ibid., 190.

24. Smithson, "Fragments of an Interview with P. A. Norvell," 192.

25. "The non-site situation [i.e., the equivalent of a map] doesn't look like the mine [from which salt rocks have been taken for an installation]" (from "Fragments of a Conversation," 190). And: "There is a physical reference, and [the] choice of subject matter is not simply a representational thing to be avoided" (ibid., 188). By "a representational thing," Smithson means either a photograph or a map.

26. Smithson, "Earth," 181.

27. Ibid., 177.

28. See *Line of Wreckage* (1968), Bayonne, New Jersey, as reproduced in Smithson, *Collected Writings*, 204–5.

29. Smithson, "Earth," 181.

30. "Fragments of a Conversation," 190. Smithson adds enigmatically: "It's important because it's an abyss between the abstraction [i.e., the map?] and the site; a kind of oblivion. You could go there on a highway, but a highway to the site is really an abstraction because you don't really have contact with the earth. A trail is more of a physical thing" (ibid.).

31. Smithson, "Fragments of an Interview with P. A. Norvell," 193.

32. Ibid., 200.

33. As in Smithson's projected *Island of Broken Glass*, which was to have consisted in one hundred tons of tinted broken glass to form a glass island about fifty yards long in the Miami Inlet. It was not built because of a public controversy over whether the glass would be injurious to wildlife. See the first conversation of "Four Conversations between Dennis Wheeler and Robert Smithson," 197–202.

34. See Smithson, "Aerial Art," 116–18.

35. "Smithson's Non-site Sights: Interview with Anthony Robbin" (1969), in Smithson, *Collected Writings*, 181.

36. "Fragments of a Conversation," 189. On site selection, see also the same interview, 194, where Smithson emphasizes the factor of serendipity: "When I get to a site that strikes the kind of timeless chord, I use it. The site selection is by chance. There is no willful choice. A site at zero degree, where the material strikes the mind, where absences become apparent, appeals to me."

37. The factor of mind is stressed by Smithson at various points, for example, in this statement: "There is no escape from the physical nor is there any escape from the mind. The two are in a constant collision course. You might say that my work is like an artistic disaster. It is a quiet catastrophe of mind and matter" (ibid., 194).

38. "Most of our abstractions are hypothetical. Our [conventional] mapping is hypothetical, because we have to make an outline. We have to outline the continents, the landmasses, and yet when you get into the actual landmasses, then you find where is the edge of this" (from "Four Conversations between Dennis Wheeler and Robert Smithson," 203).

39. The full sentence is: "A sense of the Earth as a map undergoing disruption leads the artist to the realization that nothing is certain or formal" (from Smithson's essay "A Sedimentation of the Mind," 110).

40. Ibid., 111.

41. Smithson, "Fragments of an Interview with P. A. Norvell," 194.

42. Ibid., 192.

43. From Smithson, "Earth," 185. Fully stated as "All legitimate art deals with limits. Fraudulent art feels that it has no limits. The trick is to locate those elusive limits."

44. From "Smithson's Non-site Sights," 175.

45. From Smithson, "Earth," 185.

46. "Fragments of a Conversation with P. A. Norvell," 189, 190.

47. "Interview with Robert Smithson" (1970), in Smithson, *Collected Writings*, 234.

48. Smithson, "Aerial Art," 114.

49. "Interview with Robert Smithson," 234.

50. Smithson, "A Sedimentation of the Mind," 110. The sentences preceding this quotation are also pertinent: "When one scans the ruined sites of pre-history one sees a heap of wrecked maps that upsets our present art historical limits. A rubble of logic confronts the viewer as he looks into the levels of the sedimentations." The section of the essay from which these claims come is entitled "The Wreck of Former Boundaries."

51. "Then in the non-sites we have the rectilinear grid incorporating the raw material of the site. . . . The shape [of the non-site] is based on the map that I devise in terms of my experience of the site" ("Four Conversations between Dennis Wheeler and Robert Smithson," 198).

52. "What are the lattices and grids of pure abstraction [in geometry, hence cartography], if not renderings and representations of a reduced order of nature?" (Smithson, "Frederick Law Olmsted and the Dialectical Landscape," 162). For Smithson's speculations on the relationship between cartographic grids and crystal lattices, see ibid., 54, 197, 211.

53. Smithson, "The Spiral Jetty," 147.

54. Ibid. On *alogos* and the surd, see also 199.

55. "Interview with Robert Smithson," 234.

56. Smithson, "The Spiral Jetty," 145.

57. Ibid., 146.

58. Ibid., 145; my italics.

59. Ibid., 146.

60. Ibid., 147.

61. Shapiro, *Earthwards*, 219.

62. Smithson, "Gyrostasis" (1970), in Smithson, *Collected Writings*, 136.

63. Ibid.; my italics.

64. Shapiro, *Earthwards*, 228. Shapiro insightfully traces out the dynamics of the move from vertical to horizontal in Smithson's work: see especially 223–32. He also brings in the Tower of Babel motif that is still another factor in the Spiral Jetty: see 214–23. I have had to neglect an entire thematics of signature and writing in Smithson's work that Shapiro brings out brilliantly in *Earthwards*, especially chapter 4, "Printed Matter: A Heap of Language."

65. Valéry had said that the painter "takes his body with him" into the work: see Maurice Merleau-Ponty, "Eye and Mind," trans. Carleton Dallery, in *The Merleau-Ponty Aesthetics Reader: Philosophy and Painting*, ed. Galen Johnson (Evanston, IL: Northwestern University Press, 1993), 123.

66. For a defense of this interpretation of place, see Casey, *Getting Back into Place*,

introduction. Aristotle's discussion of motion *(kinēsis)* already makes it clear that both spatial and temporal factors are involved in its basic action: see *Aristotle's Physics*, books 3 and 4, trans. E. Hussey (Oxford: Clarendon Press, 1983), especially 3: 1–3.

67. Smithson, "Spiral Jetty," 148.

68. See Plate 36, "Spirals," in Shapiro, *Earthwards*.

69. Ibid., 228.

70. The first phrase is cited by Shapiro in *Earthwards*, 4; the second is from Smithson, "Spiral Jetty," 151. Shapiro brings out the "posthistoric" or postmodern moment in Smithson's work thus: when the spiral is brought down to earth in the Spiral Jetty, it can "be read as an inscription or mark, a way of writing or signing the earth that would be analogous, as Smithson suggests several times, to the ways in which the earth was marked in prehistoric times, before the institution of the artist's signature. It is a posthistoric performance and reinscription of the prehistoric" (*Earthwards*, 228).

71. "Four Conversations between Dennis Wheeler and Robert Smithson," 217.

72. Smithson, "The Spiral Jetty," 148.

2. Memorial Mapping of the Land

1. See Martin Heidegger, "The Question concerning Technology," in *The Question concerning Technology,* trans. W. Lovitt (New York: Harper, 1977), 3–35.

2. See J. J. Gibson, *The Ecological Approach to Visual Perception* (Hillsdale, NJ: Lawrence Erlbaum, 1986), 127–43.

3. Remark in conversation of January 17, 2001, New York City.

4. This is a key phrase from Walter Benjamin, *The Arcades Project,* trans. H. Eiland and K. McLaughlin (Cambridge, MA: Harvard University Press, 1999), 473, 486.

5. I owe this observation to James Hillman in conversation, June 14, 2000, New York City.

6. Margot McLean, conversation of July 29, 2000, Thompson, CN.

7. For a discussion of commemoration that argues against any necessary representational or recollective basis for it, see my *Remembering: A Phenomenological Study,* 2nd ed. (Bloomington: Indiana University Press, 2000), chapter 10.

8. On the concept of "re-presentation," see my *Representing Place,* glossary.

9. On remembering-through, see Casey, *Remembering,* 218–21.

10. *Random House Dictionary,* 1981 ed., s.v. "scale."

11. I take *represent* here in the sense of "standing in for," "being a representative of," not as a pictorial equivalent.

12. Maurice Merleau-Ponty, *Phenomenology of Perception,* trans. C. Smith with F. Williams and D. Guerrière (New York: Humanities Press, 1989), 250; his italics.

13. Ibid., 251.

14. Ibid., 252–53.

15. Ibid., 253; my italics. More generally: "Each of the whole succession of our experiences, including the first, passes on an already acquired spatiality" (ibid.). Ultimately, the series of levels refers to a first "primordial level," which is "a horizon which cannot in principle ever be reached and thematized in our express perception" (ibid.). This would be the horizon of the perceived world itself.

16. Remark of James Hillman in the preface, "Now You See Them, Now You Don't: A Conversation between the Author and the Artist," in Hillman and McLean, *Dream Animals*, 11. Hillman analogizes such a background to that of many dreams: "Usually only bits of a dream stand out against a vague screen" (11–12).

17. Cited from e-mail correspondence of January 6, 2001.

18. See Gary Snyder, "Re-inhabitation," in his collection of essays, *The Old Ways* (San Francisco: City Lights, 1977), 57–66.

19. Margot McLean, preface to Hillman and McLean, *Dream Animals*, 1.

20. As McLean observes, the point is "not just [to] watch them on TV for entertainment, but [to] respect them by allowing them their rightful 'place'" (ibid., 6). Her paintings give to animals just such a rightful place to be.

21. Ibid., 5. James Hillman adds that such animals should be regarded as "invisibles" for civilized people: "I see your paintings as also about what I call the invisibles. The invisibles that have been forgotten and passed by" (6). McLean adds that "these paintings are not just about endangered species, they're about species. . . . [They] are not messages to 'warn' of impending disaster or loss; but rather they are images of the spirit of the animal, with their own autonomous life, their presence and their absence" (2). Hillman retorts by pointing out that *all* animals are at risk; thus, to paint *any* animals in McLean's manner is in effect to mourn their loss in advance: "I see your paintings as ritual objects, as if you are mourning the animals' leaving by eliminating their full-bodied presence" (12). I would ask whether this presence is eliminated or *relocated*—a mode of what might have been called sublimation in an earlier era.

22. "Generally speaking, our perception would not comprise either outlines, figures, backgrounds or objects, and would consequently not be perception of anything, or indeed exist at all, if the subject of perception were not this gaze which takes a grip upon things only insofar as they have a general direction; and this general direction in space is not a contingent characteristic of the object, it is the means whereby I recognize it and am conscious of it as of an object" (Merleau-Ponty, *Phenomenology of Perception*, 253).

23. "The primordial level is on the horizon of all our perceptions" (ibid., 253).

24. McLean, conversation of July 29, 2000.

25. Ludwig Wittgenstein, *Zettel*, ed. G. E. M. Anscombe and G. H. von Wright, trans. G. E. M. Anscombe (Berkeley: University of California Press, 1967), 77.

26. This is Merleau-Ponty's phrase in "Eye and Mind," where he also calls depth "the first dimension." See M. Merleau-Ponty, *The Primacy of Perception*, ed. J. Edie (Evanston, IL: Northwestern University Press, 1964), 180.

27. See Kuo Hsi's statement in Susan Bush and Hsio-yen Shih, eds., *Early Chinese Texts on Painting* (Cambridge, MA: Harvard University Press, 1985), 168–89. I discuss these forms of depth in relation to Northern Sung landscape painting in *Representing Place*, chapter 6.

28. See the discussion of Stuart below, chapter 4. Lucy R. Lippard has written a comprehensive book entitled *Overlay: Contemporary Art and the Art of Prehistory* (New York: Pantheon, 1983). For Lippard, overlay refers primarily to historical and landscape layering.

29. I am taking *pentimento* in Lillian Hellman's sense of the term: "Old paint on canvas, as it ages, sometimes becomes transparent. When that happens, it is possible, in some pictures, to see the original lines: a tree will show through a woman's dress, a child makes way for a dog, a large boat is no longer on an open sea. That is called *pentimento* because

the painter 'repented,' changed his mind. Perhaps it would be as well to say that the old conception, replaced by a later choice, is a way of seeing and then seeing again" (Lillian Hellman, *Pentimento: A Book of Portraits* [Boston: Little, Brown, 1973], 3).

30. Cited by Dinitia Smith, "The Laureate Distilled, to an Eau de Vie," *New York Times,* August 2, 2000, B1.

3. Mapping Down in Space and Time

1. Jeff Kipnis, review of the exhibition Space Probes, in *Atlanta Art Paper,* 1981. Kipnis adds that "these small . . . boxes of texture, color, and drawing were satisfying in every way."

2. Jean F. Feinberg, "Introduction," *Condensed Space* (Roslyn Harbor, NY: Nassau County Museum of Fine Arts, 1977), n.p.

3. Not that some kind of framing is not always in effect. Ironically, in the project *Cygnus A,* to be discussed next, a protective metal fence came later to enclose the work, even though it was no part of the artist's explicit intentions. Framing has always been an issue for Gellis, who feels that excessive or rigorous framing kills the work. For a general discussion of framing in art, see the interlude in Casey, *Representing Place.*

4. Merleau-Ponty, "Eye and Mind," in *The Merleau-Ponty Aesthetics Reader,* 140.

5. This phrase is from ibid., 140; Merleau-Ponty's italics.

6. Ibid.

7. Sandy Gellis, conversation, June 15, 2000, New York City.

8. For a discussion of the *Yujitu,* see Cordell D. K. Yee, "Reinterpreting Traditional Chinese Geographical Maps," in *Cartography in the Traditional East and Southeast Asian Societies,* ed. J. B. Harley and D. Woodward (Chicago: University of Chicago Press, 1994), 48–51.

9. "I do not know much about gods; but I think that the river / Is a strong brown god—sullen, untamed and intractable" (opening lines of T. S. Eliot, "The Dry Salvages," *The Four Quartets*).

10. Quoted in *Primary Source,* the brochure for a three-person show in which Gellis was featured at the University Gallery, Fine Arts Center, University of Massachusetts, Amherst, September 11–October 12, 1999.

11. *The Print Collector's Newsletter* (March–April 1988). Gellis herself prefers to speak of recording the *reception* of rainfall (conversation of July 10, 2000). And it is an exaggeration to claim that Gellis is "a conceptual artist specializing in weather" (Barry Walker, cited by Susan Tallman in "Prints and Editions," *Arts Magazine* 64, no. 7 [February 1990]: 18).

12. In *Spring 1987: In the Northern Hemisphere,* Gellis asked friends at various locations in the Northern Hemisphere to set out or bury etching plates she had sent them and then to return them to her. "The resulting images," writes Susan Tallman, "squares of dense textures and striations, are seductively beautiful and even somehow evocative of the atmospheric truculence of a Northern Spring" (from "Prints and Editions," 18).

13. Artist's statement in *Projects: Earth, Air and Water Studies,* brochure for the show at the Gallery Three Zero, February 6–March 14, 1992, 4.

14. A further avatar has taken place: in a work entitled *Hudson River Drawings,* Gellis has "drawn concentric circles on paper—one page for each day on which water and sediment samples were collected. The pages (which are fixed to glass plates) have been irregularly coated with the metallic elements found in the sediment of the river—copper, cadmium,

barium, chromium, zinc, lead, and lots of iron. On the Testwall—a large, freestanding wall that faces the Wooster St. windows of the [T'Zart & Co.] gallery—the piece becomes a work of art in progress. The jars of river water drip onto the coated papers, interacting with them, to change colors and shapes" (from a review in the *Manhattan User's Guide*, May 1995, 23). Notice that in an artwork such as this, not only do space and time combine, but also the artist and the elemental medium, water: "Ms. Gellis and the Hudson River both have their part in the final work" (ibid., 14).

15. Artist's statement, ibid., 8.

16. This map is reproduced in the *Manhattan User's Guide*, 6–7.

17. Place, affirms Aristotle, is "thought to be some such thing as a vessel" (*Physics* 209.27–28), as translated by E. Hussey in *Aristotle's Physics*, books 3–4: 23.

18. Gretchen Faust, "New York in Review," *Arts Magazine* 64, no. 4 (December 1989). The show, in which drawings for the *New Lake Project* were exhibited, was held at the Storefront for Art and Architecture.

19. Ibid. Gellis herself interprets her more explicitly environmental works as new ways to see the present world rather than as memorials of a past world (conversation of July 10, 2000).

20. Review of "Ocean Fragments" (1997–2000), in "Art on Paper," published in *Working Proof* (March–April 2000).

21. See the glossary of Casey, *Representing Place*.

22. In conversation, June 15, 2000, New York City.

23. Husserl's phrase is from his *Experience and Judgment: Investigations in a Genealogy of Logic,* ed. L. Landgrebe, trans. J. S. Churchill and K. Ameriks (Evanston, IL: Northwestern University Press, 1973). Gellis's approval of it was expressed in the conversation of June 15, 2000, New York City.

4. Plotting and Charting the Path

1. Michelle Stuart, interview, July 10, 2000, New York City.

2. Ibid.

3. For this interpretation of geometry, see Husserl, "The Origin of Geometry." See also the commentary by Jacques Derrida, introduction to his translation of this text, *L'origine de la géométrie* (Paris: Presses Universitaires de France, 1962); and Maurice Merleau-Ponty's lecture course of 1959–60, "Husserl aux limites de la phénoménologie," published in *Notes de cours sur "L'origine de la géométrie" de Husserl,* ed. R. Barbaras (Paris: Presses Universitaires de France, 1998).

4. Lawrence Alloway, "Michelle Stuart: A Fabric of Significations," *Artforum* (January 1974): especially 65: "The speckled field becomes a fabric of significations."

5. For such a seemingly straightforward work as *No. 1,* a quite complex spatiality in fact is at stake. Not only are there (i) the surface as such of the drawing and (ii) the subsurface of the ground that is traced out, but also (iii) "the *evoked* space of a hovering field" (ibid., 65; Alloway's italics) that superintends the two previous spaces.

6. When asked in conversation whether these new works were to be called earth-rubbings, Stuart demurred. I suggested "earth-mappings," and she said, "That's better" (interview of July 10, 2000, New York City).

7. Lucy R. Lippard, "Michelle Stuart's Reading in Time," preface to *Michelle Stuart: The Elements 1973–79* (New York: Red Ink Productions, 1992), n.p.

8. "The suggestion is that the earth in Ms. Stuart's work is a text to be read" (Holland Cotter, "Michelle Stuart," *New York Times,* November 6, 1992).

9. "The essence, the spirit, the patina of a place [are] captured on an obdurate rectangle" (Lippard, "Michelle Stuart's Reading in Time," n.p.).

10. Wittgenstein, *Zettel,* 77. This is not to say, however, that the two modes of scratching, rubbing and printing, give us a complete depiction of a place, as Roger Lipsey claims: "Taken together, the objective map and the subjective rubbing from one and the same site seemed to encompass all that could usefully be said about that place and, by extension, all landscape places" (Roger Lipsey, "Michelle Stuart: A Decade of Work," *Arts Magazine* 56, no. 8 [April 1982]: 111). This is to neglect the role of books, of language as a third approach to place. Nor is it adequate to say that Stuart's intention in pursuing the dual mode of pursuing place merely reflects "the artist's conviction that more than one vantage point is necessary in order to get to the wholeness of things" (ibid.). Certainly, Stuart, like many other artists, is interested in a multiple take on perceptual or historical reality, but her aim is not to attain the wholeness of things, an impossible goal in any case. Something closer to Nietzschean perspectivism is rather the case.

11. Alloway, "Michelle Stuart," in *Michelle Stuart: Voyages,* curated by Judy C. Van Wagner (New York: New York State Council on the Arts, 1979), 52.

12. From text in the Artpark catalogue for *Niagara River Gorge Path Relocated* (1975).

13. The Indo-European root of *land* is *lendh-,* "open prairie"; the same etymon underlies *launde,* the Old French origin of English *lawn.* This etymology, along with most others I discuss, derives from *The American Heritage Dictionary of the American Language,* 1981 edition.

14. This and the following quotations in the paragraph all come from Michelle Stuart, artist's statement, cited in *Michelle Stuart: Voyages,* 14. Mithras was a Greco-Roman god whose forerunner is thought to be the Persian sun god, Mithra, born from a rock.

15. "We're talking about cultural overlay, just like geological overlay. What really interests me is something that you can do in writing but it's very hard to do visually, but I always wanted to do it and I think it might just be possible, and that is to catch something that is uncatchable, to catch the essence of history, about what happens in time and in space" (from a recorded conversation between Michelle Stuart and Frederick Ted Castle, 1985, New York; cited in Castle's "To Reify the Earth" in *Michelle Stuart: Voyages,* 63).

16. From the same interview, cited ibid., 63.

17. Ibid.

18. See Alloway, "Michelle Stuart," in *Michelle Stuart: Voyages,* 51.

19. As Alloway claims: "Stuart's development can be described in formal terms as a movement from synonymous to discursive form and as a move from geological to cultural time" (ibid., 51). Here one wishes Alloway had been more Hegelian, since Stuart's work realizes the truth of both kinds of time.

20. The root of *temple* is traceable to *temein,* "to cut"; recall our discussion of scratching surfaces: the earliest temples were constructed from cut wood.

21. Stuart's dream in Singapore; cited at *Michelle Stuart: Voyages,* 30.

22. Alloway writes that "in its lyrical interweaving of mariner's temple, marine artifacts,

charts and logs, and the mythical white whale [this work] is a celebration of the theme of voyaging" (Alloway, "Michelle Stuart," in *Michelle Stuart: Voyages*, 53).

23. Smithson, "The Spiral Jetty," 147.

24. Places also contain *sounds,* and it is striking that Stuart includes recorded sounds (songs, animals' voices, her own voice reading, etc.) in other works of this period, for example, *Correspondences* (1981).

25. This phrase was used in conversation with the author, July 10, 2000, New York City.

26. The distinction between chart and map emerged at the end of the conversation of July 10, 2000. Although Stuart normally uses these terms interchangeably, upon being pressed she admitted that *chart* implies something more like a projection of a possible course that may skip over what lies between start and finish, where a responsible *map* must include all the intermediate points. My own use of *mapping* as in the locution *earth-mapping* includes elements both of charting-out and of mapping-down. The latter is closer to "cartographic mapping," as I shall be employing this term in part II. I shall return to the distinction between chart and map at the end of my treatment of Stuart.

27. Michelle Stuart, artist's statement for *Starchart: Constellations,* Wanas Castle, Knislinge, Sweden.

28. Robert Smithson remarks: "The Nazca lines have meaning only because they were photographed from airplanes, at least for our eyes conditioned by the twentieth century" ("'. . . The Earth, Subject to Cataclysms, Is a Cruel Master'" [1971], in Smithson, *Collected Writings,* 254–55).

29. Artist's statement for *Nazca Lines Star Chart with Nazca Lines Southern Hemisphere Constellation Chart Correlation* (1981–82). The second part of this title refers to a drawing that accompanies the main painting and is also in the collection of the Museum of Modern Art.

30. Alloway, "Michelle Stuart," in *Michelle Stuart: Voyages,* 51.

31. For "pale geometry," see ibid., 52.

32. Artist's statement for *Niagara River Gorge Path Relocated* in the Artpark catalogue, 1979.

33. *Geoglyph* is Stuart's own preferred term for the deposition and delineation of the heavens on the earth: "Nazca Lines Star Chart, with its accompanying drawing, depicts an abstract configuration derived from the geoglyphs, the trapezoidal geometric lines rutted into the Nazca Plateau" (from artist's statement for *Nazca Lines Star Chart with Nazca Lines Southern Hemisphere Constellation Chart Correlation,* 1981–82). A glyph is "a symbolic figure, either engraved or incised," while its root, *glyphein,* means "to carve" *(American Heritage Dictionary).* A glyph, like a written letter *(gamma),* is inscribed on a receptive surface such as a cloth, sheet, or napkin (as in the origin of *map*) or papyrus (as with *chart*).

34. Stuart's great-grandmother immigrated to Bream Bay in the North Island in 1854. Stuart found her ancestor's burial place in a small churchyard. This churchyard is located in a broad sheep meadow overlooking Bream Bay, and Stuart was struck by the stars overhead as she spent most of the night rubbing the highly eroded gravestones to discover which was that of her forebear.

35. Joseph Ruzicka, "Essential Light: The Skies of Michelle Stuart," *Art in America* (June 2000): 88. Ruzicka also suggests that "skies are the least tangible of the natural elements

treated by Stuart. . . . More numerous and better known are her landscapes—basically, assemblage-painting hybrids—in which she re-creates a place she has visited by using the actual stuff of the locale as her material: soil, feathers, fossils, vegetation, found artifacts. . . . Stuart's landscape works are essentially field samples of the places she has visited" (ibid.).

36. The quoted phrase is from the conversation of July 10, 2000, New York City.

37. The distinction between "home world" and "alien world" is found in unpublished writings of Edmund Husserl. It has been developed by Bernard Waldenfels in a number of publications, notably *Der Stachel des Fremden* (Frankfurt: Suhrkamp, 1990), and by Anthony J. Steinbock in his book *Home and Beyond: Generative Phenomenology after Husserl* (Evanston, IL: Northwestern University Press, 1995).

38. Patricia C. Phillips, "A Blossoming of Cells," *Artforum* (October 1986): 117; my italics. Phillips expands on this claim: "It is the relentless yet liberating use of what became known in art as the '70's grid' that seems to organize and activate these paintings' multiple slippages of readings; for Stuart, the grid provides a set of coordinates for presenting the occurrences of both plan and infinitely variable chance" (ibid.).

39. See Eugène Minkowski, *Lived Time: Phenomenological and Psychopathological Studies*, trans. N. Metzel (Evanston, IL: Northwestern University Press, 1970), 277ff.

40. Stephen Westfall, "Melancholy Mapping," *Art in America* (February 1987): 107.

41. Michelle Stuart, artist's statement for *On Part of Memory Being Alaska*.

42. Westfall, "Melancholy Mapping," 106.

43. For an interpretation of gardens as interplaces, see my *Getting Back into Place: Toward a Renewed Understanding of the Place-World* (Bloomington: Indiana University Press, 1993), 155, 170.

44. Cited in *Michelle Stuart: Ashes in Arcadia*, catalogue (Waltham, MA: Rose Art Museum, Brandeis University, 1988).

45. *Michelle Stuart, From the Silent Garden*, a collective volume published by the Williams College artist-in-residence program (Williamstown, MA, 1979). In the artist's statement for *Stone Alignments/Solstice Cairns*, Stuart writes, "a circle of Midsummer light drawing the shadow of a small bird over the silent garden" (cited in *Michelle Stuart: Voyages*, 14).

46. This title is autobiographical as well: "*In the Beginning . . . Yang-Na* (1984), which features swirling silvery masses against a black background, looks like a map of the cosmos, but is dedicated to the La Brea tar pits, near the house where Stuart grew up in Los Angeles" (Carey Lovelace, "Michelle Stuart's Silent Gardens," *Arts Magazine* [September 1988]: 78).

47. I take the phrase "frame of vision" from Susan L. Stoops's text in the catalogue *Silent Gardens: The American Landscape* (Waltham, MA: Rose Art Museum, Brandeis University, 1988), n.p.

48. "Preface" on a single sheet entitled "Michelle Stuart" and intended as the artist's statement for *On Part of Memory Being Alaska*. She adds: "I try to throw a net over time and space and retire with at least a few silver fish as the catch."

49. See the catalogue *Natural Histories*, published on the occasion of an exhibition at Bellas Artes, Santa Fe, New Mexico, 1996. On the idea of each gridded module as a "frame of vision," see Susan L. Stoops, Curator's Introduction in the catalogue to the Rose Art Museum Show, *Silent Gardens: The American Landscape*, especially this statement: "Each

of the grid units functions as a 'frame' of vision that can be built upon endlessly but never really comprehended in its entirety" (n.p.).

50. Phillips, "A Blossoming of Cells," 116. Phillips continues: "But she is also fascinated by the productions of culture and the phenomenological circumstances of human life." Notice how this statement of Phillips's echoes Stuart's own self-assessment cited just above—matter comes first for the artist and her critic, but culture comes quickly on its heels.

51. From the preface in the artist's statement to *On Part of Memory Being Alaska.*

52. "Whether idly leaking their procreative juices or stoutly maintaining their integrity, the apportioned seeds [i.e., apportioned in a gridded presentation] mark each month's passage as a measure of possibilities active and lapsed" (Nancy Princenthal, "Michelle Stuart at Fawbush," in *Art in America* [April 1994]: 85).

53. From the preface in the artist's statement to *On Part of Memory Being Alaska.*

54. "Echoed formally in the perpetual unfolding and repetition of the grid is the idea of the regeneration of the Earth's resources or of a self-maintaining natural world—as though the painting's composition is one that replenishes itself" (Stoops, Curator's Introduction, catalogue *Silent Gardens: The American Landscape,* n.p.).

55. On the matter/material distinction in art, see Mikel Dufrenne, *Phenomenology of Aesthetic Experience,* trans. E. S. Casey et al. (Evanston, IL: Northwestern University Press, 1973), 283, 301–2; John Dewey, *Art as Experience* (New York: Putnam, 1934), 108; and Suzanne Langer, *Feeling and Form* (New York: Scribner's, 1953), 104ff.

56. See the catalogue to which I have already made several references: *Michelle Stuart: Voyages.*

57. For more on the place/site distinction, see my *Getting Back into Place,* 103, 177–78, 267–70, 287, 289.

58. In *Stone/Tool Morphology,* photographs from eleven North and Central American prehistoric sites alternate with double images of stone tools as constructed/imagined by the artist.

59. I here allude to Heidegger's distinction between earth and world as the essential co-ingredients of any work of art. See Heidegger, "The Origin of the Work of Art," 41–57; and my unpublished essay "Between Earth and World: The Neglected Case of Land."

60. Others have noticed the importance of the double aspect, the *zweifach* character of being close-up/far away, in Stuart's paintings. In addition to Patricia C. Phillips and Carey Lovelace, there is also Stephen Westfall, "Melancholy Mapping," 106; Lawrence Alloway, "Michelle Stuart: A Fabric of Significations," 65; and Lucy R. Lippard, "Michelle Stuart's Reading in Time." But none of these critics gives to the double aspect the central significance I shall accord it.

61. On aesthetic distance, see the classical essay by Edward Bullough, "'Psychical Distance' as a Factor in Art and as an Aesthetic Principle," *British Journal of Psychology* 5, no. 2 (1912): 87–98.

62. Aristotle, *Physics* 220–27. (Hussey translates: "The least number, without qualification, is the two," *Aristotle's Physics,* books 3–4: 46.)

63. Speaking of *Bone Land . . . Chinle Crystal Dwelling* (1985–86), a work from the "Silent Gardens" octet, Lovelace says, "The viewer is not, at first, aware of the embedded elements [i.e., of grasses, stones, petals], but curiosity draws one closer, and two distinct discourses are revealed" (Lovelace, "Michelle Stuart's Silent Gardens," 78).

64. The quoted phrase is from Ralph Waldo Emerson, "The American Scholar," in *Emerson on Transcendentalism*, ed. E. L. Ericson (New York: Ungar, 1986), 26. This is "the radical law of nature," according to which "a leaf, a drop, a crystal, a moment of time, is related to the whole, and partakes of the perfection of the whole. *Each particle is a microcosm*, and faithfully renders the likeness of the world" (ibid.; my italics).

65. Phillips, "A Blossoming of Cells," 117. Phillips pursues the metaphor of the microscope: "Moving within inches of one of her paintings is like taking a sample of blood on a laboratory slide and placing it under the lens of a microscope. . . . what is initially seen as one thing is magnificently transformed into a suspended composition of many things. . . . [But] the picture must also be seen from many feet back, allowing their cellular units to converge into something once again sweeping, whole, and alive. . . . [Stuart] engenders a field of orientation in which the turbulence in each module can be assimilated into the totality and yet recognized in its autonomy" (ibid.).

66. The quoted phrase is from Lovelace, "Michelle Stuart's Silent Gardens," 78. Note that Lovelace herself, having asserted that "two distinct discourses" are to be found in Stuart's work, is moved to affirm that the artist herself finally seeks connectedness: "These pieces [in *Bone Land . . . Chinle Crystal Dwelling*] seem like close-ups, enlarged details, and the link of the very large with the very small also demonstrates Stuart's ongoing interest in drawing connections between patterns" (ibid.).

67. Phillips, "A Blossoming of Cells," 117; my italics.

68. From Michelle Stuart, artist's statement for *On Part of Memory Being Alaska*.

69. *Oxford English Dictionary: Compact Edition*, 1971, s.v. "plot."

70. By titles alone, five of the eight works refer to regions of the earth; the other three allude to the moon, the sky dome, or the origin of the universe. But by subject matter, all eight works refer to actual regions of the American landscape.

71. See Jacques Derrida, interview of 1971 with Jean-Louis Houdebine and Guy Scarpetta, in *Positions*, trans. A. Bass (Chicago: University of Chicago Press, 1981), 65–66.

72. Ibid., 43; his italics.

Concluding Reflections to Part I

1. These two maps are reproduced in Smithson, *Collected Writings*, 54 and 73, respectively.

2. See Smithson, "The Spiral Jetty," 147.

3. "Four Conversations between Dennis Wheeler and Robert Smithson (1969–70)," 217.

4. Smithson, "The Spiral Jetty," 147. Elided from this sentence is the etymology of *scale* referred to earlier.

5. Ibid.

6. Ibid.

7. Smithson and Stuart, as we have seen, import photographs directly into their work, for example, Smithson's *Non-site, Franklin, New Jersey* (Figure 1.2) and Stuart's *Codex: Canyon de Chelly, Arizona* (Plate 11). Gellis paired photographs with her samples from the Hudson River, taking both on a daily basis. McLean takes photographs of the natural animal habitats she visits, for example, the Orinoco River region.

8. Whitehead considers simple location to be the central doctrine of seventeenth-century physics and metaphysics in the West. His definition of simple location is this: "Whatever is in space is *simpliciter* in some definite portion of space" (A. N. Whitehead, *Science and the Modern World* [New York: Free Press, 1953], 52). For my own usage of *site*, see my *Getting Back into Place*, xiii, 65, 141.

9. This is not to deny that fire and air inspire the material imagination of poets, as much so as earth and water do. Such is the great theme of Gaston Bachelard's series on the poetic imagination of matter, starting with *The Psychoanalysis of Fire* (trans. A. C. M. Ross [Boston: Beacon Press, 1964]) and ending with *The Earth and Reveries of Repose* (*La terre et les rêveries du repose: Essai sur les images de l'intimité* [Paris: Corti, 1965]).

10. The quoted phrase comes from Merleau-Ponty, *The Visible and the Invisible*, 167, Working Note of November 1960.

11. Smithson, *Collected Writings*, 192.

12. Smithson, "Fragments of an Interview with P. A. Norvell," 192. Note also that "the displacement was *in* the ground, not *on* it" (Smithson, "Incidents of Mirror-Travel in the Yucatán," 119; his italics).

13. "Discussions with Heizer, Oppenheim, Smithson," 244. Travel to a site represents leaving the gallery or museum: "You are sort of spun out to the fringes of the site. The site is a place you can visit and it involves travel as an aspect too" (Smithson, "Earth," 181).

14. See, for example, Long's *Two Lines Walked through Dust-Covered Grass by the Roadside*, Kenya, 1969, as reproduced in Lippard, *Overlay*, Figure 11B. Smithson remarks, "The travel aspect of going to the site from the non-site—you'll find people just doing trips, like Richard Long" ("Interview with Robert Smithson," 235). For a discussion of Long and another map-walker, Hamish Fulton, see Wystan Curnow, "Mapping and the Extended Field of Contemporary Art," in D. Cosgrove, ed., *Mappings* (London: Reaktion Books, 1999), 258–60.

15. "It is not so much a matter of creating something as de-creating, or denaturalizing, or de-differentiating, decomposing . . ." (Smithson, "Fragments of an Interview with P. A. Norvell," 192).

16. On the "flesh of the world," see Merleau-Ponty, *The Visible and the Invisible*, 248ff.

17. Cited from Michelle Stuart's unpublished journal, "Return to the Silent Garden," in Lippard, *Overlay*, 34.

18. Smithson, "The Spiral Jetty," 146.

19. Ibid.

20. "From that gyrating space emerged the possibility of the Spiral Jetty" (ibid.).

21. Ibid., 146.

22. Smithson, "Fragments of an Interview with P. A. Norvell," 194.

23. Smithson, "A Sedimentation of the Mind: Earth Projects," 113.

24. Ibid.; his italics.

25. "Interview with Robert Smithson," 236; my italics.

26. On vicinity and neighborhood as basic categories of the topographic representation of space, see Jean Piaget and Bärbel Inhelder, *The Child's Conception of Space*, trans. F. J. Landon and J. L. Lunzer (New York: Norton, 1967), especially 13, 68, 153, 301, 451. For a discussion of Descartes's revealing use of *vicinity* at a critical moment of his writing, see *The*

Fate of Place: A Philosophical History (Berkeley: University of California Press, 1997), chapter 7, especially 161.

27. "Interview with Robert Smithson," 235. Sometimes Smithson uses *earth-map* to refer to a geological formation that is in effect a map of the (pre)history of its creation. Referring to the effects of the Great Ice Cap of Gondwanaland in Yucatán, he says that what one can now view is "an 'earth-map' made of white limestone" (Smithson, "Incidents of Mirror-Travel in the Yucatán," 121).

28. Smithson, "Incidents of Mirror-Travel in the Yucatán," 121.

29. Robert Smithson, "Vicinities of the Nine Mirror Displacements," in Smithson, *Collected Writings*, 120. Recall that in Smithson's original concept of "aerial art," there would be "earth works" at the end of airplane taxiways that are visible only upon arrival and departure; in a further irony, they would create an "artificial universe" that is not part of the landscape normally depicted on an aerial map (see Smithson, "Aerial Art," 116–17).

30. "The inevitable *abstractness* of maps [is] the result of selection, omission, isolation, distance and coordination. Map devices such as frame, scale, orientation, projection, indexing and naming reveal artificial geographies that remain unavailable to human eyes" (James Corner, "The Agency of Mapping: Speculation, Critique and Invention," in *Mappings*, ed. Cosgrove, 215; my italics).

31. On the worldless character of non-sites, see Smithson, "Fragments of a Conversation," 193. Regarding the non-site as at once abstract and material, see "Interview with Robert Smithson," especially 234: "The non-sites incorporate not just the abstract aspects, but the raw material aspects." The materiality entails three-dimensionality: "The shape imposed [by the non-site] is a three-dimensional map" (ibid.).

32. Merleau-Ponty, "Husserl aux limites de la phénoménologie," 89; my translation.

33. In view of this, Smithson's non-site installations are perhaps not as abstract as he imagined them to be: they do present portions of the earth, even if there is no trace of the body that procured these portions; but these same portions are displaced from their original sites and are "ab-stract" in the literal sense of "pulled away from."

34. "Interview with Robert Smithson," 236. He adds: "[These maps] point back in time to prehistoric land masses that don't exist now" (ibid.).

35. Heidegger, *Being and Time*, 58.

36. Smithson, "Fragments of a Conversation," 190.

37. "Earth maps . . . are left on the sites. . . . No sites exist at all; they are completely lost in time, so that the earth maps point to nonexistent sites, whereas the nonsites point to existing sites but tend to negate them" (Smithson, "Fragments of an Interview with P. A. Norvell," 193).

38. Ibid., 194. See also the comparable statement in Smithson, "Fragments of a Conversation": "There's no order outside the order of the material" (190).

5. Getting Oriented to the Earth

1. It is noteworthy, however, that de Kooning, Diebenkorn, and Rice, despite their considerable formal differences, are each inspired by scenes at *land's end*—places where the earth meets the ocean—and each maps such interplaces in extreme abstraction from their topographic particularities.

2. Eve Ingalls, interview of May 29, 1998, New Haven, CT; as amended in conversation of June 28, 1999 (same location). Ingalls also testifies to the orienting power of actual maps in her first immersion in wilderness: "I kept a map of the wilderness on my desk and started to mark what I experienced as shelter areas. That helped" ("Nudging the Sublime: An Interview with Eve Ingalls," by Sharon Olds, *Women Artist News* 11, no. 2 [Spring 1986]: 30).

3. As an example of this earth-body inscribed in an earth-map, see Ingalls's cover design (taken from her painting *Sondage*) for Michael Seidel, *Epic Geography: James Joyce's Ulysses* (Princeton: Princeton University Press, 1976). *Sondage* is part of an entire series of works in which women's bodies emerge—barely—from the earth with which they are presented as coeval and conterminous. Ingalls speaks of "the physical presence of the Earth as body" (artist's statement for the exhibition Touching Earth, Paula Allen Gallery, New York, June 1987).

4. Interview of May 29, 1998.

5. See Barbara Novak, *Nature and Culture: American Landscape and Painting 1825–1875* (Oxford: Oxford University Press, 1980), chapter 4, "The Geological Timetable: Rocks."

6. Cited from the interview of May 29, 1998.

7. Ibid.

8. Ibid.

9. Conversation of June 28, 1999.

10. I take the term *world-making* from Nelson Goodman, *Ways of Worldmaking* (Indianapolis: Hackett, 1978).

11. Interview of May 29, 1998.

12. Artist's statement for the exhibition Earth Watch Drawings, Clark University, January–February 1980. In a typed manuscript also entitled "Earth Watch Drawings" (1980), Ingalls writes, "[In these drawings] no unified landscape invites me to rest and to take stock of where I am. Discontinuities of time, space, and formation tear the incomplete, shaky tripod of my body loose from a single time-space" (manuscript, 1). These drawings underlie the more elaborate works collected together as "Broken Coordinates."

13. As cited by Michel Foucault, *The Order of Things: An Archeology of the Human Sciences* (New York: Vintage, 1973), xv.

14. Artist's statement for the exhibition Earth Watch Drawings.

15. "Big map" is Ingalls's own expression in the interview of May 29, 1998.

16. "In my drawings the earth is observed as a layering of memory surfaces, which store traces both of human activity and of natural processes" (artist's statement for the exhibition Earth Watch Drawings). Also: "Under my feet are older horizons, stratified memory surfaces which store traces both of human activity and of natural processes. My sense of existing here and now is challenged by these memory surfaces" (Ingalls, "Earth Watch Drawings," manuscript, 1).

17. Ingalls, "Earth Watch Drawings," manuscript, 1.

18. On "the smallest deviation," see Deleuze and Guatarri, *A Thousand Plateaus,* 371. Concerning smooth versus striated space, see ibid., chapters 12 and 14. See also my essay, "Smooth Spaces and Rough-Edged Places," *Review of Metaphysics* (September 1998): 571–93.

19. On the qualitative heterogeneity of duration, see Henri Bergson, *Time and Free Will: An Essay on the Immediate Data of Consciousness,* trans. F. L. Pogson (Mineola, NY: Dover, 2001), chapter 2, "The Multiplicity of Conscious States—the Idea of Duration."

20. Ingalls, "Earth Watch Drawings," manuscript, 1.

21. "Nudging the Sublime," interview by Olds, 30. Ingalls adds: "It took years of painting the female figure to realize that I was actually painting myself. About 8 years ago I stepped back and thought, I'm here already standing outside the canvas—why paint myself in there. So I removed the figure" (ibid.).

22. Ingalls's words in the interview of May 29, 1998. That is to say, figures on such a surface are seen as coming directly from an underlying ground. This is as true of *Folded Field* as of *Broken Coordinates.* (Clarification of Eve Ingalls in conversation of June 28, 1999.)

23. Interview of May 29, 1998. Strong verticals that allude to the human backbone constitute a recurrent refrain in Ingalls's work, early and late: "I have always been intensely aware of the vertical center of my body as an active orienting device. Marking off left from right, up from down, front from back, it helps me to grasp the cardinal points and to transform space into place. This vertical has been projected onto the canvases, appearing as the crack between the panels" (statement in *Heresies* 13, *Feminism and Ecology* [1981]: 46). On the general importance of the up-down, vertical dimension for the human body, see Erwin Straus, "The Upright Posture," in his *Phenomenological Psychology,* ed. E. Eng (New York: Basic Books, 1966), 138–55.

24. I borrow this term (in German, *Bodenkörper*), which can also be translated as "ground-body," from Edmund Husserl in his essay "Foundational Investigations of the Phenomenological Origin of the Spatiality of Nature," trans. F. Kersten, revised by L. Lawlor in Maurice Merleau-Ponty, *Husserl at the Limits of Phenomenology,* ed. L. Lawlor and B. Bergo (Evanston, IL: Northwestern University Press, 2002), 120ff.

25. Concerning the fragmented body, see Jacques Lacan, "Le stade du miroir comme formateur de la fonction du je," *Ecrits I* (Paris: Seuil, 1966), 90–97.

26. "Small details cluster to form larger land masses which move, fold, merge, and disintegrate before and about me, becoming a mold in which I feel my body being physically placed" (artist's statement for the exhibition Touching Earth).

27. Interview of May 29, 1998. Ingalls also observed in the same conversation that the sameness of hue as well as value in paintings of this period reinforces their surface-clinging tendency. The result is a vibrant paradox: surface-bound as these paintings are, they thrust their represented content (e.g., mountains) out from their elegant surface, "releasing" this content while still maintaining a hold on it.

28. On the "natural sublime," see Casey, *Representing Place,* part 1, chapter 4.

29. Artist's statement, 1992, for the exhibition Taking Place of a Mountain, manuscript, 1. Compare this with the following: "We know the natural world best not with our eyes, but through the movement of the body as it positions and repositions the sense organs in space" (artist's statement of December 1988, about the series "Life Pockets," manuscript).

30. On being on all fours—a recurrent image in Ingalls's writings—see, for example, this quotation: "I feel my body wrapping around the irregularities of the earth. I want to feel more on-all-fours than ever before, in the thick of things, and not to feel that I have safely rested my eyes on a stationary, distant tripod" (statement of December 1988, about

the series "Life Pockets," manuscript). Or again: "I think of the Earth as leaning against me, urging me to move over and into its intricacies, not as one would walk, but as one would go chest first or on all fours" (artist's statement for the exhibition Touching Earth).

31. Artist's statement of January 1995, about the series of triangular paintings called "Wild Signs," manuscript. "Life Pockets" is the title of a series of paintings done on a considerably smaller scale than is usual for Ingalls, who writes that in these works, "long paths of color expand the influence of one area upon another and create surfaces from and through which the viewer's eye is dropped into deep spatial pockets. Each painting is also a pocket in which I feel my body being physically placed and forced into muscular movements that are decidedly not urban" (artist's statement of December 1988, manuscript).

32. The triangular canvases—in fact, two perfect equilateral triangles and another such triangle with its apex severed to fit into the overall grouping of three figures—themselves instantiate Plato's idea that triangles are the elementary geometrical figures that bring formal order to the roiling material elements at the most rudimentary level of creation. Ingalls painted an entire series of triangular canvases during the early 1990s, as if to suggest that only such abrupt, angular shapes as these paintings possess are capable of breaking down the vast pictorial scope and sweep of the Idaho wilderness paintings of the 1980s. They set the stage for the long horizontal paintings of the mid-1990s that are complex both in composition and in conception. About these paintings Ingalls writes, "The triangular shapes which I use become mountains, valleys, burrows, geometric prisons, pyramids, planes in perspective seeking a vanishing point. The triangles seem to turn on their points, to rise and fall, to fold over one another, to behave like tectonic plates, to mimic the forces of nature" (artist's statement of October 1989, about the series "Wild Signs," manuscript).

33. "Wilderness Fragments," artist's statement of 1995, for an exhibition of the same title. Ingalls sees her recent work , especially her sculpture and print-making, as restoring the world of wilderness through bodily gesture: "I imagined that the natural world was gone—erased—except for the bit of landscape that started at the edge of the body. My task was to use my body as a drawing tool that would extend space outwards and bring the world back" ("Landscape at the Edge of the Body," artist's statement of 1996, for an exhibition of the same title).

34. Interview of May 29, 1998; with addition of conversation of June 28, 1999.

35. Ralph Waldo Emerson, "Experience," in *Ralph Waldo Emerson: Essays and Lectures* (New York: Library of America, 1983), 471.

36. Interview of May 29, 1998. Similarly, about a painting you need to be able to say that "here's the whole map and [yet] you can't forget its [particular] territories either" (ibid.).

37. "Sometimes I paint the shape of a space in which I feel that humans have once moved (as if one erased Piero della Francesca's figures and left the landscape which shaped their presence)" (artist's statement, January 1995, manuscript). The logic seems to be that the withdrawal of the artist's body as a *represented* presence allows her to become a body that clings to the earth, so much so as to become virtually invisible to the eye. Into the representational void thus created the viewer is invited to cast his or her body. Meanwhile, the artist takes up a position of contemplation outside the work.

38. "When we view wild animals, even caged ones, those animals seem to us to carry a piece of the landscape of their origin. As our lives become increasingly urbanized and withdrawn from nature, these pieces shrink and fade in our minds, stripping us of our

awareness of natural habitat. I often feel, with the passage of time, that less and less of the natural world remains attached to me" ("Between Body and Earth," artist's statement of 1998, for the exhibition of the same title). This statement should be compared with Margot McLean's implicit claim that her paintings shelter and shield animals by relocating them in another, nonnatural place.

39. Interview of May 29, 1998. Ingalls remarks elsewhere, "I wanted to pull landscape elements so close to my body that they could no longer be seen as easily as they could be felt, like a piece of clothing" ("Landscape at the Edge of the Body," artist's statement of 1996, for the exhibition of the same title); and, "[In my current work] landscape elements are pulsed so close to my body that sight is on the verge of being blinded by touch" ("Between Body and Earth," artist's statement of 1998, for the exhibition of the same title). The two statements just quoted provide a raison d'être for Ingalls's move into sculpture after her immersion in enormous landscape paintings. She notes, "While working on vast 18 foot wilderness paintings, I began to long for a more intimate encounter with nature [such as sculpture provides]" ("Landscape at the Edge of the Body," artist's statement of 1996, for the exhibition of the same title).

40. Straus, *The Primary World of Senses*, 322. Straus here strikingly employs the same word as Dan Rice does in his description of the artist's bodily insertion into landscape: *absorb*. To this notion we shall return in chapters 7 and 8.

41. "To be fully in the landscape we must sacrifice, as far as possible, all temporal, spatial and objective precision. Such a sacrifice, however, affects not only the objective [content of perception] but *ourselves as well*. In the landscape we cease to be historical beings, i.e., beings objectifiable to themselves" (ibid., 322; my italics).

42. Interview of May 29, 1998.

43. A painting that marks a significant transition from Ingalls's second to her third period is significantly entitled *Light Fields* (1987). This is a highly colored painting of animal tracks—another kind of mapping. Concerning the lightness of created work, Ingalls says to Sharon Olds: "A painting before it finally works is really heavy. As I paint, the canvas is—it's almost like a wounded butterfly. I keep doing things, until suddenly it takes off and leaves me, it just leaps up" ("Nudging the Sublime," interview with Olds).

44. Interview of May 29, 1998.

45. Pathways are not to be confused with footpaths; they are ways by which the whole body (e.g., its hands and upper parts) moves through wilderness. In a painting, they are indicated by formal factors such as colors or lines or thickness of paint. (Clarification from conversation of June 28, 1999.)

46. Stanley Cavell, *The Claim of Reason: Wittgenstein, Skepticism, Morality, and Tragedy* (Oxford: Oxford University Press, 1979), 180. I take Cavell's assertion to fit closely with Ingalls's notion that "painting gives you a whole experience" (interview of May 29, 1998).

47. Ingalls's remark is from the interview of May 29, 1998. She added that almost any representation of the natural world is "read as a landscape in a split second." (This is to implicate the *glance,* concerning which see my forthcoming book *The World at a Glance.*) The task of the painter is to slow down this automatic response in time by providing complicated structures in space. A recurrent theme in Ingalls's later reflections on her own work is her felt need to move beyond issues of assured orientation and secure placement to

a radical and risky immersion in nature—in its life pockets, where unknown resources still reside. "In my earlier work," she wrote already in 1988, "I was overwhelmed by the panoramic sweep of the wilderness that shook my sense of being securely placed and oriented in the world. Now concerns regarding orientation and placement seem almost a luxury. Thomas Cole painted a wilderness threatened by the axe. The contemporary threat is of another magnitude and has driven my attention from the panoramic sweep to a search for the oases left us. I feel compelled to let the life of these small pockets surge through my canvases before it is diminished" (artist's statement, December 1988, about the series "Life Pockets," manuscript). Ingalls paints wilderness "not only to tame it and to orient myself, but also to be able to perceive it at all, to respond to the measure of its forces" (artist's statement of October 1989, about the series "Wild Signs," manuscript).

6. Maps and Fields

1. See Stanley Cavell, *In Quest of the Ordinary: Lines of Skepticism and Romanticism* (Chicago: University of Chicago Press, 1988). "The sense of the ordinary that my work derives from the practice of the later Wittgenstein and from J. L. Austin, in their attention to the language of ordinary or everyday life, is underwritten by Emerson and Thoreau in their devotion to the thing they call the common, the familiar, the near, the low" (ibid., 4). The year 1953, let it be noted, also saw the publication of two landmark books in aesthetics: Suzanne Langer's *Feeling and Form* and Mikel Dufrenne's *Phenomenology of Aesthetic Experience*.

2. This is Robert Hughes's opinion in his *American Visions: The Epic History of Art in America* (New York: Knopf, 1997), 510. Hughes comments on the context: "What could younger artists do with the enormous, bland, and yet imperially demanding constructions of Middle American mass culture? They were right in the midst of them, affected, even formed by them. Some were fascinated by its icons but wary of its implications. They felt a compulsion to analyze and to reflect this new Americanism without being overwhelmed by it. The solution was irony" (ibid., 509). Rivers's painting is ironic because it is, in fact, inspired not by Washington's heroic action but by the defeat and retreat of Napoleon as depicted in Tolstoy's *War and Peace*.

3. Ibid., 512. Also: "The atmosphere of superpatriotism and fear of 'the enemy within' dumped an extraordinary excess of meaning into American public icons, most obviously the flag" (511).

4. Ibid., 512–13. Thus, "you are meant to pay attention to its surface, which never happens with a real flag. This surface is beautifully articulated" (513). We shall see, however, that more than surface is ultimately involved in Johns's map series. It would perhaps be more accurate to say that Johns gives us "real objects overgrown with paint" (cited by Eve Ingalls in conversation, June 28, 1999, New Haven, CT).

5. Johns's variations on traditional ready-mades include the bronze pieces that he painted in such accuracy as to suggest that the result is nothing but a found object in the Duchampian sense: for example, the various painted bronze works of 1960, one of two Ballantine Ale cans, another of a light bulb, and still another of a Savarin Coffee jar with a group of brushes thrust head down into it. The range of the ordinary objects employed by Johns is considerable: for example, rulers, dishes, and shoes (the last were first cast in

plaster, then covered with sculp-metal), not to mention such other publicly accessible things as numbers, the alphabet, and a book.

6. Johns as cited by Hughes, *American Visions*, 511.

7. Smithson, *Collected Writings*, 157: "Mapscapes as Cartographic Sites." This is the title of a subsection in the larger essay "A Museum of Language in the Vicinity of Art."

8. Johns is celebrated for having said, "I didn't want my work to be an exposure of my feelings" (Vivian Raynor, "Conversation with Jasper Johns," *Art News* 72 [March 1973]: 22).

9. Concerning the aesthetic surface, see D. W. Prall, *Aesthetic Analysis* (New York: Thomas, Crowell, 1936).

10. Hughes, *American Visions*, 512. Hughes underlines the word *painting*. Hughes is here analyzing a flag painting of Johns: "*Flag* resembles flag in its design, forty-eight stars and thirteen stripes, and in the flag it is painted on. But it is actually made, not of cloth, but of paint, and it does not 'fly'—it is static, stretched, rigid, and completely iconic" (ibid.). Compare Michael Crichton's remark about Johns's map paintings: "The artist produces an oscillation between the map (an abstraction representing something) and the painting of the map (an abstraction representing an abstraction) in such a way that multiple ways of looking are simultaneously apparent" (Michael Crichton, *Jasper Johns* [New York: Harry Abrams, in association with the Whitney Museum of American Art, 1977], 91).

11. For a more complete account of representation, including the variants of representation and *re*presentation, see Casey, *Representing Place*, chapter 12, "Re-presenting Representation." See also the glossary of terms.

12. In fact, Johns has collaborated closely with Merce Cunningham, designing costumes for his dance company and even a set that was inspired by Duchamp's *Large Glass*. The set was first made public at a performance of the Cunningham company on March 10, 1968. Johns was artistic director for this company for a number of years after 1967. Theater is directly at stake in several of Johns's later paintings, most notably in the two versions of *Dancers on a Plane* (1979, 1980), works that suggest choreographed movement on a stage. A carefully staged effect of *tableau vivant* is conveyed in Johns's series entitled "Seasons" (1985–87).

13. John Cage, "Jasper Johns: Stories and Ideas," in *Jasper Johns*, exhibition catalogue (New York: Jewish Museum, 1964), 22; my italics. It is not surprising to learn that Johns describes his *conception* of paintings as often occurring suddenly; for example, the idea for his work *Three Flags* (1958) "came to [him] all at once—the thought was complete" (cited in Crichton, *Jasper Johns*, 35).

14. Not that Johns colors all of his mapworks. A notable exception is found in his *Two Maps I* (1965–66), a lithograph of two uncolored black-and-white maps of America, one on top of the other and set within a black background.

15. The phrase "haunting presences" is that of Whitehead, commenting on Wordsworth's *The Prelude*, a poem that "is pervaded by [the] sense of the haunting presences of nature" (Alfred North Whitehead, *Science and the Modern World* [New York: Macmillan, 1925], 84–85; citing the famous lines of *The Prelude*: "Ye Presences of Nature in the sky / And on the earth! Ye Visions of the hills! / And Souls of lonely places!" Book I, lines 464–66).

16. That Johns was not averse to the idea of background is evident in this fragment written in the late 1960s: "The idea of background / (and background music) / idea of neutrality / air and the idea of air / (in breathing—in and out)" (Johns, "Sketchbook Notes," in Richard Francis, *Jasper Johns* [New York: Abbeville Press, 1984], 110).

17. Jasper Johns, "Sketchbook Notes," *Art and Literature* 4 (Spring 1965): 192.

18. Indeed, it is just because there are not excessive demands of invention in the first place that the painter feels free to innovate more completely within the found structure of a given map. What Johns says in this respect regarding his flag series is equally true for his map series: "Using the design of the American flag took care of a great deal for me because I didn't have to design it. So I went on to similar things like the targets [and maps]—things the mind already knows. That gave me room to work on other levels" (cited by Leo Steinberg, "Jasper Johns: The First Seven Years of His Art" (1962), in Steinberg's *Other Criteria: Confrontations with Twentieth-Century Art* [Oxford: Oxford University Press, 1972], 31). In the same vein and in a remark equally applicable to maps, Johns says that flags and targets are "both things which are seen and not looked at, not examined, and they both have clearly defined areas which could be measured and transferred to canvas" (quoted in Walter Hopps, "An Interview with Jasper Johns," *Artforum* 3 [March 1965]: 34; as cited in Crichton, *Jasper Johns*, 28). Michael Crichton remarks that Johns's "working method obliges him to select preexisting imagery in order that his creation will lie elsewhere" (*Jasper Johns*, 35).

19. Max Kozloff, *Jasper Johns* (New York: Harry Abrams, 1969), 28.

20. This is not to deny that the result in Johns's case is more painterly than maplike, just as there are many instances of decorated maps that remain primarily cartographic even as they edge toward landscape painting. Perfect balance or complete merging between mapping and painting is not the point. Of most interest to us are various creative commixtures of the two activities. Ingalls's early quasi-cartographic works are, as we have seen, exemplary instances of such macaronic ensembles, combining fragments of maps with drawn figures as well as the disparate in time with the incongruous in space.

21. Johns, "Sketchbook Notes," *Art and Literature*, 185.

22. It is worth nothing in this context that the initial inspiration for the entire map series stemmed from a map in a Rand McNally atlas of the United States given to Johns in jest by Robert Rauschenberg. Here the contingent and the personal conspired to provide the occasional cause of this series.

23. Crichton, *Jasper Johns*, 31, 34.

24. Ibid., 29. Stravinsky's claim runs like this: "My freedom thus consists in my moving about within the narrow frame that I have assigned myself for each one of my undertakings. . . . my freedom will be so much the greater and more meaningful, the more narrowly I limit my field of action and the more I surround myself with obstacles" (Igor Stravinsky, *Poetics of Music,* trans. A. Knodel and I. Dahl [Cambridge, MA: Harvard University Press, 1970], as cited (without pagination) in John Elderfield, "Leaving Ocean Park," in *The Art of Richard Diebenkorn*, ed. Jane Livingston [New York: Whitney Museum of American Art in association with the University of California Press, 1997], 109).

25. Cited by Crichton, *Jasper Johns*, 28; my italics.

26. This is Crichton's question, ibid.

27. The last-mentioned painting is *Passage II* (1966); the first is *Zone* (1962); the second, *Screen Piece* (1967); the third, *Tennyson* (1958); the fourth, *Skin with O'Hara Poem* (1963–65).

28. These examples come from *False Start* (1959). About this painting, Johns remarks: "It started from an idea about color—the decisions in the painting aren't based on visual

sensation primarily. The idea is that the names of color will be scattered about on the surface of the canvas and there will be blotches of color more or less on the same scale, and that one will have all the colors—but all the colors by name, more than by visual sensation" (cited in Crichton, *Jasper Johns*, 39).

29. Quoted without reference to the occasion, ibid., 91.

30. Thus I cannot agree with Crichton's view that there is a competition between image and word in Johns's paintings of this period: "In these paintings, one feels a competition between the language of the painter and spoken or written language. The competition appears literally, as brush strokes obliterate labels and vice versa; and it is felt as we look, and try to make sense of what we see" (*Jasper Johns*, 91).

31. Johns, "Sketchbook Notes" in Francis, *Jasper Johns*, 110.

32. "Johns has said he regards his paintings as information" (reported by Crichton in *Jasper Johns*, 25–26).

33. Crichton, ibid., 29. This is the answer to the question cited earlier as to how a familiar image can "become something that is to be looked at freshly."

34. "Jasper Johns Interviewed: [Part] I," by Peter Fuller, *Art Monthly* 18 (July–August 1978): 6.

35. That the crosshatch paintings of the 1970s and 1980s—for example, the elegant *Scent* (1973–74)—continue the mapping tendencies of the early 1960s is suggested by Rosenthal: "The hatching is but the latest example of the artist's study of pictorial elements [i.e., as begun in paintings of the late 1950s and early 1960s]. More often than not, he arranges the lines in bunches of parallel gestures, closer in appearance to hatch marks than crosshatches that intersect. Nevertheless writers and Johns himself have used the latter designation" (Mark Rosenthal, *Jasper Johns: Work since 1974* [Philadelphia: Philadelphia Museum of Art, 1988], 14). For an account of the hatch marks as analogous to marks on architectural drawings—maps of buildings, in effect—see Nina Sundell, *The Robert and Jane Meyerhoff Collection* (Phoenix, MD, 1980), 31. Johns's own comparison of the crosshatch design to the fingers of the human hand does not indicate that they are not *also* comparable to the hatch marks employed on maps; indeed, the two symbolic images may be closely related to each other. (On Johns's comparison of such marks to the hand, see David Shapiro, *Jasper Johns Drawings 1954–1984* [New York, 1984], 127.)

36. Elderfield, "Leaving Ocean Park," 112. But I cannot agree with Elderfield's further comment that Diebenkorn's work "became increasingly touched with humor and irony" (ibid.). This can only be said of the "Cigar Box Lid" series: what is an aberration for Diebenkorn is a central item of Johns's diet. Rather than humor and irony, "grave beauty," in Elderfield's own apt term, is what marks Diebenkorn's work (ibid.).

37. Diebenkorn made maps—of a quite conventional sort, for military purposes—when he was a member of the Marine Corps.

38. See Deleuze and Guattari, *A Thousand Plateaus*, 381–87.

39. "As the ['Ocean Park'] series was getting established in 1970, Diebenkorn experienced aerial views of landscape from a heliocopter and conceded: 'Many paths, or pathlike bands, in my paintings may have something to do with this experience, especially in that wherever there was agriculture going on you could see process—ghosts of former tilled fields, pathos of land being eroded'" (Diebenkorn as cited in Elderfield, "Leaving Ocean

Park," 112). Diebenkorn here takes up the theme of path or pathway, which we have seen to contrast importantly with route in the earlier discussion of Ingalls's work.

40. About his habit of continual reworking, of which he deliberately left traces in the finished work, Diebenkorn had this to say: "I began to feel that what I was really up to in painting, what I enjoyed almost exclusively, was altering—changing what was before me—by way of subtraction or juxtaposition or superimposition of different ideas" (cited in Jane Livingston, "The Art of Richard Diebenkorn," in *The Art of Richard Diebenkorn,* ed. Livingston, 72).

41. Concerning this struggle, Jane Livingston says, "One of the defining principles of the *Ocean Park* paintings is precisely the dichotomy between the improvisatory character Diebenkorn acknowledges and the effect of agonizing discipline they convey" (ibid., 66–67). On what Diebenkorn called "rightness of feeling," see ibid., 75ff., and especially the artist's own declaration that his "initial intent, as well as intent *in process,* was reduced to simply making things right" (cited ibid., 72; his italics). Notice that *right* and the *rect-* of *rectilinear* are etymologically affine. Concerning rightness in art more generally, see N. Goodman and C. Elgin, *Reconceptions in Philosophy and Other Arts and Sciences* (Indianapolis: Hackett, 1988), 51–53.

42. Livingston, "The Art of Richard Diebenkorn," 73.

43. On holey space, see Deleuze and Guattari, *A Thousand Plateaus,* 413–17.

44. Livingston, ibid., 65. The statement is all the more striking as applied to Ingalls, who employed only graphite and ink to blank canvas: a severely reduced chromaticism. Livingston adds: "The sheer complexity of incident within each painting, to say nothing of their comparative serial complexity, is unrivaled in the abstract painting of the era." (Ibid.)

45. See Dufrenne, *The Phenomenology of Aesthetic Experience,* 147ff., 166–98. Consult as well Goodman and Elgin, *Reconceptions in Philosophy and Other Arts and Sciences,* 49–53. In contrast with the more restrictive uses of *world* and *world-making* under discussion on chapter 5, I here allude to a more capacious or generous sense of these terms.

46. This is not to deny a decorative element in Diebenkorn as well: his paintings attain "that rare level of decorative brilliance we associate with Matisse's Moroccan period and his final body of large, cutout works" (Livingston, "The Art of Richard Diebenkorn," 85).

47. Statement of William Brice, cited in Livingston, "The Art of Richard Diebenkorn," 75. Livingston herself adds: "Rarely has an artist been more finely attuned to nuances of changing light, temperature, landscape, and streetscape" (ibid.).

48. Diebenkorn as cited by Livingston, ibid., 41.

49. Livingston, ibid., 85.

50. Diebenkorn's quasi-cartographic abstraction rivals Johns's "Crosshatch" works (even if allegiance to place, its painterly reflection, remains in force), while its intense "chromatic lyricism" competes with de Kooning's lyrical expressionism (though without the range or dazzling boldness of the latter).

51. By the end of the 1960s, Johns "turned to more private and hermetic imagery," and during the 1970s and 1980s his work became "increasingly expressive and exclamatory" (Rosenthal, *Jasper Johns: Work since 1974,* 10–11). Not that the expression of emotion was anything straightforward. As Moira Roth acidly remarks: Johns used "emotion-laden material and ran it through a filter of indifference" (Roth, "The Aesthetic of Indifference," *Artforum* 16, no. 3 [November 1977]: 52; cited in Rosenthal, *Jasper Johns,* 54).

7. Absorptive versus Cartographic Mapping

1. It can be argued that Diebenkorn's "Berkeley" paintings, realized in the mid-1950s, are topographic in impulse, since they set forth in recognizable images particular views of that city as an urban landscape. Diebenkorn, like Ingalls, passed through an important phase of representational topography—unlike Johns and de Kooning.

2. "Monolinear perspective" does not mean a single straightforward theory (e.g., that of Alberti or Brunelleschi) but the loose amalgam of ideas that have come to pass for such a theory in post-Renaissance thought. On the complexity of this situation, see James Elkins, *The Poetics of Perspective* (Ithaca: Cornell University Press, 1994); Alberto Pérez-Gómez and Louise Pelletier, *Architectural Representation and the Perspective Hinge* (Cambridge, MA: MIT Press, 1997).

3. Ian Hacking, *Rewriting the Soul: Multiple Personality and the Sciences of Memory* (Princeton: Princeton University Press, 1995), 253; my italics.

4. Ibid. Hacking asserts this as part of an argument against regarding flashback memories as special or privileged (e.g., as has happened in child abuse cases); he says that a flashback "is not peculiarly different from memory in general—and hence, not especially privileged" (ibid.). But for someone like de Kooning it *is* privileged, since its suddenness and lack of conceptual complication help to make it a valuable source of images for purposes of painting.

5. The case of the "wolf man" is the *locus classicus* for an account of deferred action. Hacking comments: "The old, and valuable, Freudian insight is that scenes that are recovered, whether it is in flashbacks, or through memory therapy, or through more ordinary reflective but unassisted recollection, become invested with meanings that they did not have at the time that they were experienced" (ibid., 254).

6. De Kooning was intensely interested in popular culture, and this culture certainly influenced his "Women" series among others. ("The concept of the American banal has always intrigued de Kooning: advertising, commercial art, giant industries for such intimate things as deodorants and toilet paper. He found it romantic, vulgar, and in its own way poignant" (Thomas B. Hess, *Willem de Kooning* [New York: Museum of Modern Art, 1968], 76). But popular culture is not an integral part of the paintings with which I am here concerned, that is, those that map the landscape in his unique way.

7. Cited from the film script made on de Kooning in *The Collected Writings of Willem de Kooning* (New York: Hanuman Books, 1990), 174. Compare the remark of Johns: "I was riding in a car, going out to the Hamptons for the weekend, when a car came in the opposite direction. It was covered with these marks, but I only saw it for a moment—then it was gone—just a brief glimpse. But I immediately thought that I would use it for my next painting" (Crichton, *Jasper Johns*, 59).

8. Reported by Dan Rice (the driver in this incident) in an interview of June 26, 1998, Madison, CT.

9. Diane Waldman, *Willem de Kooning* (New York: Harry Abrams in association with the National Museum of American Art, Smithsonian Institution, 1988), 112. Mondrian's early landscapes of his native country constitute their own quasi-cartographic mode of mapping; his later, more celebrated "linear" works can be considered abstractions from these early painting-maps.

10. I give this interpretation without claiming that de Kooning himself was thinking of

the elements at the time of painting this work. But it would be mistaken to exclude such an interpretation in principle, as Diane Waldman seems to do in this statement: "De Kooning's landscapes, by the late 1950s and early 1960s, are less about the experience of nature or natural phenomena than they are about the nature of painting" (ibid., 112). Even if in these paintings "references to nature are subliminal" (ibid.), this does not render these references insignificant.

11. Diebenkorn's early work is replete with the theme of figure in the landscape—either expressly so (e.g., *Girl Looking at Landscape* [1957]) or in the mode of immersion (e.g., *Berkeley* [1954], which features flesh-toned parts of the landscape). The "Ocean Park" series, however, is "haunted by the erasure of human presence" (Arthur Danto, cited by Elderfield, "Leaving Ocean Park," 112), as could be said of Ingalls's later works as well.

12. Waldman, *Willem de Kooning*, 117. She adds: "Here [i.e., in the late 1960s] de Kooning achieves a remarkable unification of figure and ground, form and color. The female figure, although still the theme of the painting, no longer dominates its composition." Before this, in the early and middle 1960s, women are only partly merged into the landscape, for example, in *Clamdiggers* (1964).

13. "De Kooning, having destroyed the premise that representation of the human figure and abstraction were antithetical, proceeded to demonstrate that landscape and abstraction could also exist in a dynamic relationship" (ibid., 110).

14. For a concise and insightful study of the figure of the demoness, see Janet B. Gyatso, "Down with the Demoness: Reflections on a Feminine Ground in Tibet," *Tibet Journal* 12, no. 4 (1987): 34–46.

15. Husserl has this to say about the ordinary body: "The rigid body is the normal body, for even deformation of the body can, at any phase, turn into rigidity" (Edmund Husserl, "The World of the Living Present and the Constitution of the Surrounding World External to the Organism," trans. F. A. Elliston and L. Langsdorf, in *Husserl: The Shorter Works*, ed. P. McCormick and F. A. Elliston [Notre Dame, IN: University of Notre Dame Press, 1981], 239). Notice that one may read the fleshy mass at the right side of *Two Figures in the Landscape* as composed of *two* intertwined figures, perhaps making love in the grass; but even if this is the case, much the same analysis as I have given above would still apply to this Aristophenean figure who grapples (with) the earth.

16. Willem de Kooning, *Sketchbook No. 1: Three Americans* (New York: Time, 1960), 15.

17. For further discussion of the chorographic versus the topographic, see Casey, *Representing Place*, part 2, chapter 8.

18. For a treatment of certain nineteenth-century American and European painters as well as painters of the Northern Sung era, see ibid., chapter 6, "Representing Place Elsewhere."

19. For a remarkable treatment of the lived, sensuous body that is essential to absorptive mapping, see Glen A. Mazis, *Earthbodies: Rediscovering Our Planetary Senses* (Albany: State University of New York Press, 2002).

20. Emerson, "Experience," in *Ralph Waldo Emerson*, 491.

21. Remark of 1957 cited as the second epigraph to Waldman, *Willem de Kooning*. De Kooning also says of himself, "If I stretch my arms next to the rest of myself and wonder where my fingers are—that is all the space I need as a painter" (remark of 1951 cited as the first epigraph, ibid.). This can be true only on the condition that his arms and fingers already contain the landscape he will paint by their means. De Kooning's remark is to be contrasted

with that of Ingalls, who became interested in the early 1970s in how a painting can suggest the effect of the artist's body as it stretches itself *beyond* the extent of the canvas and outward toward other objects (observation made in the interview of May 29, 1998).

22. In the end, however, Johns and Ingalls finally part ways. Johns's maps and other images remain remote from any landscape scene, whereas Ingalls begins with female figures immersed in the landscape and ends by withdrawing them from it, while nevertheless maintaining a lively sense of corporeal presence throughout.

8. Locating the General in the Earth Itself

1. Interview with Dan Rice, June 13, 1998, Madison, CT.

2. For the intimate relationship between the singular and the general—decidedly not the universal—see Gilles Deleuze, *Difference and Repetition,* trans. Paul Patton (New York: Columbia University Press, 1994), 1. For more on this theme, see especially chapters 1 and 2.

3. Ibid., 1. The notion of the work of art as a singularity without concept goes back to Kant's idea of a reflective judgment of taste and is also affine with Merleau-Ponty's similar notion of the "conceptless universality" that is operative in art (see Merleau-Ponty, "Eye and Mind," 172). In the foregoing remarks, I have stressed the relationship between particularity, the general, and repetition. Deleuze, in contrast, seizes on the link between singularity, the universal, and repetition.

4. "Generality [as such; not that generated by an authentic repetition] presents two major orders: the qualitative order of resemblances and the quantitative order of equivalences" (Deleuze, *Difference and Repetition,* 1).

5. By "remembered" I mean, once again, not *recollected* in the form of a discrete event but rather held diffusely yet firmly within the memorial mind of the painter: in short, a matter of what Bourdieu calls "habitus."

6. Husserl, from whom I borrow these terms, assimilates them to each other: see his *Ideas I,* part 1, chapter 1.

7. See Martin Heidegger, *Identity and Difference,* trans. J. Stambaugh (New York: Harper and Row, 1969).

8. The example of the Upper Cape comes from the interview of June 13, 1998.

9. Ibid.

10. Merleau-Ponty, *Phenomenology of Perception,* 197.

11. Whitehead, *Process and Reality,* 129.

12. See John Dewey, *Quest for Certainty* (New York: Minton, Balch, 1929). On the idea of experiential funding, see his *Art as Experience* (New York: Capricorn, 1934). The contrast, and deep connection, between finding and founding is the subject of Stanley Cavell's remarkable essay "Finding as Founding: Taking Steps in Emerson's 'Experience,'" in his *This New Yet Unapproachable America: Lectures after Emerson, after Wittgenstein* (Albuquerque, NM: Living Batch Press, 1989), 77–118. The core of Cavell's claim is found in his statement that "foundation reaches no further than each issue of finding" (ibid., 114). Emerson is not a foundationalist, hence his attraction for Cavell, who describes Emerson's final position as "finding as founding as finding" (ibid., 116).

13. Interview of June 13, 1998. Compare Diebenkorn's advice to himself: "Don't 'discover' a subject—of any kind." But his use of qualifying quotation marks indicates that

Diebenkorn is thinking of discovery in a sense significantly different from Rice's: Diebenkorn means it as the possession of a definite object, which is not at all what Rice has in mind (Diebenkorn, "Notes to Myself on Beginning a Painting," appended to Elderfield, "Leaving Ocean Park," 115).

14. Cited by Rice in the interview of June 13, 1998. Rice himself has said, "You paint your unconscious" (remark made in his Madison studio; November 1998). Compare Diebenkorn: "*Do* search. But in order to find other than what is searched for. . . . Somehow don't be bored—but if you must, use it in action. Use its destructive potential" (Diebenkorn, "Notes to Myself," 115; his italics). De Kooning in turn has said: "Before, it was about knowing what I didn't know. Now, it's about not knowing that I know" (remark of 1987, cited in Edward Lieber, *Willem de Kooning: Reflecting in the Studio* [New York: Abrams, 2000], 51).

15. "Thus the first and most immediate aim of the process of testing reality is not to discover an object in real perception corresponding to what is imagined, but to *re-discover* such an object, to convince oneself that it is still there" (Sigmund Freud, "Negation" (1925), trans. J. Riviere, in Freud, *General Psychological Theory: Papers on Metapsychology*, ed. P. Rieff [New York: Simon and Schuster, 1991], 215–16; his italics).

16. For Kierkegaard's sense of repetition as a forward movement into the new, see his *Repetition: An Essay in Experimental Psychology*, trans. M. Lowrie (Princeton: Princeton University Press, 1941).

17. See Sigmund Freud, "Remembering, Repeating, and Working-Through" (1914), in S. Freud, *The Standard Edition of the Complete Psychological Works*, trans. J. Strachey (London: Hogarth, 1953), vol. 12.

18. The quoted phrase is my adaptation of Bachelard's remark about the poetic image: see his *Poetics of Space*, trans. M. Jolas (Boston: Beacon Press, 1969), x: "The poetic image is a sudden salience on the surface of the psyche."

19. On reconstructive (i.e., bodily enacted) memory, see Jean Piaget and Bärbel Inhelder, *Memory and Intelligence*, trans. A. J. Pomerans (New York: Basic Books, 1973), 17–19, 355–60.

20. Remark from interview of June 26, 1998.

21. The full statement is: "Even if I never saw Maine again, I'd go on painting Maine paintings because it lives inside me; that experience has been internalized, and I can paint directly from that experience" (ibid.).

22. The citations in this sentence and the previous one are from the interview of June 26, 1998.

23. Ibid.; his emphasis.

24. Cavell, "Finding as Founding," 115; his italics. Cavell, with reference to Emerson, also speaks of "the transfiguration of philosophical grounding as lasting" (116)—another apt description of painting on Rice's model.

25. Ibid., 115, 116.

26. M. Heidegger, "Time and Being," trans. J. Stambaugh, in *On Time and Being* (New York: Harper, 1972), 12.

27. Remark made in the interview of June 26, 1998.

28. Heidegger, "Time and Being," 11.

29. For Husserl's notion of the "near sphere," see "The World of the Living Present,"

248–50, where *Kernsphäre* is translated by Elliston and Langsdorf as "core sphere." The idea of potential and actual reach I take from Alfred Schutz in his "Dimensions of the Social World," in *Collected Papers*, ed. F. Kersten (The Hague: Kluwer, 1975), II: 27ff.

30. Rice, interview of June 26, 1998.

31. "The nearing of nearness" is Heidegger's term. For him, it is not only a spatial matter but decisively temporal as well: "This nearing of nearness keeps open the approach coming from the future by withholding the present in the approach. Nearing nearness has the character of denial and withholding. It unifies in advance the ways in which what has-been, what is about to be, and the present reach out toward each other" (Heidegger, "Time and Being," 15–16). Cavell also stresses the importance of nearness in "Finding as Founding," 77, 96, 108–9, 117.

32. De Kooning is reported to have said, "The distance from one part of my painted bodies to another part is greater than that between two stars" (quoted by Eve Ingalls, interview of July 16, 1998).

33. The basic process of absorption is "psychosomatic," as Rice stresses in the interview of June 26, 1998. I borrow the term *psychical body* from Stephanie Schull. I do not mean to underrate the importance of body for Rice. He credits experiences of walking for his turn to painting that is recognizably landscapelike: "Walking the beaches [of Connecticut in the early 1970s] brought landscape and seascape back into my work" (interview of June 26, 1998). But Rice would never go to the extreme of claiming, as de Kooning does in the remark cited above, that all the space he needs as a painter is indicated by stretching his arms next to his body (see n. 21, chapter 7). Where de Kooning reaches only into himself, into his own lived body, Rice reaches out into the larger landscape—larger in spirit and scope than de Kooning's, even in the case of the near sphere that is the topic of Rice's last works.

34. On the contemplative sublime in the Hudson River School and in luminism, see my *Representing Place*, part 1, chapters 2 and 3.

35. Remark made in interview of June 26, 1998.

36. *American Heritage Dictionary*, 1991 ed., s.v. "numinous."

37. Heidegger, "Time and Being," 15. As in the case of nearness, Heidegger also gives a temporal interpretation of dimensionality: it "consists in a reaching out that opens up, in which futural approaching brings about what has been, what has been brings about futural approaching, and the reciprocal relation of both brings about the opening up of openness" (ibid.).

38. I say "anexact" and not "inexact": it is not a matter of failure to provide the measurable but of being wholly outside the realm of what can be measured.

39. On these underlayers of earth, see Hillman, *The Dream and the Underworld*, 35–36.

40. Straus, *The Primary World of Senses*, 319.

41. Remarks made in interview of June 26, 1998.

Last Thoughts on Part II

1. Even a painting of singular ecstatic moments, such as we find in de Kooning's later work, still stems from a *series* of such moments: the singularity itself is part of their common essence. For a discussion of Church's *Twilight in the Wilderness*, see Casey, *Representing Place*, chapter 3, "Apocalyptic and Contemplative Sublimity."

2. On the customary versus the momentary body, see Merleau-Ponty, *Phenomenology of Perception*, 139–47, 152–53.

3. This orientational and navigational ability is the last frontier in the loss of human memory, as the remarkable case of "M. K." attests: although he had lost every other major form of memory, he could still find his way about the hospital corridors. Concerning "M. K.," see A. Starr and L. Phillips, "Verbal and Motor Memory in the Amnesic Syndrome," *Neuropsychologica* 8 (1970): 75–88.

4. I owe this example to Dan Rice, from the interview of June 13, 1998, Madison, CT.

5. On this theme, see my *Representing Place*, 114–15.

6. For Husserl's notion of passive synthesis, see his *Experience and Judgment: Investigations in A Genealogy of Logic*, ed. L. Landgrebe, trans. J. S. Churchill and K. Ameriks (Evanston, IL: Northwestern University Press, 1973), sections 81–83. For Deleuze's retake of this notion, see his *Difference and Repetition*, trans. P. Patton (New York: Columbia University Press, 1994), 71–85.

7. This is Dan Rice's phrase, from the interview of June 13, 1998. Rice also proposed the terms *immersion* and *reservoir* at the same time. Clearly, all these terms relate closely to what I have called absorptive mapping.

8. That such objectivity is a will-o'-the-wisp is shown in dramatic detail by Mark Monmonier in his *Drawing the Line: Tales of Maps and Cartocontroversy* (New York: Henry Holt, 1995). For an engaging treatment of the rhetoric of mapping, see Tom Conley, *The Self-Made Map* (Minneapolis: University of Minnesota Press, 1996).

9. For a treatment of prehistoric maps and portolan charts, see Casey, *Representing Place*, chapters 7 and 9.

10. Deleuze and Guattari, *A Thousand Plateaus*, 371. In fact, the discussion of striated versus smooth space in this same text is closely akin to my distinction between cartographic versus absorptive mapping. Many (but not all) cartographic maps make use of striated space, while absorptive mapping draws on the experience of smooth space—its undulations, irregularities, and polydirectionality. In the end, the cartographic and the absorptive, richly ramified as they may be, are specific modes of striated and smooth space, respectively, their *application*, as it were, though not their exclusive exemplification.

11. Strictly speaking, cartographic mapping is the institutionally sanctioned extremity of "mapping of," while absorptive mapping is the experiential extreme of "mapping with/in." In between the extremes lie "mapping for" and "mapping out"—the former closer to the cartographic pole, the latter nearer to the absorptive pole.

12. But exceptions do occur: for example, Ingalls's *Take Only Pictures* (discussed in chapter 5).

13. Concerning different modes of sublimity, see Casey, *Representing Place*, chapters 2–4.

Epilogue

1. McLean, conversation, July 29, 2000; her emphasis.

2. My use of *ingression* is borrowed from A. N. Whitehead, who argues that feeling is a phase of concrescence that extends into the entire physical world. See his *Process and Reality: An Essay in Cosmology*, ed. D. R. Griffin D. W. Sherburne (New York: Free Press,

1978), 23–25, 149, 290–91. I am using *psychical* in a sense that is indebted to R. G. Colling-wood's employment of this term in his *Principles of Art,* where he distinguishes crisply between feeling and emotion. See Collingwood, *Principles of Art* (Oxford: Oxford University Press, 1938), chapter 8, especially 160–64.

3. I here allude again to Merleau-Ponty's citation of Valéry's statement that the painter "takes his body with him" into the work. I quoted this statement in chapter 1: see Merleau-Ponty, "Eye and Mind," in *The Merleau-Ponty Aesthetics Reader,* 123.

4. "I got interested in places by taking trips and just confronting the raw materials of the particular sectors before they were refined into steel or paint or anything else. My interest in the site [outside the gallery or studio] was really a return to the origins of material, sort of a dematerialization of refined matter" (Smithson, "Fragments of an Interview with P. A. Norvell," 192).

5. The quoted phrase relates to this original: "You keep going from point to point" ("Four Conversations between Dennis Wheeler and Robert Smithson," 200).

6. I refer here to Wallace Stevens's line "I was the world in which I walked, and what I saw / Or heard or felt came not but from myself" (from "Tea at the Palaz of Hoon," *Collected Poems* [New York: Knopf, 1978], 65).

7. The term *coefficient of adversity* is found in Gaston Bachelard, *Earth and Reveries of Will,* trans. K. Haltman (Dallas: Dallas Institute Publications, 2002), 39: "Every material has a coefficient of adversity."

8. James Corner, "The Agency of Mapping: Speculation, Critique and Invention," in *Mappings,* ed. D. Cosgrove (London: Reaktion Books, 1999), 225.

9. "Through rendering visible multiple and sometimes disparate field conditions, mapping allows for an understanding of terrain as only the surface expression of a complex and dynamic imbroglio of social and natural processes" (Corner, ibid., 214).

10. Lucy Lippard says this about Stuart: "All of Stuart's art is about digging—into the earth, into the past, into her personal history and psyche and those of native peoples" (Lucy R. Lippard, *Overlay: Contemporary Art History and the Art of Prehistory* [New York: Pantheon, 1983], 34).

11. Robert Smithson, "Towards the Development of an Air Terminal Site" (1967), in Smithson, *Collected Writings,* 60; his italics.

12. See, for example, Charles Simonds's miniature buildings in open landscapes, for example, Figures 20A and 20B in Lippard, *Overlay,* 98. Sometimes the distinction between sculpture and architecture cannot be clearly drawn, as in Nancy Holt's *Sun Tunnels* (1973–76), four large concrete cylinders set out in the Great Basin Desert, Utah, as reproduced in Figures 26A and 26B in Lippard, *Overlay* (107).

13. I refer to Christo's "Running Fence" in Sonoma and Martin counties, California; for more information, see www.sonomacountymuseum. com/docs/christo.html.

14. "Interview with Robert Smithson," 236.

15. Corner, "The Agency of Mapping," 225. For a more complete and nuanced treatment of performance, see Bruce Wilshire, *Role-Playing and Identity* (Bloomington: Indiana University Press, 1983); and Robert Crease, *The Play of Nature: Experimentation as Performance* (Bloomington: Indiana University Press, 2000).

16. Plato, *Meno* 76b.

17. For this fable, see Jorge Luis Borges, "On Exactitude in Science," in *Collected Fictions*, trans. A. Hurley (New York: Viking, 1998), 325.

18. Corner, "The Agency of Mapping," 214.

19. These examples, and numerous others, are treated in Casey, *Representing Place*, especially part 1.

20. Smithson said of *Spiral Jetty*, "My dialectics of site and non-site whirled into an indeterminate state, where solid and liquid lost themselves in each other" (Smithson, "The Spiral Jetty," 146). But this same indeterminacy results from the intricate interplay of site and non-site in many of Smithson's earlier works.

21. The grid in Stuart's later paintings is "a set of co-ordinates for presenting the occurrences of both plan and infinite variable chance" (Patricia C. Phillips, "A Blossoming of Cells," *Artforum* [October 1986]: 117).

22. In this respect, the employment of a map or photograph plays a role parallel to the title of many such works: for example, *Montauk Highway, Virginia, New York City Rainfall, Salt Marsh Woods, Sunset.*

23. On the work of art—especially the literary work—as an intransitive object, see Eliseo Vivas, "The Object of the Poem," in his *Essays in Criticism and Aesthetics* (New York: Noonday Press, 1955), especially 131–33.

24. Smithson, "The Spiral Jetty," 149.

25. Ibid., 146–49. I have cited part of this same quotation, embedded in a longer statement, in chapter 1.

26. *Earth-basis* (or alternatively *earth-ground*) translates Husserl's term *Erdboden*; see Edmund Husserl, "Foundational Investigations of the Phenomenological Origin of the Spatiality of Nature: The Originary Ark, the Earth, Does Not Move," trans. F. Kersten (revised L. Lawlor), in Merleau-Ponty, *Husserl at the Limits of Phenomenology*, 119–23, 126–27.

Permissions

Works by Robert Smithson copyright Estate of Robert Smithson. Licensed by VAGA, New York. All images courtesy of the James Cohan Gallery, New York.

All images by Margot McLean are reproduced courtesy of the artist.

All images by Sandy Gellis are reproduced courtesy of the artist.

All images and poetry by Michelle Stuart are reproduced courtesy of the artist.

All images by Eve Ingalls are reproduced courtesy of the artist.

Map (1961) copyright Jasper Johns. Licensed by VAGA, New York, NY. Image copyright the Museum of Modern Art. Licensed by SCALA/Art Resource, NY.

Map (1963) copyright Jasper Johns. Licensed by VAGA, New York, NY. Image copyright David Lees/CORBIS.

Corpse and Mirror (1974) copyright Jasper Johns. Licensed by VAGA, New York, NY. Image courtesy of the artist.

Ocean Park No. 31 (1970–72) reproduced courtesy of the estate of Richard Diebenkorn and Artemis • Greenberg Van Doren • Gallery, New York. Image copyright CORBIS.

Montauk Highway (1958) copyright 2003 the Willem de Kooning Foundation/Artists Rights Society (ARS) New York. Image courtesy of the Los Angeles County Museum of Art; gift from the Michael and Dorothy Blankfort Collection in honor of the museum's twenty-fifth anniversary. Photograph copyright 2003 Museum Associates/LACMA.

Two Figures in a Landscape (1967) copyright 2003 the Willem de Kooning Foundation/Artists Rights Society (ARS) New York. Image courtesy of Stedelijk Museum Amsterdam.

Untitled III (1981) copyright 2003 the Willem de Kooning Foundation/Artists Rights Society (ARS) New York. Image courtesy of the Hirshhorn Museum and Sculpture Garden,

Smithsonian Institution; partial gift of Joseph H. Hirshhorn, by exchange, and museum purchase, 1982. Photograph by Lee Stalsworth.

Untitled X (1977) copyright 2003 the Willem de Kooning Foundation/Artists Rights Society (ARS) New York. Image copyright Christie's Images Inc. 2004.

Door to the River (1960) copyright 2003 the Willem de Kooning Foundation/Artists Rights Society (ARS) New York. Image copyright Geoffrey Clements/CORBIS.

Untitled (Figures in Landscape) (1966–67) copyright 2003 the Willem de Kooning Foundation/Artists Rights Society (ARS) New York.

All images by Dan Rice are reproduced courtesy of the artist.

Poetry by Glenn Weiss is reprinted courtesy of the author.

INDEX

environmental ethics, xiv, 53, 180, 186, 197n33
Estes, Richard, xix
Evening Marsh (Rice), 154, 160–62, plate 30
experience, reservoir of, 169

False Start (Johns), 216n28
finding/founding, 221n12
"Fish in the Sky, Whose Bottom Is Pebbly with Stars" (Stuart), xxiii, 71–74
flags, use of, 214n3, 214n5, 215n10, 216n18
flashback memory, 219n4, 219n5
Flavin, Dan, 54
Flying Bird (McLean), 102
Folded Field (Ingalls), 114–16, 117, 119, 120, 172, 211n22, plate 18
"Four Conversations between Dennis Wheeler and Robert Smithson" (Smithson), 196n10, 198n50, 225n5
"Fragments of a Conversation" (Smithson), 196n17, 197n25, 197n30, 197nn36–37, 209n38
"Fragments of an Interview with P. A. [Patsy] Norvell" (Smithson), 196n15, 196n17, 208n15, 209n37, 225n4
framing, 201n3, 205n47
"Frederick Law Olmstead and the Dialectical Landscape" (Smithson), 198n52
Freud, Sigmund, 222n15

Gadamer, Hans-Georg, 54, 183
garden imagery, use of, 75–77, 78, 82, 84, 88, 89, 206n63, plate 14
Gellis, Sandy, xxiii; aerial views and, 41, 42–46, 47–48; animate/reanimate in the works of, 56; artistic practice, 41, 47, 49–53; body, use of, 55, 96, 98; boxes, use of, 42–43, 91, 102; cartographic mapping in work of, 45–47, 92, 102; commemoration of place, 53; deflection, 55–56; elemental landscapes of, 41–47, 51–53, 56; embodiment, 53–54; environmental ethics of, 53, 186; framing, 201n3; grids, use of,

92; levels in the work of, 45; location, 54; materials, use of, 42–43, 49–53, 54–55; movement, use of, 47–48, 48; multiple mapping, 45–46, 49–50, 51–53; photography, use of, 49, 51; reflection, 55–56; relocation, 54, 94; representation/re-presentation in the works of, 54–55; spatiality in the works of, 50, 51; temporality in the works of, 42–43, 44–47, 49–53, 100–101, 202n19; terraces, 47–48; travel, 178–79; view/review in the works of, 55, 56; wading, 96, 98; water, use of, 47–48, 49–53, 55, 96; weather and, 201n11
Gellis, Sandy, works of: *Condensed Spaces: Iron, Sand, String* (1976), 92; "Condensed Spaces" series (late 1970s), 41–43, 53–54, 92, 102; *Curtis Bay Project* (1989), 53; *Cygnus A* (1994), 47–48, plate 8; *Depth Charts* (1987–88), 45–47; *Diomede Project* (1989), 44–45; "Earth, Air and Water Studies" (mid-1980s), 43–44, 45, 53; *Hudson River Drawings*, 51, 201n14; "Hudson River: Sediments" project (ongoing), 51, 201n14; "Landscapes" project (1976—continuing), 51–53; *New Lake Project* (1989), 53; *New York City Rainfall: 1987* (1988), 49–50; *Night Views over Land from Seat 8A* (1986), 53–54; "Ocean Fragments" series (1997–2000), 41, 49, 55; *Ocean Fragments: Water* (1997), 41, 49, 55; *Spring 1987: In the Northern Hemisphere*, 50, 201nn10–12; *Viewing Mounds* (1988), 48, plate 9
geoglyph, 76, 204n33
geometrics, 16–17, 26, 57–59, 212n32
geometrism, morbid, 75
Gibson, J. J., 29
Girl Looking at Landscape (Diebenkorn), 220n11
glance, use of, 113, 141–42, 151, 213n47
glyph, 204n33
Goldsworthy, Andy, 180

pathways, 119–21; Diebenkorn, 217n39; Ingalls, 213n45
pentimento, 39
performativity, 180, 181–83, 191–92
Phenomenology of Perception (Merleau-Ponty), 199n15, 200nn22–23
Phillips, Patricia C., 75, 84, 205n38, 206n50, 207n65, 226n21
Philosophical Investigations (Wittgenstein), 123–24
photography, use of, 94, 95, 176; Gellis, 49, 51; role of, 226n22; Smithson, 10; Stuart, 61, 74, 79–80, 81, 85–86, 185, 207n7
Piaget, Jean: and Bärbel Inhelder, 175
Picasso, Pablo, xix
place, 202n17; books/language and, 203n10; change of level and, 33–34; commemoration of, 28, 29–35, 39, 40, 53; dialectic of, 8–9; Diebenkorn, 107; landscape and, 195n20; location and, 94–96; mapping and, xiv–xx; McLean, 34–35, 35–38, 94, 176–77; non-objective sites and, 196n11; place/nonplace, 79, 80; place works, 67–69, 75–78; relocation, 35–38; representation of, xxii–xxiii; rubbings and, 203n10; site/non-site and, 8–9; Smithson, Robert, 8–9; sound within, 204n24; Stuart, 27–29, 67–68, 75–78, 79–80; travel, 67–69, 78–82. *See also* natural place; place-world; site
place works, 67–69, 75–78
place-world, the, xxiv, 66, 117–19, 187. *See also* world/world-making
Plato, 117, 181
plotting, 87–88. *See also* charts/charting
Poetics of Music (Stravinsky), 131
Pollock, Jackson, 123
Pons Varolii (McLean), 36–37, plate 6
pop art, 123–24
Prall, D. W., 125
Prelude, The (Wordsworth), 128, 215n15
presentation, 54–55. *See also* representation; re-presentation

Princenthal, Nancy, 206n52
productive mapping, 181–83, 190–91
psychical body, the, 223n33
psycho-kinetic movements, 177–78
Puerto Rico de la Luna History Book (Stuart), 97–98

quasi-cartographic mappings, 135, 137, 163–64

rationality, 93
Rauschenberg, Robert, 123, 176
ready-mades, 124, 214n5
re-embodiment, 183
reflection, 55–56, 158–60, 196n17
re-implacement, 183
re-inhabitation: reproductive mapping, 35–38
relative global, the, 194n6
relocation: Gellis, 54, 94; McLean, 35–38, 91–94; place and, 35–38; Stuart, 63–65, 70, 79, 94–95, 89. *See also* place; re-presentation
repetition, 155–58, 183, 221n3, 221n4
replication, 183
representation: cartography, xviii–xix; Gellis, 53–54; indexicality and, 183–85; mapping and, 3–4; material production and, 91; nonrepresentation and, 80; painting and, xiii–xiv; of place, xxii–xxiii; presentation in contrast with, 54–55; Rice, 153–54; Smithson on, 197n25. *See also* mapping; topographic mapping
re-presentation, xv–xix, 31, 54–55, 183, 184
re-presentation, xviii
representational topography, 114, 219n1
Representing Place in Landscape Painting and Maps (Casey), xxii
reproduction, 183–85
reproductive mapping, 35–38, 155–58, 181–83, 188–89. *See also* productive mapping
Rice, Dan, xxiii; absorption, 169; absorptive mapping, 158–62, 169, 170–73,

mapping in work of, 91–92, 102; chaos/cosmos, 69, 89; charts/charting, 69, 86–89, 204n26; close/far, 83–84, 206n60, 206n63, 207n65; collective memories, 66–67; co-location, 95; commemoration of place, 74; cultural overlay, 66, 203n15, 206n50; diachronic/synchronic works, 67; double aspects in work of, 82–86, 88–89, 206n60, 207n66; dreams, use of, 67; economy of titles, 87; environmental activism of, 186; frame of vision, 205n49; garden imagery, 75–78, 82, 88, 89, 206n63; geoglyph, 71, 204n33; geometrics within the works of, 57–59; grids, use of, 58–59, 70, 74–75, 85, 205n49, 206n52, 226n21; imaginary, use of the, 79, 87, 88, 177; influences on, 205n46; interelemental exchange, 70–74; journey, 78–82, 88, 97–98, 178–79; land's end, 65; land works, 63–66; mapping/nonmapping, 86–89; materials, use of, 59–63, 71–72, 76–77, 78, 80–81, 96, 98, 225n10; movement, use of, 95; overlay, 39, 203n8; painterly qualities of, 81–82; performativity of, 95, 181; personal history of, 57–58, 204n34, 225n10; photography, use of, 61, 74, 79–80, 81, 85–86, 185, 207n7; place/nonplace, 79, 80; place works, 66, 67–68, 75–78; plotting, 87–88; relocation and, 63–65, 67, 70, 79, 93–95, 189; representation/nonrepresentation, 80; rock-books, 61, 185; rubbings, 59–63; scale, use of, 93; scanning, 84–85; sculptural qualities of, 81–82; site maps, 85–86; sky, use of, 69–75, 87, 98, 204n35; sound and, 204n24; spatiality, 65–66, 77–78, 83–84; star charts, 69–75; temporality, 65–68, 100–101, 203n19; trips/voyaging, 66–68, 78–82, 94, 177, 188; water, use of, 70, 96
Stuart, Michelle, works of: *Ashes in Arcadia* (1998), 76, 80, 96; *Black Star . . . Sky Dome of the North* (1985–86), 88; *Blue Stone Quarry–Moray Hill Site* (1974), 61, 85; *Bone Land . . . Chinle Crystal Dwelling* (1985–86), 206n63, 207n66; *Codex: Canyon de Chelly, Arizona* (1980), 62, 79–80, 207n7, plate 11; *Copan I* (1978), 74; *Correspondences* (1981), 96, 204n24; *Diffusion Center: Fort Ancient Site, Ohio* (1979–80), 74, 85–86, 88, 102; *"Fish in the Sky, Whose Bottom Is Pebbly with Stars"* (1999), xxiii, 71–74; *In the Beginning . . . Yang-Na* (1984), 76, 80, 205n46; *Islas Encantadas: Seymour Island Cycle* (1982), 74, 80; *Mare 15* (1972), 58, 74, 89; Mariners Chart (Stuart), 68–69, 79, 85, 102, 177; Mariners Temple, 68, 74, plate 12; "Moon" series (1973), 57–59, 85, 102; "Natural Histories" series (1987), 77; *Navigating the Seas Reflecting the Stars* (1986), 70, 97; *Nazca Lines Star Chart* (1981–82), 70, 74, 204n33, plate 13; *Niagara River Gorge Path Relocated* (1975), 63–65, 67, 70, 79, 93, 95, 189; *No. 1* ("Moon" series, 1973), 59, 202n6; *No. 4* ("Moon" series, 1973), 59, 60; *On Part of Memory Being Alaska: Black Star . . . Sky Dome of the North* (1985–86), 75, 79, 88, 205n48; *Paradisi: A Garden Mural* (1985–86), 75–76; *Passages: Mesa Verde* (1977–79), 62, 72, 79, 88, 185, 188; *Puerto Rico de la Luna History Book* (1979), 97–98; *Sacred Precincts* (1984), 67–69, 74, 85, 88, 95, 102, 177, 186, plate 12; *Sayreville Strata (Quartet)* (1976), 61, 74, 88, plate 10; *Sheep's Milk and the Cosmos* (1999), 72, 73, 79, 88; "Silent Gardens: The American Landscapes" series (Stuart), 76–78, 88, 89, 206n63; *Southern Hemisphere Star Chart II* (1981), 81; *Starchart: Constellations* (1992), 69–71; *Starmaker* (1992), 70–71; *Stone Alignments/Solstice Cairns* (1979), 65–66, 67,

Edward S. Casey is Distinguished Professor of Philosophy at the State University of New York, Stony Brook, and author of *Getting Back into Place, The Fate of Place,* and *Representing Place: Landscape Painting and Maps* (Minnesota, 2002).